his best to edge his way to the front row
without attracting too much attention, so
that by now he was panting like a sheepdog,
was dripping with sweat and trod on several
feet as he went by. This proved a failure.

There were glares. Fat Charlie tried to
pretend that he had not noticed. Everyone
was singing a spiritual that Fat Charlie
did not know. He grinned, sheepishly,
then tried to make it look as if he
was sort of singing, moving his lips in a way
that might have meant he was singing along,
and might have been muttering a prayer
under his breath, and might just be random
lip-motion.

The casket was a glorious thing, made of what
looked like heavy duty a stainless steel. In the
case of the glorious resurrection, Fat Charlie
thought when Gabriel blows his mighty horn and the
dead escape their coffins, his father was
going to be stuck in his grave, banging away
at the lid, wishing he'd been buried with a
crowbar.

A melodic final Hallelujah faded away.
Fat Charlie could hear someone shouting at the
other end of the memorial garden, back where he
had come in.

The Preacher said a prayer. And then
he said, "Now. Does anyone have anything they
want to say in memory of the Dear Departed."

It was obvious that several other people
were planning to say things, but

The Art of Neil Gaiman

The Girl the clouds love

The Art of Neil Gaiman

HAYLEY CAMPBELL

FOREWORD BY AUDREY NIFFENEGGER

HARPER
DESIGN

An Imprint of HarperCollinsPublishers

The Art of Neil Gaiman

HarperCollins books may be
purchased for educational, business, or
sales promotional use. For information
please e-mail the Special Markets
Department at SPsales@harpercollins.com.

First published in 2014 by Harper Design
An Imprint of HarperCollins*Publishers*
195 Broadway
New York, NY 10007
Tel: (212) 207-7000
Fax: (212) 207-7654
harperdesign@harpercollins.com
www.harpercollins.com

Distributed throughout North America by:
HarperCollins*Publishers*
195 Broadway
New York, NY 10007
Fax: (212) 207-7654

ISBN 978-0-06-224856-5

Library of Congress Control Number:
2013952628

For ILEX
Publisher: Alastair Campbell
Executive Publisher: Roly Allen
Managing Editor: Nick Jones
Senior Project Editor: Natalia Price-Cabrera
Specialist Editor: Frank Gallaugher
Assistant Editor: Rachel Silverlight
Commissioning Editor: Tim Pilcher
Art Director: Julie Weir
Designers: Amazing15

Cover design by Alastair Campbell
Cover photo by Allan Amato

Printed in the United States

First printing, 2014

By this
book or we
kill more rabbits
send John Bolton out
for more Bath?

It's a world almost exactly the
same as the one you inhabit

But it's a world of wonders
A world of glamour.
Delicate as a spider's web
Dangerous as a razor?

Do you believe in magic

under a spell.

"It's an invisible labyrinth. You can't
see the doors or the walls, but you can
to put ypreg."
"How do you know where everything is?"
"You don't."

contents

neil gaiman, thus far

I met Neil Gaiman and Hayley Campbell at the same party, at the same moment. I was in Sydney, Australia in a warehouse-like space filled with blue light and thumping music. It was one of those opening night parties literary festivals throw in an effort to make their festivals seem more festive. I didn't know anyone and so I stood to the side with my drink and wondered how soon I could politely sneak away. I was very jet-lagged.

Neil appeared at my side and said, "Hello, I'm Neil Gaiman and this is Hayley Campbell." I must have looked confused because he then explained that he was interviewing me on stage the next day. Neil is a kind person. He was very relaxing to talk to. He also knew many people in the room, and after a while he wandered off to talk to some of them. I looked up at Hayley (I am tall, she is taller) and asked, "How do you know Neil?" Hayley explained that he was a friend of her family, she'd known him all her life. We talked about this and that, and Hayley mentioned that she was about to move to London. I said we should get together once she was there. It was a life-changing conversation, but at the time it seemed very ordinary, as most life-changing things are apt to seem.

As time runs along we can all look back and trace the large events in our lives (marriages, children, vocations, artistic triumphs) to some small conversation in a pub, a book encountered at random in a library or a chance meeting on the street. In this book, Hayley Campbell rewinds Neil Gaiman's life and explores the connections between his life, his ideas and his work; she has interviewed Neil about every comic, novel, short story and movie he's ever created, excavated old photos and manuscripts out of boxes in Neil's attic and spoken to many of Neil's collaborators, editors and friends. She has written a delightfully comprehensive, matter-of-fact and sometimes surprising account of the development of Neil's entire body of work thus far.

Thus far: because, of course, Neil is still writing. This is a sort of mid-career retrospective combined with a portrait of the artist as a young punk, plus baby pictures and stories of bad haircuts. This book contains everything you want or need to know about Neil Gaiman (thus far). It will be one-stop-shopping for Neil scholars of the future.

How do we find the thing we are meant to do? How do we become ourselves? These are enormous questions for every young artist, but they can only be answered in retrospect. We see the path only after we've been on it for quite a long time. We read a book and we wonder how it was made. We wonder about the person who made it. We wonder if we could make something like that ourselves.

After that party in Sydney I found myself engaging in a long-running, far-ranging conversation with Neil that has taken place on stages, in cemeteries, wax museums, kitchens, and various hotel breakfast buffets on three continents. He is a good friend, but we don't often talk about personal things (we talk about fairy tales and music and such) so I was very pleased to read this book and fill many gaps in my knowledge of his writing and life.

Hayley did move to London. She became a writer and a close friend of mine (and a few years after that party in Sydney she introduced me to the man I love, but that's another story). Someday, when a young writer is writing a book about Hayley's work, this book will be the auspicious first of many.

Hayley Campbell has known Neil Gaiman for a long time and by the time you finish reading this you will feel that you have, too.

Audrey Niffenegger
London, January 25, 2014

Audrey Niffenegger is the author of the international best-sellers The Time Traveler's Wife *and* Her Fearful Symmetry *and the graphic novel* The Night Bookmobile.

OPPOSITE: Neil and Audrey at the 2011 Edinburgh International Book Fair. Photo by Chris Close.

"I think stories are important, stories are vital. storytellers are in some sense very vital. I'm somebody who makes things up for a living. when I was a kid, people said, 'neil, don't make things up—you're making that up.' and these days, what I do is make stuff up. somewhere in the back of my head, a small, still voice occasionally whispers that this is probably not an occupation for a grown man, and maybe I ought to go and get a real job. but it's what I'm good at, it's what I do. as far as I'm concerned, the world is composed of stories. for architects, the world is composed of buildings, for actors the world is composed of theaters, or whatever. for me, the world is simply composed of stories; when I look, that's what I see."

Neil Gaiman, 1994

INTRODUCTION

"As far as I'm concerned, the entire reason for becoming a writer is not having to get up in the morning."

NEIL GAIMAN DESCRIBES HIS JOB AS MAKING STUFF UP AND WRITING IT DOWN. HE HAS MANAGED TO AVOID GETTING UP IN THE MORNING BY WRITING THE KINDS OF STORIES THAT PEOPLE FALL IN LOVE WITH SO HARD THAT THEY LEND THEM TO FRIENDS AND LOVERS, AND FRIENDS NEVER GIVE THEM BACK, OR THEY DISAPPEAR INTO THE SUITCASE OF AN EX-GIRLFRIEND AS SHE CLOSES THE DOOR ON A RELATIONSHIP. GAIMAN'S WORK, LIKE LIFE, IS SEXUALLY TRANSMITTED.

He is a bestselling author whose countless fans have probably bought each of his books more than once just to replace the ones they've lost. I had to replace my copy of *Good Omens* for the purposes of this book. In doing so, I remembered that you cannot buy a Gaiman book discreetly. Someone will always say something. As you slide a copy of *American Gods* across the counter the chirpy clerk will say something like, "It's a great summer read," but actually mean it. Slipping your receipt between the pages, she'll follow it up with, "It'll make you want to go on a road trip when you're done," and you'll say, "I know," because of course this is also a replacement copy and you already went on that road trip.

A cult author is known to relatively few people yet loved by those few with a rabid eagerness. You get that from Gaiman fans, but they are not few, and they are everywhere.

The man we're talking about by the cash register and in this book is tall-ish and pale, usually dressed in a black T-shirt and black jeans to match his mop of unruly dark hair that is almost more famous than he is. He used to wear a leather jacket and indoor sunglasses as a way of making himself memorable and cartoonable in a world full of cartoonists, although he has recently shelved the jacket until his hair turns white. Born in Portchester in the south of England, he has spent the last couple of decades living in

the part of America where everyone sounds like Frances McDormand in *Fargo*, though it hasn't affected his accent as much as it would have done anyone else's. He is still exceedingly polite and English: he apologizes almost constantly, drinks unimaginable quantities of tea, and lets down his Englishness only in that he tends to talk about more interesting things than the weather. During breaks between interviews for this book as we walked through the craggy, Middle-earth landscape on Scotland's Isle of Skye, he would tell stories about the mythical wren, sunken stone circles, or simply tales of Scottish people murdering one another in elaborate Scottish ways. He has an entire filing cabinet of stories and trivia in his head that come out occasionally over dinner and disappear only once he's found a home for them in his work.

He loves Japanese food and is the kind of person who'll pull up a stool at the sushi bar and ask the chef to send him whatever he would like to cook. Gaiman likes things to be adventures: his career and his life, certainly, but also his dinners.

As a kid he read the likes of C. S. Lewis, Rudyard Kipling, Ray Bradbury, Lewis Carroll, and Roger Lancelyn Green, all of whom feed into the pool of fairy tale and myth that is at the core of his writing. In the *New Yorker* he said G. K. Chesterton in particular left him with "an idea of London as this wonderful, mythical, magical place," which became the way he saw the world. He later used Chesterton as a basis for Fiddler's Green, a much-loved character in *Sandman*.

Gaiman's fiction has a heart that feels personal and true. They are stories that sit in a particular room of the mind that everybody has: one filled with memories of jam and toast, old books with wizened old men attached to graying beards. He weaves long-standing fictional elements into the story's tapestry so it takes on a feeling of timelessness, like the story was always there and he was just the first person to put it on the page. He creates worlds with their own rules and logic—in *The Sandman*, in *American Gods*, in *The Graveyard Book*, in the shortest of short stories—and they work and make sense according to their own little

Neil Gaiman

could no longer tell you how many books he has written, nor how many awards he has won, for them.

Wrote the Ten-volume graphic novel ~~Stardust~~ Sandman, and an illustrated novel called Stardust, and a book of short stuff called Smoke + Mirrors

He was awarded the CBLDF's Defenders of Liberty award for his efforts defending [obscured] art.

He says that everything in the afterword is true except for one thing.

THURSDAY 2 September

ENGLISH
nters
...s to attend fires for the
...he unfortunate suffer-
...c teine, fire."
...enley's *Slang and Its Analogs*, 1904
...normous fire began on
...ually destroying eighty-
...gs. Until that time,
...nsible for fighting fires;
...d until the mid-1800s,
...ired their own fire
...mployees doused fires at
...ving neighboring struc-
...icating the owner's
...ome London buildings,
...as street numbering did

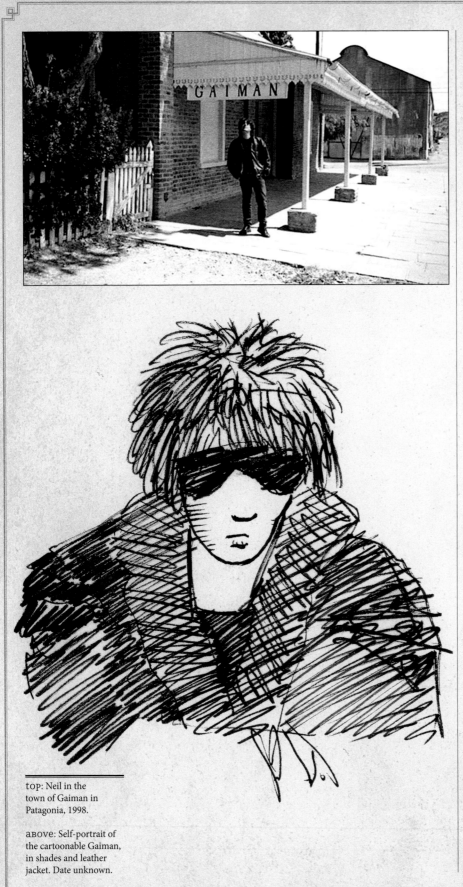

universes, as all the best stories do. In the notebook in which he wrote *Stardust* there is a note he wrote to himself: "create a mythology." It could have been found in the margins of any of his notebooks. He doesn't conform to single genres, preferring to tell the stories he wants to tell and then adding genre to the mix as if it were a collection of spices: a spoon of horror, a cup of fantasy, a pinch of science fiction to taste. These are the ingredients of myth, modern or otherwise, and these are what keep the pages turning.

Gaiman's cultural influence is vast and has taken him from his humble beginnings as a jobbing journalist to a guest role on *The Simpsons.* Between those two moments in time were millions of words read and loved by thousands of people the world over. This book is about how it happened.

Having abandoned the world of journalism—leaving a Duran Duran biography and a book about Douglas Adams in his wake—he set his sights on doing what he had told a baffled school career advisor he wanted to do all those years ago: write comics. He started off, as many UK comic creators did, in the science fiction anthology *2000 AD.* In the chaotic and exciting world of early eighties British comics, a meeting for a subsequently aborted project brought the young Gaiman together with art student Dave McKean. Together they made *Violent Cases,* the book that would soon be seen by the people who needed to see it and launch his career in the United States. It was about misremembered tales of adults, gangsters, and doctors filtered through the mind of the child who overheard them; an astonishing piece of work at any point in a career, a staggering one to come at the start of one. It was the beginning of a lifelong partnership with McKean that would produce countless books and works of art, their names, lives, and bibliographies forever entwined. When asked if all of his stories look like Dave McKean drawings in his head like they do in mine, Gaiman went one further. "My memories," he said, "the stuff I was writing about in *Violent Cases* and *Mr. Punch.* They now look like Dave McKean drawings."

TOP: Neil in the town of Gaiman in Patagonia, 1998.

ABOVE: Self-portrait of the cartoonable Gaiman, in shades and leather jacket. Date unknown.

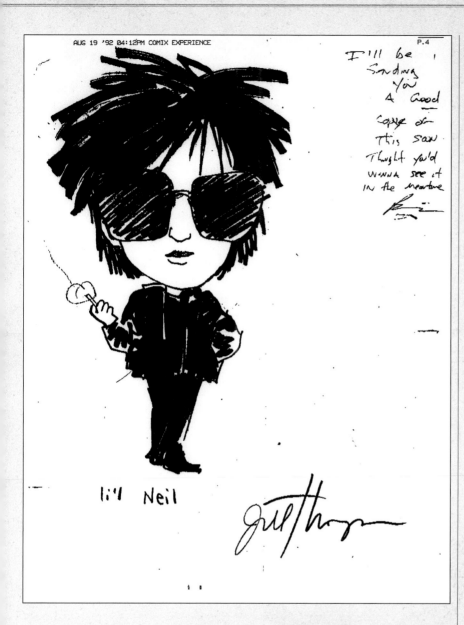

I'll be sending you a good copy of this soon. Thought you'd wanna see it in the meantime

li'l Neil

In 1987, after three years of Alan Moore's *The Saga of the Swamp Thing* changing the terrain of American comics, editors from DC were shipped over to the UK to look for other English writers, hoping the rainy little island could be mined for new stories featuring the same deep, human themes as Moore's. With *Violent Cases* under his belt, Gaiman had already touched on ideas that would have a constant presence in his burgeoning career—stuff about memory and imagination, fear, dreams, gods and myth, sexuality and death. It was not the regular stuff that filled the panels of stale superhero comics, but edgier, smarter, and just what they were looking for. It was the British Invasion of American comics, and Gaiman—along with writers Jamie Delano, Grant Morrison, and Peter Milligan—was to be one of the tea-drinking interlopers. His first project for DC was *Black Orchid*, illustrated once again by McKean. *The Sandman,* the series that made him famous, would soon follow.

Gaiman moved to America in the early nineties with his American wife, Mary, and his children (Mike and Holly, and later, Maddy) when *The Sandman* was at the peak of its popularity—when teenage goth girls were dressing like the comic's most popular character, Death, wearing top hats and smiles and adorning their

ABOVE LEFT: The cartoonable Gaiman, by *Sandman* artist Jill Thompson, by fax.

own eyes with Horus's in midnight-black eyeliner. The move was partly because it was about time his kids got to meet their American relatives, but also because in the United States, Gaiman could buy the kind of great big Addams Family house that doesn't exist in England. He still occasionally lives in it, a brick Queen Anne from the 1880s out in the woods of Wisconsin. It has hallways and high ceilings, and shelves lined with awards—a Hugo, a Nebula, a Newbery Medal. Everywhere there isn't a shelf of books or awards there is art, be it a portrait of the writer James Branch Cabell or a Charles Addams cartoon to match the house. These days the rambling old building is divided into the cat-half and the dog-half, with white German shepherds ruling one side of the house—Lola and, until his death in 2013, Cabal (whom Gaiman found shivering on the roadside and named after King Arthur's hound)—and the ever-changing cast of felines eyeing them from the other. The place has a shingled turret and an enviable basement library with thick carpet, sleeping cats, big old armchairs, and one member of that peculiarly American phenomenon: a jackalope. But, despite stories about the rest of the house, there are no ghosts here in the library. The ghost lives in the attic and runs down the hallways and causes some houseguests to run out of the house screaming in the night, although as Neil explains to visitors dragging their suitcase up to the spare room, it has never bothered him.

He writes in the gazebo at the bottom of the garden where there is a table and chair, a heater, and massive windows that look out into the garden and the woods beyond. When he types on his laptop, which currently sports a sticker that says, "It was covered in bees when I got here," he tends to hum Lou Reed songs, though whether or not he's aware of it is anyone's guess. Outside the door there's an occasionally gloved sculptural zombie hand bursting through the undergrowth, a gift from a fan to accompany the headstone for someone called Behling, though no Behling resides beneath it. There are beehives, vegetables, and flowers; it's a place where the seasons feel like exaggerated versions of themselves.

He takes the dogs for walks by the cornfields and occasionally Lola brings home a mouse-nibbled deer antler between her teeth.

Having moved to America, Gaiman discovered that the country was weird in ways that no one had ever told him. Seeing things from an outsider's perspective led him to write *American Gods*, his big sprawling novel about the gods that immigrants bring with them when they arrive. Like *Stardust* that came before it, *American Gods* spent weeks on the bestseller lists. Subsequent novels *Coraline*, *Anansi Boys*, *The Graveyard Book*, and *The Ocean at the End of the Lane* would do likewise. When asked why his work hasn't been ghettoized like that of other fantasy writers, left to the dark and neatly ordered corner of the bookshop where bestselling books dare not tread, Neil figured it was down to luck and packaging. "And also because what I tend to write, with perhaps the exception of *Stardust*, which is a classic fairy tale, tend to be books that have at least one foot in this world. Most of my books—*American Gods*, *Anansi Boys*, or *Neverwhere*—are at least recognizable as being sort of part of this world even if it's a rather delirious version of this world, or a heightened version of the world, or a world in which metaphors are roaming freely."

His highly adaptable talent would make him a hot property not just within the realms of science fiction and comics, but music too. In the early nineties he was approached by theatrical rock superstar Alice Cooper who wanted, well, a concept for his concept album. Long ago, he found a friend in Tori Amos, who was Sandman's soon-to-be-famous fan when she wrote Gaiman and his Dream King into a song that would feature on her first album, *Little Earthquakes*. Since then, he has penned lyrics for musical artists both known and unknown, most famously his modern classic love song "I Google You," which he has sung live, accompanied by his second wife and punk force of nature, Amanda Palmer of the Dresden Dolls, on piano.

He has written his own TV show, *Neverwhere*, and two episodes of *Doctor Who.* As for the silver screen: *Stardust* was adapted into a live-action film in 2007,

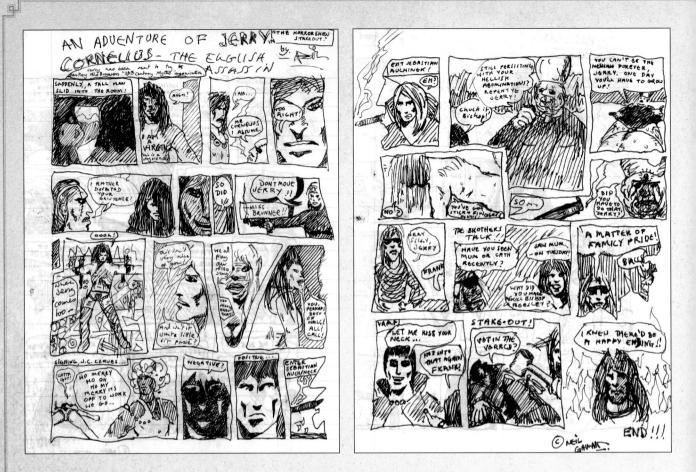

Coraline was an Oscar-nominated masterpiece by the great stop-motion director Henry Selick, and Gaiman cowrote the script (with Roger Avary) for Robert Zemeckis's *Beowulf*, finally released in 2007 after years of painstaking performance-capture animation. There are other movies and television shows in the pipeline, including *Death: The High Cost of Living*, *Murder Mysteries*, and an *American Gods* television show, but as Gaiman has said himself, in Hollywood, "things happen unless they don't."

His stories have been adapted for the stage, beginning with *Violent Cases* only a year after its publication in 1987. Since then we've seen his children's book *The Wolves in the Walls* transformed into a "musical pandemonium" in Scotland that would then go on to tour the UK and have a short run in New York. In 2009 Magnetic Fields frontman and master lyricist Stephin Merritt premiered his musical adaptation of Gaiman's novel *Coraline*, featuring parts played on piano as well as a "prepared"

piano—an avant-garde attack on a regular piano with playing cards, forks, and metal vibrators shoved between its strings—and a toy piano.

Where once you could identify Gaiman fans in the street, now it could be anyone. He classifies them by their one common feature: they are bipeds. They are "a handful of beautiful goths and a handful of boys in dresses and a handful of sci-fi fans and a handful of nervous young girls with multicolored hair and the people who look normal and the people who look like somebody's mum." Gaiman exists, as he put it to CNN, at the intersection of a dozen Venn diagrams. The longevity of his success is no doubt down to the strong connection he has maintained with these fans over the years. From the very beginning he used whatever technology was available to keep in touch with his readers, from the embryonic days of CompuServe to now having two million followers on Twitter. He had a quarterly email fanzine in which he was interviewed

by the editor and answered questions from his fans all over the world. He showered them with limited-edition things and told them how the writing of his latest book was going. He nurtured a fan base, gently and generously, and they in turn have followed him wherever he goes, offering him feedback when he needs it. People have met their future spouses on Gaiman's early internet message boards.

To him, his fans are not a faceless mass—from endless touring and appearances at conventions he has come to know hundreds of them personally in the time he spends hanging out in the hotel lobby and the breakfast bar. A signing will go on for hours past the time it is supposed to have wrapped up.

He had a blog before people had blogs, which he'd actually thought about starting earlier but didn't.

"I was just writing *American Gods* then; I didn't have anything to say." One of the reasons he started was because people had a picture of what Gaiman was like in their heads, which he felt needed a little adjusting. He told journalist Peter Murphy, "I'd show up places to do signings or whatever, and they'd all be visibly disappointed that I wasn't the Sandman. They'd obviously be expecting someone who was six foot five and kind of gloomy and all wrapped up in the beautiful sadness of things, preferably talking in iambic pentameter . . . and they'd get me! And the blog was a lovely way to counter that because nobody expects you to be talking in iambic pentameter when you've written about cleaning up catsick at three o'clock in the morning."

A Gaiman appearance more often than not involves a reading, possibly the only place in the world where a poem gets the kind of screams and applause generally reserved for rock shows. He says that readings are a wonderful thing for an author to do, simply because a writer spends so much of their time alone in a room with a piece of paper and a pen. "There is no feedback from either of these things. So the joy of reading a story out loud to a bunch of people who laugh in the right places cannot be overestimated."

"Nobody expects you to be talking in iambic pentameter when you've written about cleaning up catsick at three o'clock in the morning."

ABOVE: Evidence of time spent on phones.

Dark Horse Comics founder Mike Richardson said that "Neil is one of those very few writers who has crossed over into what is known as 'mainstream.' Neil never forgets where he's come from. He looks at comics not as a stepping stone but as part of a widening base of readers." And as a result his fans follow him, from comedic novels to substantial serious ones, from children's books to poems. They find new books to read and music to listen to just by following him online, because people like Neil and they want to know what Neil likes. And when he goes and marries a rock star, people who have never heard of her go to her gigs. Their fan bases have intermingled, and Gaiman and Palmer have become an art chimera.

Growing up in the time of punk meant that the idea was instilled in young Gaiman's head that anyone is capable of anything, and if they want to do it they should just do it. Probably this is why his career is so varied and wild. To a biographer, it is insane. It makes no sense. When did he sleep? When can I sleep? If I sleep he'll do something in the time I'm not looking and that will mean writing another chapter. Sifting through his attic of archives it becomes abundantly clear that he always wanted to do lots of different things; that while he has always had his eye on writing science fiction and fantasy, there was no real distinction between different art forms in his head. There are endless pieces of paper and faxes and letters in which comic book artists give him tips for sketching—artists like Bryan Talbot, McKean, and Jill Thompson—in case he ever wanted to draw properly. There are bits of paper with ideas for films, short stories, novels, poems, song lyrics, and comics. There are ancient Post-its that are notes for things not even Neil can decipher, but they are kept there, in the attic, just in case someone ever wanted to go through them for a big coffee-table book about the full and varied career of Neil Gaiman.

This is that book, and I am your guide through those boxes of things. Those boxes of scrawled notes on hotel notepads, diaries, photographs, artwork, and news-

OPPOSITE: Evidence of time spent in restaurants.

ABOVE: From under the bed, prized twenty-year-old comic, the then-four-year-old author's introduction to the work of Neil Gaiman.

ABOVE RIGHT: A portrait drawn by the author, age six.

RIGHT: A sample of Neil's notes. The first line wound up, in an altered form, in *The Sandman: The Wake*.

paper cuttings that live at the top of his Addams Family house in big plastic tubs. With the ghost.

It's the story of his career, how he got to where he is, and the stuff he made along the way. The art. But part of the art of Neil Gaiman is how he traverses the terrain and flits between worlds, how he bluffed his way in and then nobody asked him to leave because he's nice and smiley and funny. Above all, they let him stay because he is an incredible storyteller with a beautiful heart and an ability to make you fall in love with anything at all. And, while I have made my best efforts to organize events chronologically, a lot of stuff in Neil's life happens all at once. He doesn't work like fiction.

I first met Neil in late 1992 when I was six and he came to stay at our house. My dad, Eddie Campbell, had told me that Neil Gaiman was coming to stay and said it with such excitement in his face that I gave up my bedroom and slept on the sofa quite willingly because *Neil Gaiman was coming to stay.* I didn't know who he was, although I knew he was the writer of my favorite story at the time, "A Dream of a Thousand Cats," otherwise known as *The Sandman* #18.

That year I was the guinea pig for *The Day I Swapped My Dad for Two Goldfish*, which he had only just finished, and which he read off a thing I had never seen before in my life: a laptop. When it came out four years later he dedicated it to Hayley Campbell, "although she may be too big for it." ❖

1

preludes

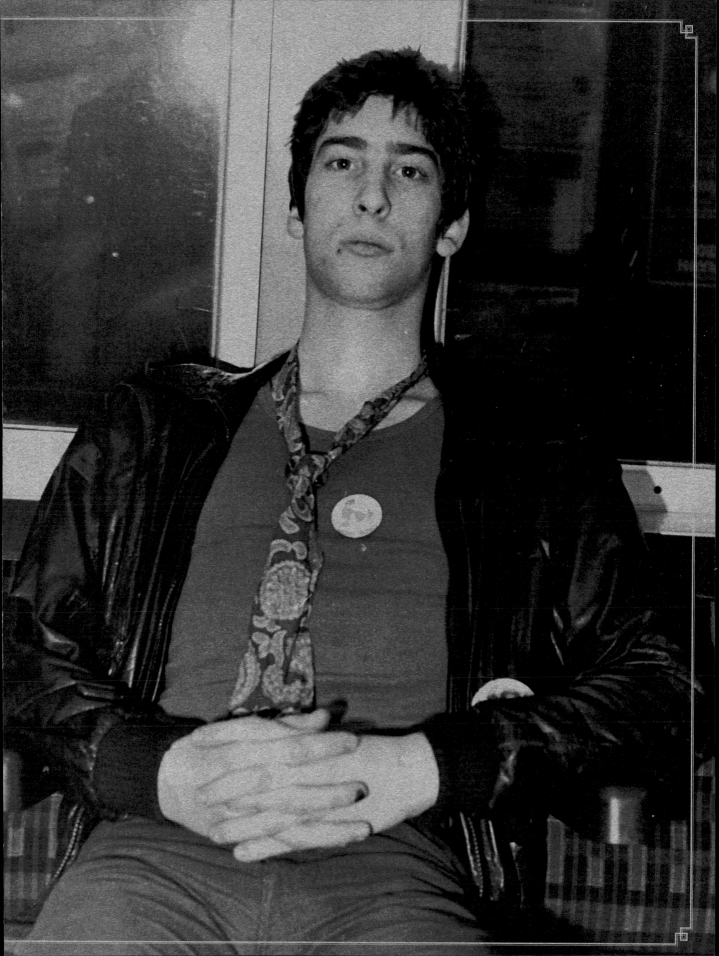

very earLy NeiL

*"I wish I had an origin story for you.
When I was four, I was bitten by a radioactive myth."*

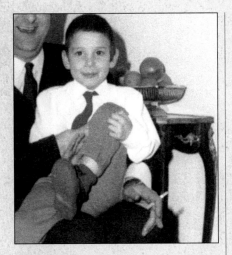

ABOVE: "When I was about four or five, my hair was bothering me, so I took matters into my own hands. I found a pair of scissors, climbed into bed, got under the sheets, to hide, I suspect, and gave myself a haircut. It was the sort of haircut you give yourself in the dark under your sheets at the age of five. This was after the attempt to repair it by my father."

NEIL RICHARD GAIMAN WAS BORN ON NOVEMBER 10, 1960, TO DAVID AND SHEILA GAIMAN (NÉE GOLDMAN) ABOVE A GROCERY STORE ON WHITE HART LANE, PORTCHESTER, A SMALL TOWN IN HAMPSHIRE ON THE SOUTHERN COAST OF ENGLAND.

As a grown man he would plunder his family history in half-remembered glimpses and misremembered details for fiction. But before they were fed through the filter of Gaiman's pen, the facts—or at least the original version of the stories—looked a bit like this.

His father ran the family grocery before finding that there was more money to be made in trading property, and his mother was a pharmacist. They were married in 1959 and Neil was the first to be born, followed by his sisters Claire and Lizzy. Neil says he was always the weird one of the bunch, although it never occurred to him at the time. "The lovely thing about being the first child is that nobody has anything to measure against, so nobody knows they're weird" (Anderson, 2001).

Before he'd learned so much as the alphabet, Gaiman was writing poems. He remembers having to dictate them to his mom since he couldn't actually write them down himself.

From the very beginning, everything was about words.

In 1965 the family moved to East Grinstead in West Sussex, where the English center for Scientology is found, so his Jewish parents could begin taking Dianetics classes. When Gaiman was eight years old he was enrolled at Aston House in Sussex, a place he later wrote about in the highly autobiographical short story "Closing Time." He was nearly expelled for saying the word "fuck":

I'd heard some dirty jokes from some kids walking home from school. They were from different schools but we'd walk home together. And so the next day when I got to

THE ART OF NEIL GAIMAN

school I told the dirty joke that I'd heard the night before. And these kids thought it was hilarious, especially the one who went home and told his parents. The next morning I found myself in the principal's office with the headmistress and they said, "Neil, do you know what a four-letter word is?" Now I was a smart eight-year-old proud of my vocabulary so I said, "Oh yes, THIS is a four letter word," and started listing words with four letters until they told me to stop. Then they started asking me about jokes that I'd heard and I suddenly realized where the conversation was going. My mother was called in to see them and that night she came home and she said, "Apparently, you said a word so bad that they would not repeat it to me. What did you say?" and I said, "Fuck." And she said, "That word is so bad you must never, ever ever ever say that again to anybody." And I thought: Cool. You can do that with just a word!

In the end, the school was going to expel me but then the other kid's parents pulled him out and the principal decided she could not lose two sets of school fees. I felt very much like a troublemaker at that point.

The first story he ever wrote was around the same time as his near-expulsion. It was a series of short stories—and it was definitely a *series*, not just a one-off—about an alien frog with a spaceship that looked like a football, his assistant the time-traveling professor, and their occasional companion, Neil Gaiman. "They'd go off and have mad time-travel-y adventures. I remember feeling very proud of my stories, and getting a lot of attention so I just kept reusing these characters for the rest of my stay at that school. Every English essay, I'd write a story about the time-traveling frog and the professor and me, or a me-character, and we'd be going off and having amazing adventures. And then I went to my new school, Ardingly. First English essay, I pulled out these characters, wrote a story about them, and got back a C grade with a comment saying, 'This all seems very silly.'

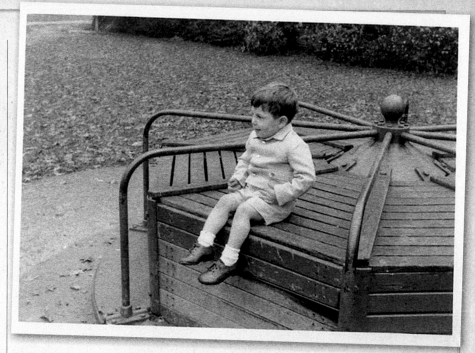

And I thought, 'Ah, that's interesting, you can't take characters from one school to another.' It was like different universes. I have to leave those characters there."

At this point Neil moved on to a kind of fan-fiction in which Conan the Barbarian meets the characters in Kenneth Bulmer's novel, *Swords of the Barbarians*, the first sword-and-sorcery book that Gaiman ever encountered. ("It was very, very disappointing, many years later meeting Ken Bulmer at some convention. In my head Ken Bulmer looked like Conan. And if you ever see a photo of Ken Bulmer you will discover he did not look like Conan. And it was a shock—because I was twenty-one

Left: A note from the doctor. Neil arrived bang on time.

above: "In Sussex, aged about twenty-two months. Waiting for my sister to be born. Such a neat child (although I've probably been dressed by my grandmother). You pushed the roundabout around until it went fast and then you jumped on. Or you tripped and were pulled around, face-down, skinning your knees" (Henderson, 2009).

or twenty-two, and I really should have known better by that point.")

The first books Gaiman ever read and liked were Enid Blyton's *Noddy* stories, but the first actual comics he encountered were about Sooty the glove puppet in a *Sooty* annual from about 1963 when Gaiman was only two or three himself. "I remember there were comics where an overweight policeman fell asleep and floated out to sea. And I remember for the next year or two, when I'd get them, comics would be things like *Pippin*, which were aimed at little kids and almost never

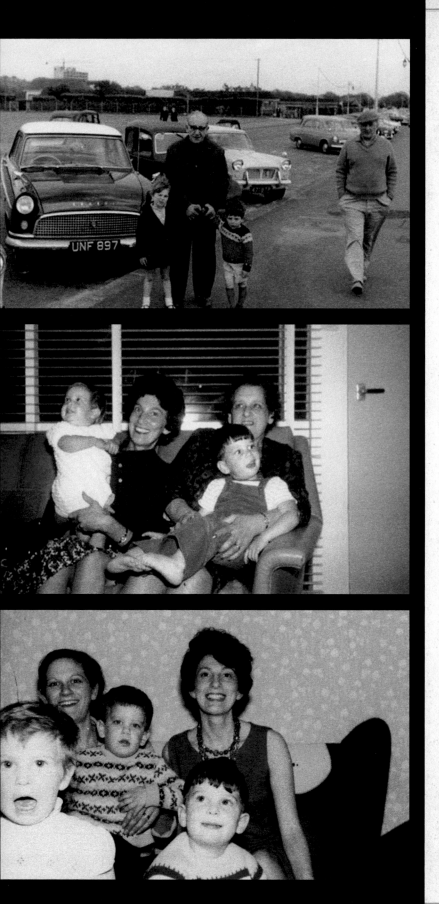

had word balloons. They'd have a picture and text underneath instead. There was one comic about these little cute woodland creatures, things that looked kind of like weasels, and jam—their problems making lots of jam, and their obsession with jam. I loved those comics."

Neil says he was probably more of a book guy than a TV guy simply because his parents weren't that into TV—he was allowed to watch *Children's Hour TV*, which wasn't actually an hour but just fifteen minutes of bad puppet shows. But at his grandparents' house in Portsmouth he could watch what he liked, and not only did he meet Doctor Who in their sitting room, he also met Batman.

"I fell in love with the *Batman* TV show. I'm not sure there's any other way to describe it. It was the best thing in the world. There was nothing about the *Batman* TV show I did not love. The moment it started showing on British television, I was watching it. Batman was primal. In weird, huge scary ways, Batman was primal."

The popularity of the TV show led the publishers of the British comic *Smash!*—which consisted mostly of humor strips but also some American Marvel reprints—to start including a similarly camp (and similarly reprinted) syndicated newspaper strip that took its lead from the TV show rather than the DC comic. It occasionally had guest appearances by people like the American comedian Jack Benny, another of Neil's lifelong loves (he has written an as-yet-unproduced musical based on Benny's life).

Smash! was one of a handful of comics that Gaiman's father brought back from his job in Portsmouth. Neil talked him into getting *Smash!* every week, which then extended to *Wham!*, *Pow!*, *Fantastic*, and *Terrific* too. It was here he met Spider-Man, Hulk, and the X-Men. And he read them to the exclusion of all else. He was someone for whom the pages served as blinkers, and he was regularly frisked for books before family gatherings lest he disappear off into a corner to read and stay there for the whole afternoon.

When Gaiman was seven years old, a boy at the end of the lane had a copy of *The*

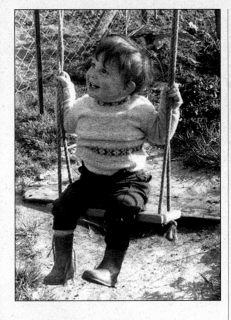

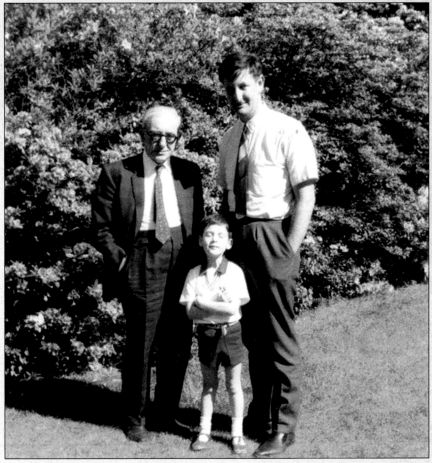

"There was nothing about the Batman TV show I did not love."

Penguin Charles Addams, an oversized black-and-white paperback that he would go over and read until the day the boy moved and took the book with him. The Addams cartoons were a focus of concentrated fascination not because they were funny, but because they were like riddles and puzzles to be unlocked or solved. "I'd stare at these drawings of people in haunted houses knitting baby clothes with too many limbs, or of ski tracks going around trees, or of one small face staring up at a screen with joy from which everyone else in the audience was staring at in horror, repulsed, and I'd work hard to figure out the story of the image, the what was going on, the why and the whether it might be funny, the what-happened-before and what-would-happen-after, and, one-by-one, they would make me happy.

"Then again, I was a seven-year-old kid whose favorite short story was probably Bradbury's 'Homecoming.'"

"Homecoming" was the first of Ray Bradbury's work he had ever read, and it changed him. "I identified more with Timothy, the boy being brought up by a loving family of vampires and monsters than I had ever identified with any fictional character before. Like him, I wanted to be brave, to not be scared of the things in the darkness. Like him, I wanted to belong."

In his grandparents' sitting room he also discovered ITV's 1967 production of *The Lion, the Witch and the Wardrobe* and immediately set out to own a copy of the book—purchasing it for himself at the age of six, as well as the third book in the series, *The Voyage of the Dawn Treader*, but missing out on the second because the shop had an incomplete collection. It got sorted out in the end, though: "I remember, for my seventh birthday, my parents got me a boxed set of the Narnia books, all seven of them, and I lay on my bed and read them. That's what I did on my seventh

OPPOSITE TOP:
"Mr. Punch territory. My cousin Sara, my paternal grandfather, and me (and an anonymous passerby) on the seafront in Southsea. July 1963" (Henderson, 2009).

OPPOSITE MIDDLE:
"My sister, my mother, her mother, and me. September 1963" (Henderson, 2009).

OPPOSITE BOTTOM:
Neil and his mother, about 1964. She would have been twenty-eight. "She's on the right, and I'm the dark-haired three-year-old sitting below her. (My sister Claire's at the front left, and behind them, my late Aunt Myra and my cousin, ace photographer Elliott Franks). And the wallpaper means the photo was taken at my grandparents' house, at Parkstone Avenue in Southsea."

ABOVE LEFT: "About three? Down at the bottom of the garden in Purbrook, in Hampshire, on the swing" (LitPark.com, 2009).

ABOVE RIGHT: Three generations of Gaiman men: Neil, his father, and his grandfather in 1967.

birthday: I read my way through the complete set. I already had *The Lion, the Witch and the Wardrobe* and *The Voyage of the Dawn Treader*, but I didn't have the others. I actually covered the set in cellophane. I made my parents get me cellophane, and we wrapped my Narnia books in them, like books were wrapped in the library" (Wagner, 2008).

Reading C. S. Lewis was the first time Gaiman remembers going crazy for a book, but it was W. S. Gilbert of the Victorian-era theatrical duo Gilbert and Sullivan—the team behind comic opera masterpieces such as *H.M.S. Pinafore* and *The Pirates of Penzance*—who was to be a more subversive obsession.

I was taken to my first Gilbert & Sullivan when I was three by my aunt Diane, who died of leukemia a couple of years later. And it was Iolanthe *and I loved it because it had magic in. My tastes have not changed. I'm very much that thing that I've always been. The subtitle of Iolanthe is 'The peer and the Peri.' A peri is a kind of Persian fairy. And when I was three I was absolutely willing to put up with the peers for the peris. It had a very scary fairy Queen, and it had magic. Didn't have much magic—the best you can say for it is that at the end all of the lords grow wings, magically, and become fairies too. But I was willing to put up with everything that wasn't magical because there was magic there.*

I made my Mum go and get me the record of Iolanthe. *And I made her get me the* Children's Mikado—*it was the story of Mikado told for children, with quotes from some of the songs in it. That and the* Children's Hiawatha, *which is an edited down* Hiawatha *she used to read me at night before I went to sleep, which I loved. 'By the mighty Gitche Gumee, by the shining big-sea-waters, stood the wigwam of Nokomis . . .' Lovely bouncy syllables.*

What he loved most of all about these Gilbert and Sullivan musicals were the words. He got words from Gilbert, and he got to see what they could do. "Everything that Gilbert was about, in many ways, is the magic of words, even all the questions of identity that Gilbert's plots so improbably hinge on are always word-based" (Wagner, 2008).

Apart from yearly visits to Sadler's Wells, the other traditional outing was to the cinema, although this was largely against Neil's will. At five he had to go and buy himself a copy of P. L. Travers's *Mary Poppins* on account of the ongoing situation with the film and how no one would take him to see it. "I would have gone to see *Mary Poppins* as many times as anyone would take me. The only thing that anybody took me to that was around for-fucking-ever—it was around for years, and people kept taking me, and I hated it, every time I'd hate it worse—was *The Sound of Music*. Adults would take you to see it as if they were doing you a favor, and I would shoot my fingers off rather than go again" (Wagner, 2008).

✦

The next important thing that happened was the box of American comics: proper four-color comics from America, not chopped up and rearranged in small British paperbacks with one panel to a page. "It was my first real exposure to American comics and it was absolutely like giving somebody The Drug. The thing that you want, the thing that you need. And it was a great, wonderful box of comics some time around 1968-ish. Maybe 1967. There were loads of *Fantastic Fours* in it, the Silver Surfer stuff. It had *The Brave and the Bold* where Batman and Green Lantern are on the front in iron stocks saying 'No, no save yourself!' And the one where Batman and Hawkman are on the cover trying to pull off each other's masks while they're in the air. And there was *Inhumans* in there, and there was some *Spider-Man*."

There were seventy to eighty mid-1960s comics in that box that he read several times over, and Gaiman still has no idea how they came into his life. "Every now and then I get grumpy about my dad having died because there are things I would love to have answered that my mother is com-pletely clueless on. There are things that I would love to know. One of the last con-versations I had with my dad, I mentioned this box of comics and he said, 'Oh yeah, I know where you got those from. I know where they came from.' I didn't say, 'Where? Who? Tell me!' I put it off. I figured, 'Oh good, it sounds like that's a story. Next time I see him I'll say: so, tell me about my box of comics.'" He never found out, but this was the person who introduced Neil Gaiman to Sandman. It's all their fault.

"It was in a Justice League/Justice Society crossover. 'To touch Anti-Matter Man was to risk instant destruction!' said the cover. And the Anti-Matter Man was this weird guy who was walking between Earth One and Earth Two, which are being held apart by The Spectre, who is very, very big and capable of holding two planets apart. And everybody is having a battle on the Spectre's back while the Anti-Matter Man is walking up and down, turning everybody's power against them. Sounds a bit silly now I come to explain it."

Outside of the box, and with only a small amount of pocket money to his name, Neil could afford one single new comic per week. In order to make sure he picked the right one, he would stand in the corner store on East Grinstead High Street and "sample" the wares, trying to read as many as he could before he got told off. "I do remember them actually picking me up and putting me on the sidewalk and me going 'No! I know what I'm going to buy!' They did actually let me back in to buy something and what I bought was a Batman TV tie-in novella. It wasn't a comic, and I assume I bought that because I thought I could get more story for my money. I was always obsessed with how much story you can get for your money."

It was partly this idea that led Gaiman to wander outside of comics where he discovered Michael Moorcock with *Stormbringer*. "Moorcock's *Stormbringer*, age nine, fucked my head in really good ways. And the fact that it ends with Elric the hero plunging his sword into Zarozinia his beautiful princess—who has now become transformed by the powers of chaos into

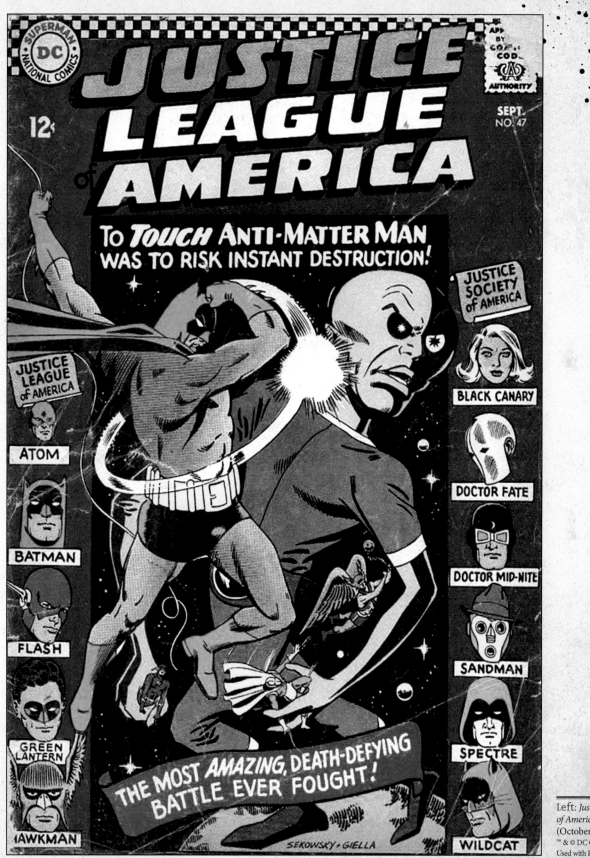

Left: *Justice League of America* #47 (October 1966).
™ & © DC Comics. Used with Permission.

Left: An early Gaiman written-and-drawn comic, dating from 1976, when Neil was sixteen.

some kind of horrible maggot creature—and he sucks her life with his big black sword and then brings about a new world and then the sword kills him and then the sword transforms into this laughing dancing demon thing that says, 'Farewell my dear friend, I was always more evil than you!' and flies off . . . you're sort of going: I didn't know you could end a book like that. He was a hero! He just got fucked by the sword! And he was about to save this princess! And she was dead! And killed! That's so cool! I was nine and that was as good as it got."

my dad would embarrass me by making me take sandwiches. I was absolutely fine given the prospect of a day spent with books and not eating. Sandwiches were embarrassing. But if I was given sandwiches, I would take them dutifully to the library and I would carry them around with me for the morning and then with relief, somewhere around lunch, I would go and sit out in the parking lot, eat my sandwiches, throw the bag away, very happily, and go back in no longer having to worry about sandwiches.

a dozen books without which I would be a different person. One of which is Samuel R. Delany's *The Einstein Intersection*, which is a reinvention of the legend of Orpheus in a science-fictional context set in the far, far future where people have left the world and things have come and are sort of inhabiting the shapes that we left, and the mythic structures that we left. It's kind of like Orpheus versus Billy the Kid. It's a strange, beautiful book. I read it when I was ten, eleven maybe. I didn't understand it but it didn't matter. I think whatever you get from those books—you may not be getting everything, you may not be getting what you're meant to be getting—but you'll get *something*. And sometimes simply knowing that there is more to be known and that you don't understand it is as important as anything."

"I was always obsessed with how much story you can get for your money."

His tenth birthday present was a self-assembly shed, which his parents constructed for him at the bottom of the garden. Here in his undisturbed bookish haven he absorbed the work of Lewis Carroll, Rudyard Kipling, William Burroughs, R. A. Lafferty, Baroness Orczy, H. P. Lovecraft, Bram Stoker, James Branch Cabell, and Kurt Vonnegut. He borrowed the first two volumes of J. R. R. Tolkien's *The Lord of the Rings* from his school library, constantly reading them and returning them and borrowing them again, but it wasn't until he won both the English prize and the school reading prize that he was able to request *The Return of the King* as his reward and find out how the saga ended. Gaiman maintains his success in most subjects at school had nothing to do with any particular aptitude, but because he would read the books as soon as he was handed them on the first day of school. He simply knew what was coming up.

I was going to the library too. I'd get my parents to drop me off at the library on their way to work in the morning during school vacations. Sometimes

I would read until the library closed at 6:30 and they would throw me out and I would walk home. And sometimes I would take books out, if I knew I wasn't going to get back the next day. They had old-style card catalogs with subjects, which were just so great because I could look up "magic" and just go through and find everything with magic in. I could go through and find ghosts, and look up witches, and just read every book on that subject. I tried going alphabetical, not reading everything but reading anything that looked interesting. Then there came a point where I'd finished the kids' books and I had to figure out how to read an adult library because there weren't subject cards. So I just had to go "Okay, I'll start at 'A,' I guess."

He worked his way through the shelves, learned the inner workings of the interlibrary loan, and ate his embarrassing sandwiches. His mind was being changed and molded by dozens of new writers every week. "I could probably list maybe

If you asked eleven-year-old Neil what he wanted to be at this point he would have said a hard science fiction author. "The fact that I wasn't actually terribly interested in hard science was something that I figured would happen. That would come in time. I would suddenly develop a passion for and a delight in theoretical physics about the same time that my testicles dropped, probably. And my voice changed and I grew hair in interesting places. And it didn't happen."

At thirteen he received books as bar mitzvah gifts and read things he might not have picked up on his own—Shakespeare and *The Complete Works of Oscar Wilde*—as well as the Bible stories he persuaded his instructor to teach him instead of studying for said bar mitzvah. He moved schools again, to Whitgift in Croydon, outside of London. Comics were his first means of communication with the other boys in school. Four of them would do the rounds of Croydon's second-hand book and magazine shops. A couple of years later, Gaiman and his pal Dave Dickson would go to the comic marts and renowned science-fiction shop Dark They Were, and Golden Eyed. But before they discovered those places they were making end-of-term pilgrimages to a shop called Fantasy Unlimited in London's East End.

Then punk happened and Neil had records to buy instead. And hair dye. ❖

PUNK

"I've been making a list of the things they don't teach you at school. They don't teach you how to love somebody. They don't teach you how to be famous. They don't teach you how to be rich or how to be poor. They don't teach you how to walk away from someone you don't love any longer. They don't teach you how to know what's going on in someone else's mind. They don't teach you what to say to someone who's dying. They don't teach you anything worth knowing."

IN GAIMAN'S ADDRESS TO PHILADELPHIA'S UNIVERSITY OF THE ARTS GRADUATING CLASS OF 2012—HIS "MAKE GOOD ART" SPEECH, PUBLISHED IN BOOK FORM IN 2013—HE GAVE THE KIND OF USEFUL ADVICE THEY DON'T GIVE YOU IN SCHOOL.

W*hen you start out on a career in the arts you have no idea what you're doing. This is great. People who know what they're doing know the rules, and they know what is possible and what is impossible. You do not. And you should not. The rules on what is possible and what is impossible in the arts were made by people who had not tested the bounds of the possible by going beyond them, and you can. If you don't know it's impossible it's easier to do. And because it hasn't been done before they haven't made up rules to stop anyone doing that particular thing again. . . . If you have an idea of what you want to make, what you were put here to do, then just go and do that.*

The root of this idea—of just going and doing it, even though you don't actually know what you're doing—can be traced back to punk. When Gaiman was in his final year at Croydon's Whitgift School in 1977 it was the deafening peak of the punk era, and he was at the center of it, geographically.

ABOVE AND OPPOSITE:
Band photos by Nick
Harman—The Ex-Execs.

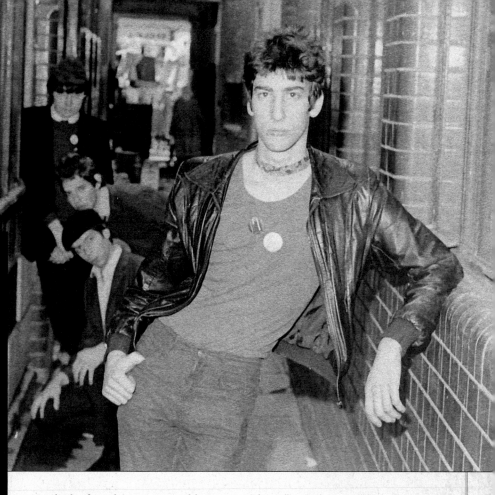

THE EX-EXECS WERE OFFERED a record contract at some point, by Heat Records, supposedly a cool, indie label founded in a record shop in Croydon. They wanted to release Neil's song "Victims" as a 45. "I just remember taking a contract we were given by Heat Records to this Australian guy who managed a band, and saying, 'Would you read the contract, I don't understand what I'm being asked to sign here, I'm sixteen and I'm certainly not signing anything that I don't understand.' And the guy read it and he said, 'Come over to my place and I'll talk to you about it.'" It transpired the contract was structured in such an unfair and exploitative way that even if the band got a number one single in the UK, they would be lucky to earn £100 each. "It wasn't really the amounts of money that were involved, because I don't think I really understood or cared about money, but it was definitely that point of me going: This is not a safe healthy thing. This is not a good thing. I don't want to do this thing. And I think the rest of the band really did want to do the thing. And I just thought there was something fundamentally screwed. I understood the concept of being screwed."

He had a firm theory, nurtured by Lou Reed, that you didn't actually have to be able to sing to do vocals, so he fronted his own punk band called Chaos, which soon became the Ex-Execs instead ("just because you could write it XXX"). "We did a terrible cover version of *Suffragette City*. We did *Sweet Jane* because you had to. Quite a good *Mystery Girls*, the New York Dolls number. The best cover we did was *Something's Got a Hold of My Heart* as if it was being done by the Stranglers, really slow and menacing."

The whole ethos gave him a new way of thinking. "The DIY attitude of punk has certainly informed all of my career, including comics. Without punk I probably would have gone through with my original plans to become a comparative theologian while dreaming wistfully of becoming a writer" (Lawley, 1991).

The band included the future eminent artist Alan Kingsbury, UK comedy producer Graham Smith, *Meteorite Men*'s Geoff Notkin, and someone called Simon Wilson (but only temporarily because he left the band or vice versa). Gaiman even started a magazine, a xeroxed, folded-over pamphlet called *Metro*.

I got a small collective of friends together: Geoff Notkin, Dave Dickson, Steve Gett, and me. And we formed Metro. *It was my name. It was a really good name because it sounded like something you'd heard of. It meant that you could get on the phone to people and say, "I'd like to interview Michael Moorcock. It's for* Metro *magazine." And they'd go, "Oh, okay."*

There were three or four issues of Metro, *I think. It did actually launch the journalistic career of Steve Gett, who interviewed the band UFO for* Metro, *and Rush, too. He went off to work for* Sounds *and became a founder member of* Kerrang!— *huge heavy metal fan. Anyway, we couldn't afford any typesetting, but what we could afford was Steve Gett's*

G aiman, for a very brief period in time, did not have his famous dark mop of hair. Like pretty much every sixteen-year-old, he made a hair mistake.

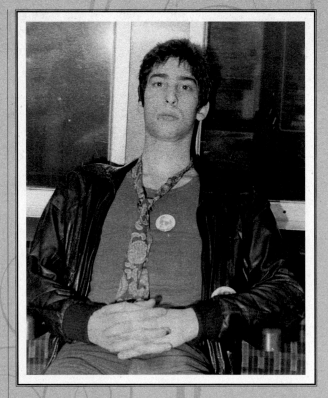

Geoff Notkin and I were only sure of one thing, which was that Billy Idol's hair was the best possible hair in the world. And this was Billy Idol with Generation X—he wasn't Billy Idol yet. So we went out together to Boots the Chemist and bought hair bleach with pictures of ladies with hair the color of Billy Idol's hair on the front so we knew it would work. And we bleached our hair. For several hours we let it sit there, we read comics, we talked, we played music. Then we washed the stuff off and we looked at the results. Geoff's hair was blonde, and looked kind of cool. My hair, which had too much red in it to start off with, was a horrible straw-orange. So I thought, "Well, it's punk and I've dyed it." And I went home.

I was sitting in the room of our house that the piano was in, writing songs, which is what I did most of the time back then, when my dad walked past, stopped, came back, did a double-take, leaned in, and blew his top. "What do you think you're doing?" And I said, "Well, I've dyed my hair." And he said, "No, no. That's disgusting. That's revolting. You can't live here. If you're going to have hair like that I'm throwing you out of the house." And I said, "Well, you're the one that's really big on human rights, what about my human rights?" And he said, "Well, you absolutely have your human rights, I will give you £15 a week and you can have your hair any color you like and you can go and rent a house, I'll keep paying your school fees, you can rent a room anywhere in town. But you're out of here."

Those days I was very good on comics but not so strong on the practicalities of life. The me of these days would simply call his bluff. And the me of these days would say, "Oh, okay. I'll move. Give me that £15 a week and I'll start arranging for somewhere to live." But at that point it seemed terrifying to me. He left the house saying, "I'll be back at midnight and when I get back your hair has to be dark again." But it was six o'clock at night—everywhere that you could possibly buy hair dye had closed at 5.30 p.m. So I phoned my cousin Leigh (because my cousin Leigh was the person who was most likely to have hair

dye) and I said, "I have to dye my hair dark, do you have any hair dye?" And she said, "Yeah, I've got a box of raven black around here somewhere. Come and get it."

So I ran over, got the box of raven black. I put the stuff on my hair, having never dyed my hair dark before, and did not read the instructions about making sure you have rubber gloves. I left it on for an hour and a half, washed it off, and when I got up the next morning my fingernails were black. And what was cool was having dyed my hair to an orange and then put black on it, I then had jet-black hair with purple highlights. The blue-black highlights hit the orange, and it was purple. The next day my Dad was happy; honor was satisfied. Later on I was at the band gig that we were dying our hair for in the first place. Geoff's hair was still blonde, and I had hair that was actually significantly cooler than the sad bleach thing, and I had the story to go with it. And that is the story of how Geoff and I dyed our hair.

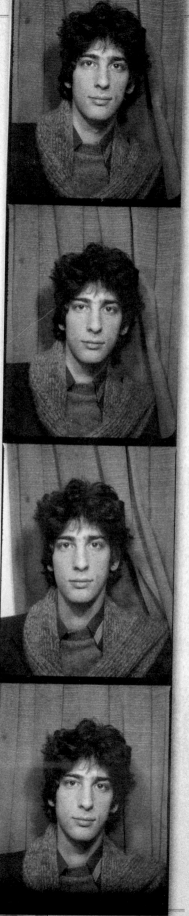

amazingly beautiful handwriting. So Steve would handwrite the entirety of Metro *and they'd be reproduced from those. And advertising space was sold, mostly for Webster's bookshop in the Whitgift Center.*

The tragic thing is that I don't think the stuff I did made it in. But the two things that I did were a Michael Moorcock interview (which Dave Dickson was meant to transcribe and never did) and a Roger Dean interview. We went down to Brighton after school on the train and it was tragic because the interview was really good and really long but the batteries went flat on our tape recorder. The only good thing to come from it was that at every interview I ever did as an adult journalist I had spare batteries and spare tapes with me, always. Because I knew that things could go wrong, and I remember the sheer horror of getting home and playing an interview and Roger Dean going, 'Oh yeah well the original idea behind those Yes covers was reallykindofthethingblibburrrrrrr...'

Gaiman didn't interview Reed until he had given up journalism in favor of fiction for about three years or so, in 1992. The piece he wrote is largely about how difficult it is to get an interview with Lou Reed (it's called "Waiting for the Man"), but once he gets him on the phone—half an hour before Reed is supposed to go on stage—he asks him questions that make it worth it, and the famously difficult Reed is interested enough that they talk right until curtain call, when the buzzers are going off and the babble of people can be heard in the background. They talk about writing and about artistic vision, and Gaiman asks the questions of someone who knows his subject like a lifelong fan.

Gaiman quoted the song "Going Down" from Reed's first solo album on the back of his first comic for DC, *Black Orchid*. During the An Evening with Neil Gaiman and Amanda Palmer tour, Palmer sang a different Velvet Underground song for every night of the tour as a birthday gift.

In October 2013 Lou Reed passed away. Gaiman wrote an article for *The Guardian* explaining Reed's influence on both him and his work, not least *The Sandman*. "It was all about stories," Gaiman wrote. "The songs implied more than they told: they made me want to know more, to imagine, to tell those stories myself." ❖

BELOW: Neil as a young punk, leaning on a window displaying Lou Reed's *Transformer*, 1976.

RIGHT: Gaiman, age seventeen and in a photo booth.

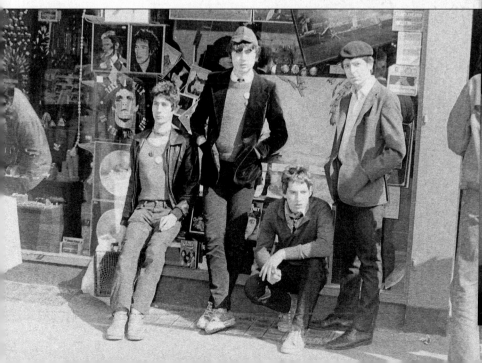

one of those first novel things

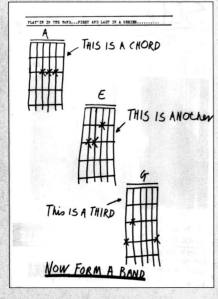

PLAY'IN IN THE BAND...FIRST AND LAST IN A SERIES............

A

THIS IS A CHORD

E

THIS IS ANOTHER

G

THIS IS A THIRD

NOW FORM A BAND

ABOVE: The famed "Now Form a Band" illustration, from punk zine *Sniffin' Glue*, which is where Neil probably came across it first (although it originally appeared in another magazine, *Sideburns #1* in December 1976).

"PUNK STILL INFORMS EVERYTHING I DO," GAIMAN SAID IN AN INTERVIEW IN 2011. "YOU HAVE TO BE WILLING TO MAKE MISTAKES, AND YOU HAVE TO BE WILLING TO MAKE MISTAKES IN PUBLIC. SOMETIMES THE BEST WAY TO LEARN SOMETHING IS BY DOING IT WRONG AND LOOKING AT WHAT YOU DID.

When I was fifteen going on sixteen, punk rock—the idea of here's a chord, here's another, here's one more chord, now form a band—is one that sort of always stayed with me. Figure out what you need and learn the rest of it, and you do it. And that was punk. It still seems to be the smartest, most glorious way to do anything: You do it" (Steel, 2011).

Instead of going to university—considering the four years he would spend there as just a four-year delay before he could start becoming the writer he wanted to be— Gaiman just picked up a pen and started writing.

"I was always writing fiction, but I was mostly writing fiction for school. I found a bunch of stuff the other day when I was back at home, which was being written during that period. Very late teens, very early twenties. Laboriously handwritten. Some of it typed up once I'd learned to type, which came late. I think for a few of the early stories I may have actually persuaded girlfriends to type for me."

He learned to type eventually, when he was writing his first novel, *My Great Aunt Ermintrude*. He was twenty-one at the time and had bought a typing manual but finished writing his novel before he finished reading the manual. He still functions as a hunt-and-peck typist to this day because of it, which goes to show that sometimes leaping straight in doesn't always turn out magic.

My Great Aunt Ermintrude is a children's book, which has lived in a box in the attic ever since Gaiman decided that he'd done one of those "first novel things" and that what everybody should do with his first novel is put it in a box in the attic and forget about it. But in the wake of the success of *Coraline*, he fished it out to read to his daughter Maddy, who was seven. "I figured after twenty years you can't be embarrassed about the things you did wrong, and the things you didn't know how to do. I couldn't really even remember the plot." With decades between the writing and the reading, Gaiman was struck by one single page of the manuscript. "The book doesn't sound like me except for one page, which was really, really, *really* weird. You can see me doing Hugh Lofting, or Roald Dahl, or Noel Langley, who wrote the *Land of Green Ginger*. You can see I was a relatively good mimic

when I started off but I didn't have a voice. You can just see me doing voices, deploying everybody. But there was just one page in it which was pure me. Then we put it back in the box and sent it back up to the attic where I hope it will remain at least until I die. In my memory it was a great deal better than it actually was."

But at the time of writing those stories—pre-*Coraline*, pre-*Maddy*, pre-everything that brought about the book you're holding—Gaiman wasn't showing them to anyone.

I'd just write stories. If I got to the end of a story I'd be proud of myself. And then I got really serious about being a writer. And I went: I have to do this. I have to do this properly.

I remember a really bad night. I never kept any kinds of diaries back then so I have no idea when it was. I was twenty-one, maybe twenty-two. I was in bed imagining my life, and I got to the point in my imagining when I was old and dying, and I thought: if I die and I haven't been a writer, I will lie on my deathbed going, "I could have been a writer. Really could have been a writer." Whatever it is that I've done—if I've been any of the things I wanted to be or the things I didn't want to be, or the things that I thought were inevitable, like becoming an English teacher—I'd be lying there on my deathbed going, "I could have been a writer," and I wouldn't know if I was kidding myself. I wouldn't know if I really could have been a writer. And the thing that would kill me would not be having failed, it would be this idea of having had this life and having had this idea that this *was* the thing I wanted to be and this *was* the thing I could have been, and not knowing if I was lying to myself.

And at that point it all got really simple. I went: what I need to do is I need to go and be a writer. And if I fail and I'm not a writer, then I will never have that problem. I will go to my death going, "Well, at least I knew I wasn't a writer. And you know

what? I was a very good estate agent." Or whatever it was I wound up being.

I just remember that bad night. I don't deal terribly well with insomnia. I don't normally have it. I was just lying there thinking this stuff, and that night kind of changed everything for me. The truth was I had no Plan B. There was nothing in my head except "I'm gonna write stuff and I'm going to sell what I write, and that's what I'm going to do." And I remember spending about a month doing very little other than

ABOVE:
The plotted sequel.

drinking tea, writing stories, typing them up and sending them out.

Gaiman says that when he reads those stories now it's clear they weren't really good enough; he didn't know how to end a story, or begin it, and he didn't really sound like him yet, although he didn't think it at the time. "The awful thing is, is if an eighteen- or nineteen-year-old came up to me with those stories and said, 'I want to be a writer! Will you read this stuff and tell me if I've got what it takes?' I don't know that I would have read it and said, 'Yes, kid, you're going to be a writer.' I think I might have read it and said, 'Estate agency might look promising. Get interested in houses.' But I chose to believe I was brilliant."

It was after *My Great Aunt Ermintrude* came back from Kestrel Books with a note saying that it was good but not good enough that Gaiman became even more assured of his own brilliance. He explains his boldness using the same mathematical principle that can be applied to the stupid, how sometimes the stupid succeed because they don't know they're stupid, and if they were only 5 percent less stupid they would be smart enough to know their plans wouldn't work. "The great thing about not being very good yet is I didn't know I wasn't very good yet. I thought I was brilliant. And thinking that I was brilliant gave me the confidence to keep going until I actually happened to learn my craft enough to not be crap.

"I thought: if I'm brilliant, and if these stories are good, and if I'm good, then it's not that I'm not writing well enough, it's that I don't know how it all works. I'm going to find out how it works. That was the smartest thing I ever thought. Quite possibly nothing else has ever been quite that smart." ❖

RIGHT: Blurb for *My Great Aunt Ermintrude.*

OPPOSITE: The one page from *My Great Aunt Ermintrude* that sounds like Neil also happens to be the one page from *My Great Aunt Ermintrude* that he would not let me read. So we'll have to take his word for it.

Blorb

GREAT AUNT ERMINTRUDE'S Incredible Desert Adventure.

A mysterious cry for help sends Great Aunt Ermintrude and her trusty camel to the wilds of the Kharan-Kharesh desert, to rescue the lovely Brightest Star (daughter of the richest carpet merchant in the East) from the ghastly clutches of wicked Sultan Sogsag Ben Nurge.

Can Great Aunt Ermintrude, Hump the camel, a lazy parrot, a lovesick legionnaire, two guards (both named Mort), a poetry-crazed slave, and the money-grubbing carpet merchant prevail against the forces of evil? (Said forces consisting of Ninety-one thieves, ruffians, cutthroats, torturers etc, and a large number of fierce and vicious dogs-and-dragons).

Not a hope, Impossible, you say?

But she does have half-a-magic-carpet, and she wields a mean umbrella.

And besides, Great Aunt Ermintrude is a Very Resourceful Woman.......

They went into the Great Hall, where the Sultan received his guests,
and the professor put his suitcase down on the table and opened it up.

"I have here," the professor explained, "the most wonderful collection
of magical things in the history of the world." He rummaged around in
the suitcase and pulled out an old and tarnished yellow ring.

"This, for example, is the Ring of Solomon, which has power over the demons and
djinns below, the animals and birds of this plane, and the angels above.
With this ring in your posession you would be the most powerful man on
Earth."

"Does it work?" asked the Sultan, exitedly.

"Well, no. There are three words of power to make it work and a
master word over them all. And I've forgotten what they are. Now let me
see...Abaracanara?...no that's not it...Babarakandra?...no that's not
it either..."

"Humph!" snorted the Sultan. "What else have you got?"

"This, " said the Professor, pulling out an egg from a box, "is
a Phoenix egg. There is only one Phoenix, you know. When it's time comes
to die (it lives for a thousand years, I might add) it flies to a certain
place and builds for itself a pyre of sweet scented woods, and spices, and herbs. Then
a small cockatrice (or perhaps it is a basilisk. I've never been able
to tell them apart, have you? What a pity,) comes out from under a rock
nearby, and stares at the pyre, which bursts into flames, thereupon the Phoenix
flies into it and is burned up. In the ashes an egg such as this is appears,
which, in due time, hatches out into the Phoenix."

"And will this hatch out into a phoenix?"

"I'm afraid not. It's addled. Such a shame really, as the Phoenix was such
a pretty bird. Did you ever see one? No? I don't suppose that you ever
will, now."

"Pfuie!" spluttered the Sultan.

"This is Aladdin's lamp, " the Professor said, before the Sultan
could say anything else, and he pulled an old brass lamp from the suitcase. "Although I'm
afraid the Genie is on holiday-- has been for quite a while,--and he isn't expected
back for another century or so."

"Pardon me for asking," the Sultan said with a sarcastic sniff.
"But, har har har, do you happen to have anything that works?"

"But of course, sire." The Professor pulled out three silver bracelets from his
case. One big, one medium sized and one quite small. "These work perfectly --
they are love spells. If you give one to a lady of your acquaintance, and she wears it
within twenty four hours she will be head over heels in love with you."

"Ooooh!" squeaked the Sultan , a nasty little light glinting

top shelf

GAIMAN HATCHED A PLAN to become a journalist, figuring that journalists are allowed to ask questions.

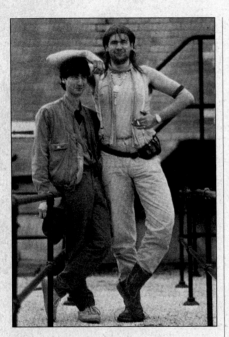

ABOVE: Interview with Fish out of the band Marillion, 1984. "I'd not yet had the courage to go black. I told my grandmother, when I was eleven or twelve, that when I grew up I was probably going to wear black. And she got really upset with me, because she believed that the only people who ever wore black were fascists. I really wanted to wear black, went halfway there and then finally, I think in about 1987, I went oh, fuck it, she's been dead since 1979. She probably isn't going to mind. And I bought my first black T-shirt."

H e could use his new vaguely official position to find out everything he needed to know about the world of books with a view to squeezing his way in, and while he was doing it he would be paid to learn how to write crisply, economically, and on deadline. Also he would be able to feed himself, a problem *My Great Aunt Ermintrude* was not helping with. He bought a copy of the *Writers' & Artists' Yearbook*—which has the addresses and phone numbers of every editor of every magazine, newspaper, periodical, and publisher in the country—and started on page one. But mostly, as always, he just made it up as he went along.

I was twenty-two and a few things happened very close together. I saw that Gene Wolfe was going to be in England for Fantasy Con 13, in Birmingham at The New Imperial Hotel. I called his publisher, Gollancz, and I said, "I'm a freelance journalist and I'd like to do an interview with Gene." And they said, "Cool, we've also got Robert Silverberg who's going to be a guest at the same convention."

So I phoned a few editors. I pitched it to Editor #1 and he said, "No, but why don't you try the Daily Telegraph *Way of the World column? They do some odd stuff." And I thought, well, it's never going to be in the* Daily Telegraph *Way of the World column, but screw it, I'll give them a call. So I phoned the* Daily Telegraph *and they said "Gene Wolfe? Who is he?" And I said, what about Bob Silverberg? "Who's he?" Well, Bob Silverberg's the guy who put sex into science fiction. (It's not really true, but it's true-ish. You can make a case for it.) And he said a sentence at that point that changed the course of my life for the next five years and actually allowed me to be fed and made everything possible. He said, "Why don't you try* Penthouse? *They like anything artsy with a sex edge."*

So I phoned the editor of Penthouse *who was a very nice Australian guy, said, "Hello, I'm a freelance journalist, got an interview with Bob Silverberg, the man who put sex into science fiction." He said "Oh! Great! Yeah! We love that! And if you can get us an interview with Douglas Adams too, I'm a huge Hitchhiker's fan." I said, "I'll see what I can do."*

So I went off to Birmingham, interviewed Bob Silverberg, sent the interview off to Penthouse. *And then I had an idea for somebody else I wanted to interview. John Cooper Clarke was going to be on the interview circuit—I'm a huge John Cooper Clarke fan. I thought that'd be fun, so I called* Penthouse; *they said, "No, not for us."*

It cannot be argued that John Cooper Clarke put the sex into anything, so it's not surprising *Penthouse* said no. But the strange punk rock performance poet couldn't have been a more perfect pitch for the place Gaiman called next.

"I'd gone out in the spirit of pure research once the first *Penthouse* story had sold. I'd bought myself every top-shelf magazine on the racks and gone through them all—*Knave*, *Men Only*, the whole run of them—and ended up going: *Knave* is really interesting. I like the sensibility here. There's really interesting articles and they've got [science-fiction writer] Dave Langford writing for them; this isn't like the other ones."

> "*I'd bought myself every top-shelf magazine on the racks and gone through them all . . . and ended up going: Knave is really interesting.*"

Knave was a soft-core pornography magazine far tamer and essentially more English than its American equivalents.It was also undergoing some massive changes thanks to a newly appointed editor, Ian Pemble, who was giving the whole magazine an overhaul for the sake of his own sanity, and all of which happened around the time Gaiman picked up a copy from the newsstand.

"There was a whole series of strange coincidences that happened and when it's there it's life and you deal with it. But

RIGHT: Table of contents from *Knave* Volume 17 #8, 1985, showing Neil's story "Manuscript Found in a Milkbottle."

VOLUME 17 NUMBER 8

...unt Editor* Rupert Metcalf ART *Art Editor* Tony Limerick *Assistant Art Editor* Melissa ...*tic Administration* Elise Mayor *Syndication* Linda Read *Studio Manager* Henry Fikret ... Peter Hancocks ADMINISTRATION *Circulation Director* David Holliday *Circulation*

ABC
ISSN 0265-1289

3

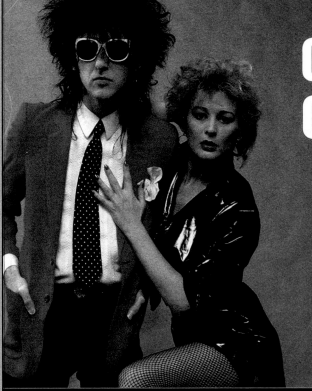

John Cooper Clarke:

Going through Gaiman's attic you can see that in the beginning he catalogued everything—every article he wrote was carefully Stanley-knifed at the fold and was archived in a ring binder. *Knave* photographers evidently favored that a model lie with her head on the left of the double-page spread, her waist at the crease, and her lower half on the right-hand side. The design and flow of the magazine meant that Gaiman's articles tended to fall on the page after the center spread. Consequently, there is a file in Gaiman's attic featuring just the lower-halfs of headless 1980s pornographic models.

"I kept everything," he said, "back when I thought these kinds of things mattered." But there is an obvious point where the noise just got too loud, everything moved too fast, and the magazines were thrown in a bucket, whole, if at all.

''I'd consider killing you, if I thought you were alive. What kind of creature bore you, was it some kind of bat?'' When John Cooper Clarke chooses to be nasty, he is. Having achieved the difficult feat of popularising his poetry with rock music audiences, he has been busy with a new book and a Channel 4 film. *Neil Gaiman* went to find out more.

he first thing that you notice about John Cooper Clarke is that he actually looks like his pictures. Like an emaciated vulture with a shock of exploding black hair, bottle-thick sunglasses, spindly stork legs and a narrow, angular face. He looks like a human pipecleaner. A matchstick man.

In the unlikely event of you not having heard of him, John Cooper Clarke is a poet. He writes contemporary poetry about everyday things, which he recites to audiences at breakneck speed, while lurching good-naturedly around the stage. In between the poems he tells jokes — rapid-fire shaggy dog stories. Not that the poems themselves aren't funny: they are. But the laughter is often uneasy.

The people that inhabit John Cooper Clarke Land are grotesques and caricatures of you and me and the bloke next door. Joggers. Daily Express readers. Package holidays. Reader's Wives.

So far he's brought out three LPs of poetry, and more recently a book, *Ten Years In An Open-Necked Shirt*. It takes its title from the semi-autobiographical prose-poem that starts the collection, telling how Lenny Siberia, bastard son of Captain Africa (the lard mogul) and Tracy, was adopted by two alsatian dogs named Sheba and Rex, went to a good Catholic school in Salford, wrote poetry and, "in a vain attempt at bourgeois credibility changes his name to John Cooper Clarke: the name behind the hairstyle."

Ten Years In An Open-Necked Shirt is also the title of an upcoming film on Channel Four, about John. At the time of writing this, C4 are still threatening to cut out a number or two on the grounds of obscenity — especially a vitriolic little

RIGHT: John Cooper Clarke, Neil's first interview for *Knave*, 1984.

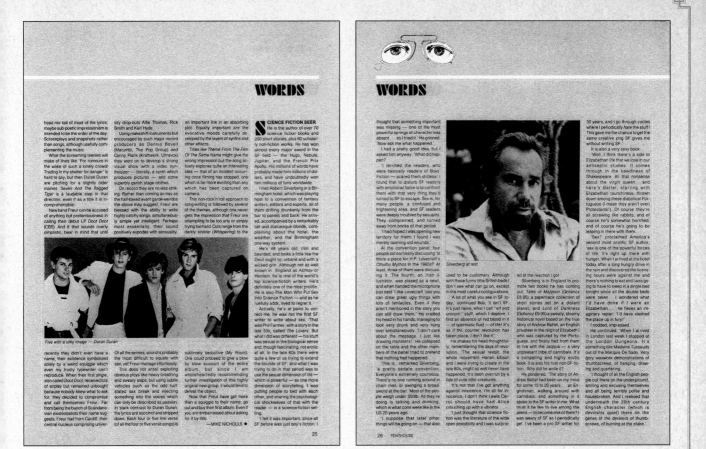

looking back it was quite extraordinary," says Ian Pemble, an incredibly nice man wearing what he referred to as "an absolute riot of beige" and nothing like what you would expect an old editor of an eighties porn magazine to be.

Pemble spent his academically unimpressive university years secretly writing poetry, and only admitted to it when he moved to London and started doing readings in rooms above pubs in Notting Hill. "In the sixties you didn't admit to poetry. It was a very unmanly thing to do." It was around then that a friend offered him a job as assistant editor on the magazines *Knave* and *Fiesta,* both under the Galaxy Publications umbrella. By 1982 Pemble was out of work when the job of editor for *Knave* came along, and despite being thoroughly sick of writing about sex for a living, he took a punt. "I probably wouldn't have taken it, or even gone for it, but I'd never been an editor. And it was kind of unfinished business."

At the time, *Knave* was as artless as any other pornographic magazine. It was owned by Russell Gay, a glamour photographer in the fifties and the head of Galaxy Publications. In an unlikely turn of events, Gay suddenly needed to sell the company. "Russell left unexpectedly, although I don't remember there being an official explanation. However, we later heard he'd moved to Monaco, and its reputation as a tax haven might be pertinent. More importantly for me and the rest of the staff we discovered he'd sold out to our printers." At its peak, *Knave* had a circulation of 50,000, but its sister title, *Fiesta,* was nearer 600,000, so the printers, who feared losing the biggest job they had, bought the lot. Suddenly they found themselves with a publishing empire, and they had no idea what to do with it.

"They had no option but to let me and the other editor, a guy called Chris, just get on with it. I gradually evolved this idea that I would keep the naked ladies—I think even the printers would have balked if I'd tried to get rid of them—and all the readers' letters. But I made a rule that

ABOVE: Neil's Silverberg piece for *Penthouse* in 1984 begins on the same page as a piece by someone else on Duran Duran.

everything else had to be interesting and/or funny. If it was about sex, it had to be genuinely good and not just dirty jokes and swear words. And with fiction I banned sex altogether. The men's magazines were about the only place where you could still get original fiction published. Certainly in those days. So after fourteen years of hacking out boring sex stuff—and I really didn't want to do that anymore, I wanted to put some good stuff in this magazine—I got a call from the young Neil Gaiman."

Says Gaiman:

I phoned Ian Pemble at Knave *and said: John Cooper Clarke. He said "Absolutely." I did a photo session, did the interview, handed it in, and it was really good. I was starting to learn how to write, how to flex my weird writing muscles and discovering I had an aptitude for journalism. And also an aptitude for figuring out how people talked and getting it down on paper in a way that evoked how they talked without necessarily being the exact words.*

Knave *was a wonderful, weird magical happenstance. It was fortuitous that the point I came along was really the point at which Ian, who'd been editing and assistant editing men's magazines for a while, had just sort of gone: Fuck it, people are buying this magazine for the photographs of the naked ladies and the mucky reader's letters. That's why they buy it. I'm going to try and experiment and I'm just going to put stuff in the magazine I'd like to read. I'm not actually going to care if it has a sex angle, or if it doesn't have a sex angle, it's just going to be stuff I'd like to read. So he said yes to John Cooper Clarke, and then said, "Do any other interviews you want, the only thing is they have to be interesting." And that was suddenly my key on the interview thing. No sex angle had to happen, the only thing was* interesting *people, and I wasn't allowed to just do science-fiction writers.*

But he did fit those writers in whenever he could, making connections and lasting friendships with the likes of horror writer Ramsey Campbell, Clive Barker, Arthur C. Clarke, Frank Herbert, Harry Harrison, William Gibson, and Douglas Adams. Then there were the other guys: Patrick Macnee of *The Avengers,* Denholm Elliott, *Pink Flamingos'* infamous Divine, British comedian Rik Mayall, Terry Jones of *Monty Python* fame, Richard O'Brien of *The Rocky Horror Picture Show,* and more. Through-out all of these interviews Gaiman was not just a faceless scribe for hire: the voice was clearly his own, and his personality ran through the articles. He even turned up in the pictures.

"He was networking before it was even invented," said his old editor. "Normally these people get interviewed by some hack who hasn't done their research properly and is asking all the obvious questions. But Neil was a totally creative person who understood and got people talking." ❖

Every picture book tells a story

COMICS
by NEIL GAIMAN

FRONT COVER: Moore . . .

. . . and his magazine

TODAY. SUNDAY JULY 27. 1986.

IMAGINE a world much like our own, but in which Nixon is still president, the Russians resent the American presence in Afghanistan, and the nuclear clock stands just a few seconds from midnight.

This is the scenario assumed by Watchmen, a new and critically acclaimed addition to the racks of comic-books, but ones with a mature readership in mind.

Alan Moore, writer of the twelve-part series, (two have been published so far) is keen to argue that comics should be seen as a legitimate art form.

"I'd like to make it acceptable for adults to read comics on the Tube. I don't see any reason why they should be a second-rate medium: it's just that from their inception they've been regarded as a medium for kids and nothing more.

"When I write comics I try to write them as if I were writing a book for adults, or a film or TV, and I try to get the same kinds of concerns and sensibilities into them."

The garishly coloured comic-books in which the adventures of Batman, Superman, Spiderman et al have been chronicled for over half a century, have in fact been described as the only original American art form.

At a time when they are being taken seriously, it may be a surprise to find that much of the ground-breaking work in American comics stems from Britain.

Watchmen may be published in America, by D C Comics, but it is written, drawn, lettered and coloured here, by Alan and artist Dave Gibbons.

"It's much more attractive to work for the States — you get much more respect," says Alan. But he also believes that the British eye has something new to offer.

THERE'S something about a non-American drawing or writing about America: you've got a more detached view. You see the quirks. On the surface our stuff looks like American stuff. But when you look a bit deeper you find there's enough of a sideways twist to make it more interesting than the home-grown product.

"By having Watchmen take place in an America in which Nixon was never deposed; in which two Washington Post reporters were found dead in an underground garage, and nobody ever thought anything of it, we can comment on Superpower politics without upsetting Reaganites.

"The feeling of the comic, the feeling of doom and apocalypse, comes from the world around us. But by making this statement in terms of a world in which superheroes exist, you can say the same things and get the same emotions over while sidestepping people's prejudices. On one level that is what Watchmen is about. On the other hand it is a twelve-issue series, with an awful lot going on."

The changing British comic scene owes much to a genuine English comic, 2000 AD, launched over a decade ago. Its blend of science fiction, social comment and humour in an all-action format, coincided with the arrival on the scene of a new breed of English artists and writers.

Moore, a tall, bearded writer from Northampton who started out on 2000 AD and now works on Swamp Thing, Marvelman, and Watchmen, is one of the best and most popular writers of comics on either side of the Atlantic.

But Watchmen is not the only American comic to win both serious critical and public acclaim. A four-issue "graphical novel", Frank Miller's Dark Knight, has been much praised recently. It reinterprets Batman as a 50-year-old "terrorist superhero" coming out of retirement to a hail of public acclaim and resentment, reminiscent of the Bernard Goetz subway vigilante furore.

WE know comics aren't just for kids any more, but it is difficult to convince people of that," said publisher Dick Giordano, although the high sales figures for Dark Knight and Watchmen tend to suggest that the more adult comics are finding their audience.

Meanwhile, the British influence continues at all levels. The recently revamped Superman, for example, is being written and drawn by Birmingham-born John Byrne.

The cry, as in movies, is: "The British are coming." For comics, however, unlike the film business, the cry is perfectly true.

All comics mentioned here are available from specialist comic bookshops or by mail order from Forbidden Planet, 23 Denmark Street, London WC2H 8NN.

"I was starting to learn how to write, how to flex my weird writing muscles."

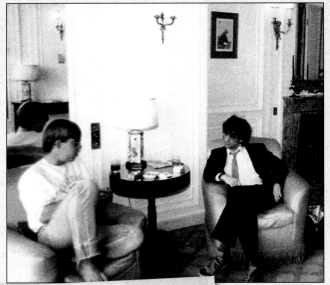

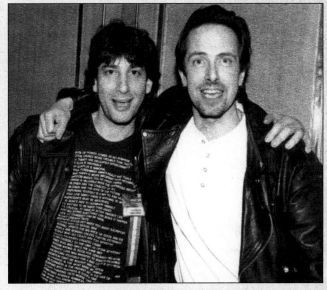

Neil at the feet of the master.

AND NOW FOR SOMETHING COMPLETELY TERRY
Continued

was *Jesus Christ — Lust For Glory!* We only changed it because it wasn't funny. There aren't any laughs in saying 'Does God exist?' and anyway we re-read the gospels, and decided that Christ was a pretty good bloke. We quite liked him. The comedy was the human error. (All comedy is people being daft or wrong in some way). Here's a guy saying 'Let's all be nice to each other' and everyone goes 'Yeah! He's right!' and then they go around for 2,000 years killing each other because they can't agree whether or not he was standing on a rock when he said it. That was where the comedy was, and I'm afraid in the end we've always gone for the comedy rather than any serious message."

How does he feel when people start doing *Python* sketches at him in the street?

"It isn't so bad for me; I'm fairly anonymous. It is bad for someone like John — it makes him cringe and scoot

Portrait of an ardent reader.

around and not go into shops — he hates it. With me it's quite nice, as it happens often enough to keep the old ego tickled without being annoying."

And the middle-aged women that he so often portrays?

"Yes. Everyone else just got led up playing them, so I was landed with them. I quite enjoy doing these sweet, middle-aged old ladies. Mandy, mother of Brian, was a bit more vituperative than I would have liked — my favourite was the loving mother of 60 children in the 'Every Sperm is Sacred' sequence. Mike originally wanted a real woman to do it, but I twisted his arm."

Changing the subject, Terry's book on Chaucer was a work that shook the academic's previously comfortable view of the character of the Knight in Chaucer's *Canterbury Tales*. Was this some kind of cry for respectability?

"Well, there is a cry for respectability in the notes at the back, and in the length of the notes, but I didn't do it

because I wanted to be respectable. It was just something that had been niggling away at me and had been since 1983 when I was at Oxford. I even wrote an essay on it back then that they didn't like very much at all. It was lucky that I had enough money from films to be able to spend a year without earning while I wrote and researched it. I tried to write it simply, so that anyone could read it, but I put all the notes in to get through to the academic world. I had to be respectable for them. They still don't like it . . . probably in twenty years' time they'll accept it."

Will the *Pythons* ever work together as a team again? He shrugs. "I don't know. In the past it's been about every four years that we've got together to do films. I think if it happens again it'll be in a different way. Some of us will write something and say 'This would be really good for the whole team, really, wouldn't it?' I don't think we'll sit down and say 'Let's do another film'."

Are the *Python* teams still friends?

"Ah. We never stopped being friends; but I'm not sure we ever *started* being friends. We've always liked each other in a work situation. I had dinner with Eric a few weeks ago, and it was smashing, but the first time we've met each other socially for ages. Mike and I are friends, but we always have been friends — we play squash together, and we write together. Right now we are doing a musical and also a new edition of a book we did some years back. *Bert Fegg's Nasty Book For Boys And Girls*. The American edition was longer than the British one." He picked up a copy of the American issue, and we started giggling over it. This was because a) it was quite funny, and b) by this time we were as drunk as editors. "Yes . . . here's *Pam The Bengal Tiger*. It's a bit like *Pass The Parcel*, except instead of a parcel you have a wrapped-up Bengal Tiger. The person who takes the last piece of paper off the Bengal Tiger is deemed the loser, and is bitten to death by the enraged mammal. The winners get sweeties.' And here's *Spoons* — 'The object of the game is to collect up spoons from the floor without being killed by a Bengal . . .'."

Yes, things are definitely getting silly now. John Copthorne (glamour photographer to obscure Balkan royalty and secretly a very silly person) began taking photos of Terry hamming it up outrageously with copies of *Knave* and dictionaries and things, and I carried on trying to interview.

Does he have any ambitions left?

"Well, I never wanted to be rich and famous, for a start. My ambitions have always been centred around making things. When I was a child I'd tell people I wanted to do something creative as soon as I knew what the word meant. Leaving aside ambitions like wanting to go to bed with as many beautiful women as possible . . . I just like making things, so being in a situation where I can make

things and people give me money for it, is really fun. I find things like the possibility of being able to buy a country house a real pain in the neck. It clutters up the mind-space, which in my case is extremely limited, and I need it all for reading the labels on bottles of wine. I'm not knocking fame. It makes it easier to do things, and much harder to pay for things. People keep buying you dinner."

Talking about going to bed with beautiful women, what about sex? "I en-

"I enjoy sex a lot! I'd say it's one of life's most enjoyable things . . ."

joy sex a lot! I'd say it's one of life's most enjoyable things. Sex and wine rank right up there with having finished things. Like having finished a book. What I like best about sex is the great release from responsibility — it's like being taken over by something. Being part of the life-stream instead of being in control," he started giggling. "My ambition is to be a sex object, really. I'm going to have to work very hard at it. I don't think I have much time left."

How about his lifestyle? Does he use his money to do anything exotic, like shark-fishing off the Great Barrier Reef? "No . . ." he pondered, searching for something exotic he does. "Well, I play squash with Michael Palin a lot, and generally try to go to bed with as many of the neighbours as possible."

And what do the neighbours think about having a *Python* living in the street?

"Oh, they think we live in the house next door. The big one. The snag about this road is that the numbering isn't in a strictly numerical progression."

We'd noticed. Then Terry was posting all over his study, carrying on a fairly lunatic monologue as he did so; "Right! Now I'm writing on a piece of paper! How extraordinary! He underlines the number 61 and then, yes, he rubs it out because there was no point in underlining it in the first place. This is typical of a writer's behaviour when confronted by cameras . . ."

The last word on Terry Jones came from the photographer as we wrapped up and stumbled, a little unsteadily, off into the night. "You know," he said. "I liked him. He's the first celebrity we've done I'd actually want to go out for a drink with . . ."

Neil at the feet of the master.

"We've always gone for the comedy rather than any serious message."

TOP LEFT: Gaiman interviewed Dave Sim in the Savoy Hotel in 1986, when Sim was thirty and Gaiman just twenty-six. It was the first time they met, and Sim's comic *Cerebus* had been running for almost a decade. This photo appeared on the back cover of *Cerebus* #126 five years later.

TOP RIGHT: Neil and Clive Barker in 1996, years after they first met. They were often mistaken for each other in these early years. "We were about the same height and had dark hair and big noses," said Neil.

ABOVE AND RIGHT: Interview with Terry Jones, 1984. Neil turns up in the pictures.

peace anD Love existed onLy on weekenDs

The Misery Of Sex.

By Neil, Eugene, Kim, & Phil

Extracts from Dr. Siggy V. Dope's forthcoming bestseller 'The Misery Of Sex'. In it Siggy bravely challenges his fellow sexologists who persist in saying that sex is in any way fun, enjoyable, neurosis free, easily available, and healthy.

Picking people up. (the misery of trying to get laid).

Cruising. this is best done in your lounge. since ocean liners are very expensive. Cat, Sofa, a mormon, your wife.

Not putting adverts in personal columns. or putting ads such these in p.c.
e.g. (see sheet)
Contact mags a no-no!
If you are devoted to the misery of sex you wouldn't buy one. if you saw one you wouldn't read it, if you did you wouldn't advertise. if you did you won't give a false address (e.g. the local vicar) if you actually answered one you wouldn't talk to them when you met.

Pubs, clubs, discos, partigs, autopsies, funerals.

Opening lines.
'I want you to know I'm really depressed.'
'looking back I don't think my mother ever liked me....'

ABOVE AND OPPOSITE:
The Misery of Sex, a book
that never happened.
Notes and typed outline
by Eugene Byrne.

ON top of the countless interviews He DID, Gaiman also ROPED IN a few friends to collaborate on material to fill out the rest of the magazine.

With Kim Newman, whom he had met at a British Fantasy Society open night, and Eugene Byrne, who went to school with Newman, Gaiman wrote funny articles and short fiction occasionally under pseudonyms so it didn't look like one guy was responsible for the whole magazine (Gerry Musgrave, Richard Grey, and W. C. Gull are all him). They wrote ongoing series like their "How To" articles ("How to Be a Barbarian," "How to Be Psycho," "How to Be a Cult"), their "A Day in the Life of . . ." ("A Day in the Life of Spock: Vulcan Confessions," "A Day in the Life of a Man with No Name," "A Day in the Life of Emmanuel"—it was a men's mag after all), and fake interviews with fake people about education, or religion, or making films. Or Santa.

"My influences for this stuff were things like *Mad* magazine," says Newman. "I remember we had a lot of the paperbacks and collections of that, and we'd all read those until they fell apart. And we would also sit around and watch *Sgt. Bilko* a lot."

Articles would earn them collectively about £200 to £250 a pop, but they couldn't get *Knave* to cut three checks. In order to get around the messiness of divvying out the money, the trio got themselves a joint bank account into which they would pool the money and then dole it out on a quarterly basis. Gaiman and Newman still get a treasurer's report from Byrne, the custodian of what they called The Peace and Love Corporation. "We haven't seen each other for years, although the bank account still exists, and contains several pounds, and Eugene, as custodian of the account, emails us both every year and lets us know that it's still there. Our current plan involves not ever taking anything out of the bank account and then, using the miracle of compound interest, in several thousand years' time owning the galaxy, before being wiped out in the stock market crash of October 3719."

Peace and Love existed only on weekends. "Eugene would have come up from Bristol," says Neil. "And Phil Nutman, or Stefan Jaworzyn. Whatever combination of us was there. We'd get together, we'd do a weekend, and we would rough out a dozen articles or do a musical or whatever. They were always done in these mad thirty-six hour benders where you work until you can't think anymore, go out for a pizza, drink cheap white wine, and eat pâté, and at some point there are five of you sitting on the floor and going to sleep wherever there are cushions and blankets. And then you get up the next morning

THE MISERY OF SEX

By Eugene Byrne, Neil Gaiman, Kim Newman, Phil Nutman.

Are you sexually fulfilled ? Is your love life a never-ending cornucopia
of erotic encounters ? If it is, then something is seriously wrong.
Perhaps this isn't your fault; clearly your life style has been influenced
by popular 'positivists' who insist brain death will set in if you aren't
getting the most from your orgasms. What is sex if it isn't angst-ridden,
infrequent, and loaded with guilt ? To redress the balance we present
exclusive extracts from Dr. Sigmund Von Doppelganger's forthcoming best-
seller, "The Misery Of Sex". In it Siggy bravely challenges his fellow
sexologists who persist in saying that sex is in anyway fun, enjoyable,
neurosis-free, easily available, and healthy.

Picking People Up (The misery of trying to get laid).

The best way to find new sexual partners is to go out and search for them.
This is known as cruising. But why make life easy ? If picking up people
is as simple as shopping at Sainsbury's you aren't making the most of misery.

Cruising is best done in your lounge since ocean liners are very expensive.
Even if you do this you will still have a varied selection of potential
partners. Those you may pick up in your front room include the cat , the
sofa, a Mormon, or your wife. The latter choice is highly recommended if
you want to be thoroughly miserable.

Lazy individuals may prefer to cruise by means of the ubiquitous contact
magazines that clutter up the shelves of every local adult book emporium.
These publications are not advisable because you might actually meet someone.
Or the more discreet amongst you may consider the 'respectable' route for
finding new 'friends'; the personal columns of listings magazines. The
individual who is devoted to the misery of sex would not, of course, place
an advert in either type of magazine, or if they did they would place adverts
such as these:

> Lonely sensitive guy, 35, needs an angel for theatre, classical
> concerts, cordon bleu cookery, backgammon games, walks in the
> country, etc. Please write (with photo) to Knuckles 'Mad
> Mangler' O'Leary, c/o the Incredibly Dangerous Wing, H.M.
> Prison, Dartmoor.
> Charming Bloke, 3I, would like to meet a lady with a weak
> heart and a controlling interest in a brewery with a view

ABOVE: *The Complete Guide to Bloody Everything*, another book that never happened. Typed by Eugene, the first of the bunch to get a computer.

"I remember when Neil was writing funny stuff he was actually a lot more vicious than he is in his funny stuff now. He seems to have mellowed."

and you do it again until you all run out of steam, and then whoever took notes (because we'd alternate the note-taking process) would then have to type them up and turn it into an article. So the ones that I remember really well are anything that I had to type up."

The thing they mostly did when they got together was plan. They planned several novels no one would buy, including one called *Neutrino Junction*, "about one

lone man's near-future struggle to retrieve his welfare entitlements in the face of a heart-less bureaucracy. That sort of thing was satirical back in the eighties," says Byrne. They planned a video game based on the novel that actually has no resemblance to the novel, in which the player has to find out who they are before they prematurely explode. British horror film director Norman J. Warren asked occasional Peace and Love Corporation

member Phil Nutman for some low-budget horror movie ideas of which he, Newman, Gaiman, and Stefan Jaworzyn duly delivered four. No movies were made so Newman picked them back up and—figuring he would rather have a published novel than an unproduced screenplay—turned *Bad Dreams* into his second novel, while *Bloody Students* became a book called *Orgy of the Blood Parasites*. "Consequently, I'm sure Neil, Stephan, and Phil could look at that novel and say which bits they wrote," he says.

"Neil might say that I discovered him."

Lots of these notes, along with small lakes of correction fluid and letters from Gaiman apologizing for being late, are in a ring binder in Newman's house, next to the script for the musical they wrote called *Rock Rock* for reasons known only to the authors. "In a weekend we could at least get eight or ten articles for *Knave* outlined," says Newman, a man who can write a novel in the time it takes to type it.

"Eugene's the funniest of the group. He's the least self-censoring. Although actually, I remember when Neil was writing funny stuff he was actually a lot more vicious than he is in his funny stuff now. He seems to have mellowed and become gentle, maybe it's having kids. Although having kids made Eugene more vicious.

"Neil might say that I discovered him, but only on a technicality: it's not as if he'd been wailing in the wilderness for years and I plucked him from obscurity. He would have been discovered anyway, sooner rather than later because of the talent. But the funny thing is, he couldn't have sent stuff to an editor that was better placed to publish it than when he did."

THE RAM JAM CORPORATION
28 Lexington Street London W1R 3HR

Pete Tamlyn,
2, Poplar Road,
The Coppice,
AYLESBURY,
Bucks.,
HP20 1XN.
(0296) 88994

Dear Neil,

Hi, 'tis me.

Re Skyball, Rod says he's going to phone you to fix something up. Indeed, he may already have done so. (Then again, why are people so unreliable?)

Re computer games, bumpf enclosed. Note that this is aimed mainly at slimy Adrian Mole types who responded to the ad. in White Dwarf. The £500 minimum is obviously what we reckon we can afford to guarantee. It is based on an assumed £3 wholesale price for the game, us getting the worst deal we settle for out of the publisher and giving you our lowest rate. Assumed sales are 10,000 units. Obviously actual real author, people such as yourselves would get a somewhat better deal for royalties. The most any game has sold is around 250,000 (The Hobbit) but 30-40,000 is not an unreasonable expectation for a good game. The advance doesn't go up, but the end result goodies do.

If you think that this might be a fun idea, albeit not paying the millions that you are used to, give us a ring and I'll arrange to show you the system.

Xraamb'o the Martian Invader wiped the sweat from his three brows and rested his atomic ray gun on his middle thigh. Surveying the devastation he had wrought he grinned at the camera crew. "These Earthlings are a right slimy load of geeks", he thought, "still, it was a good idea to rope them in as unsuspecting extras. This will gross grodzillions at the box office......"

Cheers,

Pete

Company registered in England No:1823029 Registered Office: Balfour House, 390–398 High Road, Ilford, Essex IG1 1U

The Peace and Love Corporation existed for about a year and a half, although there was no definite end to it. Newman says: "It must have ended something like maybe 1988, maybe 1987. There's a point when the magazines changed and they stopped running articles, although we carried on working for a magazine called *The Truth*, which did quite similar stuff. When *The Truth* ceased publication as a magazine all our markets for this sort of stuff had gone. We didn't carry on, although notionally some of the film projects were still active but nothing ever happened with them.

ABOVE: Letter from Pete Tamlyn about a computer game—Tamlyn was then a freelance game designer and regular contributor to leading role-playing magazine *White Dwarf*.

Says Newman: "The computer game thing. Neil knew somebody who was sort of an innovator in computer games. And we went and had a meeting with him and we outlined what was probably doable now, but then was probably impossible. I think it's one of those things where the guy [not Tamlyn] was a complete crook. I remember I mentioned I had an agent and he literally went white in the meeting, and I thought: This isn't going to happen."

Jacqui slammed down the phone as he walked in. Then she crumpled up a piece of paper and flung it across the room. "For Chrissakes!"

"How's your day been?" Rod dumped a cup of coffee on her desk and sat down at the table opposite.

"Thanks. How was my day? You really want to know? I got in at 10.30. The amateur shoot was meant to start at 11.30, so at 11.00 our amateur phoned to say she was cancelling out..."

"So you get in a pro. It's happened before."

"Yeah, yeah. I phoned Velda -- you know Velda, with the birthmark,-- and her husband answered to say they'd split last week and he didn't know where she was. I got hold of Cherie, who said she couldn't make it because she was splitting with her husband and going to live with Velda's husband -- not that they've got a thing together, at least I don't think so... So I've got this lovely seaside set all ready and waiting -- Vern worked all night on it -- I get onto the agency and you wouldn't believe what they sent over. Thirty-five if she was a day, and sagging --!"

Rod was shaking his head. "Forget it. Forget I said anything."

"But you asked, dear, and I haven't started yet. So we plaster her in make-up and Vern does wonderful things with lights and the phone rings and it'd Derek for Chrissakes. Mr-Boy-Wonder-Sodding-Publisher Derek who doesn't show his face in this office from one week to another."

"Got a spare cigarette?"

"Sure," she fumbled on her desk until she found the packet and threw it over to him. "Help Yourself. Anyway Derek had just returned from the States with this ." She passed *a magazine* it across the desk. "Page 75. Apparently it's tripled their sales."

Rod thumbed the magazine open to page 75. 'I Spent a Month With the Klu Klux Klan!' proclaimed a banner headline. "So?"

"Investigative Slice-Of-Life Journalism. Derek has decided that it will boost our sales if we get in on it."

"He's out of his mind! People don't buy COY for the words. We aren't the News of the Screws."

"Right now he's having delusions of Murdoch-hood. Or it might be Hefner-hood. He's the publisher, and that's what he wants in COY."

Rod shrugged. "So get one of the regulars to write it. Brian or John. They used to do Confessions magazines."

Jacqui shook her head. "Uh-uh. Derek wants the real thing. 'Our intrepid reporter penetrates the National Front'--that stuff."

Rod grinned and sipped his coffee. "So who's the mug?"

Jacqui smiled sweetly.

"You are."

He choked on his coffee.

"Hang on a second here! I'm a fiction writer and film critic. I'm no investigative journalist. No way am I infiltrating the NF or working in a Neasden brothel for sodding Derek!"

never heard of.) The speaker, a Dr Pomplemousse, is very concerned
about a scheme to paint the Eiffel Tower pink as part of Gay Pride
Year. It is hard not to agree with him: this would be an insult to
our courageous French allies who went through so much in two world
wars. Richard Baker ~~should be ashamed of himself for giggling~~ giggles during
this ~~such an~~ important item. The man obviously has no sense of the importance of France's cultural heritage. ~~Story: I wonder if the BBC will try to get
away with an April Fool's Day news story? I wouldn't put it past them
to try and play a joke on their listeners.~~

9.30 am. Dressing made very difficult, as someone has been in the
wardrobe and stolen all of your clothes, leaving only: one tracksuit
bottoms, one dinner jacket, a pair of riding boots and one Tyrolean hat.
A message pinned to the jacket reads "April Fool! Dennis."
You do not know anyone named Dennis.

9.40 am. Breakfast. You wonder who swapped the ~~ovo~~ and the Alpen packets
over? It is apparent somebody has because half-way through breakfast ~~before~~ you notice you are foaming
at the mouth. After entertaining and then dismissing the
idea what this may indicate the onset of rabies, you fall
to pondering the peculiar character of other people's ideas
of humour.

9.55.am. Having missed the your you train, shared a car to work with Steve
Fletcher, (the overdressed Casanova from advertising), and Roger
Hufflett, one of the other reporters. You must say that you thought
Steve's gag of putting a whoopee cushion under Hufflett's seat is very funny:
~~cracking wheeze~~ but the lighthearted mood was is ruined when one of
them -- it is not clear which one -- puts a gekko down the back
of your dinner jacket. A most thoughtless and unpleasant action.
You did not speak much during the rest of the journey, but
listened to the radio instead. According to an urgent newsflash
~~fpit~~

terrorists have painted the Eiffel Tower green, and thousands of irate
French gays are picketing the Place de la Concorde. You listen carefully to see
whether the BBC will try an April fool joke, but none is forthcoming. Perhaps they got
their fingers burned over the Panorama spaghetti tree incident. What
a laugh that was!
Memo: ought to check what does spaghetti
grow on?

Hufflett has found a piece in "Penthouse" on
the historical significance of April Inst, and insists
on reading it aloud when you would rather turn
over and look at the pictures. The article reads as
follows: -

Editors' note: In Eugene's notebook were ~~shorthand notes~~ untitled ~~notes~~ of
Hufflett's talk, which we reproduce here. The Editors disclaim all responsibility for any inconvenience or embarrassment -- this may cause our readers. ~~None of the so-called historical facts given here are provable, and it may be assumed that Eugene was having his leg pulled.~~

'April the First was the saint's day of Saint Melvin of Cytheria, the
little-known ~~thirteenth~~ 13th disciple that all the others used to make fun
of. It was St Melvin who missed the Last Supper because St Peter told
him it was being held at Steve and Jo's place. According to legend,
he waited there for five hours, making small-talk with the embarrassed
couple. At the fifth hour, he went home. He was martyred when St Paul
charged him with ~~preaching the~~ the mission of preaching the Word of the
Lord to the peoples of Africa. A Muslim ~~stranger~~ misdirected him, and he was
eaten by Eskimos.

"We kept trying to put together sort of a humor book, because they were quite popular in the eighties. And we even had some meetings about them, and for one reason or another we never sold it. It may well be that we weren't as funny as we thought we were. I remember we wanted to do a book, and we were really annoyed because somebody later used our title, *How to Lose Friends and Irritate People*. But again, nobody bought it. So that's another thing that's not on our résumés." ❖

"*It may well be that we weren't as funny as we thought we were.*"

OPPOSITE: A bit of *The Creeps* by Neil. He says the dialogue is taken straight from the *Knave* offices. "I've toned it down a lot, otherwise you'd never believe it …"

ABOVE: *The Smedley Diaries.* Kim Newman has no memory of this. "I don't know what it was about, I don't know if it would have been any good. Brian Smedley was this guy who was at school with me and Eugene so we used the name Smedley a lot in things. And you know what? He didn't think it was very funny. Particularly when it was in porn magazines. But that made us do it more."

the end of peace and love

"LOOKING BACK ON KNAVE IN TERMS OF THINGS THAT DID ME GOOD AS A WRITER (I WOULD POINT TO MAYBE HALF A DOZEN KEY THINGS), ONE WOULD BE CHRISTOPHER LLOYD—WHO WAS THE EDITOR OF *FIESTA* AND ALSO, UNDER THE NAME OF M. J. DRUITT, KNAVE'S BOOK REVIEWER—DECIDING HE WAS SICK OF REVIEWING BOOKS AND ASKING IF I WOULD LIKE THE BOOK REVIEW COLUMN.

"What was great was it wasn't science fiction/fantasy, it was a mixture. Suddenly I was getting every publishing catalogue and just going through them without any regard for genre, without any regard for fiction or nonfiction, just going oh, that looks interesting, I'll order this, I'll order that. There might be a detective book, a book about photography, a movie thing. I was simply asking publishers for stuff that was interesting."

Gaiman would read and review everything he was sent and got a lot of it done on the three-hour commute into London from Sussex, averaging two or three books a day. "So I wound up spending three or four years reading continually and solidly outside of my comfort zone, and outside of what I thought of as my interests."

Kim Newman, who was already a prolific reviewer and on the press list for any film screening going, also wangled invites for Gaiman, which provided Gaiman with another thing to write about. From about the end of 1983 Gaiman saw and reviewed every film that came out for *Penthouse*. "Then there was this horrible point in 1987 where I remember thinking: How many films have I seen as a film reviewer in the last four years? How many of them left my life immeasurably enhanced? And how many of those films would I not have seen naturally, that I'm so grateful I saw them because I was exposed to something I'd never have seen? Maybe *Brazil*. I might not have seen *Brazil*. Definitely wouldn't have seen *Pumping Iron 2: The Women*. And I thought: two films is not enough, I think I'm done. So I stopped. I let everybody know I wasn't film reviewing anymore and was just grateful to get my time back. I got fourteen extra hours a week."

Elsewhere, Gaiman's journalism appeared in *Space Voyager*, *Reflex*, *American Fantasy*, *Fantasy Empire*, the *BFS* [British Fantasy Society] *Journals*, *The Comics Journal*, *Today*, *Publishing News*, and occasional *Knave*-collaborator Stefan Jaworzyn's underground horror fanzine, *Shock Xpress*. In an interview with Alex Amado, Gaiman said:

"Harlan Ellison Trial sketches." by Neil Gaiman

OPPOSITE AND ABOVE: Two-page comic Neil wrote and drew for the Chicago Comicon 1994 ashcan called "Harlan & Me," plus design sketches for the comic.

I liked doing interviews, and I liked doing long magazine pieces. But I wound up drifting over into newspaper journalism. I was a freelancer working for most of the big London newspapers, and I was terrible. I was really appalling. And I used to get really upset when people would rewrite my stuff. I remember I once did an interview with two lady comedians—actually one of them was American—Ruby Wax and Dawn French. I thought they were really great and we really got on. I typed up the interview, and when I saw it in print, the headline was "Will Two Man-Eating Feminists Make Mincemeat of Our Reporter?" I said "What is this?" Then about two or three weeks later I got a phone call from the newspaper, called Today, and they said, "Well, you are our fantasy and science fiction correspondent, and we want you to do a piece on Dungeons and Dragons. Now what we want is an article showing how it drives people mad and makes them use black magic and commit suicide." There was a vaguely incredulous pause on my side and I said, "Well, no!" They said, "Why not?" I said, "Well, because I'm not working for you anymore," and I hung up the phone. That was really how I quit journalism. I actually have more respect, strangely enough, for American journalism, than I do for English journalism. American journalism tends to be more balanced, possibly because they know that if they go too far overboard, somebody is going to be suing them for millions of dollars. Whereas English journalism seems to be designed to send other people's children home in tears. I didn't like it, so I stopped.

Before he stopped he earned some extra cash working as a stand-in editor for Fitness magazine when the real editor suddenly quit, ghosting half of one issue of Fitness so expertly he can't even tell which bits are his. When he was offered a permanent job as features editor on Penthouse, he had to think about it. "It was the first time anybody had ever offered me a real job that would have come with a paycheck and everything. But I thought there's this thing that I'm going for—I really want to be a writer, I want to write books, I want to write comics. If I go and become features editor on Penthouse there is a career arc from there." He turned it down.

"The amazing thing was that within four or five months of having gone 'Right, that's it—as of tomorrow I am a freelance journalist,' I had two contracts to write two books, having never written a book and having never written anything longer than a 3,000-word article. I remember typing out the words: 'Don't let your mouth write no check your tail can't cash.' It's a Bo Diddley quote. And I cut it out and I stuck it to my typewriter, because I knew that I was plausible enough that people were giving me contracts. And I had no idea what I was doing. Can I write a book? I don't know. Got a contract. My entire career has consisted of my mouth writing checks and my tail having to figure out how to cash them" (Locus Online, 2005). ❖

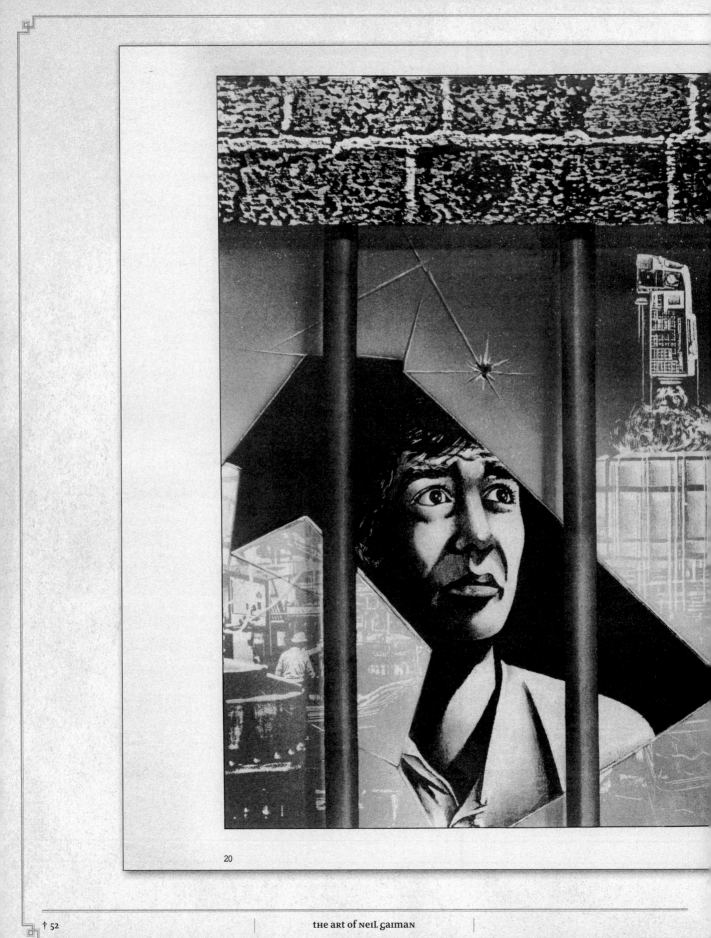

20

THE FIRST SHORT STORY Gaiman ever sold was called "Featherquest" to *Imagine Magazine* in 1984, but the first time he was actually proud of a published short story was "We Can Get Them for You Wholesale" that same year. "I thought: this is good, what a real short story. What a pity that nobody in the world is ever going to see it because it's in *Knave* and nobody reads *Knave*." It's all like Kurt Vonnegut's character, Kilgore Trout: supposedly the greatest science-fiction writer in the world but known to nobody simply because all his work was published in pornographic magazines.

While the few short stories of Gaiman's from *Knave* later reappeared in collections ("We Can Get Them for You Wholesale" being one of them—it was rejected by Pemble initially until Gaiman rewrote the ending), there is one that languishes forgotten in the basements of vintage magazine shops of London's Soho: "Manuscript Found in a Milkbottle," published in 1985. Says Gaiman: "It's pretty awful. There is a reason it has never been reprinted."

Manuscript Found In a Milkbottle

Down the centuries, along the star lanes, across the light years — men will bless the name of *Neil Gaiman*. For here, in an almost throw-away aside, he comes up with the first feasible means of faster-than-light travel. *Scientific American* was full, *New Scientist* were out — so he flogged it to us instead . . .

Milkmen have secrets. Surely you have suspected that. Anybody who can be so bright and cheerful so early in the morning must have something to hide, some hidden source of amusement, you may be sure. I suppose that you thought — if you've thought about it at all — that the cheerful fellow in the white cap got his sardonic grin and whistle from a quick tumble in the kitchen with the busty blonde housewife at Number Twenty Seven.

But that's what they want you to believe. It's all a plot, a cunningly orchestrated international conspiracy. I am the only one who knows the truth. And I am locked up in this damned dairy, to prevent me from warning the world.

Let me introduce myself. My name is Pond. James Pond. I am a troubleshooter with the Ministry of Agriculture, code-name 546/b/TM9, licensed to leave London. Or at least I was at the time these horrifying events began — events that even now the world reels in ignorance of!

It was the Summer of '82 — 6th June to be precise — that it all started. I remember it as if it were yesterday. The

Illustration by Nigel Hills

21

ghastly beyond belief

> *"You could compile the worst book in the world entirely out of selected passages from the best writers in the world."*

above: *Ghastly Beyond Belief* cover drafts, 1984. The notes indicate Gaiman and Newman's requests had been registered. The very first sketch (the napkin one) never made it out of Arrow's art department.

opposite: Cover by Alan Craddock.

But what happens if you pick out the worst bits from the worst writers? *ghastly beyond belief*, published in april 1985 and coedited by kim newman, was a compilation of quotes from the worst and most bizarre science fiction books, television shows, and movies: a book-length tribute to terrible prose.

It came about when Gaiman and Newman were introduced at the British Fantasy Society by Gollancz editor Jo Fletcher, when Gaiman was just twenty-two and Newman twenty-three. Gaiman mentioned he wanted to do a collection of science-fiction/fantasy quotations called *Beam Me Up, Scotty*. Newman leaped at the idea, said he'd do the film half of it, and within two days had mailed a sample chapter and outline. Gaiman in turn wrote his part and sent them both—along with a proposal—to three publishers. One of them didn't reply, one of them said no, the other—Faith Brooker, then a very junior editor at Arrow Books, whom Gaiman had also met at the BFS—liked the idea. She took them out for lunch to discuss it. "The boys came in together with the idea, which, I believe, was to be seen as a fairly serious, completist, and, dare one say, nerdy endeavor," says Brooker. "SF fans, as you may be aware, have a certain penchant for such things."

Over the course of their lunch it became increasingly obvious that the quotes that made them laugh worked best, so Brooker suggested they push it toward that. Obviously a book of bad science-fiction quotes needs a very particular kind of cover, so that important element was decided on before the lunch plates were cleared away. "Nobody had told me at that point that authors weren't supposed to get involved with cover designs," said Neil in a later interview. "So I just designed a cover on a napkin, indicating the word 'ghastly' had to be green, the girl has to be running away, and here's the brain monster behind her, and we need Saturn in the sky, and a rocket ship. Brooker didn't know authors didn't do that either, so she gave it to an art director, who gave it to an artist

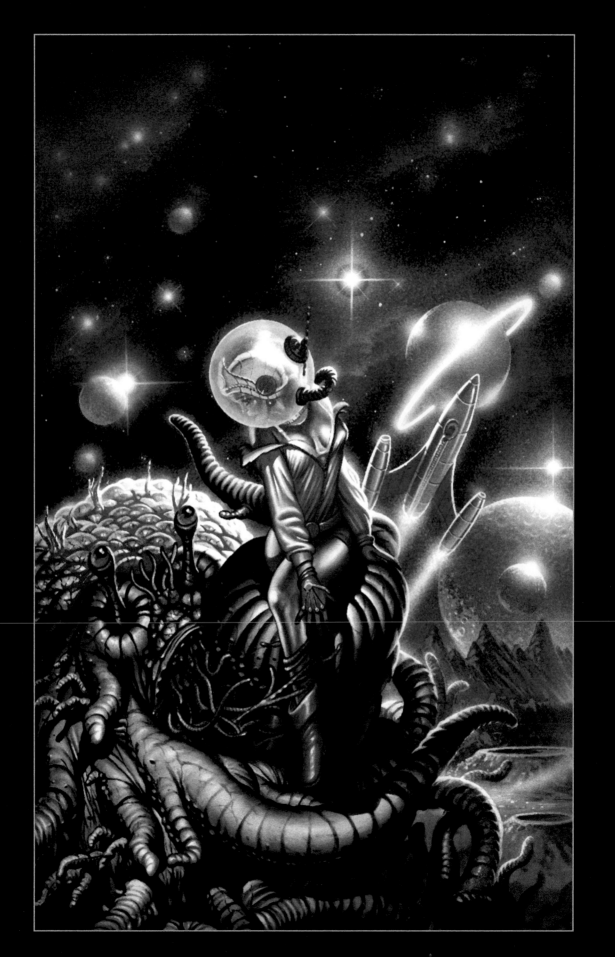

[Alan Craddock], and that's why we got that cover" (Wagner, 2008).

Legendary science-fiction writer Harry Harrison provided an introduction after being cornered one night in the Troy Club on Hanway Street, "a very small room upstairs where quite a lot of showbiz and publishing industry people would be sat around there destroying their livers. It was called the Troy Club because the woman who ran it was called Helen." Harrison wrote the introduction for nothing, which was undoubtedly an incredible boost for two nervous young writers who had so far not done all that much.

As for how the book did when it made it to the shelves, it's mysterious. Kim said that if anyone's to blame for the lack of sales it's probably the guys who designed the cover on a napkin in the pub and then got exactly what they asked for. Gaiman reckons there's more to it. The numbers on the royalty statements did not quite add

up. On paper the 10,000 print run didn't sell out, and Newman and Gaiman never earned out their advance. Arrow (who was largely uncommunicative after Faith Brooker left for fairer publishing climes) claimed to have pulped the entire run. Yet when Neil toured Australia in 1992 he found that an unlikely number of people were sliding copies of *Ghastly Beyond Belief* across the signing table.

By that point they'd become rare as hen's teeth in the UK, and I said to the Australians, how do you all have these? They said they'd been in dollar shops for years. What Arrow had obviously done was ship all the copies of Ghastly Beyond Belief *that they were telling us that they'd pulped, and had not let us buy, at a time when people loved it, to Australia and were selling them in dollar shops. Which made me sad. I would have bought a*

```
          Synopsis.              9. Dec. 83.

"Beam Me Up, Scotty..." - The Book of Science Fiction and
Fantasy Quotations.

Chapter:                    Title/Subject
0.     ...       ....   Acknowledgements, introduction.
1.     ...       ....   Quotations about SF/Fantasy,
               including definitions of SF, nasty things
               said about SF, overblown statements made
               about SF.
2.     ...       ....   (Probably the longest chapter)
               Quotations from SF and Fantasy stories, by
               author.
3.     ...       ....   Great titles of books and short
               stories.And awful titles.
4.     ...       ....   "The Larger they Come...".
               Quotes about some of the big name authors
               (Ellison, Asimov, Heinlein, Tolkien, etc).
               Also great critical boo-boos ( eg:Anthony
               Boucher's "of course it will never make a
               best-seller list" review of Lord of the Rings.)
5.     ...       ....Famous film and TV SF quotes, including
               catchphrases and "Intro spiels".
6      ...       ....   "Hooks and Twists". Great hook
               beginnings, of the 'One day the Pope forgot
               to take her Pill...' kind. Also a section giving
               away all famous twist endings, SF whodunnits,etc
7      ...       .....   Blurbs.(Including book jacket blurbs,
               film poster and trailer blurbs). Great blurbs,
               unusual blurbs, awful blurbs, innacurate blurbs
               and plot giveaway blurbs.
8      ...       ....   The Worst of SF. Dreadful story quotes
               (including abominations perpetrated in award-
               winning books).
9      ...       ....   The Moving Worst.. Dreadful film and
               TV quotes.
10.    ...       ....   Miscellaneous: great, weird or
               whatever quotes or oddments we run into while
               compiling the book that don't fit anywhere.
```

NEIL GAIMAN
Harwood House
Harwood Lane
East Grinstead
West Sussex RH19 4NQ
Tel: (0342) 21459

16 Dec 83

Dear Kim,

Hiya. Sorry I didn't get a chance to phone you over the last few days but I've had a couple of heavy deadlines to meet and I've been working night and day (literally). So here's the score: I spoke to Faith at Hutchinson/Arrow - she's interested and wants a fuller synopsis. George Allen & Unwin (who publish the Nigel Rees quote unquote stuff and Maxim's Book of Rock quotations) are also interested and are meant to be phoning me over the next week.

I'm going to spend some time over Xmas doing up a fullish synopsis (say four or five pages) of what we plan on doing, with a lengthy piece on the kind of SF quotations we're looking at. When you get back from Somerset give me a ring. Have a nice Xmas.

best wishes
neil.

P.S. a) Douglas Adams gave a verbal OK on using anything from the Hitchhiker books as quotations, and also gave me a great Dr Who quotation, said quotation having earned Terry Nation 99 percent of his bank balance. It seems the original description of the Daleks ran "Enter a robot on wheels..."

b) If you get a chance can you check out what the legal/copyright scene with quots is? multo gracias etc.

box. By that point they were fifty quid each, and these days they're a hundred and fifty quid a copy. The trouble was by that point people would actually have reprinted them, only Kim and I looked at it and thought, "There are so many errors that got into this book, and it's such an odd mish-mash of things . . ."

But I'm just pleased somebody published it. It's one of those things where it might have sold better with cartoons of bad quotes, but I don't think it would have sold much better. It was this mad little idea of a book of quotes—some of which were terrible, and some of which were great. It was a mixture of things that we loved, a weird book that it didn't know what it wanted to be, but I got a lot of things out of it. I even got my friendship with Polly Samson, who is still, almost thirty years later, a good friend of mine. She was our publicist at Arrow, and I think it was her first publicity job, and this was her first book. It was everybody's first go. ❖

"It was this mad little idea of a book of quotes—some of which were terrible, and some of which were great."

where hyperdock meets hyperspace and in order to know death, it is first necessary to "fuck life in the gall bladder." How do you determine signs of intelligent life in the midst of so many damaged brains gibbering stuff about killer rabbits and Zevata's golden whiskers? No, it's not easy. Best to know the worst, though. Thus extracts from science fiction books and films have been drawn

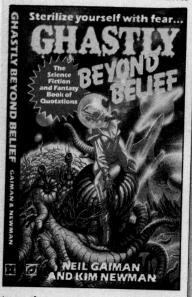

RIGHT AND BELOW: *Ghastly Beyond Belief* royalty statement, December 1985, in which Newman and Gaiman still owe their publisher £128.28. The form cover letter comes across as ever so slightly sarcastic given what it's attached to.

Hutchinson Publishing Group Limited

Brookmount House
62-65 Chandos Place
Covent Garden
London WC2N 4NW

PLEASE REPLY TO

Accounts and Royalties
Hutchinson (Management Services) Ltd
Tiptree, Colchester
Essex CO5 0SR

Distribution Tiptree Book Services Limited Tiptree, Colchester, Essex CO5 0SR Telephone Tiptree 816382 Telex 99487

Overseas Melbourne, Sydney, Auckland, Johannesburg and agencies throughout the world.

Date as postmark

Dear Sir/Madam

I have pleasure in enclosing Royalty Statement(s) for the half-year ended 30 June 1985.

A cheque in settlement of any amount due will be forwarded to you at the end of October.

Would you please retain Royalty Statements for Income Tax and VAT purposes, as no further copies can be supplied.

Yours faithfully

L A HARRISS (Mrs)
Supervisor
Royalty Department

CENTURY HUTCHINSON LIMITED

ROYALTY STATEMENT

Title GHASTLY BEYOND BELIEF
Author KIM NEWMAN & NEIL GAIMAN

Imprint Arrow/Zenith

together that collectively destroy civilisation as we think we know it. Amongst the list of acknowledgements will be found the name of Ian Pemble, editor of this magazine, apparently responsible for drawing the authors' attention to this sentence: "They were featureless and telic, like lambent gangrene. They looked horribly like children." Makes you wonder about *his* mind, doesn't it? *(No, that was Dave Langford, on Stephen Donaldson, in* Knave. *Sorry 'bout that — Ed.)*

RIGHT: From 1985. "We got reviewed in everything," says Kim. Back then publishers used to cut out reviews and post them to you. These days you have to do your own googling. Featuring reviews by Anne Billson, Colin Greenland—people who were not their friends at the time but soon became friends.

DURAN DURAN:
the first four years of the fab five

"THERE'S ONLY ONE BOOK I've ever written that was written solely for the money. and it wasn't even very much money, but when you're very young and very hungry, and somebody's just offered you the opportunity to write a book, you take it," Gaiman told Alex Amado.

"I spent several months writing a book that I wouldn't have wanted to read."

It's been said in a couple of articles that Gaiman doesn't even own a copy of his first published book, a bio-discography of the hugely successful English pop group Duran Duran. But it's there in his library, in the dark corner just to the right of the jackalope and a couple of shelves below the ring binder of adolescent fiction.

Kim Newman was in the process of writing a book called *Nightmare Movies* when the publisher, Proteus, mentioned they needed some more writers for a line of rock-and-roll biographies they were doing. Knowing his pal Neil had written swathes of pieces for rock magazines—reviews of gigs and albums—Newman put him forward. "I got a phone call from a lady named Kay Rowley, who was Kim's editor, and she said would you like to write a rock-and-roll book for us? A rock-and-roll biography? And I thought 'Oh God, yes! I'm in!'" Gaiman started rattling off names of bands he'd like to do: The Velvet Underground, David Bowie, maybe Lou Reed on his own and after that, Elvis Costello? "Ah. Let me tell you what your choices are. We've already figured out what books there are. They're on the schedule. Nine months from now they'll be published. Your choices: do you want to write the Duran Duran book, the Barry Manilow book, or the Def Leppard book?"

Gaiman thought about the three unappealing options, but not for very long. "I figured Duran Duran had done much less. They'd done three albums by that point and were just about to bring out a fourth. With Barry Manilow, I figured I was going to have to listen to, you know, forty Barry Manilow albums" (Richards, 2001). So he signed the deal and suggested Dave Dickson for the Def Leppard one, since he'd already written about the band for *Kerrang!* and would be similarly enamored with the £2,000 advance.

"It was the kind of biography where you go down to the BBC and you say: 'Hello, BBC press cuttings library? I would like to buy everything you have with the words "Duran Duran" in it.' And you pay £150 for all their photocopying and you take it away and you take all of these press clippings and you write it into a book. And you listen to the albums (Richards, 2001).

"It seemed very, very straightforward. And honestly it was. I wrote a book. But I was dead not proud of it."

OPPOSITE: *Duran Duran* book cover, Proteus, 1984.

While Gaiman had no personal interest in the band itself, the book does sound like Neil. It starts with an essay about the nature of life and art and the pendulum swing—how every movement *this* way has a movement *that* way. He was able to wedge in a piece about punk, because it was punk's counter swing that became the new romantics, the flamboyant peacock people with their puffy shirts and mascara. He talks about the band's influences and focuses on David Bowie and Roxy Music; any commissioned writer would have done the same but probably would have devoted less of the word count to them. Gaiman somehow managed to make the best of a less-than-ideal situation by fitting the subject into its place in the world, or its place in *his* world.

The book was published at the height of Duran Duran's fame, and became a minor bestseller with the first printing selling out in mere days. But.

What happened then was the publisher, before they could go back for the second printing, was taken into involuntary bankruptcy. And that was that. That was a really good thing, actually. I got the £2,000 up front but I never got any of the royalties I should have gotten. It never went on to make me any money, which meant that I got to stop and take stock. And I thought, Okay, so I spent several months writing a book that I wouldn't have wanted to read. I don't think I'll ever do that again. And I learned a lesson that every now and then the universe conspires to remind me of. If somebody was to write my life as one of these comedic tragedies they would point to this as one of those recurring themes that I need to be retaught every now and again, which is: Whenever I do things for the money . . .

Whenever I do things because I want to do it and because it seems fun or interesting and so on and so forth, it almost always works. And it almost always winds up more than paying for itself. Whenever I do

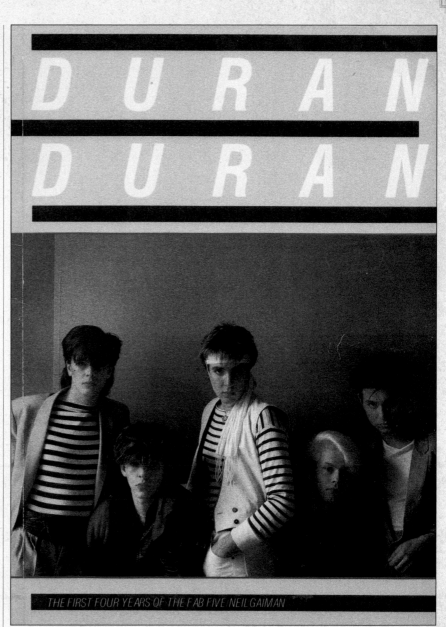

THE FIRST FOUR YEARS OF THE FAB FIVE NEIL GAIMAN

things for the money, not only does it prove to be a pain in the neck and come with all sorts of awful things attached, but I normally don't wind up getting the money, either. So after a while, you do start to learn to just avoid the things where people dangle huge wads of cash in front of you. Go for the one that seems interesting, because even if it all falls apart you've got something interesting out of it. Whereas, the other way, you normally wind up getting absolutely nothing out of it.

Gaiman kept the book more or less a secret, dropping it from bibliographies and never mentioning it in interviews. It wasn't until 1996 that he came clean to none other than lead singer Simon Le Bon, on a yacht in the Mediterranean. "We'd spent a couple of days together, and I thought this is becoming kind of awkward, so I sidled over to him and told him when I was a very young hungry journalist I wrote a book about Duran Duran. He asked which one and when I told him he said: 'We liked that.' I relaxed a little—my twenty-three-year-old self was gratified" (Masters, 2010). ❖

DON'T PANIC:
the official hitchhiker's guide to the galaxy companion

"It's all absolutely devastatingly true—except the bits that are lies . . ."

ABOVE: Neil and Douglas, 1984. Photo by John Copthorne. "This would have been the second time I met him. It was for the *Knave* interview, because *Knave* sent a photographer and there was just a test snap with me in the picture. He was a grown-up and I wasn't, when I first met him, but I wasn't nervous. I don't think I was nervous meeting *any*body. I was cocky, I guess. I was really interested, I wanted to do a good interview." Douglas is playing Marvin's "How I Hate the Night" song, and Neil is twenty-two, still smoking, and still wearing gray.

GAIMAN HAS SAID THAT ONE OF THE THINGS HE WAS VERY GOOD AT AS A YOUNG WRITER WAS DEPLOYING VOICES.

"I was very, very good at taking a voice that already existed and just parodying it." While not essentially a parody, his biography and guide to Douglas Adams's *Galaxy*, published when Gaiman was twenty-seven, is brilliantly written in Adams's own voice. It's one of many projects that sprang from Gaiman's time as a starving (or at least very hungry) journalist.

In the early eighties, *Hitchhiker's* had already been around for years: there had been a radio series, three of five novels, a TV series, a computer game, but, despite the greatest of efforts, there hadn't yet been a film. Arthur Dent, Ford Prefect, the two-headed Zaphod Beeblebrox, and Marvin the paranoid android were household names.

Back when Gaiman got his first commission for an interview for *Penthouse*, the editor mentioned that he was a big fan of Douglas Adams and that if Neil could get an interview with him that would be another job in the bag. "So I phoned up Douglas' publishers and I did. And by the time I got the interview, that editor had already been fired. But Douglas spoke so much that not only did I sell *that* interview, but leftover bits of the interview in question went to two other magazines—*Knave* and *Fantasy Empire*. So, by the end of doing one interview, I'd done three Douglas Adams interviews" (Huddleston, 2004).

Much like *Duran Duran: The First Four Years of the Fab Five*, *Don't Panic* was Kim Newman's fault. "A guy called Richard Hollis had been hired to write a *Hitchhiker's Guide to the Galaxy* companion. And Richard was a really nice guy who worked at Forbidden Planet, and I do not know why it didn't happen. He wrote a few chapters, which he gave me, but I don't think there was anything in them I used. But he flaked out, so Titan Publishing's boss Nick Landau asked Kim if he would write a *Hitchhiker's Guide to the Galaxy* book, and Kim said, 'No, but Neil has interviewed Douglas a lot, Neil knows Douglas, Neil would do a great job.' So I spent the second half of 1986 doing more interviews.

"I'd sit in corners of his office going through old filing cabinets, pulling out draft after draft of *Hitchhiker's* in its various incarnations, long-forgotten comedy sketches, *Doctor*

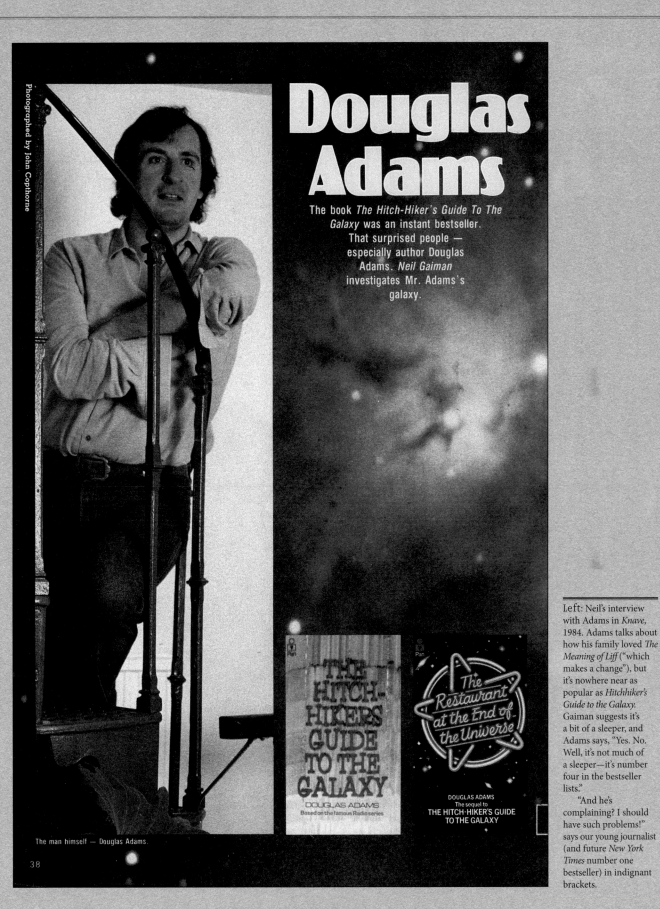

Photographed by John Copthorne

Douglas Adams

The book *The Hitch-Hiker's Guide To The Galaxy* was an instant bestseller. That surprised people — especially author Douglas Adams. *Neil Gaiman* investigates Mr. Adams's galaxy.

THE HITCH-HIKERS GUIDE TO THE GALAXY

DOUGLAS ADAMS
Based on the famous Radio series

The *Restaurant at the End of the Universe*

DOUGLAS ADAMS
The sequel to
THE HITCH-HIKER'S GUIDE
TO THE GALAXY

The man himself — Douglas Adams.

38

Left: Neil's interview with Adams in *Knave*, 1984. Adams talks about how his family loved *The Meaning of Liff* ("which makes a change"), but it's nowhere near as popular as *Hitchhiker's Guide to the Galaxy*. Gaiman suggests it's a bit of a sleeper, and Adams says, "Yes. No. Well, it's not much of a sleeper—it's number four in the bestseller lists."

"And he's complaining? I should have such problems!" says our young journalist (and future *New York Times* number one bestseller) in indignant brackets.

Two heads but one *Hitch-hiker's* TV series star Mark Wing-Davey as Zaphod Beeblebrox

Douglas Adams is the man behind Arthur Dent, the jerk in the dressing gown; Ford Prefect, a hoopy guy who knows where his towel is; Zaphod Beeblebrox, two-headed, three-armed, hip-talking ex-Galactic President and con-man, and Marvin, the Paranoid Android ('Life, don't talk to me about Life.' That one.) Not to mention oodles of other space-faring loonies with names like Slartibartfast, Wowbagger the Infinitely Prolonged, Hurling Frootang, and Deep Thought the almost ultimate computer. Also not to mention the Infinite Improbability Drive, histromathics, and the Restaurant at the End of the Universe. Which means, assuming that you haven't been on Mars for the last five years (or even on the legendary planet of Magrathea, where they build custom-made planets for the Ultra-Rich) that Douglas Adams is the man behind *The Hitchhikers Guide to the Galaxy*.

It started off as a radio show. Then it was a book. Then a TV series (and two more bestselling books). Currently Douglas is working on a film screenplay and a fourth book — tentatively entitled *So Long and Thanks For All The Fish*, which will chronicle how Arthur Dent and no doubt the usual crew of intergalactic misfits, go in search of God's Final Message to His Creation.

Douglas Adams — in conjunction with John (*Not The Nine o'Clock News*) Lloyd — is also the author of one of the strangest little black books to crash the bestseller list in recent years. Called *The Meaning of Liff* it has 'This book will change your life!' stuck on the cover, and is a dictionary of all those things we haven't had specific words for until now. Like *Wingnet* (a kind of poltergeist which specialises in stealing new copies of the A-Z from your car) or *Hemsbridge* (the dried yellow substance found between the prongs of your fork in restaurants).

So who is this man who has given the world so much?

He's currently living in Islington, in a large house filled with giant pencils, crayons, teacups and toothbrushes and a word-processor, on which the second draft of the Hitchhiker screenplay is currently being composed. He's tall, in his early thirties, and definitely very British. I started off by asking him a question he must have been asked many times before. Where did he get the original idea for *Hitchhiker*?

'The title's where it first came from, and that goes back to 1971. I was hitchhiking around Europe, and I had a copy of *A Hitchhikers Guide to Europe* (which was a book I'd actually nicked from somewhere). I didn't have a copy of *Europe on $5 a day* as I didn't have that kind of money. I didn't have the money to buy the book, either. Anyway, I was rather drunk one night in Innsbruck, and as I watched the stars come out it occurred to me — partly because I was so bored by Innsbruck — that somebody should write *The Hitchhikers Guide to the Galaxy*. I've still got that original copy of *Hitchhikers Guide to Europe* somewhere. I should look after it, I suppose it's played quite a large part in my life, in one way and another.

'After hitchhiking I went up to university, where I enjoyed some success in writing and performing, and I thought the world would beat a path to my door when I left, which it didn't do, so I started doing little bits for radio — *Week-ending* and so on, but I wasn't very good at that. I've always had a lot of difficulty in writing anything, and writing to order is not one of my strong points. Then some curious things happened. I had done some stuff for a Cambridge footlights production, which Graham Chapman (of *Monty Python*) had seen when it came briefly and disastrously to London. He liked some of the stuff in it and we went off for a few drinks and one thing led to another and I ended up working with him for about 18 months — mostly on projects which never saw the light of day. Graham is ... not the least weird person in the world, and at that point he was going through not his least weird period. He was basically having a lot of trouble with the bottle. And after 18 months it hadn't worked out the way

39

40

"I spent a while (I needed the money and couldn't face another piece of paper) as a bodyguard to an Arab royal family."

I'd hoped. All I'd got was a massive overdraft. Then I spent a while (I needed the money and couldn't face another piece of paper) as a bodyguard to an arab royal family.

'For ages and ages I'd been trying to interest the BBC in a science fiction comedy, but no-one was interested until a producer named Simon Brett came along who bullied me back into shape — and out of that came *Hitchhiker*. At that time I'd left London to go and live with my parents in Dorset, 'cos I couldn't afford to live in London and feed myself and things like that. It took me 6 months to write 6 episodes for which I was paid £1000. So I decided that I just couldn't afford to be a writer, and when I was offered a job as a radio producer I leapt at it.'

He only lasted for six months as a radio producer, rapidly reaching the awe-inspiring heights of script-writer on *Dr Who*. Although it was apparent that *Hitchhiker* was starting to take off he didn't have any idea how successful it was going to be, and spent a frantic two years writing the first *Hitchhikers* book, scripting the second radio series, script editing *Dr Who*, and on occasion even writing scripts for the Doctor.

'When I was script editor one of our regular stalwart writers — who we'd left alone as he was a reliable guy — turned out to have been going through a real turmoil. His wife had left him and he was distraught. He'd done his best, but we just didn't have a script and we were in deep shit. Come Friday, with the director arriving to start production on Mon-day we had to have a new four episode show. So the producer took me back to his place, locked me in his study, and hosed me down with whisky and black coffee for a weekend and there was this script. It was called 'The City of Death' and had had all sorts of bizarre things in it including a guest appearance from John Cleese in the last episode.'

At the end of two years he left the world of Daleks and the Tardis to concentrate full-time on *Hitchhiker*. I asked him when he realised that *Hitchhiker* was going to be so popular.

'Last week ... No, I suppose it was when the first book came out and went straight to the top of the Sunday Times bestseller list. It was a surprising moment for everybody — myself especially.'

So where did the characters come from? Ford Prefect (Arthur Dent's best friend, and not, as claimed, from Guildford, but from Betelgeuse) for instance ...

'Well, I remember the idea I had when I created Ford, which was that he was my reaction against Dr Who. Dr Who's always rushing around and saving people and planets and generally doing good works, so to speak. I thought the keynote in the character of Ford Prefect was that given the choice between getting involved and saving the world from some disaster on the one hand, and on the other going to a really good party, he'd go to the party. Every time. So that was the departure point for Ford.

'One of the problems I encountered, particularly in the third book — and there were a *lot* of troubles with the third book — was that all the characters are such a feckless lot that I find I've constructed an appalling situation and I'd find myself going round each of the characters in turn to see how they react to it ... and none of them want to get involved. That can be rather a problem really, if you've got this plot going on, and none of your heroes want to bother.

'I suppose part of it is that I don't really regard *Hitchhiker* as being about those characters. This may or may not be a flaw. But the way it operates in my mind — it's really about ideas, and the characters are there to make the ideas happen. It's probably something I'll grow out of but that's why the characters are two dimensional. Well ... two and a half dimensional.'

We discuss our favourite lines from *Hitchhiker*, since he's still trying to think of a title that both he and his agent are happy with for *Hitchhiker* 4. (His agent doesn't like *So Long and Thanks For All The Fish*, and thinks it should be called *God's Final Message to His Creation*, which is sort of uninspiring). My favourite line in the first book is the one about the spaceships hanging in the air in exactly the way that bricks don't. But

ABOVE: Neil as The Book. In 2012 *The Hitchhiker's Guide to the Galaxy* radio series was staged live, bringing together the original cast of Simon Jones, Mark Wing-Davey, Geoffrey McGivern, Susan Sheridan, and Stephen Moore for the first time in years. Peter Jones, voice of The Book in both the radio and on television, died in 2000, so a different guest star would step in every night with Gaiman enlisted in for the Edinburgh Playhouse performance. "I always loved Peter Jones' delivery of the Guide, and all I can hope to do on stage is that, really" (Rudden, 2012). By all accounts, he did.

Who scripts, press-clippings" (Gaiman, 2003). Adams was keen for the book to exist and would answer questions and explain the things dug up from the filing cabinet, and he always made sure Gaiman had a cup of tea on the go.

I was an enormous fan. I was awed. He was living at the time in a house in Islington—the house itself turns up in So Long, and Thanks for All the Fish. He'd just come back from America, where he'd spent a very miserable year or so trying to get the Hitchhiker movie off the ground. It was one of those recurring motifs in Douglas' life. And he'd just returned to London, to his spiritual base, and was very keen on talking. I think at the time his book, The Meaning of Liff, which he did with John Lloyd, had just come out. A book he was desperately proud of and loved promoting. And I think he was happier with it than he was with many of his later novels. He was enthusiastic, tall, amiable, terribly polite. I learned as an author so much about how to treat fans and how to treat journalists from just watching Douglas. He treated everybody with unfailing affability and politeness (Huddleston, 2004).

"I learned a lot about the pitfalls of a writer's life from watching Douglas."

From the *Hitch-Hiker's* TV series: Simon Jones (left) as Arthur Dent and David Dixon as Ford Prefect.

Zaphod Beeblebrox getting in close with Trillian (Sandra Dickinson)

it wouldn't make a book title. From the next book, *The Restaurant at the End of the Universe* I was quite fond of Hotblack Desiato, the megastar who was dead for a year, for tax purposes. Turns out Hotblack Desiato is actually the name of an Islington Estate Agents.

"It's funny," he explained. "All the names in the book are made up, except for those that are genuinely names of stars, like Betelgeuse or Arcturus. (A lot of people think that 'Beetlejuice' is a made up word, as it sounds so silly.) Hotblacks have only been around here two or three years and the first time I saw their sign I nearly crashed my car with delight. It was such a wonderful name. And I had this appalling rock star character who I was trying to name, and I phoned up Hotblacks and said, 'Look, can I use your name?' They said fine. It hasn't done them any harm at all, except that a number of people have phoned them up and said, 'Come on — it's a bit cheeky, nicking a name from Hitchhiker to call your Estate Agency.' It's terribly unfair really. And they were terribly upset when I didn't buy a house from them."

On the more down-to-Earth side, what does he say to the accusation that he's milking *Hitchhiker* for all it's worth — that the idea was only good for maybe a book or two and the rest is just an effort to get more money? He shrugs.

"Put it this way. If I actually thought there was no more to be done with it then I wouldn't do anything more with it. Having said that, obviously the financial side of it can't be ignored. You can't say I mustn't do it, as I'd make some money if I did it. I think the people who say that wouldn't necessarily do the same if they were in that position."

Leaving the uncharted frontiers of intergalactic space for a minute I ask him about his strangest little best-seller *The Meaning of Liff*. How did this come about?

"Well, about five years ago John Lloyd and myself were sitting in a tavern in Corfu playing charades and drinking retsina. And because of the retsina we were drinking we needed to find something that didn't require too much standing up. So we started playing this game of making up words to place names. We wrote them all down, and Johnnie stuck them in a drawer somewhere and forgot about them. When he was putting together one of his books — *Not 1982*, I think, — he was stuck for things to go on the bottoms of some pages. And on some of the tops of pages. And on some of the middles of pages. So he dug them out and stuck them in, and they were very popular. So we thought 'Let's do a few more'. We set aside a few weeks and rented a beach house in . . ." he started laughing, ". . . oh dear . . . in Malibu . . ."

"Where else?" I muttered.

". . . I say it and blush, I'm afraid. We just sat there, drank beer, stared at the ocean and thought up words. What we were trying to do was identify all those things that everybody knows, and experiences, and has been through, but for which words don't exist. It's interesting, something for which there's a word is

much more thought about, more discussed — more recognised and more real — than something which in all other respects may be equally real in terms of the experience we've had of it, but there's no word for it, so it's always vague and amorphous. Like *Woking*, which is one of my favourites. It's standing in the kitchen wondering what you came in here for. Which we all do. But until you've actually given it a word it's not something people recognise."

The photographer and I nodded sagely, in the manner of men who often find themselves in a kitchen wondering what they came in for, and are pleased to find there is a word that describes this phenomen. Douglas continued.

"Another example — Granada TV wanted to do a film of the book for one of their weekend shows, and so we went up to Manchester to film some of these things in the street. One of them was a *Sturry*. Now a sturry is the token run pedestrians do crossing the road in order to try and kid the motorist they're getting across quickly. Of course it's completely dishonest, because a sturry as such will fall into one of two categories: either it's going to be slightly slower than the walk it's replacing, or people do hurry slightly, not to get out of the motorist's way, but to get *into* his way, so he doesn't have a chance to go past before you get there. And there's

"John Lloyd was stuck for things to go on the bottoms of some pages. And on some of the tops of pages. And on some of the middles of pages."

41

". . . that which has to be cleaned off the castle floors in the morning after a bagpipe contest or a vampire attack."

always a little patronising wave of the hand at that point.

"Anyway, we were talking to the guy directing the film and he said 'That one I don't recognise', and we said OK, let's go out on the high street. In two minutes we saw six sturries. We were seeing them all afternoon."

"All the words aren't all serious, though," he continued. "Some of them are just silly. Like *Spittal of Glenshee*, that which has to be cleaned off the castle floors in the morning after a bagpipe contest or a vampire attack. One that we came up with in Corfu is *Shoeburyness* — the vague, uncomfortable feeling that you get from sitting down in a seat still warm from someone else's bottom. But it's the observations of behaviour that are the most fascinating. Like *Hickling* — that's the practice of infuriating theatre-goers by not only arriving late to a centre-row seat, but loudly apologising to and patting each member of the audience in turn as you go past.

Hastings, which are things said on the spur of the moment to explain to someone who comes into a room unexpectedly, just what it is you are doing.

"Then there are the things never expressed in the language before as they weren't the kind of things that people actually talked about. Like *Hobbs Cross*. This is the awkward leaping maneuver a girl has to go through in bed in order to make *him* sleep in the wet patch. It was a real pleasure doing this book as I normally don't enjoy writing at all. And my family like it, which makes a change. It's selling quite briskly, but nowhere near as well as a *Hitchhiker* book or a *Not the Nine o'Clock News* book. I think that's because people have no idea what it is — it's totally enigmatic and anonymous, unless you happen to recognise our names — in both of our cases our product is more famous than we are. But on the other hand it has terrific word of mouth."

"So it's a bit of a sleeper?" I suggest.

"Yes. No. Well, it's not much of a sleeper — it's number four in the best-seller lists."

(And he's complaining? I should have such problems!)

At that point the photographer decided it was time to take the pictures and we wandered around the house, posing Douglas on his spiral staircase, and making him drink out of his giant cup and write with his giant pencil, and finally, since he asked nicely, posing him sprawling on this couch-thing playing the *Hitchhiker* theme on his electric guitar. He's actually not a bad guitarist. We spent most of the time talking about Elvis Costello but you don't want to hear about that, do you? (No. — Ed.)

I asked him how he came to choose the *Hitchhiker* theme music. He laughed. "It shouldn't have worked, but it did," he explained. "I figured that as it was set in space it should have something spacey with synthesisers on it. And since it was funny it should have something to show it wasn't too serious, like banjo music. So I went through my record collection looking for something with synthesiser and banjo and that was what I came up with."

Like everything else Douglas Adams has done, it seems to have worked.

42

Don't Panic is not a biography of Adams, but more a biography of an idea—the five-book trilogy, the computer games, the towel, the television series—how they came into being, and how and where they fit in the world. It's full of anecdotal stories about what did and didn't work in the *Hitchhiker's Guide to the Galaxy*, how stuff that worked on radio didn't work in the television series, and how things that work in a television series don't always work in a novel. This was still Gaiman very much learning his craft by going out and asking questions—figuring out the mechanics of books by asking the people who make them. He told the story right up until 1987, when his interview tape ran out, and over the years more chapters and appendices have been added by other people.

"What I walked away with from writing *Don't Panic* was the sense that 'I can do this' (Wagner, 2008).

"It was my first real excursion into nonfiction. I could definitely see myself doing another nonfiction book. It would be fun. I learned a load of things from it, and it would be nice to go back. I learned a lot about the pitfalls of a writer's life from watching Douglas. I also think for me *Don't Panic* represents a road not taken. I could have gone on and become somebody who wrote books about other people. Having said that, I had so much fun with the style of *Don't Panic*, writing in this classic English humorist sort of style, that I then went on and did a book called *Good Omens* with Terry Pratchett. So if it hadn't been for *Don't Panic* there would never have been a *Good Omens*" (Huddleston, 2004). ❖

good omens
the nice and accurate prophecies of agnes nutter, witch

"*A funny novel about the end of the world and how we're all going to die.*"

NOW IN HIS late twenties, with his feet firmly planted in the realm of english humor, gaiman wrote the beginning of a story he didn't know how to finish.

"I wrote the first five-thousand-word scene of *Good Omens*, and then sort of abandoned it . . . I had the thought that 'Terry Pratchett is the guy who writes funny fantasy novels, *I* will be considered the guy who writes funny horror novels, and that is not where I want to live.' I knew enough about myself to realize I would be doomed if I was that one thing. Already I'd seen friends of mine, moderately successful, talking about the book they wanted to do that their publishers wouldn't let them do, because it wasn't like the last one, it didn't fit some preconceived notion" (Wagner, 2008).

Gaiman's story was a parody of Richmal Crompton's *William* books, hugely popular funny short stories that ran from the 1920s featuring a mischievous eleven-year-old boy and his gang of friends, the Outlaws. Under the working title of *William the Antichrist*, Gaiman's five thousand words covered everything leading up to the birth of the child that would bring about the apocalypse. He sent it off to a few friends, went off and wrote a pile of other things, and then largely forgot about the story's existence until Terry Pratchett, who was one of the people who'd been sent a copy of the opening scene, phoned him up and asked him about it.

Pratchett was another connection Gaiman had made while working as a journalist. It was to promote the release of Pratchett's novel, *The Color of Magic*, and happened in a Chinese restaurant during the time when Gaiman was still sporting an ill-advised gray hat in an effort to look as suave as Kim Newman (who at that time was striding around town in a dapper trilby). "It was Terry's first interview as an author where somebody took him out to lunch and asked him questions. I was interviewing him for *Space Voyager* magazine. A magazine so poor, I had to take the photos of Terry after the lunch" (Gaiman, 2001).

Cut to three years later, in 1988: "I got this phone call from Terry, saying 'Remember that plot? I know what happens next. Do you want to collaborate on it, or do you want to sell it to me?' And I said, 'I'll collaborate, please'" (*Locus Online*, 2006 (1991)).

ISBN 0-575-04800-X

above: Neil and Terry in 1990. Said Gaiman on his blog:

"It was taken in Kensal Green Cemetery in February.

"Terry borrowed the white jacket from our editor, Malcolm Edwards, and grumbled that it did nothing to keep him warm on a very cold day. 'Sometimes you have to be cold to look cool,' I told him. 'It's all right for you,' he said. 'You're wearing a leather jacket.'

"'You could wear a leather jacket too.'

"'I'm wearing white,' said Terry, pointedly. 'That way, when they come after us for writing a blasphemous book, they'll know I'm the nice one.'"

From the U.S. hardcover edition published by Workman Pub., 1990.

Pratchett by this point had already written about four of the *Discworld* novels, but he was still a few years away from becoming the UK's biggest selling author of the 1990s. "People tend to forget that Terry wasn't 'Terry Pratchett' back then," says Gaiman. "He wasn't this continent-sized, vast, one-in-every-three-books-bought-in-the-UK-is-a-Terry-Pratchett-type author. He'd done half a dozen or so books, and was doing okay." Pratchett, who had also found his start in journalism, had only recently quit his job to focus on writing fiction full-time. "He was barely Neil Gaiman then, and I was only just Terry Pratchett," he told *Locus* magazine in 2006.

But Gaiman has frequently described the team-up as an apprenticeship. "Terry could build a novel like a fine Chippendale chair maker could make a piece of furniture. He knew how they were crafted" (*Locus Online*, 2006). It was as if Gaiman had been invited into the workshop to be shown how it was done. "It was a lot of fun writing it. Terry likes writing a lot more than I do. I quite like *having* written, and I love *going* to write. Going to write is *great*. But Terry actually likes writing, which I don't because it makes my back hurt; and anyway, there are people I should be on the phone to. So I'd wake up in the early afternoon and there'd be this message from him on the answering machine saying, 'Get up, you bastard. Get up. Get up. I've been here since seven o'clock this morning, and I've written all this.' Then I'd ring him back and we'd talk. And then I'd work on *Sandman* and *Books of Magic* and stuff like that until about two o'clock in the morning, as I remember, and then at two, no matter where I was at or what I'd done, I would go over and do five hundred words of *Good Omens*" (*Comics Journal* #155, 1993).

The story stretched and grew into a novel—a quasi-parody of the film *The Omen* and then some. It was about the birth of the Antichrist, the coming of the End Times, and the various attempts of Aziraphale the angel and the demon Crowley (formerly Crawly, the serpent who did not fall but Sauntered Vaguely Downwards), to stop them from happening. Both the angel and the demon—old

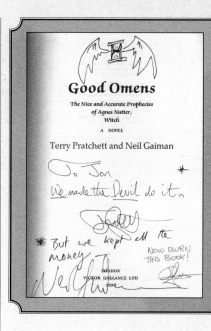

acquaintances from the Gates of Eden—have vested interests in averting the Apocalypse in that they've become quite comfortable in their human lives.

By the time Gaiman and Pratchett had finished the novel, the character was no longer called William, and *Adam the Antichrist* didn't have the same ring to it. "With William the Antichrist, you had William the Conqueror. That has a nice ring to it. Terry and I spent three weeks after we'd finished it, throwing titles back and forth at each other. It was terrible, the amount of awful titles we came up with, and then one day I phoned Terry up and said, 'I've got it: *Good Omens*'" (Kraft, 1993).

The book took nine weeks to write. In those pre-email days, the two writers would phone each other and post a floppy disk back and forth, until right at the end when they both owned modems, though they were working at a speed so slow that Gaiman and Pratchett could have dictated the story down the phone faster than it uploaded. Interviews with the duo were at the time—and still are, when it occasionally happens—very much like their collaborative style: a double-act of two people racing each other to the good bits.

"So that was how we wrote the novel together. And there are bits of the book that are me, there are bits that are him, there are bits that are me revised by him, and bits that

are him revised by me. There are bits he thinks I wrote and I think he wrote, and there are bits that I'm quite sure that I wrote and he claims that he wrote. I sort of wish now that when it had just come out, I'd gone through it with markers then and noted down whose bits were whose down to the word, because I could have done it then; now I couldn't" (*Comics Journal* #155, 1993).

They both brought different sensibilities to the same story but they melded so well it's seamless.

It was Gaiman's first novel (with a not-to-be-sneezed at print run of 90,000), published in 1990 when he was thirty, and he and his coauthor were nominated for both Locus and World Fantasy Awards the following year. Pratchett went on to write more *Discworld* novels, and Gaiman was already chasing the monthly deadlines for *The Sandman*, the comic that would make him famous.

He told Peter Murphy, "Terry and I have written a lot of things that people love, but there's something about people turning up at signings with their copies of *Good Omens* that have been around the world with them, y'know, they're swollen 'cos they got dropped in the bath or in some soup or a puddle, and they're held together with tape at the back and they *want this thing signed* because it's become a place that you go when things get rocky." ❖

BEFORE THE BOOK was published, Gaiman and Pratchett talked about whose name would go first on the book and decided that Pratchett would go first in the UK, because he sold more books in the UK than Gaiman, and Gaiman's would go first in America because he sold more there. Gaiman always had plans for a marketing reissue: an edition of two books, one with a white cover, one with a black—one with Pratchett's name first, one with his own. In 2006 it finally happened, when the rights changed from Ace's hands to William Morrow. "I get the white cover with the black demon on it; he gets the black cover with the white angel on it. White will be the new black" (*Locus Online*, 2006).

Chapter 2
BRITISH COMICS

1984

"Now in '84, I discovered Alan Moore in Victoria Station, not personally, but copies of Swamp Thing."

ABOVE: *Swamp Thing* #28, September 1984.

OPPOSITE: Gaiman's *Swamp Thing* "Jack in the Green" story. Art by Bissette. Released in Neil Gaiman's *Midnight Days* TPB (a collection of his DC short stories) for the first time. "It's a ten page story about a man dying—very 'Neil Gaiman' really, in that nothing happens" (Howe, 1999).

EIGHT YEARS BEFORE THIS DISCOVERY, GAIMAN HAD ESSENTIALLY ABANDONED ANY HOPE OF WORKING IN COMICS, THE IDEA HAVING BEEN SQUASHED OUT OF HIM BY THE KIND OF SCHOOL CAREERS ADVISOR THAT STEREOTYPES ARE BUILT ON.

"At that point I pretty much gave up the idea of writing comics, and then I stopped reading comics. That was about '76, '77, I was sixteen going on seventeen; it was a time when comics had dropped to eighteen pages an issue, and they started printing them on blotting paper, and all the people whose work I thought was interesting had either stopped doing interesting work or stopped working in comics. The only thing I carried on buying over the next five years was the Spirit reprints, and then in about '82 or '83, I'd become aware of *Warrior*" (*Fantasy Advertiser* #109, 1989).

Warrior was a British comics anthology edited by Dez Skinn—a former Marvel UK editorial director—that ran for three years before it ended in February 1985. While it only had a short lifespan, it's notable on the British comics map for being the place where (the then emerging-talent) Alan Moore's reinvention of *Marvelman* with Garry Leach first appeared, as well as his dystopian vision *V for Vendetta* with David Lloyd. DC Comics editor Len Wein was a regular reader of the magazine, which means that if we extrapolate the graph, Alan Moore wouldn't have been hired to revive the dying title *Swamp Thing* if there had been no *Warrior*, and without Alan Moore there would have been no British Invasion. In 1989 Gaiman told Brian Hibbs, owner of San Francisco's Comix Experience:

One day in early '84 I was in Victoria Station in London and they had a pile of comics at the newsagents, including Swamp Thing. *It was a title that I had loved as a kid, so I picked it up, thumbed through it, and thought, "Hang on, this is literate, this is really interesting." But by this point I had a very deeply ingrained prejudice against comics, and put it back down. Over the next month or so I'd pick up the* Swamp Things, *flip through them, and put them back down again. And finally, I think it was* Swamp Thing *#28—I bought it and took it home with me, and that was that. I'd discovered*

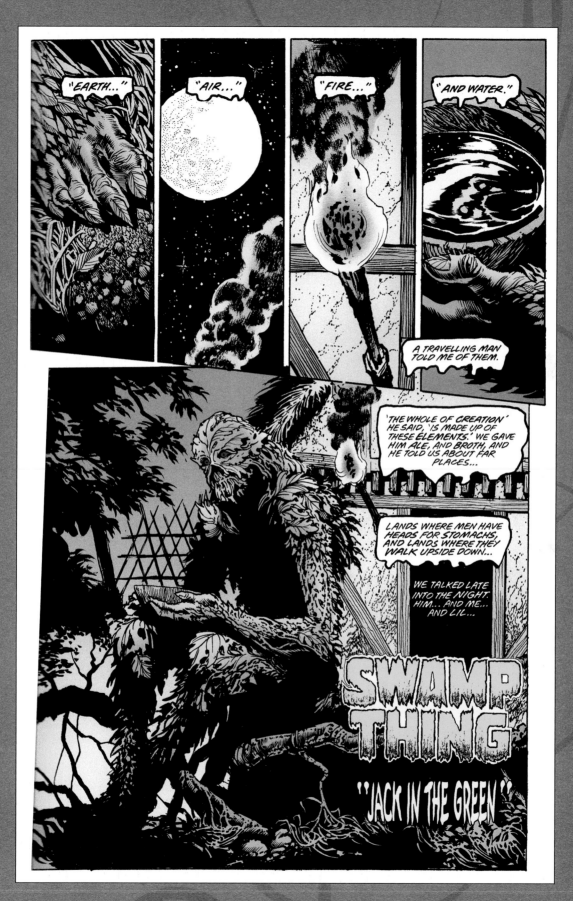

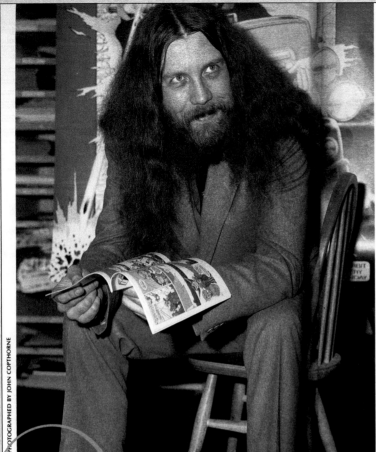

THE KNAVE INTERVIEW

"MOORE About Comics"

Unless you're an avid reader of comics you might well say "Alan who?" But in his field Alan Moore is the man. NEIL GAIMAN has been talking to him . . .

Ever since those first, faltering days, way back in the glimmering mists of pre-history, when Knave first started doing interviews, we've tried to keep some kind of balance between the famous names and the interesting interviews. Because, sad to say, some of the most famous people we have interviewed have been deadly dull, trotting out the same ageing anecdotes, and some of the lesser-known personalities have been the most interesting.

Which brings us to point one: Who is Alan Moore?

Alan Moore is an incredibly tall, hirsute individual, who writes comics. He writes intelligent, often groundbreaking comics, and is currently about the most sought-after writer of comics in America. He's English. And the odds are that unless you bought this magazine because his name was on the cover, you won't have heard of him.

Which is probably a pity, because with his work in *Warrior* in England, and more recently with *Swamp Thing* in the US, he has done some of the best creative work in any medium that I have seen in quite a while.

I interviewed him in the basement of London's Forbidden Planet bookshop. After a photo session which included posing him against a Judge Dread poster ("But I've never written Judge Dread" he protested feebly) we settled down with our cups of coffee, and he began to tell me the story of his life . . .

"I left school at the age of seventeen, and my first job was hacking up sheep carcasses for the Co-op Hide and Skin Division. It certainly gave me an insight into life, because we had to turn up at 7.30 a.m. and drag these blood-stained sheepskins out of these vats of freezing cold water, blood, and various animal by-products. Then we used to mutilate them in a variety of strange ways . . . but, oddly, a form of concentration-camp humour arose, and many was the happy hour that we had throwing whacked-off sheep's testicles at each other. It doesn't sound

that funny, out of context. Y'had to be there, I suppose . . .

"Then I started as a toilet cleaner, which seemed to be more my line, and I've worked my way down since then, eventually ending up as a comics writer. Somewhere along the line, back when I was a teenage werewolf, the arts lab movement was spreading. Small cells of people who'd do poetry readings, concerts, magazines and theatre; everybody who joined the group would learn a little bit of what everybody else was doing — it was great. It wasn't a formal artistic training, but it was influential.

"Northampton, where I live, is a small, dark, grimy town. A friend of mine described it as the 'Murder Mecca of the Midlands' — we have a fantastic number of completely bizarre murders up there, and they're different to murders anywhere else, because they're much more *warped*. You get headlines in Northampton papers like 'Vampire Killer Gets Life', and it's true! A boring town with a lot of evil shit going on. And very small Bohemian intelligentsia, only four of us, and we all know each other."

So how did he wind up writing comics?

"Getting into comics for me was a matter of going round the back, poisoning the dogs and climbing over the fence. I didn't go into it the route that people normally do, in that I didn't go straight into writing comics. I had a period of 2 or 3 years when I had delusions of adequacy as an artist, and I started drawing a strip for *Sounds*, writing and drawing it every week. First a Private Eye parody, called Rosco Mosco, then an SF comedy, and then — having done it for a couple of years — I was forced to the terrifying conclusion that I couldn't actually draw. However, I had learned an awful lot about telling a story during that time — how to get the pictures to move in sequence, and all the other things you find out, and I realised that I could write faster, write better, and make a lot more money writing than I could drawing. So I started sending sample scripts in to things like

38
39

says NEIL, "I DON'T like the title, and I do know how to spell Judge Dredd and Roscoe Moscow, but here's a nice pen-portrait of Alan Moore written at the end of 1985, published in the March 1986 issue of *Knave*, some months before the first issue of *Watchmen* was published. (I'd read the first three issues by then, in lovely Dave Gibbons photocopies.)" In the article Moore talks about Miracleman—"a really endearingly stupid superhero"—whose reins he would later hand over to Gaiman.

Alan Moore, discovered what he was doing. I realized you could do work in comics that was as every bit as mature, and interesting, and exciting, as anything that was being done in mainstream fiction or in modern horror literature. It was like coming back to an old lover, and discovering that she was still beautiful.

By September 1985 *Swamp Thing* #40 had hit the shelves and so had Gaiman's first book, *Ghastly Beyond Belief.* "It was about the time of the menstrual werewolf story. I had never written a letter to a comic and I thought, well, maybe I ought to write a fan letter, and I didn't really know how you went about doing it. So I got a copy of *Ghastly Beyond Belief* and I shoved it in an envelope and posted it to Alan—I got his address from Ian at the *Knave* office— and said, 'I think what you are doing is

absolutely incredible, here's something I've done, I hope you like it,' and I got a phone call the next day or the day after saying 'I just lost a whole day thanks to you. Loved the book.'

"We chatted on the phone every few weeks or months or whatever, and he was a big fan of people like Clive Barker and Ramsey Campbell and didn't know any of them, and I knew all these guys. The British Fantasy Convention was coming up at that time so I said, 'Would you like to come down to the con and I'll introduce you to all these guys and look after you?' And he did" (*Fantasy Advertiser* #109, 1989).

At that same convention Gaiman met Diana Wynne Jones, who was guest of honor at what was the first convention she had ever attended. Neil kept her company while she stood nervously at the bar, and downstairs Moore was reading Jones's *The Ogre Downstairs* to his daughters, Amber

and Leah, as their bedtime book. With the kids safely asleep he'd come back out and talk about comics. "I remember the stuff that he was telling me about that hadn't come out yet. He was telling me about the last Superman story ("Whatever Happened to the Man of Tomorrow?"), which hadn't yet come out. And he was telling me about a thing he did that *never* came out, which was Bernie Wrightson and him collaborating on "Superman Goes to Hell" and Lex Luthor going to rescue him.

At one point I sat him down and said, "Right. How do you do it? How do you write comics? Not plots and dialogue and that sort of thing, but what does a comic script look like?" Because I didn't have a clue. So he showed me on half a sheet of notebook paper and just sort of explained how to write comics the Alan Moore way. In terms of what you tell your artist, and showed me page one, panel one. "Some people, Neil, do lowercase for the caption description, and then they go uppercase for the dialogue, but I don't like doing that because it makes it look like everybody's shouting."

So I went off and I wrote a John Constantine short story called "The Day My Pad Went Mad," and I wrote it in the offices of Penthouse, *which would have been back when I was being features editor, or doing a stint ghosting on* Fitness *magazine, one of those two. It was about John Constantine returning home to his little apartment in East Croydon—don't know why it was East Croydon, just because I knew East Croydon, probably—and something horrible happening. He'd got back after six months and something horrible has been growing in the fridge—evil stuff, tentacles coming out—and he has to fight his way through. I think there may have been an antichrist in the story, some kid who could have been the antichrist who John Constantine sort of talks out of it—a thing that*

I later went back to from a slightly different direction. Anyway, I sent it to Alan and I said, "What do you think?" He said, "Yeah, it's alright. Ending's a bit iffy."

Then I wrote my "Jack in the Green" story (which eventually was drawn fifteen years after it was written). And I sent it to Alan. And he said "Yeah, that's good. I would have liked to have written that." Years later, I phoned Alan, and said, "Guess what? Steve Bissette and John Totleben are going to draw my 'Jack in the Green' story!" And he said "Fair enough Neil, but the one that I really liked was the one about that stuff growing in John Constantine's fridge."

"I didn't have a clue. So he showed me on half a sheet of notebook paper and just sort of explained how to write comics the Alan Moore way."

At Mexicon in early 1986, Gaiman and Moore met again, but this time Moore had two issues of the as-yet-unpublished *Watchmen* in his bag. "I was reading them and going: this is something special. This is not the same." *Watchmen* would dominate an article Gaiman wrote for *Time Out* in September, by which point four issues of the comic had come out and the series had become a phenomenon.

Incidentally, Alan Moore has always worked on the same Bo Diddley principle as Neil. Moore said, "I am a creature of impulse; but I have to cash the checks that my mouth has written. I have some big extravagant idea of what I am going to do and I tell everybody about it; then I have to do it so I don't look like a twat." ❖

2000 AD

2000 AD Launched in 1977 and was originally intended as a weekly science-fiction comic for boys but, as Gaiman put it in his *time out* piece, it "rapidly accumulated an older readership due to the lunatic, mutant-battling exploits of Judge Dredd, an all-in-one cop, judge, and jury in a post-apocalyptic america."

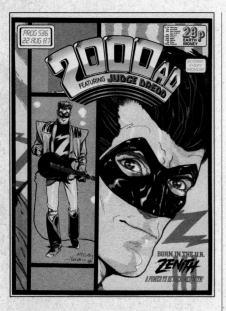

above: Cover to *2000 AD* prog 536, August 1987, in which Gaiman's third *Future Shocks* tale appeared. Also notable for the first appearance of Grant Morrison and Steve Yeowell's *Zenith*.

Lots of British creators had their start in *2000 AD*—Brian Bolland, Dave Gibbons, Kevin O'Neill, and Alan Moore among them. Moore created a bunch of characters for them over the years—two alien juvenile delinquents, *DR and Quinch*, and *Halo Jones*, a fiftieth-century everywoman in a hard science fiction story—but before they existed, Moore was an unknown entity in the world of comics. He started out the same way every untested writer did: he wrote some *Future Shocks*. Six years later, Gaiman would follow suit.

Future Shocks are *2000 AD*'s short, self-contained, twist-ending pieces, four of which were written by Gaiman between 1986 and 1987. "I did 'You're Never Alone with a Phone,' which was the first thing that John Hicklenton ever drew, about how telephones are going to get more and more intelligent, and then they will actually start talking to each other and ignore us. Which I think was remarkably prescient when I think about it."

It was his first comic, and the first time Gaiman got to see how his script translated to the drawn page. "I remember just being shocked at this bit where I had a sixty-word word balloon. I tell people the most important thing sometimes about learning to be a writer is seeing your mistakes in print, because the moment you see them you think, 'Oh, well, I won't do that again. I thought I could put this whole thing into a panel, but I couldn't and this is terrible.'"

"Conversation Piece," drawn by David Wyatt, was a two-page story between two disembodied voices about the use of the planet earth as a decorative ornament that followed in September. "That was a really good story. 'Phone' wasn't very good."

His next *Future Shock*—"I'm a Believer," published in August 1987 and illustrated by Massimo Belardinelli—was the point at which Gaiman started to go off the whole idea of *2000 AD*, having only really just begun.

It was a story that was actually based on something that my computer repairman told me. I just remember him saying that there was one computer that they had

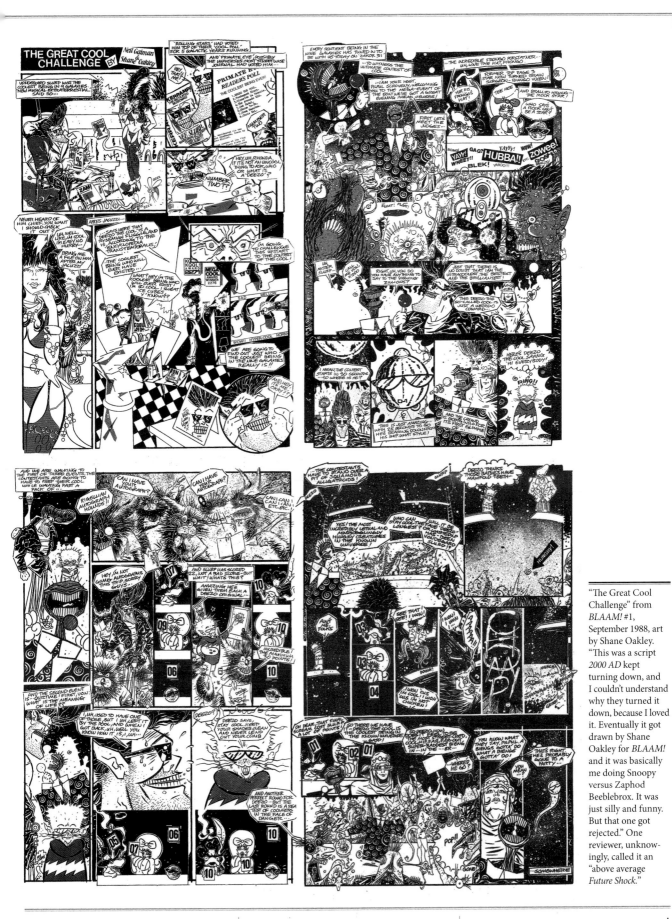

"The Great Cool Challenge" from *BLAAM!* #1, September 1988, art by Shane Oakley. "This was a script *2000 AD* kept turning down, and I couldn't understand why they turned it down, because I loved it. Eventually it got drawn by Shane Oakley for *BLAAM!* and it was basically me doing Snoopy versus Zaphod Beeblebrox. It was just silly and funny. But that one got rejected." One reviewer, unknowingly, called it an "above average *Future Shock*."

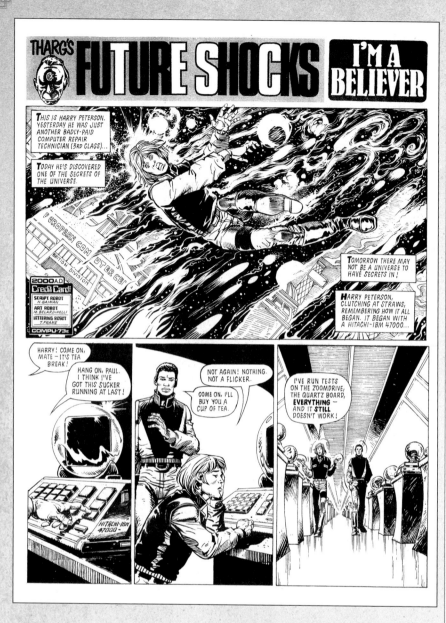

story, and so I wrote a Future Shock, and I must have been writing Don't Panic or researching it at that point, because I had all those Hitchhiker-*y* rhythms in my head—I wrote it as a Douglas Adams thing. And they went through and they took out all the jokes before it was published and I thought: They may not have been the greatest jokes, but there wasn't much point to this short story without them. It would be like editing Douglas Adams and taking the jokes out and keeping the plot. The plot isn't very good, and if you take out the jokes you really don't have much left.

> "I always had this theory which was: I should bet on myself. And invest in myself."

back in his homebase that they kept around to play as a practical joke for the young computer trainees, because piece by piece there was nothing wrong with it, but it didn't work. You could test every single piece and everything worked, then you assemble this thing, turn it on, nothing happened and nobody could figure out why. So they'd keep it for whenever a new guy would come in. They'd say: This one's just come in, can you just figure out what's wrong with it? And then watch somebody spend a day slowly going mad. I thought that was a fun little

The fourth and final of Gaiman's *Future Shocks* harked back to his days as a starving journalist, when he was prolific enough that he had to pretend to be several people at once. Drawn by Steve Yeowell, it was called "What's in a Name?" and was about a man who had to have his pen names surgically removed. "It was a story about my own personal travails with pen names, because I'd had a lot of pen names. And there were times when I would actually use pen names in person because it was easier. I was *Penthouse*'s film reviewer as Gerry Musgrave, and it was so much easier to phone the film company and say 'Gerry Musgrave from *Penthouse*, I need to attend this film screening, can you put me on the list' than it was 'Neil Gaiman, writing for *Penthouse* as Gerry Musgrave.' So I would wind up meeting people and using the pen names, and then people would get confused, and I would get confused, and

it was silly. So I wrote this story about somebody who has to have his pen names surgically removed and the nice thing about that was I got to list all my old pen names at the end."

There was one last *2000 AD* story after that. It appeared in the 1988 *Judge Dredd Annual*, and it wasn't a *Future Shock*.

It was a short story called "Sweet Justice." I think I titled it "Justice Is Sweet" and they changed it. It was Judge Hershey (because Leigh Baulch wanted to draw Judge Hershey) going to Brit-Cit. And I put Judge Pratchett in it and people said things like, "Mind how you go, now." I remember the bad guy was Hunter Tremayne, although I believe he was called Severian Clute in the thing. It was about somebody who thought they were dealing sugar but they were actually dealing tiny sweet spider eggs, and the giant spiders came and I think people may have erupted into spiders. Years later they came to reprint it by which point they had actually gone to Brit-Cit and whatever I'd written in that short story was no longer canon. So they got somebody else in to rewrite it. I've never reread it—either version. They never asked me, they never sent it. And I know it's still in print out there somewhere. It's one of those things that I see from time to time: This book includes Neil Gaiman's 'Sweet Justice!'"

Then, as the final nail, the mid-eighties publishing company Quality Communications—set up in 1982 by Dez Skinn to release *Warrior*—took on the task of repackaging *2000 AD* for the American market. "They were stretching it on a photocopier, changing the proportions so everyone was long and thin. And coloring them in very, very badly. Mostly sort of garish oranges. And then my thing came out and I didn't get a copy, and I didn't get any royalties. And I thought, 'That's why I don't want to do that anymore.'" It wasn't the fact that it was a low-paid gig that made Gaiman go off it.

Low-paid gigs are fine as long as the thing you did goes off into the world exactly the way you want it to, and that it makes you happy. "But I always had this theory which was: I should bet on myself. And invest in myself. And it seemed to me like writing something that you were never going to get royalties on, no matter what happened or what success it had, was not betting on yourself, was not investing in yourself. That's one-off. That seemed wrong.

"And that was it. That's why my entire work for *2000 AD* consisted of four *Future Shocks* and a short story." ❖

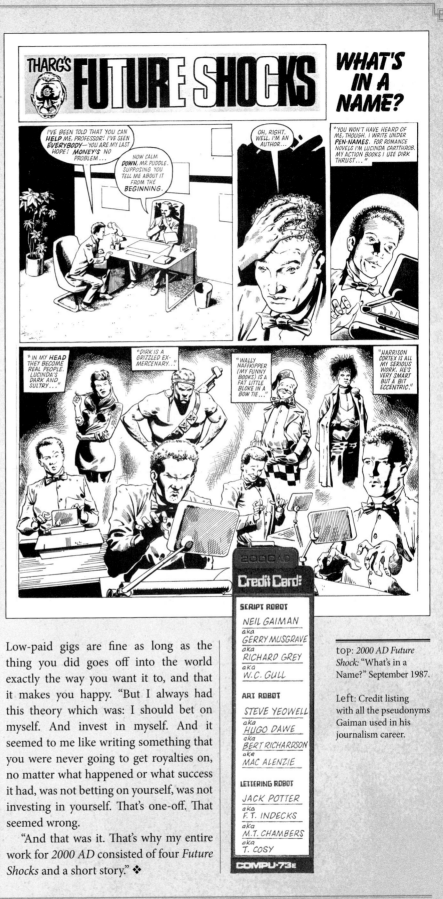

top: *2000 AD Future Shock*: "What's in a Name?" September 1987.

Left: Credit listing with all the pseudonyms Gaiman used in his journalism career.

BorderLine

"I met Dave through a magazine that never happened. They got together a bunch of people to work on it, who were innocent and inexperienced and didn't know that it was so likely not to happen and one of them was Dave and one was me."

HEART of ICE PRESENTS

BORDERLINE

THE NEW COMIC MAGAZINE

'Collossus!' by Steve Craddock & Dave Harwood
'The Fox' by Dave McKean & Hunter Tremayne
'Going To California' by Dave McKean & Hunter Tremayne
'The Heretic' by Hunter Tremayne & B. W. Sinclair
'The Old Magic' by Neil Gaiman & Nigel Hills
'Harlequinade' by Buick McKane & Matt Brooker
'Hearts Of Ice' by Buick McKane
'A Knave' by Pat Kelleher & Andrew Wildman
'The Light Brigade' by Neil Gaiman & Nigel Kitchin
'Man-Elf' by Guy Charles
'The End Of The Third Form At St. Andrews Eve'
by Neil Gaiman & Martin Griffiths

COMING SOON

ABOVE: Advertisement for *Borderline* from UKCAC 1986 booklet.

OPPOSITE: "The Light Brigade," originally created for *Borderline*, written and drawn in 1986, published in 1989 in *Trident* #1 alongside Eddie Campbell's "Bacchus" and Grant Morrison and Paul Grist's "St. Swithin's Day."

the 1980s comics scene in the uk was buzzing, convoluted, and complex.

There were a couple of key players, many lesser players, and occasional crazy people. Gaiman caught an excellent snapshot of the time in his piece for *Time Out*, "The Comics Explosion," describing the whole scene from the top down: Alan Moore's *Watchmen*, then only four issues in, was already a phenomenon warranting a cover story, although it was changed at the last moment when the editor got cold feet and ditched their Dave Gibbons *Watchmen* cover in favor of Scottish dancer Michael Clark. More and more shops were opening that sold nothing but comics, and London was the epicenter of the whole thing.

The British comics industry had been fairly anonymous up until this point, barring *2000 AD*, when an assortment of mavericks appeared—*Warrior*, *Escape*, and *Harrier*. Tony Bennett's Knockabout had been around since the mid-seventies, primarily as a way of getting Gilbert Shelton's pot-smoking *Fabulous Furry Freak Brothers* to British people but had expanded their line by the mid-eighties. *Warrior*, already mentioned, was a comic built on the idea that creators should have more freedom and retain the rights to their own work, unlike what was going on in regular corporate setups wherein creators were (and still for the most part are) exploited or not given due credit. *Escape*, in 1983, was Paul Gravett and Peter Stanbury's answer to Art Spiegelman and Françoise Mouly's *Raw* magazine, an anthology that took its cues from the well-produced and respected French comics as a way of distancing themselves from the American spandex variety and Britain's own *2000 AD*. Martin Lock's *Harrier* came a year later and featured a number of big name appearances before its death at the end of the decade: Gibbons, Moore, O'Neill, Eddie Campbell, and Glenn Dakin were all there. Publishers were looking for things to publish.

In 1986 Gaiman was not quite twenty-six, was still working as a journalist, and had written a couple of stories for *2000 AD*. A lot of his time was spent in the Cafe München

"I was a very proud twenty-five-year-old journalist, because this was the first big article on comics to be published in the UK, in a 'real' magazine. It's hard to communicate, in this golden age of geeks, how hard this was to make happen, or how important it was for a number of things, including morale." The Comedian with the gun (perhaps the assassination of Kennedy) is an image that did not appear in the original *Watchmen* book. Originally it was slated to be the *Time Out* cover image, but the editor at the time went for something else at the last minute instead. "The follow up to it was a huge article on comics commissioned by the *Sunday Times Magazine*, for which I interviewed everyone, got original Brian Bolland art, and which was rejected by the editor when I sent it in because, he explained, 'it lacked balance.' I asked what kind of balance he needed. There was a pause. 'Well, these comics . . .' he said. And then blurted out, 'You seem to think they're a *good* thing.'"

Dave McKean's ad for *Borderline*, 1986.

underneath London's Centre Point building, chosen by virtue of its proximity to Forbidden Planet, a comic shop owned by Nick Landau—himself a publisher of books and graphic novels under the umbrella Titan Books, launched in 1981. These days Forbidden Planet is a gaping museum of geek fandom filled with fluorescent light and linoleum, but in the mid-eighties they were still operating out of the same tiny little shop at 23 Denmark Street they had been in since 1978. The nearby Cafe München was, as writer and activist Roz Kaveney wrote, "a place to meet, and a place to wait for Neil Gaiman, who was always late for everything; it had cold beer, and microwaved goulash, and chairs that were not actively uncomfortable. If writing and freelancing beats working for a living, the München was the place most of us treated as our office. It was a place where SF editors got drunk and suggested unviable projects to aspiring writers, a place where

bad fantasy trilogies were thought of and forgotten." It was probably where Kim Newman and company started writing their play *Waiting for Neil* and finished it while waiting for Neil. The sign for the Cafe München fire escape is still up by the bins around the back of Centre Point. If you go through that door you can drink where it's always 1986, which is when this happened: "I went into the Cafe München and ran into Gamma [Paul Gamble, who oversaw the science-fiction and fantasy books at Forbidden Planet]. Gamma had just come back from a funeral, and was with somebody else who'd been at the funeral and introduced him. He said, 'This is Hunter Tremayne, who writes comics.' I said, 'I've always wanted to write comics.' And we chatted a bit."

This is the same Hunter Tremayne who was the baddie in Neil's 1988 *Judge Dredd Annual* strip, "Sweet Justice," so his story already has a certain trajectory. This is how

it got that way: "A few days later my phone rang. And it was this guy Hunter Tremayne saying, 'I got your number from Gamma and were you serious? Do you want to write comics?' I said, 'Yeah!' And he said, 'Great, I've got funding for this amazing comic. We've got £50,000 to launch the first issue with. Come along to the meeting on Thursday afternoon.'"

Tremayne was the self-appointed head of a brand new one-man publishing house he called Heart of Ice. He wanted to produce a British anthology along the lines of *Escape* and other anthologies floating around at the time, only with people who had never done comics before—all new, untried fresh talent. If you flip through comics news magazines from the late seventies there are mentions of a Hunter Tremayne wanting to do this kind of thing years before. Those never happened, and neither did this. But Gaiman wasn't to know that. "So I went to the meeting on

Thursday afternoon and there were a few people there, one of whom was Leigh Baulch, who at that point was art director or something-or-other at Titan Books. And the following meeting, a week later, Leigh had brought Dave McKean along because he'd seen Dave's fanzines and got in touch. So there was me, Dave McKean, eventually Mark Buckingham and Matt Brooker, Nigel Kitching, Floyd Hughes. Good young people."

Tremayne had bought loads of advertising for *Borderline*, getting mentions in the UKCAC (United Kingdom Comic Art Convention) program as well as Gravett's *Escape* magazine. Gravett had gone down to the meeting to see what this thing was that he was advertising, and to meet all the new bright young things so he could write an article about it.

Ideas-wise, Gaiman was working on three things at those ongoing Thursday meetings. First was "The Light Brigade,"

ABOVE: Neil's piece on *Watchmen* in *Time Out*, September 1986.

he End of the Third Form...' is a rollicking, bizarre and
trageous school adventure story, an edifice of bad taste, black
mor and over-the-top entertainment.

t Andrew's Eve is a third-rate, second division boys' public
chool, set out in the countryside. It's an enormous building, a
wkward mix of architectural styles of the last seven hundred
ears, full of winding stone staircases, casement windows, stone
towers, abandoned cellars and the like.

the story starts we meet three New Boys, hopelessly lost in
this maze of a school. They are SEBASTIAN BLAISE, our hero,
MERCY, Blaise's friend and the Darbyshire to his Jennings, and
LEMMING, an undersized little rodent of a boy.

They eventually find their way to the classroom where they we
supposed to be. It is a French lesson, taken by a crazed old
sadist, Mr SEFTON PORTER, who humiliates the three, then sen
Blaise to pick up some books from the school office.

On his way back from the office Blaise stops off by a pay ph
and telephones his mother, begging her to take him away fror
school.

[During the course of this conversation it is revealed that
Blaise's father was killed in the Carpathians recently on
camping holiday, when he was mistaken for a wolf.]

She tells him to grow up, and is not interested in his p
e in her new boyfriend.

Meanwhile, in the basement beneath the biology labs Mr LE
biology master, is assembling a boy out of bits -- a pro
has been working on for years. He has everything except
He works on the 'monst

airs, and gone out into the school. Upstairs, in the labs,
is fast asleep, his cup of tea getting cold on the desk
de his head.

ise has reverted to boy form. He decides that the only thing
do is to run away, and packs a bag in the dorm.

wn on the rugby field the invocation has taken effect; instead
giving the headmaster & co. any power at all, it simply causes
e graveyard to disgorge its dead. The dead reveal that they
ied, that the spell was just to allow them to walk the Earth in
hysical form again. These are walking corpses, skeletal
x-headmasters, clad in tattered cloaks and rotting mortar
oards. They advance on the Head and prefects...

Blundering about, the monster comes on a bunch of boys who have
got together in a quiet place for a cigarette. One of them throws
a chair at the monsters's head (Mercy) which, not having been
sewn on too well, comes off and is knocked out of a window. The
rest of the monster carries on without it. Mercy's head lies
ound in the quadrangle, being menaced by the school peacock.

After waiting twenty minutes, and discovering that yet another
suicide attempt has failed, since he is still alive and not
gassed, Lemming heads off to explore the catacombs.

Leer wakes in the labs to find that the bringing the
dead-back-to-life spell of the Headmaster's has combined with the
revivifying spray in the air to bring to life a large number of
killer zombie bunny rabbits, who stump around on pawless legs and
him. He manages to get downstairs away from them, and lock
asement. y start breaking their bottles to get

Mr Sefton Porter is becoming mor
concept of evil.

Blaise is getting worried. As th
having more and more trouble wit
memory blackouts, and generally
turning into a wolf from time to
this, although he's more worried
he hasn't done his Geography 'pr
g trouble.

Then Mercy is killed in a stupid
wander around with his tie half
him like this, and one of them (
pulls his tie really tight, then
strangles. Other kids walking pas
don't care.

Mercy's body is taken into the Sa
abroad to where his Guardian live

Leer creeps into the sanatorium t
Mercy's head ('If anyone notices
will assume it's just another sch
pursued back to the biology labs
get back and barricade himself in
something of a hurry, he stitches
it with his revivifying liquid. N
es upstairs for a cup of tea.

Down on the rugby field, the Head
started the invocation that will

eanwhile, Sefton Porter has come
he embodiment of pure evil on Ea
icide Lemming, when he discovers
fice, trying to steal enough ju
bbing Lemming by the ear, he dr
ow the school and locks him in.
ming finds an old gas-lamp brac
as himself.

he biology labs basement, the
iousness. It's actually been
t done anything, since all th
various places, have obtained
fficulty in cooperating. Now

ground. He says he met a
him the way out.

bonfire.

Left: "The End of the Third Form at St. Andrew's Eve," 1983/1986. Script by Neil. Pages one and two are lost to time, but this is most of it.

RIGHT: The front page for *The Panelologist* (1977) features a small piece on Hunter Tremayne, who was talking about an ambitious new anthology comic he was going to be editing. That never happened either.

en failures.

e obsessed with the

on approaches he is
weird, having odd
ery indication of
's a bit worried about
emory blackout has meant
he's liable to get into

. He has a tendency to
couple of prefects see
s MALACHI) grabs Mercy,
cts go off. Mercy
e's shamming, or just

before being shipped

ight and removes
ng,' he figures, 'they
ank.') Although he is
l wolf, he manages to
ment, where, in
to the body and sprays
ppens. Depressed, he

nd twelve prefects have
n Supreme Power.

THE MIDNIGHT ROSE COLLECTIVE consisted of Neil, Roz Kaveney, Alex Stewart, and Mary Gentle. They devised and edited anthologies that published the work mostly (but not entirely) of people sitting near them in the Cafe München. There was *Temps*—and its sequel *Eurotemps*—the premise of which Gaiman says came burbling from him in a bar late one night at the Milford SF writers conference, "muttering that if there really were superheroes in the UK they'd all wind up as civil servants working for some useless government department that would send you the wrong one." Gaiman cowrote the framing story with Kaveney for their next book, *The Weerde*. The Collective's other books—*The Weerde: Book of the Ancients* and *Villains*—didn't have anything by Gaiman in them.

later drawn by Nigel Kitching and eventually published years later in the inaugural issue of *Trident*, a 1989 anthology series edited by Martin Skidmore. "It was my little cyberpunk thing, software pirates off the Spanish mainframe. And these weird kids in cyberspace were a sort of peculiar superhero crew."

Second was "The End of the Third Form at St. Andrew's Eve" with Martin Griffiths, which almost found a home in *Harrier*, but Gaiman didn't have the time to finish it. Paul Gravett once described it as Billy Bunter blended with *Night of the Living Dead*.

Gaiman's third project was "The Old Magic" with Nigel Hills, which was never drawn but plotted. "Hunter Tremayne had a plot and it was a bit meh, so I took it and made it work. It was about a young magician learning magic in some sort of sword and sorcery world." (Nigel Hills was, incidentally, the artist who provided the illustrations to go alongside one of Gaiman's short stories, "Manuscript Found in a Milk Bottle," in *Knave*.)

At the same time, Dave McKean, just twenty-two and still at art school, was writing and drawing two stories: a period detective story called "The Fox," and a thriller road movie story ("It was going to be about a blind guy on a mission of vengeance," says Neil) called "Going to California."

Paul Gravett saw this stuff and asked Dave and me to do something for Escape. I think he just wanted a ten-page strip, and when we came to him and said, 'Can we do an original forty-eight-page graphic novel called Violent Cases?' he said yes. Bless him.

But all this was done for a comic that wasn't printed. Gradually we realized that it wasn't quite working like we thought it was going to work. And it looked like the offices in Wimpole Street we were going to were the offices of a telephone sales company from which Hunter appeared to have been fired but still had access. And some of these telephone sales people were going to fund this thing except maybe they weren't, actually. And then it all got weirder and weirder.

We watched Borderline go down, like a ship, sinking. There was this weird point toward the end where it seemed like the thing would come out except that he was doing everything he could to stop it coming out, and that's the point where I thought, I don't think he wants to be the publisher of a magazine, I think he just likes being part of this group of people who are talking about putting out a magazine. But by then, Dave and I were doing Violent Cases. ❖

VIOLENT CASES

"Violent Cases was pretty much written as a short story with picture-sized holes in it."

IN AN INTERVIEW IN 1987, GAIMAN TRIED TO EXPLAIN WHY THERE WAS A NEW WAVE HAPPENING IN THE WORD OF COMICS, WHERE PREVIOUSLY IT HAD BEEN MORE OR LESS STAGNANT.

"By 1976 comics were very much at a dead end, even though there was still some interesting stuff going on. Whereas now all the visually creative people who would have written books or made movies or gone into fine arts are saying, 'Well heck, this is as valid a medium as any other. Why don't I put those ideas into comics?' Or better still, 'Why don't I come up with some ideas that can only be done in comics?' That's what attracts people to comics, the interplay between words and pictures." *Violent Cases* is one of those things that could only be done as a comic.

McKean said, "I used to pick comics up when I was twelve or thirteen, and I always had the feeling that something really very good could be done with comics. But I used to spend four months liking Neal Adams and then the next one along the line and so on. But then 'Hit It!' came out, drawn by Bill Sienkiewicz [a *Moon Knight* story written by Doug Moench in 1982], and that knocked me down and I got interested in comics again. It showed that somebody was in there trying something new" (*Speakeasy* #79, 1987).

At art school Dave McKean discovered expressionism through the work of American pop artist Jim Dine and cartoonist Ralph Steadman; he later found that kind of expressionistic technique being employed in strange and surreal ways by the likes of American artist Marshall Arisman (these days most famous for his cover to Bret Easton Ellis's *American Psycho*), Brad Holland, and Matt Mahurin. The bold designs of Polish poster artists Stasys Eidrigevičius, Jan Lenica, and Franciszek Starowieyski—and the still infamously weird work of filmmaker Jan Svankmajer—are influences that contributed heavily to the kind of work McKean was producing in the eighties.

"I recall the buzz in Titan Books' basement when McKean brought in the moody cover art montaged with faded photos, a torn dollar bill and playing card, and real ivy leaves. Comics weren't supposed to look like this," said Paul Gravett—editor of *Escape* and the cheery face of the Fast Fiction table at the bimonthly Westminster Central Hall Comic Marts—in *Comics International* in 2003. Eddie Campbell named him "The Man at the Crossroads," because it was Gravett's idea for Gaiman and McKean to collaborate

ABOVE: Dave McKean and Neil in 1988. Neil's holding the Mekon Award they had just won for *Violent Cases*.

on something for his anthology. *Escape* gave them free rein to do anything they liked, with the (later ignored) stipulation that it was only supposed to be a few pages long. McKean and Gaiman talked about it and found they both wanted to do a comic for people who didn't read comics—something with no superheroes and no identifiable genre. Something *else*.

Gaiman wrote a story tentatively called "In the Land of the Giants" and took it to that year's Milford science fiction workshop where professional writers who want to get better spend a week intensively critiquing stories and novels-in-progress and workshopping ideas. It was the second one he'd been to.

> "*I was starting to learn and understand the use of subtext and metaphor.*"

I first went I think in '85, and that was a complete turnaround for me. I wrote a short story, and it was torn to pieces. I may or may not have learned a lot about writing, but I learned a hell of a lot about reading. I was sitting between John Clute and Gwyneth Jones. John Clute is probably the most eminent critic in science fiction. Gwyneth Jones is an incredibly perspicacious critic, and a terrifyingly dense writer. I like some, not all, of Gwyneth's writing, but as a critic she's a laser beam.

And I was sitting between these two people, and there was this horrible moment two or three days into the thing when I realized that the stories I was reading were not the stories they were reading. They were reading all the words. They were putting it all together. They were doing the work. I'd listen to them talking about what they'd read in these stories and realize

it wasn't what I'd read. And I was wrong, and they were right.

It was at the same time incredibly humbling and incredibly educational. I learned how to read, which really changed things when I started to write fiction after that. I was starting to learn and understand the use of subtext, the use of metaphor, the use of allusion—the tools of fiction. Because I'd seen how these guys did it. I started to understand something that only crystallized about eight months later when I started to write Violent Cases. That honesty is important. All of my fiction had been

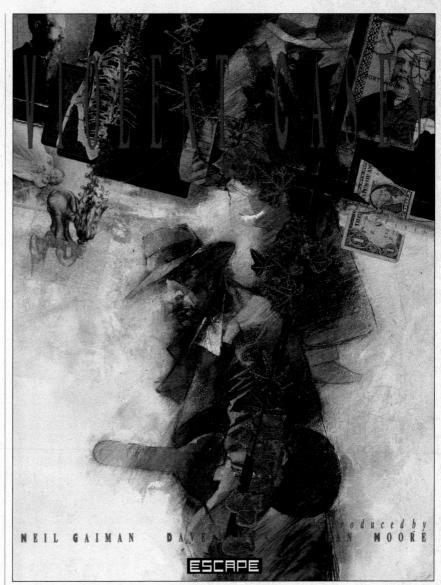

NEIL GAIMAN DAVEduced by ...N MOORE

ESCAPE

ABOVE: Cover of an early edition of the book (Escape/Titan, 1987).

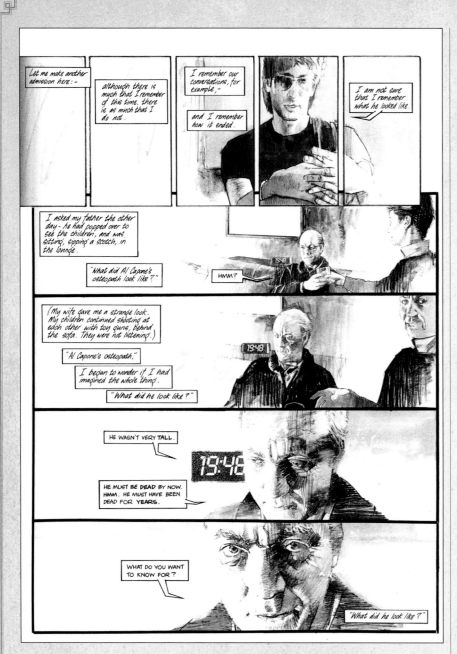

using other people's voices. And there was a point around then that I started to realize that all one has to offer as a writer is oneself. All that makes me different from all the other writers out there is me. Violent Cases *was the first thing that did that (Comics Forum #1, 1992).*

It was Milford attendee Garry Kilworth who pointed out that the title had been sitting in the text all along, right there in the gangsters' violin cases with their

tommy-guns. The story traveled around with Gaiman on thin crinkly typing paper folded into a rectangle. Roz Kaveney remembers it being the first thing she ever read by him, pulled out of his pocket at the Cafe München.

"It was originally written as a text story," Gaiman explained. "That was because I didn't know how to write for Dave, to get the best out of Dave, so I wrote it as prose, and then we got together. He did some breakdowns, we talked about them, he did different things, and then I re-edited it and wrote it up."

Violent Cases is about two things. "It's about violence on large and small levels, and it's about the unreliability of memory on a load of different levels. How reliable is what people are telling you, how much you remember, or say you remember, what you remember, how much of it you got from films, how much you got from people telling you what you were doing at the time, how much you remember from earlier memories. It's trying to examine all of those in a way that you couldn't do in prose fiction and you couldn't do in the movies" (*Fantasy Advertiser* #109, 1989). It was a story that could only be told in comics, and yet it was using comic book tools in new and strange ways to do it. "I was also taking on board some of what I was being shown in comics. Like the stuff Eddie Campbell was doing. It was very important. You couldn't have had *Violent Cases* without *Alec*. What I learned from Eddie was the value of minute incidents in the building up of fraudulent biographical narrative. I wouldn't say it was influenced by Eddie, but the only place in comics that *Violent Cases* plugs into from a story viewpoint is to Eddie. Which you don't see because the visuals are Dave" (*Comics Forum* #1, 1992).

From the outside it is a young man's recollection of several trips to an aging osteopath in late sixties Portsmouth, England, starting when he was four years old after an accident in which his father dislocates the boy's arm while trying to drag him upstairs to bed. Through the foggy and imperfect remembrance of things the boy was told but was not old enough

IN 1988 *VIOLENT CASES* was adapted into a stage play in London. Or, rather, it wasn't adapted, and that was precisely what was wrong with it.

"As an excited young person who'd just written his first graphic novel I was thrilled when a director approached me and said, 'We want to do it completely faithfully on stage.' And I said absolutely, what's the script? And he said, 'The script is the graphic novel.' I said wow, brilliant. And I came along to the first night of *Violent Cases* on stage, and the script was so accurately the graphic novel that I could mutter under my breath along with what was happening on stage. But I discovered—absolutely fascinated—that things that were huge and important in the graphic novel went by in a second on the stage and were trivial or did not even register, whereas moments that were trivial little here-is-something-that-is-about-to-illuminate-what-happens-next in the graphic novel became the moments of stage magic. And it became this rather soft-focused, rather warm and cuddly thing, having been this rather hellish graphic novel. With not a word changed. Totally faithful adaptation and totally wrong. But it taught me an amazing lesson, which is you cannot transliterate. You have to translate. You have to be willing to go: this medium is not this medium, let's recreate it, and let's do it in a way that will work. Which is why I've always been very open for people to, up to a point, play with things and see what makes them work."

BISMARK HERRING PRESENT

V I O L E N T C A S E S

A STAGEPLAY BASED ON THE GRAPHIC NOVEL BY NEIL GAIMAN AND DAVE McKEAN

to understand at the time, we learn that the osteopath had once treated legendary gangster Al Capone. It features all the psychological complexities of memory and imagination that would come to be Gaiman hallmarks: the adult world viewed from eyes that don't comprehend it, that don't understand why grown-ups leave the house smelling like strangers or come home red-faced and arguing in whispers. What Gaiman likes most is how the story is structured like a childhood memory bubbling up in the cold light of adulthood. He said in 1992, "I wanted to do something that would recreate for other people that kind of emotional state that I would get from Robert Aickman's fiction, an English writer who died about ten years ago and wrote chiefly short stories. He creates things that are obviously unities, they make sense, but he leaves you at the end with the feeling that you must have missed something. Somebody palmed a card, if there was a card. The feeling that you've been given a story that would all make sense if only you had the key, if there is a key, and there must be a key, or there wouldn't be a story.

"The ending is built up too. It has a feeling that childhood things remembered in adulthood have. Shapes change, patterns change . . . sometimes things that you didn't grasp at the time fall into place. You suddenly realise, oh! My uncle must have been having an affair, that was why no one

ABOVE: Stage play program, featuring new art by Dave McKean, 1988.

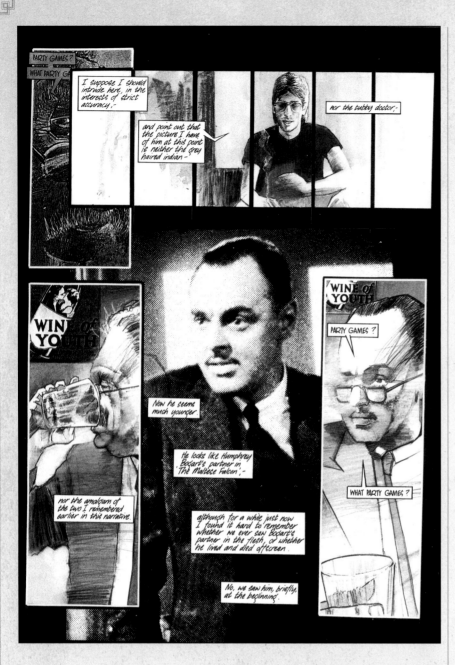

Children are excited by ambulances, police cars, and crowds. It's only when you get older that you realize that there are people who have been turned into mincemeat in there" (*Speakeasy* #79, 1987).

McKean added, "In most American comics there is a tremendous amount of violence, but it's always the same violence; it's always people being punched through office blocks. Then they step out of the rubble, dust themselves off, and say, 'Now you've made me really angry.' We wanted to do something about how we perceive violence, so that the reader has a bit more of a gut reaction. The thing that really brings it all home is that it's a baseball bat. If it had been a gun it wouldn't have been the same. But a baseball bat is so visual, and you actually need that contact, you need actual physical strength. So it had much more impact. But the boy who's heard all about these terrible things that gangsters have done is waving at them when he sees them. When one of them notices the boy he tips his hat, and the child is absolutely over the moon about it" (*Speakeasy* #79, 1987).

The model for the man is mid-twenties Neil with black T-shirt, indoor aviator sunglasses, and clouds of cigarette smoke, all of which add another layer of unreliability, of how-much-of-this-is-true.

> Part of it is my memories. I'd compare it to a mosaic; all the little red tiles are my memories, but a red tile may be half a sentence, the other half is fiction. A lot of it had to do with the fact that my son Michael was at the time about three going on four, and I was remembering a lot of stuff, because I was doing a lot of stuff that my parents did to me that I swore I'd never do to my kids. Throwing a kid over your shoulder and carrying him up to bed for the fourteenth time that evening, being utterly pissed off, dumping him on the bed and saying "Now stay there!" and stomping out, shutting the door . . . and I'd think, "Did I just do that?" Part of it came from a very bad case of flu and a rather weird fever dream. The story, as you go through, drifts further and further away from the truth, so for

would talk to him for a year. The things adults do, that you never question; they're just there" (*Comics Forum* #2, 1992).

The book is quietly violent but in a way that's more like a cold, creeping realization rather than hard and blunt. "There are tiny little acts of violence all the way through the book, and there's this huge act of violence at the end. But since the viewpoint of the character is of a four-year-old, it doesn't upset him. You have to be old enough to develop some kind of imagination before you start wincing at a car accident.

example the first gangster story you get is the story of Legs Diamond, it's a true story. The next stuff about being buried in silver coffins, has elements of truth in it, but I've exaggerated and played around with it. Then you get the stuff about the party; it's not true at all. It's a sort of folk memory version of what actually happened (Fantasy Advertiser #109, 1989).

One of the reasons *Violent Cases* worked is that the two creators were in constant contact with each other via phone calls, visits (the boy is based on reference photos McKean took of Gaiman's son, Mike), and input from both sides. "A lot of the American comics are produced by people living thousands of miles apart, who've probably never even met each other," said McKean. "Inevitably there's a compromise; inevitably people are disappointed. The writer's disappointed with the pictures because the artist gets the scripts and it's not really what he wanted, but he'll do it anyway. That is not the recipe for good comics" (*Speakeasy* #79, 1987).

> *"Part of it came from a very bad case of flu and a rather weird fever dream."*

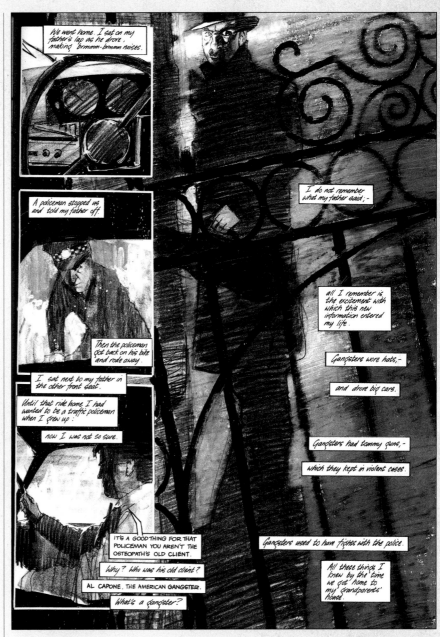

It was finished in early 1987 and published in October that same year in the UK by Titan Books, in association with *Escape*. It was reproduced in black and white, and it wasn't until 1991 that the U.S. Tundra edition published McKean's art in all its intended blues, grays, and browns.

There were vague plans for sequels. In the year of its publication, Gaiman said, "*Violent Cases* is all narrated at the age of four. The next book will be at the age of eight and will be about fear. There's a working title of *Dreams and Houses*, but then the working title for this one was *Al Capone's Osteopath*. *Dreams and Houses* is about when you are old enough to be scared of things, scared of everything. Scared of the strange shapes of clothes hanging on the back of the door" (*Speakeasy* #79, 1987).

And the third one is about travel. They take place at about four-year intervals" (*Fantasy Advertiser* #109, 1989). *Mr. Punch*, written in 1994, was not the sequel they had planned, but it was a thematic sequel of sorts. ❖

CHAPTER

3

Vertigo Heights

print was *Miracleman* #24, in August 1993. *Miracleman* #25, though both written and drawn, has yet to be published.

Moore's problems with *Miracleman* and Eclipse were part of the parcel he handed over to Gaiman. Eclipse's unprofessional dealings and "creativity" with the royalties all played a part in the delays that plagued that series (so untrustworthy was the company that Gaiman and Buckingham would not start a lick of work on the next issue until they had been paid in full for the last, and Eclipse were slow to open their wallet). Also, Gaiman and Buckingham never really had any deadlines. According to Buckingham:

> We were supposed to have deadlines, but it became a very fluid situation. Certainly, we seemed to have more editors than we had issues of comics. I think there was one issue we actually got through three editors before it was finished.
>
> I was inking stuff and doing bits and pieces elsewhere, but Miracleman was always the real personal gem project; it was always the little baby that I was nursing in the corner. Others would come passing through, but that was the one I held gently and took the most care of. It just meant that sometimes it took a long time to actually get the issue together. Certainly Neil never turned out a script for Miracleman without being careful of what he was writing; he would write when he was ready, not because it was asked for, and so I showed equal reverence with the art. There were times when it was a shame we weren't getting it out quicker. Certainly I think if we had been sticking rigidly to the schedule we might have finished the series before Eclipse suddenly collapsed (Khoury, 2001).

In the years since there were murmurs of *Miracleman* making a reappearance, of Gaiman and Bucky being given the chance to finish what they started. But the complications over ownership stopped it from happening. In 2009 Marvel Comics announced they had bought *Miracleman* off its creator Mick Anglo. In early 2014,

Marvel finally began republishing the series, beginning with the Alan Moore stories. Gaiman says:

> I would love at some point one day in the future to finish the story if I can. I'm holding on to Miracleman in my head, and there's definitely part of me going well I sort of *remember* it. I think between me and Mark Buckingham we could. But I wrote the first seven pages of Miracleman #26 in 1993, twenty years ago.
>
> There was a long delay between Miracleman #15 and #16, but when Alan went back to Miracleman it was five years after he'd stopped writing it. Twenty years . . . it would be very weird to try and go back, and go, well okay: this is what I was saying. The next issue was the big Warpsmiths one, but the

Warpsmiths are Garry Leach's so unless we get permission from Garry...I don't know. We'll find out.

Says Buckingham, "It remains the project I would drop everything to return to. Just because it's the most obviously me of anything I've done. So many other projects I've worked on or things I've done have shown influences of other people or have been me tailoring material to fit what's gone before or what I'm feeling the audience wants from me. Certainly with *Miracleman* it was very much my personality and Neil's personality coming to the fore and telling a story that we wanted to tell in a way we wanted to tell it. I don't think I've ever had as much freedom creatively on anything else and would relish the chance to be pure again" (Khoury, 2001). ❖

SPAWN

IN 1993 GAIMAN WROTE a single issue of a comic outside of his own particular kind of world, and created a character to live in it. Ten years later, and for the better part of a decade, Gaiman's Angela was the subject of a court case.

It all started at a room in a convention in Atlanta. Neil had been signing for hours, Todd McFarlane had been signing for hours, both in the same room but never getting the chance to say hello. "So at the end of the Saturday of the con, I went over and I said hi to Todd after I'd finished signing. I think there was a level on which he seemed a little nervous that I was coming over, because he didn't know what I thought of his stuff or anything. We chatted, and I thought, gee, he's really nice. Then at the awards ceremony that evening, we met again, and I thought the same" (Kraft, 1993).

In 1992 Todd McFarlane had founded Image Comics along with several other high profile comics illustrators as a response to the bum deal they had at Marvel. Their main complaint was that although their artwork and newly created characters were being merchandised heavily, the artists weren't receiving any money above their standard page rate or whatever modest royalties they got on the sales of comics. Marvel declined to hand over ownership and creative control of the artists' work, so they walked. Image was set up with the singular ideal that creators could publish their work and own it outright. One of the first and most successful of these new creator-owned characters was Spawn, a murdered CIA agent turned demon whom McFarlane dug out of his old high school sketchbooks, dusted off, and sent out into the world. But the problem was that the Image guys were primarily artists, not writers. Said Neil in an interview in 1993:

> [McFarlane] rang me up and he said, "Hey, Neil, they're all sticking it to me 'cos I'm not a writer! And I never said I was a writer. I'm a fuck who plays baseball, y'know? So I figured I'd ask you guys who, like, win awards, and the critics love ya, to write some issues of Spawn. Are you interested?" (Comics Journal 155, 1993)
>
> So what do I do at this point? I have two options: either I take a moral stand and say no, Image comics have bad writing and therefore I will not write an episode, or I could do something to improve it. And it was sort of like, yeah, fine, I have no moral objections to a well-written Image comic. What the hell, they are creator-owned; there is a million times less compromise than with Marvel. So his attitude was basically, "You have carte blanche. I will draw it but that's as far as it goes, you have complete and utter carte blanche" (Kraft, 1993).

Also, by this point Gaiman had a son who was ten years old, watched *X-Men* on Saturday mornings, and took it as a personal insult that his dad never wrote the kind of comics *he* liked. "He regards it as very unfair. Here I am writing all these comics, and I don't write

above: *Spawn* #9,
March 1993.

anything that he likes, with people hitting each other and having cool superpowers" (*It* #1, 1994).

McFarlane lined up four different award-winning writers to do an issue each: Alan Moore, Gaiman, Dave Sim, and Frank Miller. It was Alan's first superhero story in five years, and although he had no idea who McFarlane or Spawn was when he was asked to do it, he did it because Image was neither Marvel nor DC. A rogue troublemaker. He liked the idea of it.

Gaiman said at the time: "It was really fun reading Alan's issue of *Spawn*. They sent me Alan's script, and it was obvious that Alan was doing basically what I'm doing with mine. Which is saying, 'Okay, I'm writing a good story for twelve-year-olds.' The readership of *Spawn* is not the readership of *Sandman*. I would hope that in a few years' time some of them may be my readers, but frankly, right now, most of them would be bored shitless by having to read a *Sandman*. And they wouldn't even want to be in the same *room* as *Signal to Noise*—one look would convince them that this is not a comic. And I'm not sure I'd argue with them" (*Comics Journal* 155, 1993). ❖

angela

aLan moore's issue was about the afterlife in the *Spawn* universe, and Gaiman went from there. "I have a thing for angels. Every year or so I think, 'Good, that was it, that was the last piece of fiction I ever do about angels, angels are now out of my system.' And then a year or two later, I go back and do something else with angels. And it was just some of the stuff about the afterlife, and the idea that these spawn are sort of the army of hell and so on, and I thought, okay, let's go. It's time for Neil to do some more stuff with angels.

"I was thinking that the only reason that you'd have an army of hell is if the other side was worse. You don't have an army to fight librarians and milk monitors; I'm sorry, you don't need one. So it's one little story about an angelic hitman, or hitlady" (Kraft, 1993).

This angelic hit lady, Angela, appeared for the first time in *Spawn* #9 (1993), again in *Spawn* #26 (1994), and later in a follow-up miniseries called *Angela* (1994), also scripted by Gaiman, that gave her a proper introduction to the *Spawn* universe.

Then McFarlane decided that Gaiman was work-for-hire and had no hold over Angela or the two other characters he introduced—Cogliostro and Medieval Spawn. McFarlane claimed that all previous agreements were null and void, that he was the sole owner of everything, and that Gaiman was entitled to no royalties or credit in their later appearances, nor from the reprints of the stories he had already done. The previous agreements were made in 1997, when Gaiman tried to use the Angela situation

to his advantage. In 1996 McFarlane had purchased what he thought were the rights to *Miracleman*, along with all of (the then-bankrupt) Eclipse's copyrights, film, and remaining stock and inventory, with the intention to include the much fought-over character in *Spawn* at some point. In July of the following year, Gaiman suggested they do a swap: Angela, Cogliostro, and Medieval Spawn in exchange for *Miracleman* and outstanding royalties. Despite agreeing in writing, McFarlane had reneged on the deal by October and filed three trademark registrations for *Miracleman*. Come February 1999, Gaiman had received a letter saying the deal and all previous deals were off.

In 2002 Gaiman filed and won a lawsuit against McFarlane. In 2010 they were back in court again disputing the ownership of *Spawn* characters.

The crux of the argument was whether or not a character (Cogliostro) based on a stock character (an old wino) becomes sufficiently distinctive to be copyrightable when the character is drawn, named, and given speech. Judge Posner decided that without Gaiman's input, it would have been merely a drawing, and in 2012 when it was finally over the characters were split 50/50, and Gaiman felt that much good had come out of it. "I think the various decisions, particularly the Posner decision, were huge in terms of what the nature of dual copyright in comics is. What is copyrightable in comics is now something that there is a definite legal precedent for. There were a lot of things that were misty in copyright [law] that are now much clearer."

marvel 1602

Four of the Fantastick

Reed (Radleigh?) Richardson, Susan Storm
Johny Storm, Benjamin Grimm
set out on a mission of exploration
thing a ship, the Fantastick
Becalmed in the Sargasso they
see a wall of light in front of
them — the surviving crew abandon
ship, leaving the Four on the ship—
perhaps Reed refuses to leave —
the others stay beside him.
They go through the shimmering
curtain ... and come out the other
side.
They are transformed — Reed realizes
immediately that's going on —
the elements have become manifest
in them: earth, air, fire + water.
They return to England —

above and opposite:
Notes for *Marvel: 1602.*

BEFORE WE GO BACK 400-ODD YEARS, WE'LL GO BACK TO 2001 WHERE *MARVEL: 1602* TIES INTO THE WHOLE TODD MCFARLANE CASE, WHICH WAS AT THAT POINT BEING PREPARED BUT HAD NOT YET MADE IT TO COURT.

Joe Quesada had been editor-in-chief at Marvel for a year and was keen to lure Gaiman over from DC's camp. *Sandman* had finished five years prior to this, and Gaiman hadn't written a comic since, having spent the intervening time doing novels and children's books. But now he had a reason and a need to return to comics, specifically to Marvel comics. In order to take McFarlane to court, Gaiman needed a legal fighting fund, and who better to join forces with than the company that would benefit if *Miracleman/Marvelman* was cut loose from its legal binds?

On October 24, Gaiman and Marvel announced a new company called Marvels and Miracles LLC and said that all profits from Gaiman's comic would go straight into the fund, "which I formed initially to help clarify the rights to the much-missed *Miracleman*, so that ultimately old and new stories can again be put into the hands of *Miracleman*'s readers," said Gaiman at the conference. "Once those rights have become clear, I plan to dedicate all of the profits which any *Miracleman* publishing might generate, beyond those needed to make sure that the original creators are being properly paid, to a comics-related charitable organization" (Weiland, 2001).

The previous month when they were discussing ideas for the comic, Marvel suggested Gaiman do something along the lines of a *Secret Wars* story—one big story with all the Marvel heroes and villains in it. But this was just after the World Trade Center attacks and wars were a long way away from what Gaiman wanted to do.

"The first day planes were flying again, I had to go to a sci-fi/comics thing in Trieste, in Northern Italy, and I wound up with a day on my own in Venice just to sit and plot whatever it was I was going to do for Marvel. I decided that whatever I did, given the mood I was in at that point, it wasn't going to have skyscrapers, it wasn't going to have bombs, and it probably wasn't going to have any guns or planes in it. That was simply what I felt like at the time. As soon as I put that together, the ideas of *1602* sort of fell straight into my head" (Weiland, 2001).

His idea was to write a story with the same sort of playfulness he remembered from the early Marvel Comics days of Stan Lee, Jack Kirby, and Steve Ditko, only set 400 years ago in seventeenth-century England and completely apart from the goings on in comics in the early 2000s. As Gaiman put it in his letter to the illustrator Andy Kubert, "We're not trying to mirror the Marvel Universe here: we're doing something that's more fun than that—we're trying to create it. We get to make up our own" (Gaiman, *Marvel 1602* #1, 2003). It would also

allow non-Marvel readers—the fans who only popped into comic shops once a month to pick up an issue of *Sandman*—to join in without having to brush up on the backstory.

What Gaiman had always liked about Marvel, and planned to incorporate into the series, was that Marvel was one great big universe in which every character interacted with everybody in the universe one way or another. "The DC Universe always feels like a bunch of discrete elements where, in order to get from somebody's comic to somebody else's comic, you practically need a passport, or at least a long bus ride. Whereas you always feel that Marvel is, for good or ill, a universe. As a kid that was incredibly frustrating because in England, where comics came over as ballast on ships, the only rules were every Marvel comic would be continued in a different Marvel comic. That was rule one. Rule two was you would never find that comic" (Weiland, 2001).

Gaiman roped in as many of the Marvel characters as he could and had them interact

> "*I decided . . . it probably wasn't going to have any guns or planes in it.*"

with the real world of the time: it's a series that is grounded in the reality of 1602—its history, its religion.

"It was a nice place to set the story. It gave me America, and it gave me a lot of things that I wanted in terms of the way the world was changing. It also gave me the sense of wonder and magic. It's right at the end of Queen Elizabeth's reign. I wanted to set it when she's very old" (Weiland, 2003). He gave the characters Elizabethan names and adapted their powers and roles for Elizabethan times, analogs of current Marvel characters. Sir Nicholas Fury is head of Queen Elizabeth's intelligence organization, Dr. Stephen Strange is her court physician and magician, and a group

of young people with unusual powers are being persecuted by the Inquisition. Called the Witchbreed, a lot of them take sanctuary with an exiled Spaniard called Carlos Javier. Everything begins with strange weather and talk of the end of the world.

Gaiman said that writing the series was odd. If you take 400 years of technological developments and superhero powers out of your superhero comic, you suddenly find that comic doesn't work the way it usually does. "I keep being fascinated and frustrated when I write this by the length of time it takes people to get places. We're so used to standard superhero comics or even standard fiction in which people hop into airplanes, get into cars, or they fly. Currently I have

one flying character, one levitating character, and a lot of people taking a long time to get places, which is really interesting. It changes the way you have to tell the story" (Weiland, 2003). Also, he hadn't written any comics in half a decade and needed to find his feet again. What didn't help was when the story went from being six thirty-six-page chapters to eight twenty-two-page chapters—he lost forty pages of story and had to do a lot of chopping and changing and throwing things out.

Though it sold well, the critical reception was mixed—some loved it, some hated it, and some thought it was too in-jokey. Some thought it wasn't *Sandman*, but then some always do. ❖

the eternals

Eternals.

In the background — manipulating the Marvel Universe.

Need Jon Constantine type who is a Rogue eternal: Wolverine is part Eternal. They are behind everything — Argardin thing. Ours also want Mutants to rule— now numbers are down to 800...

Idea — Bits start in different years. 14th C. 19th C.

Romance — bond - hate — all goes beyond the ages.

Conspiracy Theory.

Tone — Born Again // Every thing American Gothic Superheroes / JLA

AFTER THE SALES SUCCESS OF *1602*, **QUESADA TRIED HIS LUCK AGAIN. FOR THE FOLLOWING COUPLE OF YEARS, EVERY TIME GAIMAN AND QUESADA WOULD BUMP INTO EACH OTHER, HE'D ASK IF THERE WERE ANY IDEAS FOR A SECOND PROJECT.**

There always were, but after taking them back to the Marvel office and batting them around, it would inevitably transpire that someone else (usually Brian Michael Bendis) was doing something a bit too similar. "That happened maybe three or four times, and to be honest, I don't actually think that any of the ideas I had, once they were executed, would have been particularly like anything Brian would have done anyway. But we kept following little trails, and ending with 'Oh, okay—I guess I'm not going to do that.'" For a while Gaiman liked the idea of taking *1602* and flipping it—doing a series called *2061* in which we'd find out how everything played out after *1602*. "I had all that stuff plotted out, and all these things with the *1602* Nick Fury in our time, or in the future. It was a fun story, but it didn't really set Joe on fire, and I wasn't particularly burning to do it" (*Newsarama*, 2006).

Quesada suggested Gaiman do something with the Eternals, a bunch of superhumans created in earth's prehistory by alien giants called the Celestials, but actually created by Jack Kirby in 1976 after he'd left Marvel for DC and come back again. In a lot of ways *The Eternals* was Kirby continuing with a stream of ideas he'd had at DC in the canceled series *The New Gods,* as if he were trying to fit in things that he had wanted to do originally but hadn't had the chance. Gaiman was about sixteen when he read *The Eternals* as a monthly comic and hadn't been that impressed (although he points out he bought all of them, so he must have liked them). After Quesada brought the idea up he went back and reread the whole lot.

"It's not his absolutely classic best thing ever where he has more great ideas than anybody can do anything with, but you can see this weird struggle going on—and I don't know the real story of what was going on back then—but there's this editorial struggle going on. It's very obvious that what Kirby wants to do is not quite what he's doing, and there's some kind of pressure being exerted from above. I definitely don't feel that this is Kirby not on the top of his game because he was getting old; I feel that it reads more like Kirby's not on top of his game because they tied one hand behind his back and weren't quite letting him be 'Kirby.' It's a different kind of thing as a result" (*Newsarama*, 2006).

It was these pressures from above that caused Kirby to quit Marvel for the second time. After that, no one really knew what to do with the Eternals. They tried to fit bits of Eternals mythology into the Marvel Universe, but it was awkward. "It was like someone trying to mix a really, really fine jet fuel with a really nice vintage red wine, and in the

end, you produced something that you couldn't drink, nor could you put it in your car. It didn't really work" (*Newsarama*, 2006). Quesada wanted Gaiman to take this strange free-floating idea and do something with it, fit it into the Universe and make it stick.

Gaiman's *Eternals* was published in 2006, with artwork by John Romita, Jr., and was supposed to be six issues long but sprawled into seven. The biggest change between Kirby's Eternals and Gaiman's was that the Celestials did not create the human race but instead took proto–*Homo sapiens* and made the Eternals (and their opposites, the Deviants) from that.

"I had an enormous amount of fun sitting down with my copies of *New Scientist* and trying to figure things out from a Darwinian perspective and trying to figure out why they don't work from a Darwinian perspective. The most obvious way is that if the Eternals don't die, and are that amazingly perfect, why didn't they outbreed humanity half a million years ago? That, oddly enough, was the starting point for most of the plot. It began with asking myself that question, and it got to a lot of really interesting places. I got to play with the Celestials as they wandered into the storyline, and I got to ask what the Eternals are as that point was raised in the

OPPOSITE AND ABOVE: Handwritten notes on *Eternals* from Neil's notebooks.

Left: Notes on *Eternals* written on the back of a loose tip-in signing page for the limited edition of *American Gods*.

Handwritten notes (left page)

human. Either Ikaris is insane. Or someth... cross
a Eternal places aren't there either.
gets his memory back. Gets enough of the
Eternals to form a proto-unimind.
also knows the clue to how
... to overlore in the past — in
legalities t betrayals — only it with...
Sprite. 12 years old. Smarter and trickier
... of them who only wanted to Age. the
... to grow up.
accessed someth (the Uni-mind again?) on
d secrets of the Eternals (eg that were?
have died? Kept in Ikaris in Celestial
?)

...y of Ikaris's regaining his memory (aided by
) and restoring the Eternals. Gives them
... to do.
... problem with Eternals is why t so.
now the game recovers sweetly up the
...inals, scattered and memory-wiped.
d (t dreamy celestial — or just celestial
) reconfigured reality t wiped the... all.
Olympians — why there. It's all gone.
② it gets worse. Makkari, Thena, Sprite — film star?
) sensi. Uni-mind. — Sprite in California — only the
celestial. ④ Eternals vs. Sprite v Dreaming Celestial.
...ilding — restoration. ⑥ Raising up Eternals? What Tg are
?

Handwritten notes (right page)

In the beginning the Celestials took a small
ape-like creature and they dismantled it.
They stripped it back to its DNA, built it
back up, compared the results, to the other experiment
subjects — a cave bear, an octopus, a panda, —
and injected it. Interrogated it.
Then they destroyed it, recoded it, produced
three templates: Human, the experiment with two
controls — Eternals, unchanging, perfect, wanting to
aspire to — Gods, almost, immortal, indestructible — and Deviants,
who also mutate, change, cannot breed true. Then
they left. Their ways are unknowable.

Any sufficiently advanced technology is indistinguishable from
magic. (Clarke! law.) Advance sufficiently beyond that t
you're dealing with gods. And beyond that again, and it's
God.

Idea #1: the Celestials collect dead Eternals.
Idea #2: Eternals don't age, breed or die..? Wild were
they were all made at the same time. All 200 approx.
WHY make eternals, humans t Deviants?? In Marvel Universe — because they
give you superheroes t mutants?
Rogue Eternal? Sprite? — 14 yr old boy.
Story takes place over 500,000 years.

Poss Plot — Ikaris beaten up, comes around — he's Ikaris of the
Eternals — But he name or his stuff, the Ikaris. He's
semi-amnesiac — But he sees (someone? Makkari?)
and it starts coming back.
Only the people he thought of →
Eternals crew?

story. I realized that I could do a kind of weird reboot of part of the plot that was completely faithful to more or less everything that had gone before, particularly the Kirby stuff. But it also shows that things you thought you knew either didn't happen quite like that, or they didn't mean what you thought they did. Everything from the arrival of the Second Host to the arrival of Arishem in 1996. They mean different things to what we thought they meant" (*Newsarama*, 2006).

Gaiman's series sees the Eternals loose in the world and living as humans, unaware of who they really are. The story is about awakening them, making them realize how they are different, and why they are here. We get to see superheroes discovering that they are superheroes, that they have ties to the divine. It's a great classic hero story, and Kirby was along for the whole ride. "One of the things that fascinates me is that whenever I get stuck on a plot point on *Eternals*, I go back and look at it, and it's *there*. It'll be in a line of dialogue or a small scene that makes you realize he knew far more about these characters than ever made it on to the page. I'm actually far more impressed by the *Eternals* now since I've started to write it than I was when I first read it through and was getting ready to write it. I thought, initially, that there was all this stuff that Jack hadn't figured out, but now I know—he had it all figured out" (*Newsarama*, 2006). ❖

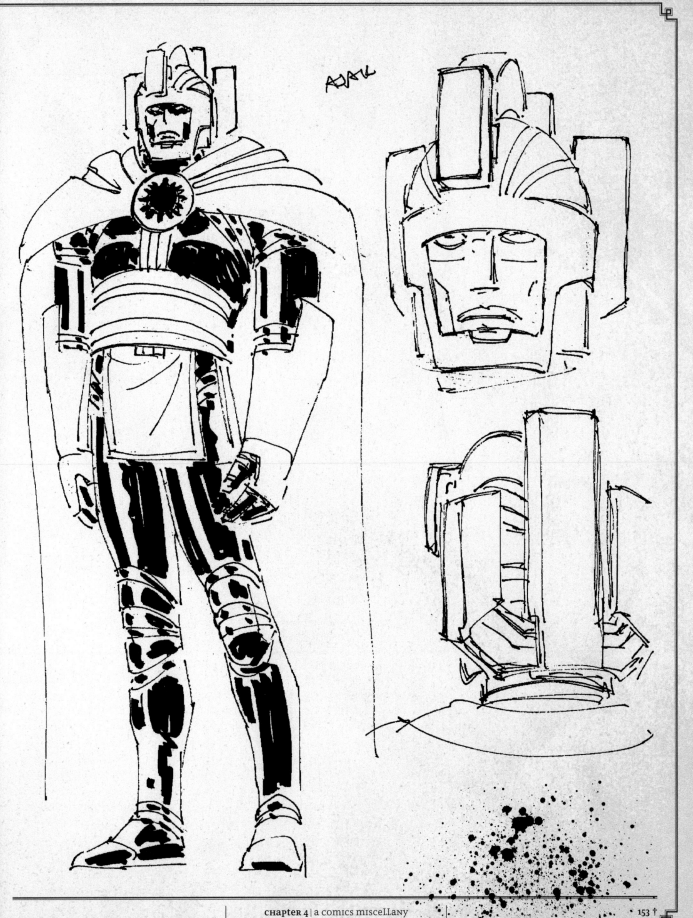

"BeiNG aN accouNt of the Life aND death of emperor heLioGaboLus"

a 24-HOUR COMIC.

"A Noble Failure."

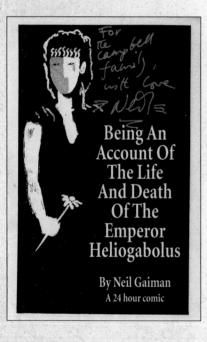

STEPHEN R. BISSETTE SET THE SCENE FOR THE MADNESS ON HIS BLOG THIS WAY: "SCOTT [MCCLOUD] AND I BOTH HAD BAD REPS FOR BEING S-L-O-W CARTOONISTS, CHALLENGED BY EVEN THE MOST EXPANSIVE OF DEADLINES." IT WAS THE KIND OF THING THAT COULD ONLY BE FIXED BY A SILLY DARE, AND SILLY DARES HAVE A TENDENCY TO GET OUT OF HAND. THIS WAS ONE OF THOSE.

The 24-Hour Comic idea began in 1990 when McCloud, creator of the comic *Zot!*, dared his friend Bissette to draw a complete twenty-four-page comic in a single day. He took up the challenge, and since it was his idea, McCloud did one too. Just twenty-four hours, no prior plotting: the clock starts and you write, draw, and letter your entire book there and then. The rules stipulate that the time is continuous: bathroom and food breaks are of course allowed, but you're cutting into your comic-making time. The likelihood of panic and madness is somewhere on the scale of probable to definite.

The idea might have ended there—and not become a global phenomenon with an annual event—except McCloud and Bissette sent copies of their "bastard offspring" to a bunch of pals who decided they wanted to have a go too. Dave Sim, *Teenage Mutant Ninja Turtles* cocreator Kevin Eastman, Rick Veitch, and Gaiman were all readying their pens and caffeine.

Then Gaiman drew a one-page, four-panel strip instead (revealing the truth about why he wears sunglasses) just to get the need to do a comic out of his system. He faxed it off to Bissette, who must have asked to print it because there's another ancient fax in a tub in Gaiman's attic: a one-page comic in which Mr. Beelzebub delivers a message from his boss, N. Gaiman Esq., saying no, hold the phones, you can't print that—he's going to do it properly: there will be a 24-Hour Comic forthcoming. Cue the balloons and the FX, he says.

Neil's 24-Hour Comic starts with a one-page trial faxed off to Dave McKean. McKean faxed back a three-page art lesson and ran out the door to go to Dublin. Gaiman is then on his own with a pot of tea and an idea he couldn't wedge into *Sandman*: the life of a wildly eccentric Roman Emperor called Heliogabolus.

> "I'd always wanted to put Heliogabolus in Sandman."

"Occasionally I get an idea and I think, 'I couldn't really get this into *Sandman*; it would necessitate too much arguing.' I'd always wanted to put Heliogabolus in *Sandman*, but I loved this idea of a penocracy, and while DC let me get away with murder in *Sandman*, I didn't really think they'd be big on the idea of a country ruled by penis size. So he didn't actually wind up in *Sandman*, but in my 24-Hour Comic" (*Comics Journal* #144, 1993).

Somewhere during the sleepless night it became apparent that he was not going to make the full twenty-four pages. He hadn't planned out the full twenty-four pages; he was just drawing each panel as it came, then doing the next panel, then faxing the pages to Bissette and McCloud as they were completed. "Somehow, when I got near the end, the disparate threads knotted

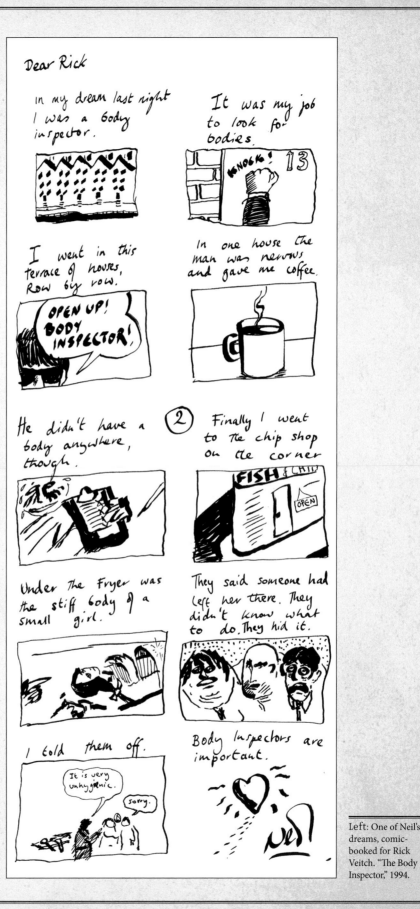

Left: One of Neil's dreams, comic-booked for Rick Veitch. "The Body Inspector," 1994.

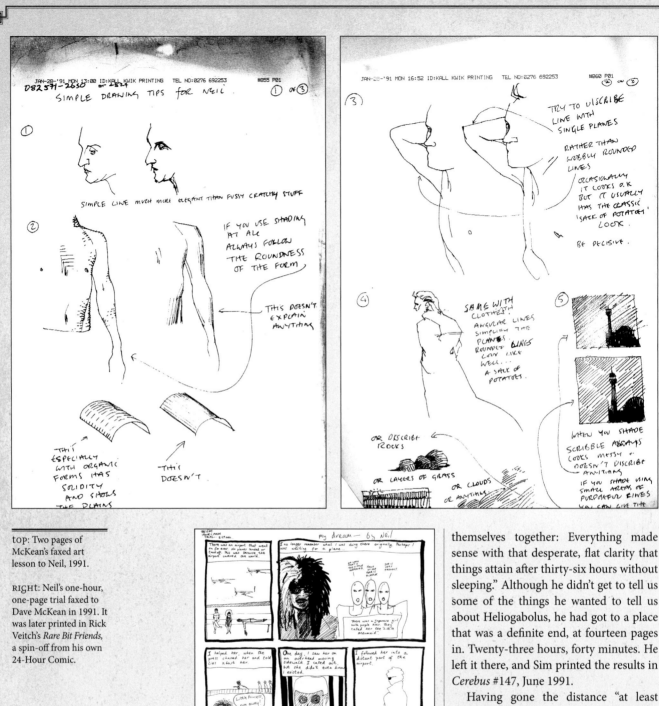

TOP: Two pages of McKean's faxed art lesson to Neil, 1991.

RIGHT: Neil's one-hour, one-page trial faxed to Dave McKean in 1991. It was later printed in Rick Veitch's *Rare Bit Friends*, a spin-off from his own 24-Hour Comic.

themselves together: Everything made sense with that desperate, flat clarity that things attain after thirty-six hours without sleeping." Although he didn't get to tell us some of the things he wanted to tell us about Heliogabolus, he had got to a place that was a definite end, at fourteen pages in. Twenty-three hours, forty minutes. He left it there, and Sim printed the results in *Cerebus* #147, June 1991.

Having gone the distance "at least where time and physical endurance were concerned," McCloud christened it the Noble Failure Variant #1: The Gaiman Variation, wherein the artist reaches the twenty-four-hour mark and is not finished so ties it up as best he can and ends it there. This was in opposition to The Eastman Variation, wherein you keep going past the twenty-four hours until you *are* done. Kevin Eastman completed his in fifty hours. ❖

HI STEVE
WELL, INSPIRED BY YOUR 24 PAGE/24 HOUR STRIP, I DECIDED TO DRAW MY OWN STRIP. FIRST SINCE I WAS 15. JUST FOUR PANELS, MIND YOU, AND NO HANDS. I DRAW CRAPPY HANDS...
MY STRIP'S ABOUT SUNGLASSES.
YOU KNOW.
SHADES...

PEOPLE SOMETIMES ASK WHY I WEAR SHADES.
I AVOID ANSWERING - SAY SOMETHING ABOUT HAVING LIGHT-SENSITIVE EYES.
YOU KNOW THE KIND OF THING.
WHAT I DON'T SAY IS THIS:

WHAT THE PEOPLE WHO DON'T WEAR SHADES DON'T KNOW IS THAT SOME OF US WEAR SHADES BECAUSE THEY'RE ALL THAT STOP US BEING EYE-NAKED -- FORCED TO GAZE, UNPROTECTED AT THE WET AND B'LEEDING FACE OF REALITY AS IT SQUIRMS AND PULSES AND WRITHES LIKE A RAZOR SLICING A CHILD'S EYEBALL OR THE SIGHT OF SOMETHING DEAD, TWITCHING, JUST ONCE, BEFORE COLLAPSING AND BLOATING...

...IT'S ALL THAT STANDS BETWEEN ME AND THE PIT.
THREE PIECES OF MOULDED PLASTIC, TWO LENSES, AND A COUPLE OF SCREWS.

Best -
Neil

OKAY, BISSETTE! LISTEN UP NOW!

FIRST, THE BAD NEWS. MY CLIENT SAYS - AFTER LONG & ARDUOUS THOUGHT - "NO WAY JOSE" TO PUBLISHING HIS ESSAY ON SHADES.
BECAUSE IT WAS DONE FOR YOU. NOT FOR ANYONE ELSE. JUST YOU.
WE REGRET ETC ETC ETC ETC.

YOU LISTENING? GOOD... BECOS I GOT A IMPORTANT MESSAGE FROM DA MAN

UH HUH. N GAIMAN ESQUIRE.

BUT THERE'S GOOD NEWS TOO!

NOW, MR BEELZEBUB!

NOT NOW DOLORES. AFTER I SAY "TO WIT".

I HAVE HERE A PROMISE FROM MR GAIMAN - SIGNED IN BLOOD - TO WIT...

I promise signed Neil

NOW, GODDAMMIT DOLORES! I SAID TO WIT! NOW!

MAKE WITH THE BALLOONS AND THE FX!

YAHAHAHA! YES! IN DECEMBER HE'S GOING TO DO HIS OWN 24-HR COMIC! FOR YOU TO DO WITH AS YOU WISH!

AND HE ALSO PROMISES THAT...

WHAT THE FUCK?

WHO LET THEM IN?

WHATS DA MATTER ASSHOLE? AINCHA NEVER SEEN A WABBIT BEFORE?

PLANTA DARRADO CARROTS.

RUN FOR THE HILLS!

SOMEBODY LET IN THE RABBITS!

YARGH!

Neil Gaiman

Augustus circa 15 BC. (late forties)(?)

Neil Gaiman

top: Neil's four-panel strip on sunglasses to Steve Bissette, 1991.

far Left: Neil's recall of the strip on shades and a promise to do a twenty-four-page comic soon, 1991.

Left: Not part of the 24-Hour Comic debacle, but another faxed drawing of a Roman Emperor, this time for Bryan Talbot in 1991.

Drawn years after the 24-Hour Comic, another unfinished comic about his problem with customs. Neil has a problem with customs; he is always selected to be shuffled off into a partitioned room where they go through his stuff and don't believe him when they ask what his business is. He apparently doesn't look like what customs think writers look like, and there is no documentation for writers with which to prove themselves.

When Neil flew to Australia for the Sydney Writers' Festival in May 2006, he was delighted to find a full-page article about himself in the Australian newspaper he was handed on the plane. It had a picture of his face, a picture of his work, and an explanation for why he was in the country. He tore it out and folded it into his jacket pocket just in case.

TOP RIGHT: For reasons that have long fallen out of the heads of the perpetrators: Gaiman and Bissette spent a lot of time in the early nineties sending each other drawings of vampiric rabbits over their fax machines. Neither party remembers why, but some of these rabbits appear in Gaiman's one-page strip.

RIGHT: Interior pages of the final 24-Hour Comic, 1992.

OPPOSITE: Neil's other illustration efforts included "Murders on the Rue Morgue," an illustrated version of a song by Alan Moore. Appeared in *Negative Burn* #13, July 1994.

12

5

sweeney todd
the demon barber of fleet street

"Sweeney Todd is about Manners, and Mirrors, and Meat. It's about razors, and women, and men. It's about death, and about London."

GAIMAN AND MICHAEL ZULLI MET IN 1988 IN THE aftermath of a *swamp thing* controversy (GAIMAN HAD NOTHING TO DO WITH IT DIRECTLY, BUT BOTH HE AND ZULLI WERE INVOLVED IN THE FALLOUT).

OPPOSITE: In the prologue, Zulli uses Neil's likeness in the same way that McKean did in *Violent Cases*, although he says it's not Neil but just some guy who looks like Neil and is doing the exact same research as Neil. It was done in pen and ink, and Zulli decided that everything that came after the prologue was going to be in any and all media *except* pen and ink. "It's all going to be done in paint, pencil, pastels, shoe polish, spaghetti sauce, whatever I can get my hands on" (*Comics Buyer's Guide*, 1992).

Rick Veitch, who was *Swamp Thing*'s penciler and became writer of the series after Alan Moore, had written an issue that featured Jesus Christ being given water by Swamp Thing as he hung from the cross. Although DC had originally approved the idea and Michael Zulli had begun drawing it, the company got cold feet over the religious aspect of it and pulled the plug, and Veitch walked. Gaiman and Jamie Delano had long been slated to take over the series when Veitch's run ended, but in light of DC's behavior and in solidarity with their friend, they stepped down, and Gaiman never got to expand on his plans in the vegetable theology essay from *Black Orchid*. Zulli and Gaiman met soon after at the San Diego Comic-Con on a panel about religion in comics, where they sat down and blasted DC for being idiots, in stereo.

Their first collaboration followed a year or so later in *The Sandman* #13, in which we meet Hob Gadling for the very first time—the man who boasts that death is a sucker's game and he will have nothing to do with it. The whole story hinges on an experiment: Death grants the man immortality, and Dream checks in on him once a century, meeting on the same day in the same place each time. Although the setting, the people, the clothing, and the mannerisms all change, Dream and Hob are the same two men meeting over a beer, talking about life without death. We see time pass in the details—had they not been so thoroughly researched the story would have deflated, become ambiguous and meant nothing. "*Sandman* #13 was set in all kinds of historical periods," said Neil in 1992. "I went out and bought sixty to seventy pounds worth of reference and I said, in

TRAVELLING INTO LONDON, FRESHLY SHAVED, MY FACE FEELING SMOOTH, TAUT, ALIEN.

NEXT TRAIN
LINE: VICTORIA

I DISLIKE SHAVING.

THE ACT ITSELF OFTEN SEEMS TO TAKE ON THE QUALITY OF RITUAL, OR OF SACRIFICE.

WET. SOAP. WASH. LATHER. A PLASTIC BIC FOR THE FIRST ASSAULT ON THE WORST OF THE STUBBLE. WASH AGAIN. LATHER. A TWIN-BLADED DISPOSABLE FOR THE SECOND, SMOOTHER SHAVE—SOMETIMES, LIKE TODAY, EVEN A THIRD SHAVE. WASH, AND DRY.

Way out →
≥ British Rail →

I TRY TO SHAVE ONLY ONCE OR TWICE A WEEK.

AFTER SHAVING THERE'S ALWAYS A PERIOD OF A FEW HOURS DURING WHICH I FEEL LIKE SOMEBODY ELSE—SOMEONE PINK AND VULNERABLE, AND MUCH YOUNGER. I FEEL LIKE A BOY AGAIN.

MY FATHER ONCE TOLD ME THAT HE HATED HAVING TO MAKE ME GET A HAIRCUT, WHEN I WAS LITTLE. I WOULD TURN INTO SOMEONE ELSE, HE SAID.

102 103

THIS PAGE:
The *Sweeney Todd*
penny dreadful, 1992.

Taboo 6 – The Sweeney Todd Penny Dreadful

Sweeney Todd, as it will appear in *Taboo*, will be a work in progress. Messrs Zulli and Gaiman reserve to themselves the right to alter, amend, revise, delete or otherwise change the work between this appearance and its final form.
Sweeny Todd 'Penny Dreadful' by Neil Gaiman and Michael Zulli; contents are © 1992 Neil Gaiman, Michael Zulli, and SpiderBaby Grafix & Publications. All Rights Reserved. *Sweeney Todd 'Penny Dreadful'* is a limited edition, and will never be reprinted in this format. Those who create unauthorized and unlawful reprints will be served up piping hot at Mrs. Lovett's in Bell Yard.

Mr. Zulli was (gratefully) assisted in the design & production of this book by Mr. S.R. Bissette and Mr. M. Arsenault

> "This is the only thing I've ever written that has actually disturbed me."

order for this to work, it has to be tangibly in the historical periods we are talking about. It can't be in that loosely defined time known as 'Historical.' We were working together, and Michael and I were talking and saying how much fun it would be to do a genuine historical comic book using all of this research. We talked an awful lot, and somewhere in there it became apparent that both of us were

fascinated by the Sondheim play *Sweeney Todd*. I was saying to him that, of course, Sweeney goes back further than that. Somewhere in there we decided to do it" (*Comics Buyer's Guide*, 1992).

The existence of an actual demon barber on London's Fleet Street is strongly disputed. He and Mrs. Lovett and her pies turned up in an 1840s penny dreadful—a name for the kind of Victorian periodical

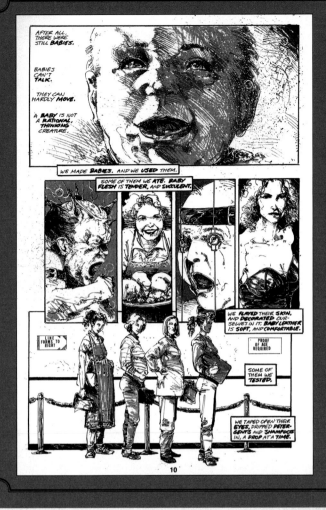

Babycakes

"ONE OF THE THINGS I want Sweeney to be about is meat," said Neil. "One of the other places that Sweeney sort of came from was 'Babycakes.'" 'Babycakes' was a four-page comic originally done for CETA (Creators for the Ethical Treatment of Animals) and later reprinted in the 1990 issue of *Taboo*. Although Michael and I are both leather-shoe-wearing carnivores, we say, okay, what would happen if the animals went away? Maybe we would use babies. They are really small, they don't move much, they can't think, and they can't complain. It was just sort of comparing the two: using babies for animal purposes. It was a little fable," Zulli remembers showing the comic to people he knew and watching their reaction: "It elicited a lot of clenched faces and strained groans and sounds out of people, so I know that I had hit a nerve—if not several" (*Comics Buyer's Guide*, 1992).

Said Neil, before a reading in 2001, "This is the only thing I've ever written that has actually disturbed me. Some years ago I did a CD, an audio CD called *Warning: Contains Language*, which I thought was a really good title and which the Diamond catalogue called *Untitled Neil Gaiman Audio CD Beware Contains Foul Language*, which kind of missed the point. I had this on it. A few years ago I came downstairs and my son was playing it. And I walked in halfway through and heard my voice reciting this and went: Eurghh, that guy is sick."

that got you grim tales of blood and murder for a penny—and the story continued over eighteen installments before living on in plays and musicals, as well as in the mind of every man in his barber's chair getting a close shave with a cut-throat razor.

Zulli and Gaiman used the idea of the penny dreadful as a way of introducing the world to Sweeney Todd before they began their own tale. Gaiman plundered the British Museum's catalogue for research and reported back that that Sweeney Todd may have been true ("there are rumors, and perhaps more than rumors"), and told us that writers are lazy and liable to lie, and everything is derivative and nobody knows if anything is true. The sixteen-page pamphlet detailed Sweeney's entire history to date and

was slipped into every pre-ordered copy of *Taboo* #6 in June 1992, the seminal horror anthology masterminded by Bissette (fellow 24-Hour Comic madman). *Taboo* was a square-bound, high-quality pub-lication best known as the birthplace of Alan Moore and Eddie Campbell's *From Hell*, and Gaiman chose it because he would be able to vary the lengths of the chapters as he needed to—there was no need to stretch something or cram it into the twenty-four pages of a regular comic. Having already spent years fitting *Sandman* into twenty-four-page monthly installments, this was a particular concern of Neil's given he was planning on making something huge and important and needed room to move.

In December the following year, the prologue was published in *Taboo* #7.

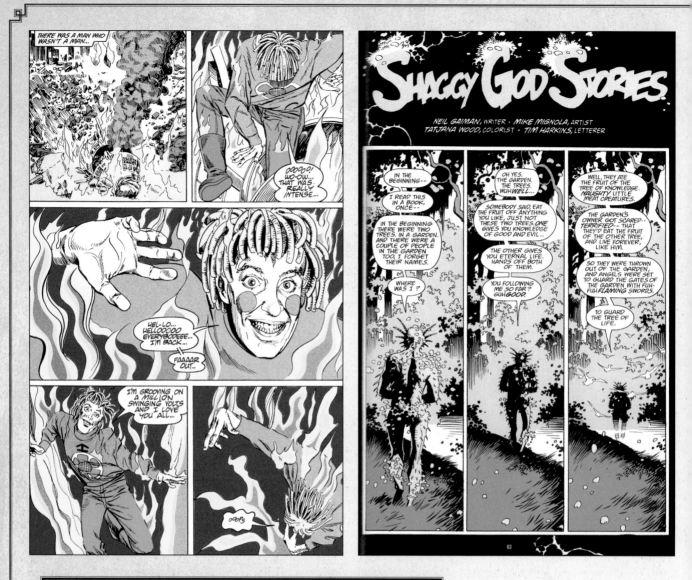

HAVING ABANDONED *SWAMP THING* in the wake of the Veitch controversy, Gaiman only wrote two more short stories within the vegetable theology he set out for *Black Orchid*. The first was "Brothers," with art by Richard Piers Rayner and Mike Hoffman, which dragged back Brother Power the Geek. "The main problem with that story was that halfway through writing it, *Swamp Thing* #89 happened, and my enthusiasm for it went away. It was like in the first half, I was in there kicking and firing on all four cylinders, and then after that there was a very nasty taste in my mouth." That same *Swamp Thing Annual* contained Gaiman's ten-page response to DC's rejection of the crucifixion in the DC Universe: "Shaggy God Stories" illustrated by Mike Mignola. "I thought, 'Well, let's see how blasphemous I can be then,' and in that one story I think I managed to examine the use of the tree motif in every major religion, in the context of a lunatic ex-mad scientist and superhero having a conversation with a Venus fly trap. I felt I came out if it okay, that I had fun with it" (Kraft, 1993).

Illustrated in pencils and paints, collage and peacock feathers, it sees Gaiman and Titan's Mike Lake looking for a piece of architecture from the past, taking two rolls of reference photos to send to Zulli in America. They talk about the history of London, a place so old and filled with stories that you don't have to dig far to convince yourself that it's a place of death and murder and that something evil has happened on every square inch of it; a place where heads of executed felons on spikes are never removed but fall off and get played with in the streets by dogs and children. In 1992 Gaiman said:

> *We go from there to a young gentleman named Edmund Wilde, who will be our eyes and ears through*

most of the story, and who is a journalist in the 1860s. From there we are going to go further back. We are actually going to have to follow Wilde, as he becomes obsessed with the story of Sweeney, and as he tries to track it down and find out what truths it has and where truths are. The primary research is all being done in the 1860s for us by Mr. Wilde.

The story is going to be told to us and told to Edmund by a number of different people who all have their own take on this. . . . There will be all sorts of Sweeneys in there. There will be all sorts of Mrs. Lovetts—partly because one of the dark stars around which my fiction tends to orbit is that of mythology and religion, and I think that the mythology and religion of Sweeney will begin to assume some very strange and interesting import-ance, as the idea of Sweeney as a priest will continue to occur. It's definitely one of the three basic archetypes that we are heading to and going back to. . . . The place where Sweeney was killing people is one of the bounds of the City of London. We are looking at it as essentially a sacrificial act: the act of murder as sacrifice (Comics Buyer's Guide, 1992).

Sweeney Todd is a story about stories, "about urban legends and legendary towns." It's about "trying to figure out how much meat there is on a person and how much of it can go into pies. Part of Sweeney is having to figure out: do you bone the body down in the basement and carry the meat in a sack around the corner to Mrs. Lovett's? Do you actually have underground tunnels? Do you just cut off the good bits? All that kind of stuff" (Comics Buyer's Guide, 1992).

Or at least that's what it was going to be about, but the prologue was the last we saw of Sweeney.

Taboo lasted nine issues, and Sweeney Todd did not appear in either of the last two. In an interview with The Comics Journal in 1995 (the same one that caused Alan Moore to sever all ties to his Swamp Thing collaborator), Bissette said that part of the reason why Taboo sank the way it did was because long-running fan-favorite serial From Hell had become available in its own installments outside of the anthology, and "the other death blow was Neil Gaiman's aborted Sweeney Todd. Neil turned in the first prologue, the one that saw print, and never wrote another chapter. To argue on Neil's behalf, I think Neil was able to perceive quicker than I was that Taboo was already a dead, stiff, cold corpse. Why invest further energy into a failed venture just as the Vertigo line was being launched with Neil as the clearest star in their firmament?"

* * *

"We are looking at [murder] as essentially a sacrificial act."

* * *

Said Neil in 2012, "I've only ever got grumpy with Steve Bissette once in my life. And it was some interview he did with The Comics Journal. In there he talked about the things that finished off Taboo, which included Neil and Michael not continuing with Sweeney Todd. And I phoned him up and I said: we handed in that Sweeney Todd to you, you phoned us up and said you had a huge backlog of Taboo stuff and you would call us when it was time to start the next one. And that was the last thing that ever happened with Taboo. And he goes, 'Oh yeah. It was, wasn't it.' I'm going, I wouldn't mind but you're now on record saying Neil and Michael killed Taboo, and we didn't."

With Taboo gone, their plan was to find another publisher and carry on doing the story. It wasn't dead, but on a hiatus from which it never recovered. There are still hopes that one day he and Zulli will figure out a way of getting it going again. ❖

BELOW: Hob Gadling in *The Sandman* #13, February 1990.

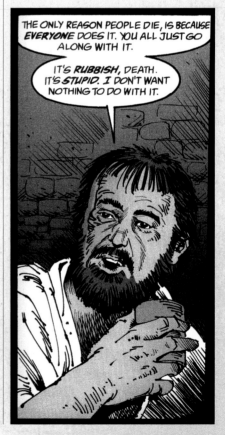

THE ONLY REASON PEOPLE DIE, IS BECAUSE *EVERYONE* DOES IT. YOU ALL JUST GO ALONG WITH IT.

IT'S *RUBBISH*, DEATH. IT'S *STUPID*. I DON'T WANT NOTHING TO DO WITH IT.

the Books of magic

JOHN CONSTANTINE WAS THE FIRST COMIC BOOK CHARACTER GAIMAN EVER WROTE.

It was in a little tryout story to take back to Alan Moore to see if he'd got the hang of writing comics yet—the cautionary tale about emptying your fridge before you go on holiday. Later he turned up in "Dream a Little Dream of Me," the third issue of *Sandman*, where Constantine takes Morpheus to get his stolen pouch of sand off his junky ex-girlfriend. In 1990 the trench coat cockney turned up again in *The Books of Magic* and in a one-off *Hellblazer* story, "Hold Me."

"Hold Me" was illustrated and colored by Dave McKean (with a little help from Danny Vozzo), and was one of the few times in their collaborative life that McKean worked from a full script. It only happened that way because it was originally supposed to go to another artist, who flaked. In a world where the abundance of collaborators on *Sandman* would occasionally reveal distracting seams, "Hold Me" was a perfect little story created by just two people and remains one of Gaiman's favorites. There are no superfluous horrors (McKean took them out), there are no demons or tentacles; it's an inky dark story about a forgotten homeless person who is simply very cold. Sort of.

The Books of Magic was a project inherited from the hands of J. M. DeMatteis. DC wanted a prose book highlighting their mystical characters, with spot illustrations by Jon J. Muth, Kent Williams, and McKean, and DeMatteis backed out after all three artists declined to take part. Karen Berger phoned Gaiman.

"Karen rang me up and said, 'We want to do a book which would be a Who's Who and a guide and a history for all our magical characters, and which has a story. Instead of a Who's Who of the DC Universe, it would be a comic and it would have a plot. Can you do it?' I laughed hollowly at her, said, 'Don't be silly,' and put the phone down. About twenty-four hours later, I was sitting around and I suddenly figured out how you could do it and a way of making it work. I rang Karen back, flushed with the enthusiasm of my own genius, and said, 'It can be done!' and she said great and sent me a contract. Again, carried on by the enthusiasm of the project, I signed it and wound up writing it. In an alternate past, I would have said, 'This is how you do it, now go and find someone to do it,' but it turned out very well" (Kraft, 1993).

Gaiman scripted a four-part series about an English teenager called Timothy Hunter who discovers that he is destined to be the world's greatest wizard. Along with his owl Yo-Yo, he is shown around every corner of the DC Universe in which there is magic with the Trenchcoat Brigade as his guides. The idea is that once he knows everything he needs to know about magic and the things magic entails, he will be able to make an informed decision about whether he wants anything to do with it or not. Phantom Stranger (two failed pitches and Gaiman finally got him in somewhere) takes him to see the birth of the universe and the start of magic on earth, John Constantine

takes him to America and dumps him on Zatanna, Dr. Occult walks him through Faerie, and Mister E takes him far into the future.

"There was a level on which this was an artists' book. *Sandman* is a writer's book. With *Sandman*, I'm at the front. With *Books of Magic*, I sat down and wrote something that was vaguely like a film script. It was a film script written for them to tell the story as they wanted" (Kraft, 1993).

Each chapter was illustrated, and largely painted, by a different artist: John Bolton, Scott Hampton, Charles Vess (who was illustrating the award-winning *Sandman* issue "A Midsummer Night's Dream" that same year), and Paul Johnson, respectively. For everyone but Vess it was the first time working with Gaiman, and each issue is completely different in tone and story. Four years after it was published, the film rights were sold. Gaiman was signed up to be executive producer, which meant he got to read the scripts and offer opinions, although it didn't mean they had to listen to his opinions. So far nothing more has happened with the film and a lot of that has to do with Harry Potter, who turned up seven years after *The Books of Magic*.

Despite the fact that Bolton designed the character of Hunter based on his own son, and Gaiman's character came from the archetypal boy wizard who has appeared in countless fictions, when J. K. Rowling's *Harry Potter* arrived on the scene Timothy Hunter was at the center of a newspaper-born plagiarism controversy. Gaiman quite rightly denounced it as "bollocks."

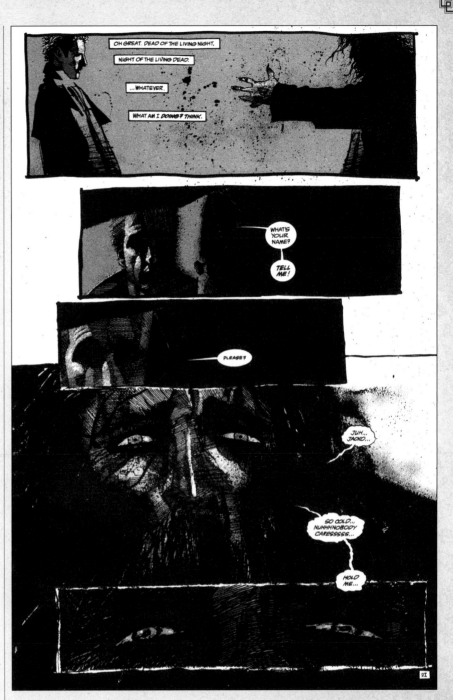

I was certainly not the first writer to create a bespectacled kid who had the potential to be the world's greatest magician. To create a kid with magical power—and more important, magical potential—and to use owls and so on, it's all stuff that's fairly obvious going on what went before. J. K. Rowling was not the first person to send a kid to wizard school. From Jane Yolen and Diane Duane in recent years—Diana Wynne Jones is marvelous—going back to T. H. White and E. Nesbit.

When I was eighteen, I started trying to write my first book, and I got nine pages into it. And because I didn't really have any experience of anything other than school, I was writing a story about a kid who was sent to wizard school, and Mr. Croup and Mr. Vandemar (who wound up in Neverwhere*) were going to be the baddies. I was cleaning* up *and doing some tidying in the basement, and I came across these pages, and I thought, now if anybody ever found these, they'd be going, "Cool! Look at this* Harry Potter *rip-off!" Which is fine, except it was a* Harry Potter *rip-off I was writing in 1978 (The-trades.com, 2002).* ❖

THE TRAGICAL COMEDY
OR COMICAL TRAGEDY of
MR. PUNCH

"Now, Mister Punch, you are to be hung by the neck until you are

Dead—

Dead—

Dead!"

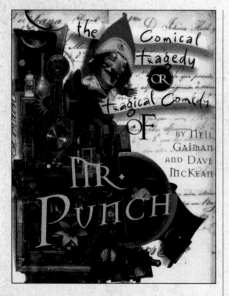

ABOVE: Cover of the Bloomsbury edition, 2006, with "Tragical Comedy" and "Comical Tragedy" swapped in the title.

OPPOSITE: On the cover of *The Comics Journal*, January 1993.

MR. PUNCH WOULD HAVE BEEN AN ENTIRELY DIFFERENT BOOK HAD GAIMAN AND MCKEAN GONE THROUGH WITH THEIR ORIGINAL PLAN IN 1988.

"I think we nearly did it, basically, in terror. Because we knew how we'd done *Violent Cases*. And then we did *Black Orchid*, which was us going, 'This is what a good mainstream comic should be,' and neither of us was terribly happy with it. I rather liked a few pages, and that was about all.

"After we did *Black Orchid*, we both felt very, very shaky, and we nearly went back and did another *Violent Cases* at that point. And I think it's a good thing that we didn't. Because we got to go on and do other things instead, and also we got to come back to this kind of territory at a time when we both had done an awful lot of other things, got a lot of experience under our belts, and I think changed our opinions a lot about what constitutes a story" (*Comics Journal* #155, 1993).

It started with a book Gaiman had picked up in a thrift store called *How to Do a Punch and Judy*. It explained how to put on a Punch and Judy show—a particularly peculiar British puppet show, a jagged diamond in the tacky crown of strange English seaside attractions. "The book ends with this wonderful little description of the plot: the baby starts crying, Punch throws the baby out the window and kills it; Judy comes up and complains; he kills her; a policeman comes to arrest him; he kills the policeman; he has a fight with a crocodile; the doctor comes to heal him; he kills the doctor; they come to hang him; he kills the hangman; the devil comes to take him off to hell; he kills the devil. And the last line was:

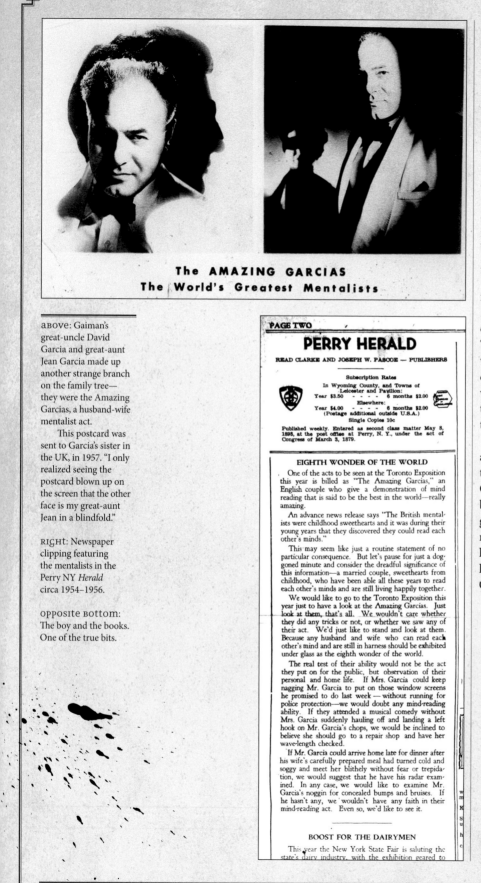

The AMAZING GARCIAS
The World's Greatest Mentalists

ABOVE: Gaiman's great-uncle David Garcia and great-aunt Jean Garcia made up another strange branch on the family tree—they were the Amazing Garcias, a husband-wife mentalist act.

This postcard was sent to Garcia's sister in the UK, in 1957. "I only realized seeing the postcard blown up on the screen that the other face is my great-aunt Jean in a blindfold."

RIGHT: Newspaper clipping featuring the mentalists in the Perry NY *Herald* circa 1954–1956.

OPPOSITE BOTTOM: The boy and the books. One of the true bits.

PAGE TWO

PERRY HERALD

READ CLARKE AND JOSEPH W. PASCOE — PUBLISHERS

Subscription Rates

In Wyoming County, and Towns of Leicester and Pavilion:
Year $3.50 - - - - 6 months $2.00
Elsewhere:
Year $4.00 - - - - 6 months $2.00
(Postage additional outside U.S.A.)
Single Copies 10c

Published weekly. Entered as second class matter May 8, 1895, at the post office at Perry, N. Y., under the act of Congress of March 3, 1879.

EIGHTH WONDER OF THE WORLD

One of the acts to be seen at the Toronto Exposition this year is billed as "The Amazing Garcias," an English couple who give a demonstration of mind reading that is said to be the best in the world—really amazing.

An advance news release says "The British mentalists were childhood sweethearts and it was during their young years that they discovered they could read each other's minds."

This may seem like just a routine statement of no particular consequence. But let's pause for just a dog-goned minute and consider the dreadful significance of this information—a married couple, sweethearts from childhood, who have been able all these years to read each other's minds and are still living happily together.

We would like to go to the Toronto Exposition this year just to have a look at the Amazing Garcias. Just look at them, that's all. We wouldn't care whether they did any tricks or not, or whether we saw any of their act. We'd just like to stand and look at them. Because any husband and wife who can read each other's mind and are still in harness should be exhibited under glass as the eighth wonder of the world.

The real test of their ability would not be the act they put on for the public, but observation of their personal and home life. If Mrs. Garcia could keep nagging Mr. Garcia to put on those window screens he promised to do last week — without running for police protection—we would doubt any mind-reading ability. If they attended a musical comedy without Mrs. Garcia suddenly hauling off and landing a left hook on Mr. Garcia's chops, we would be inclined to believe she should go to a repair shop and have her wave-length checked.

If Mr. Garcia could arrive home late for dinner after his wife's carefully prepared meal had turned cold and soggy and meet her blithely without fear or trepidation, we would suggest that he have his radar examined. In any case, we would like to examine Mr. Garcia's noggin for concealed bumps and bruises. If he hasn't any, we wouldn't have any faith in their mind-reading act. Even so, we'd like to see it.

BOOST FOR THE DAIRYMEN

This year the New York State Fair is saluting the state's dairy industry, with the exhibition geared to

'And Mister Punch then goes off to spread joy and happiness to children all over the land'" (Hogan, 1994).

Gaiman's story, another fractured narration of childhood memories and perception, is run through with a thread of violence that is as affecting, if not more, than that in *Violent Cases*. "Pretty much everything—all the weird little anecdotal stuff in *Mr. Punch*—is true, except for the things I made up" (Wagner, 2008). Gaiman's great-grandfather Morrie did own an amusement park with a mermaid in it (although it was sold long before Neil was born), and his great-uncle Monty really was a hunchback.

He said in 1992, "Three weeks ago at a family wedding, I asked my Aunt Janet [about Monty]. She said, 'He was dropped out of a window by your great-grandfather.' Then she paused and said, 'No, no. That was one of the twins, who died.' Which considering I'm doing a story which begins with Mr. Punch throwing the baby out of the window means I'm in weird family territory" (*Comics Forum #1*, 1992).

Gaiman wrote the first draft of the story and showed it to no one but McKean, who thought it was brilliant but unfocused. Gaiman had wanted the spine of the story to be the series of murders, but the system had got lost somewhere; the relentlessness of the murders had diffused. A long talk in a hotel lobby in New York at four in the morning led to a second draft, which McKean liked. Gaiman said:

> *The actual subject matter of* Violent Cases, *at the end of the day, is the same subject matter as* Mr. Punch. *It's a subject matter that fascinates and obsesses me: violence, cruelty, madness, and what it's like to be a kid in an adult world, and how horrible parties are, and all that stuff. And like* Violent Cases, *it's essentially an autobiography full of lies. It is unreliable autobiography, thronged by analogues of my family. Here's a thing that really did happen to me; here's a thing that should have happened to me if things had happened to me the way things were in the story; here's something that didn't actually*

happen at the time I say it did—it was a family legend that happened fifteen years earlier but I've moved it up. All that kind of stuff (Comics Journal #155, 1993).

And then I give them to Dave, who wasn't there, and he imposes his vision of events on it (Roel, 1994).

McKean's artwork was unlike anything else on the shelves and remains so. It was a weird combination of built sets, puppets, paintings, and photography, and is McKean's favorite of their countless collaborations. Neil's, too. "*Mr. Punch* was the first time I've

"Like Violent Cases, it's essentially an autobiography full of lies."

ever really felt that the thing that I wanted to do in my head when I started is there in the book, at the end. I don't feel any urge to apologize, which I normally do, when I finish something. You know, 'I could have got it right if I had a few more pages, I could have got it right if . . . a little more time, a little more something.' Whatever. You could have got it closer to the vision, you could have got it closer to the strange Platonic ideal that was in the back of your head when you started. *Mr. Punch* really did it" (Roel, 1994).

Probably if there was just one thing that he would have changed in hindsight, it would be to make the truth a little murkier by replacing McKean's English-looking models with old photographs of Gaiman's family. "One of the great things about my family is you've got this great Jewish nose running through the family. You have a bunch of people who all do look rather like Mr. Punch. I don't actually have it anywhere near as much, but my dad had a great 'Punch beak,' my grandfather had it—you had that sort of visual thing" (Wagner, 2008).

the gaiman family

Gaiman's great-great-grandfather was the owner of the largest department store in Łódź, Poland, where his name was not Gaiman but Chaiman, or Haiman. Gaiman's great-grandfather emigrated to Antwerp, Belgium, some time before 1914. He had married an older woman in the hope that it would cause him to settle down, and together they left Poland for Belgium, where he embarked on a doomed career as a diamond courier. A missing diamond and mislaid blame resulted in the move (or, rather, the escape) to England, whereupon he abandoned his family and disappeared entirely from the family's story, barring the occasional appearance in photographs and a couple of sightings almost mythic in their mystery.

"My great aunt Betty, who is currently in her nineties, talks about how one day there was a knock on the door, and there was a very good-looking man with a distinguished beard who said, 'I am your father,' and she had no memory of ever having seen him before. Whether he was in prison, whether he abandoned them for long periods, or quite what happened, I don't know, and I don't think anybody is quite sure" (Wagner, 2008).

Neil's grandfather Morrie, who in 1914 was eleven years old, became the sole breadwinner for the family, which was not a small one. With only a tentative grasp of the English language, he found employment as a busboy in a London hotel, and as a sideline he supplied American servicemen with black market whiskey during the First World War. Years later, his son David (Neil's father) remembered being in one such hotel with his father some time in the late 1940s and glimpsing the long-lost great-grandfather in a window across the street. "He was dining across the road with an attractive young blonde woman who was definitely not my great-grandmother. He may have been a con-man—he was definitely a black sheep," says Neil. "If I had known it at the time I wrote *Mr. Punch*, it would have gone in" (Wagner, 2008).

Incidentally, it was Neil's grandmother who changed the Polish surname to the one we see on that hefty wedge of novels on the shelf. And she did it simply because she liked it better that way. While not technically legal, it transpires that if you just write your name differently on some wedding announcements no one will ever say anything, and life goes on as if that's the way it always was. Making up the rules as you go along seems to be a dominant gene in the Gaiman family pool.

The book was adapted for the stage in 2008 by the Rogue Artists of America, and three years before that it was a one-hour radio play for the BBC written by Gaiman, with music by McKean, who said the experience reminded him "how powerful, and how slippery, as a narrative, it is" (Wagner, 2008). ❖

Neil & McKean's Gonzo Diary

IN 1994 MCKEAN PLAYED Steadman to Neil's Hunter S. Thompson in a gonzo tour diary from their time on the road. It was mostly just to keep themselves occupied while traveling and was never supposed to see print (McKean had his qualms about letting it out of the cage for this book, mumbling something to do with being unkind to Chinese restaurants).

Says Neil, "It's our little travel diary, which we kept on the road just to keep ourselves entertained. There was definitely no purpose in mind of ever getting it published; it was just this thing that we did in the days before Twitter. I'd write an account of our day and I'd give it to him and he'd do a drawing. Dave and I have done a lot of tours together. It's been fun, actually. We tour relatively well together because we're very different."

Ultimately, the tour for *Mr. Punch* changed how Neil interacts with his readers. "It was an enormous signing tour, and it went on for ages. And by the end of it, we were completely fried, and I swore I would never do another signing tour" (Roel, 1994). But he did, in 1996 for *Neverwhere*, and he got around hating signing tours by devising a plan in which he would do readings and Q&A sessions at every stop. "It gives me something to do, otherwise, I wind up feeling like some kind of strange fraud: you just turn up somewhere and you sign—people put books in front of you, and you sign and they say thank you or they give you little presents. I thought if I'm actually at least getting out there and doing readings, I'm doing something" (Roel, 1994).

THE CLOSET BEAST TELLS US THAT HE KNEW BOB WHEN HE WAS AN OUT OF WORK LONG NECKED BUM. NOW HE'S A RICH LOUD MOUTHED BLEACHED-YELLOW CAP-TOOTHED BUM. "ONCE A BUM" HE INFORMS US "ALWAYS A BUM".

THEN HE NICKED MY WATCH.

tHe Last temptatION

"He rang me up and said, 'I have an artist who wants to do a concept album. Do you have a concept?'"

GaImaN ObServeD IN tHe earLy NINeties tHat peopLe WHO LIkeD *SANDMAN* were GraDuaLLy becomING pervasive. JaSON fIber of epic records waS ONe of tHem. He perSuaDeD HIS bOSS tO reaD SOme *SANDMAN*; tHe bOSS ENDED up LOVING *SANDMAN* too AND prOmptLy GOt GaIman ON tHe LINe.

"I answered the phone and a voice said 'Hey, Neil, this is Bob [Pfeifer] from Epic Records, and we have an artist who wants to do a concept album.' And I said, 'And?' And he said, 'Well, he wants to know if you have a concept.' And I thought this has got to be some kind of joke. And I couldn't think of anyone on Sony apart from Michael Jackson and Barbra Streisand, and I didn't really want to work with either of them. I said, 'Who are we talking about here?' and he said, 'Alice Cooper'" (Roel, 1997).

Gaiman has seminal memories of being about thirteen and watching Cooper doing "Teenage Lament '74" on the BBC's *Top of the Pops* music TV show. And like most people born around 1960, he owned one Alice Cooper album, which in his case was *Welcome to My Nightmare*, released when Gaiman was about fifteen.

To get the story, Cooper and Gaiman got together and sat in a room and talked about what scares Alice. "We wound up talking about those movies they show high school kids in America to deter them from doing what society deems 'bad things.' They're these really scary movies about sex, drinking, and rock music" (*Comics Forum* #7, 1994). They came up with the story that cast Alice Cooper as the Willy Wonka-style showman of a horrible old theater (with a staff of dead people) who attempts to lure an impressionable teenage boy into joining the staff. "It was a pretty organic experience; there was a lot of give and take between us, we both contributed ideas, and it was personally very refreshing to work like that. After we finished the story, Alice went away and made the album" (*It* #1, 1994). The album starts with an anthemic cry of a bored youth—Cooper's long-

running character Steven, whose first appearance was on Gaiman's sole Alice Cooper purchase as a teenager. Steven has weaved in and out of albums ever since. Jobless, carless, girlfriendless, he basically lives in the 7-Eleven and wants to run away from the bore of authority and join the circus—his own private sideshow of freaks, "finger-lickin' chicken-eating" geeks, and hunchback midgets. Cooper is there in his top hat waiting for him to sign on the bloody line.

Almost immediately after the album was finished, three different comic companies decided to create music titles. Gaiman had piles of plots that never made it into the album, so he figured it was a good idea. He said in 1994 that "part of the thing about doing the Alice comic was almost the challenge. People have been doing rock-and-roll comics for about twenty years so far, and I can't remember any good ones. I really can't. They're odd little things. Why aren't there any good rock comics? Whenever one thinks of them, one thinks of those silly things that Malibu did, or the strange things that Marvel do. You know, rock-and-roll bands turn into superheroes. So what I wanted to do was take a look at Alice as an icon. Essentially, with Alice, what you're being

"What I wanted to do was take a look at Alice as an icon."

Alice video idea — how about Christopher Lee playing the Showman in the video —

Oh no, professor! Do you not see? It is the wrong man!

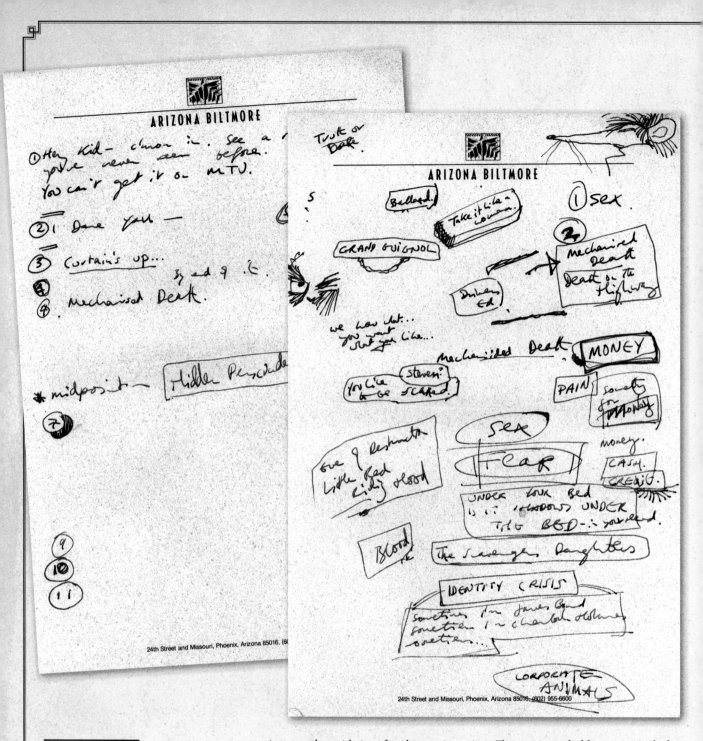

Notes from Neil and
Alice Cooper's original
brainstorming session

given to play with is a free horror icon. Alice is an icon. Everybody knows the face, with the lines under the eyes. The hair. Him staring out at you. It's up there with Dracula, or Frankenstein, or the Wolfman, or Jason, or Freddy. It's one of the icons of twentieth century horror; it just doesn't have a story that goes with it. So all I wanted to do was give it a story" (*It* #1, 1994).

There was a bidding war and they went with Marvel, because Alice was keen to work with them again after the success of *Marvel Premiere*—an anthology that started in the early seventies and died in the early eighties, functioning as a testing ground for new characters and a home for old ones that had nowhere else to go. Their fiftieth issue featured an adaptation of Cooper's 1978 album, *From*

the Inside, and was his first appearance as a comic book character. The rest of the experimental Marvel Music line would disappear into obscurity pretty swiftly—that Billy Ray Cyrus one-shot was a particular misfire—but over a decade later Gaiman's *The Last Temptation* still sells well.

He took the initial idea and fleshed it out into a whimsically demented story of faith and temptation, a horror-tinged version of *A Christmas Carol* in which Steven is shown what his life would be like through a series of dark and twisted morality plays in Cooper's theater of horrors. Gaiman's blood-and-gore compatriot Michael Zulli provided the illustrations. It was their fourth collaboration and his typically lush and atmospheric artwork lent the three-issue miniseries a decidedly creepy air. ❖

aʙovᴇ: Alice and Neil.

Left: In the mid-ninties Gaiman also worked on concepts for a series of comics published by Tekno Comix. He wrote the series bible, creating a number of new characters, which were split between three comics: Lady Justice, Mr. Hero the Newmatic Man, and Teknophage. He's pictured here promoting the comics and talking to Leonard Nimoy, who also "wrote" one, as two Mickeys (Mouse and Spillane) hug.

BATMAN

"It starts in an alley with Joe Chill."

WHEN GAIMAN WAS A LITTLE BOY IN HIS GRANDPARENTS' LIVING ROOM WATCHING BATMAN JUMP AROUND ON-SCREEN HE PROBABLY NEVER THOUGHT HE WOULD BE THE GUY TO WRITE HIS HERO'S FUNERAL. AFTER ALL, THE LAST THING HE WANTED WAS FOR BATMAN TO GET HURT.

When I was five, I was in a car with my dad and he mentioned that there was this Batman TV show in America about a man who dressed up in a costume and fought crime. The only bat I ever knew was a cricket bat, so what I thought he looked like was rather odd, based on that. Months later, the series hit the UK, and I remember watching and being affected by it. Really worrying, genuinely worrying, on a deep primal level, 'Will he be okay?' That is the way it was with every deathtrap. If I missed the end of an episode, I'd get my friends to tell me he was okay" (Thill, 2009).

The TV show was the gateway drug to comics and Batman stayed with him for life, and grew up with him. The camp sixties Batman suited the younger Gaiman just fine; Neal Adams's long-eared shadowy character turned up just in time for his teenage years; and when he was twenty-five Frank Miller's *The Dark Knight Returns* arrived. Gaiman wrote his first piece of academic criticism on a Batman comic. It was no summer fling.

Before he said his good-bye to the Caped Crusader, Gaiman got a chance to write a handful of stories of the less final variety: he put him in *Black Orchid* and the following year wrote a secret origin of the beautiful and deadly Poison Ivy from the perspective of a thoroughly seduced prison inspector. Soon after came a story about a film crew in Gotham trying to get some interviews with its baddies that contained a mad and delirious vignette about the TV show Riddler living in a warehouse with all the old props, pontificating from atop an enormous typewriter. Then in 1996 he wrote a *Batman: Black and White* story, a completely funny and unexpected thing in which Batman and the Joker are waiting in the green room for their scene, doing a crossword to pass the time. They wonder how Mr. Freeze and his family are doing (he never gets any work these days). Each of Gaiman's visits to Gotham was entirely discrete and all so fleeting.

OPPOSITE: Batman's appearance in *Black Orchid*, 1989.

ABOVE: Alex Ross variant cover to *Batman #686*.

And then, in late 2008, Batman died. Or he sort of died. Batman was *dying*, and if there's anyone in DC's arsenal who knows how to write death, capital D or otherwise, it's Gaiman. Dan DiDio phoned and said they were going to do with Batman what they had done twenty-three years before with Superman and Alan Moore's *Whatever Happened to the Man of Tomorrow?*: end the monthlies, reboot the numbering, and keep Batman off the shelves for a bit. He asked if Gaiman would write the last ever Batman story.

> *It was one of those strange combinations. I thought that if I didn't do it, someone else would and [they would] mess it up. But also, I really love Batman. The platonic ideal of Batman, as well as the number of specific Batmans over the years. I thought it would be really interesting.*
>
> *In a lot of ways,* Whatever Happened to the Caped Crusader? *is a love letter, as was Alan's* Whatever

Happened to the Man of Tomorrow?. *That was his love letter to Julius Schwartz and Mort Weisinger and Curt Swan and all of the guys who had worked on Superman. And it was a love letter to the Superman who lived in Alan's heart, who wasn't going to be around anymore. I wanted to write the same love letter to Batman (Thill, 2009).*

ABOVE: "A Black and White World" with Simon Bisley (1996). The second of Gaiman and Bisley's Batman stories but the only one that actually happened. In 1989 there were plans to do a fully painted Batman book called *The Night Circus*. Gaiman got paid his $900 advance, Bisley did a painting for a "slightly dubious" DC to convince them that he could do Batman, but for contractual reasons (Bisley was signed exclusively elsewhere) it never happened, although a couple of years later Bisley did paint the *2000 AD*/DC Comics crossover, *Batman/Judge Dredd: Judgment on Gotham*.

And so, in February 2009, we got the first part of *Whatever Happened to the Caped Crusader?*, which included a direct homage to Moore's work. The second half followed two months later. Neither stayed on the shelves very long—not only was it the first Gaiman comic in years, it was the last ever Batman story. At the Graphic Festival in 2012, Gaiman said, "The idea was that it is always the last Batman story. In twenty years from now it will have been, it will still be, the last Batman story. That makes me happy. Just the idea of Batman as an idea."

The story starts in a little bar with Selina Kyle talking to Joe Chill, murderer of Bruce Wayne's parents. Batman is there, a disembodied presence getting to watch his own funeral in the backroom of a bar in Crime Alley, dead in a coffin in the place where he was born. One of the things about Gaiman's post-*Sandman* forays into comics is that they are so rare that when he does them, he does them in a way that allows him to play with as many characters as possible. Everybody is here: Dick Grayson, the Joker, Commissioner Gordon, the Penguin, Poison Ivy, and of course Catwoman, whose car is guarded outside by a pride of alley cats.

Only it's not a funeral. It's Batman seeing his life flash before his eyes, narrated by those who were there: each character tells their version of how they saw him die, each character talks of how he affected their lives. But all the while Batman is protesting, *It didn't happen like that.* There are contradictions, nobody can be telling the truth, but if Batman is just an idea then maybe they are.

"I wanted to play very, very fair with the reader. So what I was trying to say is that it honestly doesn't matter if it is in or out of continuity. And it doesn't matter whichever Batman you love, whether that is Frank Miller's *Dark Knight Returns* and Christopher Nolan's *Dark Knight*, or the Batman TV show or even the various, glorious animated series. This is the last Batman story. He's dead, and this is what's happening. It's been seventy years, and it's been wonderful, but this is the last one" (Thill, 2009). ❖

TOP: Poison Ivy in "Pavane" with Mark Buckingham (from *Secret Origins* #36, 1989).

CHAPTER 5

THE COMIC BOOK Legal defense fund

"Freedom of speech is an absolute. The rule is, if you don't like the pictures, you don't look at them."

Neil Gaiman

Third Angel

A Midsummer's Reading Benefitting the Comic Book Legal Defense Fund

This Ticket Admits One Person

ABOVE: A ticket to a CBLDF reading, 2003.

OPPOSITE:
Jill Thompson art from the *Sandman* sketchbook, 1992.

THE COMIC BOOK Legal defense fund was founded in 1986 to support the freedom of speech in comics: that comics, Like any other art form in the united states of america, should be accorded the same constitutional rights.

It wasn't purely moving to America that got Gaiman involved in the CBLDF, but it helped. Gaiman grew up in England, where there is no First Amendment and freedom of speech is not guaranteed. The UK has laws like the Obscene Publications Act, which means you can't publish obscene things, and the Official Secrets Act, which means you can't say secret things.

"I was born the day of the conclusion of the *Lady Chatterley* trial in England, the day it was decided that *Lady Chatterley's Lover*, with its swearing, buggery, and raw sex between the classes, was fit to be published in a cheap edition that poor people and servants could read. This was the same England in which, some years earlier, the director of public prosecutions had threatened to prosecute Professor F. R. Leavis if he so much as referred to James Joyce's *Ulysses* in a lecture, and in which, when I was sixteen and listening to the Sex Pistols, the publisher of *Gay News* was sentenced to prison for the crime of Criminal Blasphemy, for publishing an erotic poem featuring a fantasy about Jesus."

Gaiman first got involved in fundraising for freedom of speech in comics about 1984, when Knockabout Comics—the tiny publishing house initially set up by Tony Bennett to distribute Gilbert Shelton's infamous pot-smoking hippy comic *The Fabulous Furry Freak Brothers*—started becoming frequently embroiled in long, expensive court cases just to get books back. They were pulled up by customs for importing anything that contained rude words, sex, and stories in which characters used marijuana, which in terms of underground "comix" was basically everything. Plus, anything that came in the same box as the dirty books was also doomed.

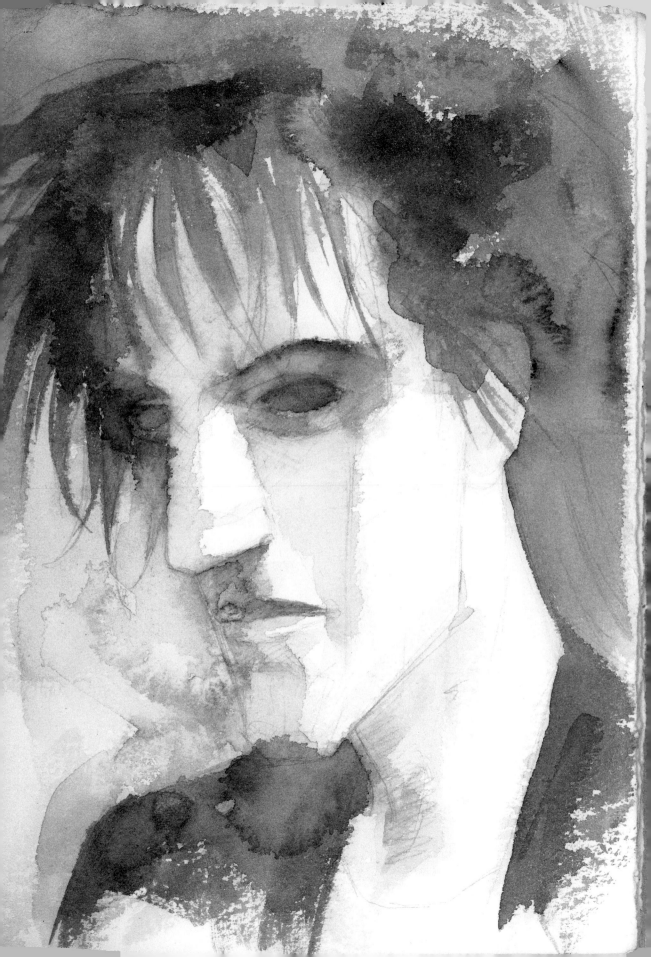

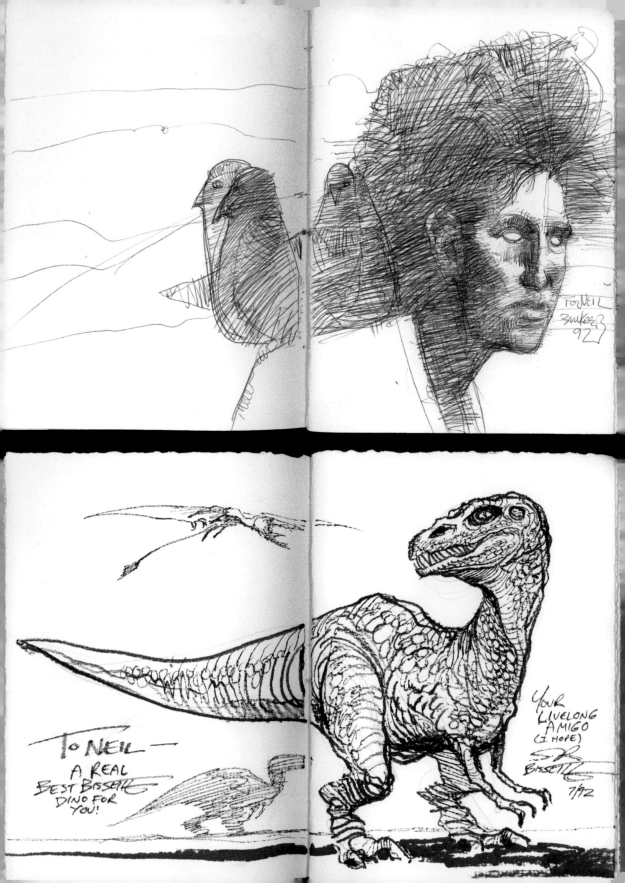

FOR NEIL
BISSETTE
92

TO NEIL —
A REAL
BEST BISSETTE
DINO FOR
YOU!

YOUR
LIVELONG
AMIGO
(I HOPE)
BISSETTE
7/92

His first personal involvement with comics and censorship was in late 1987 when his work in an anthology called *Outrageous Tales from the Old Testament*, originally published by Knockbout in 1987, almost got a Swedish publisher sent to jail.

It was the first thing I wrote in comics, or at least the first solid work that I was professionally paid for, which almost immediately I found myself defending. I did a BBC Radio 4 phone-in thing defending it against some rent-a-quote Conservative Member of Parliament who hadn't read it, but had been told what it was and knew that people shouldn't read this kind of thing. And the next thing that happened was my story came incredibly close to sending a Swedish publisher to prison (for the Swedish edition).

I retell the story in the Book of Judges *that has a horrible gang rape in it that ends in murder, that then ends in the guy cutting up his wife and sending a chunk of her to each of the tribes of Israel to protest this awful thing that's happened. And it's horrible. And it was written in the script as:* this is horrible. *And it's in the Bible, and people should know the stories in the Bible. That was the whole point of* Outrageous Tales from the Old Testament: *we were not exaggerating. Then I learned that our Swedish publisher was facing a prison sentence for depicting violence against women and I wrote an essay for his defense. It really was only the fact, I suspect, that the story was told completely straight from the Bible that actually kept him out of prison.*

Most famous of all Knockabout's cases was in 1996, when they had imported some Robert Crumb comics to coincide with a major BBC television documentary on Crumb, only to have them confiscated.

Back in 1990, when Gaiman was thinking about writing a story about the French Revolution in *Sandman #29*, he thought he'd like to include the Marquis de Sade as a character, given that he was in jail when the whole business was going on. But in 1990 the work of de Sade was deemed too obscene for the UK. Next time Gaiman was in the United States, he bought the books at Borders and smuggled them back in his luggage.

Then, in 1992, he emigrated. He was being paid in American dollars and his career was by now almost entirely in America. When he left the UK, he was presented with a sketchbook masterminded by his old friend Dave McKean. There are drawings and paintings from friends and *Sandman* collaborators like Mark Buckingham, Kelley Jones, Chris Bachalo, Charles Vess, and *Cerebus* creator Dave Sim. Over a decade later, in 2004, pages from the sketchbook were included in the program for Fiddler's Green, a

My story came incredibly close to sending a Swedish publisher to prison."

Sandman convention held in Minneapolis (and named after a favorite *Sandman* character) to benefit the Comic Book Legal Defense Fund, something Gaiman became heavily involved with once his bags were unpacked in his new house.

The Comic Book Legal Defense Fund had been something that was on my radar for a while. I'd been reading the comics press, in this case I think it was mostly the Comics Buyers Guide*, and it began when Friendly Frank's Comics got busted by a cop for selling the cop a copy of* Omaha the Cat Dancer*. This guy's arrested and he's going to go to prison, and he's just sold an adult comic to* an *adult. So Friendly Frank's Fighting Fund was formed. People threw money in to defend this guy and to defend the case,*

the case was won and there was money left over. So the Comic Book Legal Defense Fund was formed. Truthfully it's not necessarily the greatest name for essentially the Comics First Amendment Defense League or whatever it really is, but it began with a fighting fund. The idea was if you need legally defending, we have a fund here. The remit has expanded a little over the years beyond just that, and sometimes we go on the aggressive too.

What really moved the CBLDF from being an ad hoc fighting fund to something that could actually start to fix things was the fact that Dave Sim gave all his money from the *Spawn* issue he did to the money pool. It all happened around the time of a cartoonist's arrest.

"Mike Diana got arrested for essentially a fanzine he was doing called *Boiled Angel*. It had some pretty good comics in it, in the sense that they were powerful, they were personal, they were obviously heavily influenced by EC horror comics. Mike Diana's drawing style was not terribly pretty; it was a very raw drawing style so everything was very symbolic and it seemed to be rooted in Mike's abuse as a child and obsession with horror movies and all those sorts of stories. But I like Mike Diana. I thought Mike Diana's comics were powerful and strong. I was significantly less of a fan of the rest of the zine, which read like a serial killer fanzine and I don't have much time for serial killers and I have no time at all for serial killer fans. The real ones."

The previous year, a policeman in California ended up with an issue of *Boiled Angel*, parts of which reminded him of the then-unsolved Gainsville student murders in Florida where Diana lived and worked in his father's convenience store. In 1992, after blood tests ruled him out as a suspect in the murder case, they tried Diana for obscenity instead. He became the first American artist to be arrested for obscenity.

Money needed to be raised in order to defend Mike Diana. I went out there and I did a couple of gigs. We brought in the head of the comic book museum in San Francisco, and we brought in Peter Kuper from New York to testify this stuff is art. But Mike Diana was found guilty of obscenity, and Mike's sentence involved over a thousand hours of community service. He was not allowed within ten feet of

THIS SPREAD: Chris Bachalo pages from the *Sandman* sketchbook, 1992.

FOR NEIL

→ ALL
DRESSED
UP.
AND

Actually, Neil
it is a known
fact that
FLAKES
make the
best self-
publishers.

...

Just because
I'm me

DAVE
SIM

DAY 6 OF NEIL GAIMIN HELD
HOSTAGE — 7·29·92

anyone under the age of eighteen, and he was a convenience store clerk so if anybody under the age of eighteen comes into the store he had to go into the back. He had to pay for a course in journalistic ethics at his own expense. He was sentenced to psychiatric treatment at his own expense. He was sentenced to three years probation and a $3,000 fine.

And all of these things were bad, but none of them were as bad as the fact that the local police were ordered to make random twenty-four-hour-spot checks on Mike at work and at home, unannounced—they could break down the doors if they wanted—they had to come in suddenly to make sure he was not drawing anything and did not have time to flush any drawings, if he is committing art, down the toilet. And honestly it was that last thing.

It was the idea that they'd not only found him guilty of obscenity—that I could sort of, somehow, on some weird level, go, "okay"—but it was the fact that they were now appointing the police to make sure he would not commit future obscenities . . .

I absolutely understand somebody going: you should not be able to depict images of violence towards women. But they're lines on paper, and they're covered by the First Amendment. That's the deal here, because if it doesn't cover that, then it doesn't cover the stuff that you need to save. I needed to become a First Amendment absolutist, and I still find it uncomfortable being a First Amendment absolutist. I was not put on this earth to be an absolutist of anything. I'm somebody whose natural response to an awful lot of stuff is to say: yes, I see your point of view, or at least to try and find common ground. But when it comes to the First Amendment, there is no common ground.

There are people saying to me: well, are you saying people should be allowed to make snuff movies? And I'm going no, they shouldn't, because that involves murdering somebody, and murder is a crime, and you shouldn't be murdering anybody. And pedophilia is a monstrous crime and it is a most monstrous crime because it is hurting kids and that's real. A child cannot give consent, this is bad. I get this. And then suddenly I find myself having pointless arguments online with people about Japanese manga drawings of couples with babyish faces having sex or whatever. "This is being used by those pedophiles to excite themselves and work themselves up!" And I'm going, No. You can't do that one. These are not

ABOVE: Mike Dringenberg artwork from the *Sandman* sketchbook, 1992.

OPPOSITE TOP: Michael Zulli's and Dave Sim's contributions, 1992.

OPPOSITE BOTTOM: Michael Chabon and Neil in 2007.

> It's good manners
> after they've been doing it for
> a couple of hours to inquire if they'd
> like to have a coffee, coke or beer, or
> possibly brave your bathroom facilities.

'Okay, now you just go down the stairs until you can't go any more then push forward to your right until you get to a door. The wood's a little mushy so don't push too hard. . .'

> Panic early.
> It is not unknown for
> distributors to forget to process
> your order for 100 graphic novels,
> because they are busy people

who have important things to do. Panic in enough time to get whatever you need from an alternative source, from another store, from the publishers.

> I'd especially like
> to mention a store in
> Connecticut where I sat
> undisturbed for an hour, save
> only for the presence of a bright

fourteen year old with five copies of Miracleman no. 17 who wanted to know by exactly how much my signing the comic would raise its value.

real people. These are drawings. And if you think they're real then you also have to imprison people for murder every time they kill a fictional character.

Gaiman went on the road all through the 1990s to raise money for Mike Diana's case and any that came after it. "The Guardian Angel Tours were just me. And partly it was just I loved the idea of taking a theater and doing a reading like Charles Dickens used to do. But I also did not have the self-confidence to say: I am going to take a theater, because I thought it was a bit weird and big-headed. But I felt like I could do it for the CBLDF. That way,

"These are drawings. And if you think they're real then you also have to imprison people for murder every time they kill a fictional character."

people don't have to like me and I'm not getting the money for it, all of the money will go to the CBLDF. I loved it because I got to go on the road and read to an audience."

It was also a really good chance to try out short stories, and introduce fans of *Sandman* to his other work. It was in 2000 on the Last Angel tour, the final of his CBLDF travels, that Gaiman stood before an audience at the Aladdin, in Portland, and pointed at a huge stack of papers leaning against the wall. It was the as-yet-unpublished novel, *American Gods,* only just staying upright.

He stopped touring because it was becoming increasingly difficult to find two spare weeks a year in which to do it.

ABOVE: One of the many things that Gaiman did for the CBLDF was put out a benefit book called *Gods & Tulips* (1999), which included two essays: one, a speech likening the teetering and fleeting heights of 1990s comic book economics to that of the Dutch tulip crisis; and a second one, on signings. Having already been on the frontline of the world of signings for years—good and bad—Gaiman was as close to an expert as you were going to get.

OPPOSITE TOP: Dave McKean's paint and gold-leaf Dream King was used for the cover of the program for the 2004 CBLDF benefit convention Fiddler's Green. Gaiman keeps the original in a little cabinet in his house, next to handwritten novels and notebooks. "Now this is a special thing," said Neil, handing it over delicately.

Instead he would do things like auctioning off the name of a cruise ship in his novel *Anansi Boys* on eBay for $3,533, which had an interesting rollover effect: Michael Chabon had alerted Neil to the fact that fellow defenders of free speech, the First Amendment Project, were rapidly running out of money having spent it all on defending free speech. So a bunch of famous writers organized a similar thing: win the auction and you could be killed off in a Stephen King book, have the spelling and pronunciation of your name mutilated in a Lemony Snicket novel, or be a name on a gravestone in Gaiman's next novel, *The Graveyard Book*.

In 2012 Gaiman stepped down from the board of directors. That year he founded the Gaiman Foundation and gave $60,000 to the CBLDF in order to help them educate through various initiatives (Kids Right to Read Project, Banned Books Week, etc.). The Foundation exists to help a variety of causes. The CBLDF was its first stop. ❖

RIGHT: a McKean page from *Outrageous Tales from the Old Testament*, 1987.

SHORT STORIES

"I believe we owe it to each other to tell stories.
It's as close to a credo as I have or will, I suspect, ever get."

A
Little Gold Book
of
GHASTLY
STUFF

by
NEIL GAIMAN

above: Cover by Gahan Wilson who also provided the cover for Gaiman's short collaboration with Gene Wolfe, *A Walking Tour of the Shambles* in 2002, which took readers on a tour through a fictional part of Chicago and its nonexistent landmarks. Wilson also illustrated Gaiman's "It Was a Dark and Silly Night . . ." for the *Little Lit* anthology.

ONE OF THE REASONS FOR DOING THE GUARDIAN ANGEL TOURS THAT HE NEVER REALLY MENTIONED AT THE TIME WAS, VERY SIMPLY, STAGE FRIGHT. GAIMAN CONQUERED IT IN MUCH THE SAME WAY AS HE CONQUERED EVERYTHING ELSE: HE JUST GOT UP AND DID IT.

"I used to get stage fright in mind-manglingly huge and impossible quantities. Serious crippling stage fright. So I figured the best way to deal with serious crippling stage fright was to learn how to get up on stage in front of thousands of people. Which I did. And I now get it a little. You know, it's never completely gone away, but I don't mind because I kind of like the little adrenalin bursts that I get now when I'm performing, or about to perform anyway. The jittery terror."

These days you can catch Gaiman reading stories as a support act before an Amanda Palmer gig or you can stay at home and watch countless shaky YouTube videos of readings from all around the world. He has gone on storytelling tour buses with other storytellers, like a rock band only with pens and books instead of guitars. He uses readings to see audience reactions, quietly gauging if a story is working or not. In 2012, having finishing a piece called "The Sleeper and the Spindle" after six weeks of working on it, he organized an event for that very purpose. He was forthcoming about it. He didn't promise it would work, and in case it didn't, he was going to read other works too.

I love the audience reactions. Writing something is such an incredibly solitary thing to do. And then you publish a story and it goes out and people come back and they say I really liked that thing you did, and I say thank you. But you weren't there when they read it.

With readings, what I like best is that moment in a reading when everything in the room gets hyper-quiet. You've reached a point in the story where it's really, really important and everybody's suddenly quiet. And everybody cares. And they aren't moving because they know if they move it disturbs the air. And the lines about hearing pins drop? You can hear pins drop. And that, for me, is that's what I love best. That

"HARLEQUIN VALENTINE"

"Oh, Harlequin in love is a sorry creature."

"HARLEQUIN VALENTINE" IS A PLAY on the old commedia dell'arte trickster character, written in a bouncy, playful, and slightly unhinged way. It was originally for a book called *Strange Attraction*, being a collection of twenty-four poems and stories based on a Ferris wheel made by sculptor Lisa Snellings, who requested that Gaiman write something about the man who takes the tickets. "It's a story from the point of view of an invisible harlequin who has fallen in love with a young lady and must demonstrate his love. As the story starts, he has cut out his heart and pinned it to her front door" (Baker, 2007). *Books of Magic* artist John Bolton turned it into a comic a year later.

moment when you really feel that you've captured them. You've been going around gathering up people as if you're gathering pieces of string. Now suddenly you have this thing that you're holding that's all of them. You're holding them all, weaved. And I love it when they laugh at the same time. And I love doing voices. It's silly and fun. I love when I take something that I genuinely don't know if it works or not, and I make it work. Not even that I make it work, that I learn it works. That I put it on stage in front of an audience and it's just me and there's no props and there's no anything: there's just me and some words. And I find out if something works or not. That's what I love.

The first short story he ever sold was "Featherquest." It appeared in the May 1984 issue of *Imagine Magazine* when he was twenty-three, on the suggestion of Colin Greenland, whom he had met at a Brian Aldiss signing in Forbidden Planet. "It was 8,000 words long, and they said if you cut it to 4,000 words, we'll take it. So I

Left: Dave McKean's illustrations for the 2014 Subterranean Press edition of *Smoke & Mirrors*.

"the price"

"And then there is the black cat."

a partly true story about a strange cat that turned up on the Gaiman doorstep one night. A short animated film by Christopher Salmon is currently in production, funded by Kickstarter. A very tired Neil provided his own voice for the project. "I recorded the audio in the middle of a tour when I was completely exhausted. I got to the recording studio, recorded it, and then slept on a sofa for an hour or so. And then I had to do some signing. But I was completely trashed. So hopefully there'll be a quality in the voice that will reflect the complete exhaustion."

above right: "The Facts in the Case of the Departure of Miss Finch," as written in Neil's notebook.

right: The short story "Shoggoth's Old Peculiar" (2004 chapbook published by DreamHaven shown here) was not Gaiman's first try doing Lovecraft. "I Cthulhu: or What's a Tentacle-Faced Thing Like Me Doing in a Sunken City Like This (Latitude 47° 9'S, Longitude 126° 43'W)?" turned up first in 1987.

SHOGGOTH'S OLD PECULIAR

NEIL GAIMAN

ILLUSTRATIONS BY JOUNI KOPONEN

"I'd sold fiction. That was for me big and important."

cut it to 4,000 words. It wasn't very good to begin with; it was worse when it was published. And they paid me £30. I think a few months later I wrote 'How to Sell the Ponti Bridge' and they published that, and again I got my £30 and was thrilled because I'd sold fiction. That was for me big and important. Everything else didn't matter.

But selling short stories did." "Featherquest" remained lost to everyone but mold and vintage magazine shops until 2011 when it was reprinted in *The Little Gold Book of Ghastly Stuff* along with some essays and other forgotten things (Gaiman thought it was good enough to warrant restoring most of the lost words).

Soon Ian Pemble at *Knave* was buying short stories off Gaiman, publishing the likes of "We Can Get Them for You Wholesale" and "The Case of Four and Twenty Blackbirds." Life fed into story when *Penthouse* commissioned him to write a piece of fiction for their twentieth anniversary issue in 1985. He gave them "Looking for the Girl," which Gaiman pinpoints as the first time he had written a short story that sounded in any way like him, the point where he was edging toward a style. He researched it by flipping through two

Handwritten left notebook page:

"...wood and Stone were good men. "You would have been ~~invited~~ given the opportunity to escape as the ~~their~~ crossed the Darkstars.

"Enough," said Vedavardy. "The Bloodshed has begun. Where is your man, with the spear? We need to perform the dedication."

Handwritten right notebook page:

short story

"Time is fluid here," said the Demon.

He knew it was a demon. There was nothing else it could have been, just as he knew this place was Hell: there was nowhere else it could have been. The walls were grey, the ceiling low, insubstantial. A narrow bunk... floor...

"Come close," said the Demon. And he did.

The Demon was thin. It was scarred, and seemed to have been flayed, at some point in the past — now the skin had grown back, in patches. Its lips were thin and ascetic, and its eyes were a demon's eyes. ~~The~~ Eyes that had seen

decades of magazines at the *Penthouse* office, two decades of girls who never aged. It was written at the age of twenty-five, "back when I thought thirty was old," he says.

"Short stories are fun, because you can see the end of them when you begin. Normally, for me, a short story is actually in the tone of voice. If you have an idea, and you have a voice for that idea, whether it's a narrative voice or a character's voice, you pretty much have a short story" (Baker, 2007).

After Gaiman has written a short story (which usually only happens because someone's asked him for something to put in an anthology), it goes out into the world. Sometimes it stays as text, gets reprinted in later collections, gets read aloud, breaks a heart, or maybe it mends one. Occasionally it turns into other things. ❖

Handwritten center notebook:

How to talk to Girls at Parties

"Come on," said Kev. "It'll be great."

"No it won't," I said, although I'd lost this fight and I knew it.

"It'll be great," said Kev, for the hundredth time. "Girls! Girls! Girls!" He grinned with white teeth. We went to an all-boys school in South London. ~~We had no experience~~ While it would be a lie to say we had no experience with girls — Kev seemed to have had many girlfriends, while I had kissed several of my sister's friends — it would be perfectly true to say that we both spoke to, interacted with, understood, boys.

We were walking through the back streets that turned about East Croydon Station in those days. A friend ~~of a friend~~ had told Kev about a party, and Kev was going, whether I liked it or not. Seeing my parents were away that week,

the truth is a cave in the black mountains

*"There is one way there, and one way only.
And that way is treacherous and hard."*

THIS IS ONE SHORT STORY THAT STARTED WITH SOMETHING SMALL AND WENT SOMEWHERE MUCH BIGGER. IT'S ABOUT A SCOTTISH DWARF IN A TINY KILT GOING IN SEARCH OF A CAVE FULL OF GOLD, ACCOMPANIED BY A REAVER CALLED CALUM MCINNES

It's a story that melds Jacobean history with a sixteenth-century legend about the Isle of Skye and something that was supposed to have happened with the Border Reavers 300 years ago—or to steal a line from *Good Omens*, it's a story about "the Scots, locked in eternal combat with their mortal enemies, the Scots." It's full of murder and revenge, secrets and ghosts. It was originally written for an anthology Gaiman edited with Al Sarrantonio called *Stories*, but then the Sydney Opera House phoned.

They asked Neil if he'd like to do something for the Graphic Festival, a celebration of visual art, comics, and other forms—something that intersected words and pictures and music; something that could be a unique event on stage at the Sydney Opera House. He said he had a story that he'd just finished and that had never been published or seen anywhere before, set in a slightly skewed version of Scotland a few hundred years ago. "It was the perfect length and it would give them something to work with, and I thought that Eddie would be the perfect artist for that and he's in Australia. It just felt right, the Scottishness and the Australianess meant that I'd be getting something right" (Huff, 2011).

Eddie Campbell is a Glaswegian artist who moved to Australia in the mid-eighties. Back in Gaiman's journalist days, he championed Campbell's autobiographical comics alongside *Watchmen* and *Love & Rockets*. Campbell had since contributed to the *Sandman Gallery*, illustrated a Gaiman-penned issue of *The Spirit: The New Adventures* (in the style of Will Eisner), and a three-page prologue to a *Green Lantern* story, but he

OPPOSITE:
Truth paintings.

and Gaiman had never collaborated on something that was entirely new, something that was purely their own. "The Truth" would put a Scotsman back into a cold and craggy place with a palette of purple, black, and green. And despite Gaiman murdering a dozen Campbells in the story, Eddie signed up to do it. He painted thirty-five illustrations to be projected behind Gaiman as he read, pictures of huge black mountains with veins of white water cutting through the shadows, rocks and jagged islands jutting from gray sea like the bones of the earth.

As for the music, that was festival cocurator Jordan Verzar's idea. He sent Gaiman some FourPlay music—"an electric string quartet famous in Australia for being not only avant-garde but also a rock group, capable of going from classical to *The Simpsons* theme to torch songs"—and Gaiman says they had him at the *Doctor Who* theme. "I was just listening and going: This. Is. Brilliant. And going through everything else, and then I went onto iTunes

and just bought everything by them and started listening to them obsessively going: this is just perfect," he said in a Graphic Festival interview.

"So I sent the story to FourPlay, they sent music back to me, I sent them notes on what they'd done with some suggestions rather nervously, and then we had a day to rehearse the day before the show. Which was basically me reading with them playing at the same time and at the end of that, that was when we made the big notes. 'The way you're doing the end is too upbeat, it needs to be more haunting until the end and then move back into the moving theme and then you need to punch up the Lara singing to happen here and here and here to link in the theme and memory . . .' It was that kind of thing. And they would go off into these huddles. FourPlay squabble and huddle better than anybody. It's amazing. Lara is bossy and they all have their roles, like the Fantastic Four. I'm not even going further into that because I know people will start saying,

TO NEIL GAIMEN
WITH WARM REGARDS AND APPRECIATION
APPRECIATION FOR YOUR PARTICIPATION
IN THE NEW SPIRIT SELLER

WILL EISNER
FLORIDA 1998

'Are you saying that Tim or Peter is Mr. Fantastic?' and I'm not going to get into that" (Huff, 2011).

In the lead-up to the event, Gaiman was terrified. He had no idea if it was going to work, but that was also part of the fun. "I like the fact that it is unique. It's not like anything I've ever done before. You can't really point to a great tradition of authors telling stories while string quartets improv music over it to giant paintings being projected behind it" (Huff, 2011). It was such an oddity that explaining to people what it was became something of a difficulty (for Gaiman and anyone), and the closest anyone got was saying it was a bit like making a movie in your own head. You are given audio, visual, and story, and you combine the elements yourself.

The Truth Is a Cave in the Black Mountains was performed, words, art, music, and all, in August 2010. It sold out the Sydney Opera House concert stage, got a standing ovation when it was done, and it got Gaiman an open invitation to return. The curators of MONA FOMA, Tasmania's

> " I like the fact that
> it is unique. It's not
> like anything I've evr
> done before. "

music and arts festival, were there that night and asked if they would do it again. It was performed for the second time in January 2011, to three thousand people, with fifteen more Campbell paintings than the first.

The whole weird experiment was such a huge and unexpected success that Gaiman and the band went into the recording studio and did a live eighty-minute take, a clean recording rather than a fuzzy one from the night. "There are places where I start reading and I almost feel like I'm the fifth instrument. A lot of the time I'm there and I'm telling the story, but there are a few places where they'll be playing and I'm reading and because I know where the beats are I can hit the beats with the sentence and it combines and becomes something great" (Huff, 2011).

No one's heard it yet, but ultimately the story will be available in three formats: one, as a graphic novel put together by Campbell, an eighty-page color book with even more illustrations than Tasmania got; two, the book with a recording of Gaiman's voice and FourPlay's music; and the third, an experimental enhanced ebook that will give ebooks further reason for existing and doubters a reason for envy. ❖

—when I was a boy I read The Spirit and it made me want to write comics.

As an adult Eisner's work on the Spirit makes me chuckle why I wanted to write stories in the first place.

The joy of The Spirit—once it had become what it was going to be, once Eisner came back from the war, was not only in the blend of words and pictures but in the smoothness of the storytelling—and in the build of short stories sorts of O. Henry

Excuse the sentimentality for the structure.

making small movies—or Broadway Theatre—although they divid me most of radio...

ABOVE: Neil writes about Will Eisner.

OPPOSITE: Will Eisner drawing for Neil thanking him for taking part in the new *Spirit* series, 1998. Gaiman's story for the series, "The Return of Mink Stole," published in *The Spirit: The New Adventures* #2, April 1998, was drawn by Eddie Campbell.

poetry

OPPOSITE LEFT AND BELOW LEFT: "The Day the Saucers Came," as written.

OPPOSITE RIGHT: "The Day the Saucers Came," Christmas print with art by Jouni Koponen.

POETRY SHOULD, TECHNICALLY, IF we were organizing a Life chronologically, go at the very beginning of this book—before journalism, before comics, before everything—because poems were the first things that Gaiman wrote.

His mother transcribed his first composition at the age of almost three, and everything grew from there. But poems, along with short stories, make a Gaiman reading special. People scream like they do at rock shows at a Gaiman reading, even for poems.

I remember when I was a little bit older, probably eight going on nine, I'd lie down on my bed and just write poems that were big poems about dragons, and knights coming and killing them with swords. They were very ripped off from, or heavily influenced by, Tolkien and C. S. Lewis who were my favorite things in the world at that age, so you know, poems about young dragons landing and taking over things and then being old dragons, and kings coming by and killing them and stuff.

It was definitely poems first, but they were poems that were story poems. I will probably wind up at some point with a book of poems actually getting published, and I know I'm not a real poet because I want everything to be a story. I definitely envy real poets. I think the genius of poets is that they can encapsulate a moment or a mood or an emotion and just make it flash for you and give it to you in a way you've never felt it before, and my urge is to make everything into a story. I want beginnings, I want middles, I want ends. For me the perfect poem is something like "The Day the Saucers Came," where stuff happens. Or even "Instructions." Stuff happens. ❖

BELOW: "The White Road."

Be bold, be bold, but not too bold...

"I have no story," I said.
"save that I wish you would visit
my house one day. There are
such sights I would show you."
She lowers her eyes modestly
and shivers,
While her friends and foster host
and cheer.
"That's no story, Mister Fox," says
a pale woman, in the corner, her
hair was fair, her eyes the green
of beryl.

The White Road

Be bold, be bold, but not too bold
or else your life's blood shall run cold.

"Will you tell me your dreams?" he said.
She feels the cold hand in her breast,
shrunken, a dead thing.
"I dreamed I saw

① That day the saucers landed. Hundreds of them, golden,
Silent, coming down from the sky like great snowflakes,
And the people of Earth stood and stared as they descended,
Waiting, dry-mouthed to find what waited inside for us.
And none of us knowing if we would be here tomorrow
But you did not notice it because,

That day, the day the saucers came, by some coincidence,
Was the day that the graves gave up their dead
And the zombies pushed up through soft earth
or erupted, shambling, and dull-eyed, unstoppable
came towards us, the living, and we screamed and ran,
But you did not notice this because,

On the saucer day, which was the zombie day, it was
Ragnarok also, and the television screens showed us
A ship built of dead-man's nails, ~~the~~ a serpent, a wolf,
All bigger than the mind could hold, and the cameraman could
Not get far enough away, and the the gods came out
But you did not see them coming because

On the saucer-zombie-battling gods day the floodgates broke
and each of us was engulfed by genies and sprites,
Offering us wishes and wonders and eternities,
And charm and cleverness and true brave hearts and pots of gold
~~which the And~~
While giants feefofummed across the land, and killer bees,

But you had no idea of any of this because

② That day, the saucer day the zombie day,
the Ragnarok and fairies day, the day the great winds came
and snows, and the cities turned to crystal, the day
all plants died, plastics dissolved, the day the
computers turned, the screens telling us we would obey, the day
that cars rose up, the children went away, the day that
Angels, drunk and maddened, stumbled from the bars,
And all the bells of London were sounded, the day
Animals spoke to us in Assyrian, the Yeti day,
the fluttering capes and arrival of the time machine day,
You didn't notice any of this because
you were sitting in your room, not doing anything,
not even reading, not really, just
looking at your telephone,
wondering if I was going to call.

Neil Gaiman
The Day the Saucers Came
illustrations by Jouni Koponen

That day, the saucers landed. Hundreds of them, golden,
Silent, coming down from the sky like great snowflakes,
And the people of Earth stood and stared as they descended,
Waiting, dry-mouthed, to find what waited inside for us
And none of us knowing if we would be here tomorrow

But you didn't notice it because

That day, the day the saucers came, by some coincidence,
Was the day that the graves gave up their dead
And the zombies pushed up through soft earth
or erupted, shambling and dull-eyed, unstoppable,
Came towards us, the living, and we screamed and ran,

But you did not notice this because

On the saucer day, which was the zombie day, it was
Ragnarok also, and the television screens showed us
A ship built of dead-men's nails, a serpent, a wolf,
All bigger than the mind could hold, and the cameraman could
Not get far enough away, and then the Gods came out

But you did not see them coming because

On the saucer-zombie-battling-gods day the floodgates broke
And each of us was engulfed by genies and sprites
Offering us wishes and wonders and eternities

And charm and cleverness and true brave hearts and pots of gold
While giants feefofummed across the land, and killer bees,

But you had no idea of any of this because

That day, the Saucer day the zombie day
The Ragnarok and fairies day, the day the great winds came
And snows, and cities turned to crystal, the day
All plants died, plastics dissolved, the day the
Computers turned, the screens telling us we would obey, the day

Angels, drunk and muddled, stumbled from the bars,
And all the bells of London were sounded, the day
Animals spoke to us in Assyrian, the Yeti day,
The fluttering capes and arrival of the Time Machine day,

You didn't notice any of this because

you were sitting in your room, not doing anything,
not even reading, not really, just
looking at your telephone,

wondering if I was going to call.

She's lived in heating pipes and vents

and run with dogs, and battled wolves.

Melinda powers up the old machine

that, stranded on its back, blocks off the stairs

a little robot and a big bad wolf,

And they'll have guns, and hand—grenades,

they'll do exactly as she says.

THIS SPREAD:
"Melinda," which started out as a Christmas print illustrated by Polish artist Dagmara Matuszak and got out of hand. It was turned into a limited edition book by Hill House in 2004.

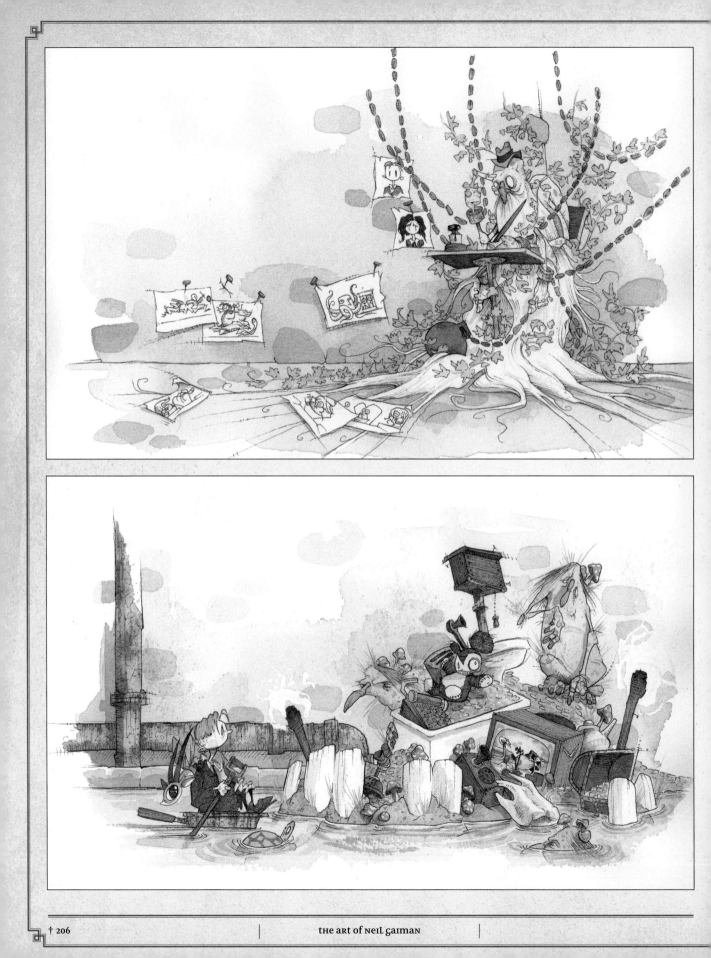

THE ART OF NEIL GAIMAN

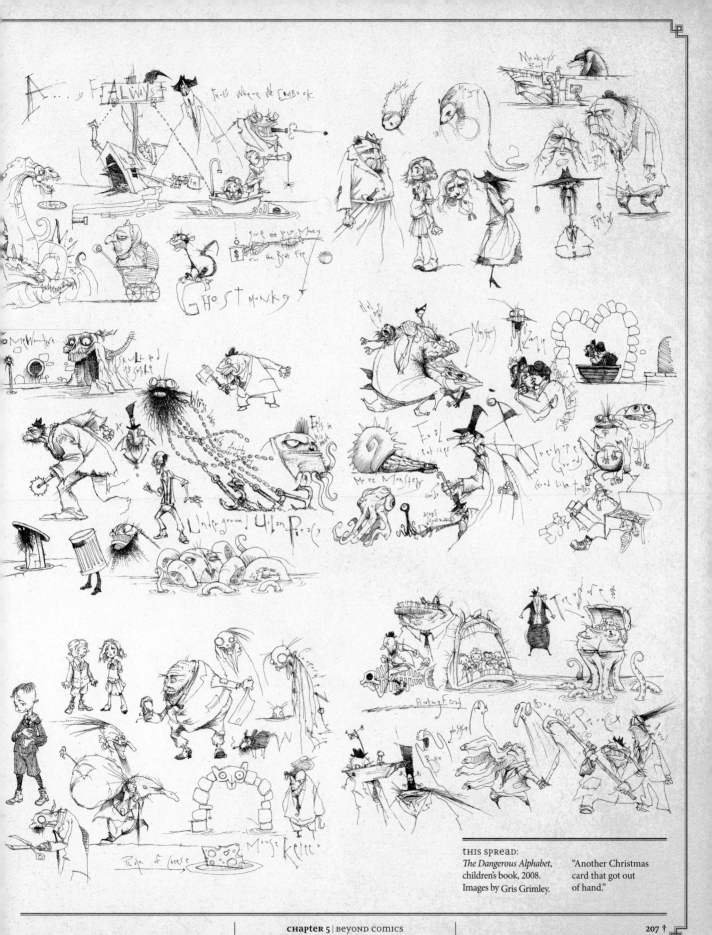

THIS SPREAD:
The Dangerous Alphabet, children's book, 2008. Images by Gris Grimley.

"Another Christmas card that got out of hand."

36/48

ABOVE: "A Writer's Prayer," Christmas print.

BELOW RIGHT: Limited edition scroll sent by Neil to friends and family.

BELOW: "The Song of the Lost," a poem for the 9/11 *Heroes* anthology.

A WRITER'S PRAYER

Oh Lord,
let me not be one of those who writes too much.
Who spreads himself too thinly with his words
diluting all the things he has to say
like butter spread too thinly over toast,
or watered milk in some worn-out hotel.
But let me write the things I have to say
and then be silent, till I need to speak.

Oh Lord,
let me not be one of those who writes too little.
A decade man between each tale. Or more.
Where every word accrues significance
and dread replaces joy upon the page.
Perfection is like chasing the horizon.
You kept perfection, gave the rest to us.
So let me earn the wisdom to move on.

But over and above those two mad spectres of
parsimony and profligacy,
Lord,
let me be brave. And let me, while I craft my tales, be wise.
Let me say true things in a voice that's true,
and, with the truth in mind, let me write lies.

Neil Gaiman April 24, 1999

102/150

Wood engravings & type hand printed by George A. Walker
for Neil Gaiman
limited to 150 copies

moving from Venice to Venice —
from a here-and-now tourist
town to a strange parallel world
with the same map, in which
the council of ten still rules from
behind the scenes, and all is
secretive and underhand...
In the Venetian Empire, we
would have got off-planet
a hundred years ago — they
could have wanted someone to
trade with, and wanted more,
to trade — the power of discovery,
of moving on.
Perhaps the start of the change
could have been the Venetians
backing Columbus et al — a
world in which Venice
allowed the S. Americans —
Kept as trading partners.
Weird combination of high and
low tech... Venice still going
as a trading place. Forbidden lig,
motorized boats.
Moving back and forth between
Venices.

information
nation

The Song of the Lost. 3

I'll take the touch of his lips,
she said,
I'll take the scent of his hair.
But all she had was a
photograph,
of an unsuspecting stare,
and she pins it up
on the lamposts.
She tells you, that he's out, lost,
And this is the price of
distraction; this is the
hell of the cost.

They will not give up hope,
or help,
Though the night is dark, fog and store and
And she hopes he's in a,
hospital,
confused, asleep, alive,
And she asks you if you've seen
him —
He was up on the hundredth floor

singes.

Footsteps in the dust. A scraping and scratching candle in the middle of the cellar flickers, d flames. The candle sits on the floor, in ndle holder thickly covered by the misshapen its predecessors.
~~dead candles~~. Strange shadows dance across walls.

The person who lit the candle stands in the quietly. Waiting. Two tiny reflected flames stare ~~mmmm~~ ~~be seen~~ candle e all that can be seen of the face or the iting.

~~Something on~~ In a far corner droplets oozing from decaying stonework mark the pa Drip, drip. The never cutting things creep sic across the light, some avoiding the light, stayi shadows

In the flicker of a candle flame a shadow starts. Remains. Where there was one ~~p~~ ~~are you~~

"You have need of ~~our services~~?" The voice ~~is~~ s

"I do." ~~the right signal~~ A faint rustling; the ttering light catches a sheet of parchme led from a cloak, unfolded, passed from atch of darkness to the next. "This's oy." The voice is as dry as the rustle of parchment.

"You are sure he has the Stone?"

"That is my worry. Just bring the boy. You wi well rewarded."

A pause. A large lizard, braver than the ventures into the small circle of light th candle, and looks around.

Neverwhere

"It's all Lenny's fault."

THE TOTALLY STONKING, SURPRISINGLY EDUCATIONAL, **AND UTTERLY MINDBOGGLING COMIC RELIEF COMIC** IS PARTLY TO BLAME FOR *NEVERWHERE*, BECAUSE IT WAS ON THIS THAT GAIMAN MET THE ENGLISH COMEDIAN LENNY HENRY (WHO IS ALSO PARTLY TO BLAME FOR *ANANSI BOYS*).

ABOVE: *AARGH!*, 1988. Cover by Dave McKean.

OPPOSITE: Gaiman's short story in *ARRGH!*, "From Homogenous to Honey," was illustrated by *The Adventures of Luther Arkwright* creator and future *Sandman* artist Bryan Talbot.

Henry, together with comedy scriptwriter Richard Curtis, founded Comic Relief in 1985 as a way of getting money to starving people in Ethiopia. Usually the purse strings of the British masses were coaxed open with a celebrity-led telethon on Red Nose Day (on which said masses sport plastic red noses) but in 1990 Gaiman had an idea to do a charity comic for it. Two years before this, Gaiman had contributed to Alan Moore's *AARGH!* anthology—Artists Against Rampant Government Homophobia—to fight a new amendment to the Local Authorities Act, which stipulated that local authorities weren't allowed to promote or encourage homosexuality. The book raised over £20,000, so comics had already proven themselves as a viable way of fundraising. Gaiman took the idea to Richard Curtis. "Dave McKean and I went to see him, Lenny was waiting there, we went out for a pizza, and we've been friends ever since."

In the early 1990s, Gaiman was a judge for the Arthur C. Clarke awards and bumped into Henry during an awards meeting in London's Groucho Club. "He came over afterwards and he said, 'The BBC were just talking to me. Would you be interested in writing a fantasy TV show?' And I said sure. And he said, 'Well, the only idea I've got is something about tribes of homeless people in London. Can you do anything with that?'"

Gaiman thought about it and decided he didn't want to do anything that might make it appear cool to be homeless in London.

So I said, Let me make it a metaphor. If I create London Below, if I create a place that doesn't exist and put tribes of people there, then I'm not going to have anybody running away to find London Below. That's not going to work. So that was what I came back with. And I wrote an outline for Neverwhere, *and the great thing was that the outline was just like the opening. I had no idea where it went; I just knew how it began. And I took Croup and Vandemar, who were characters who'd been living in*

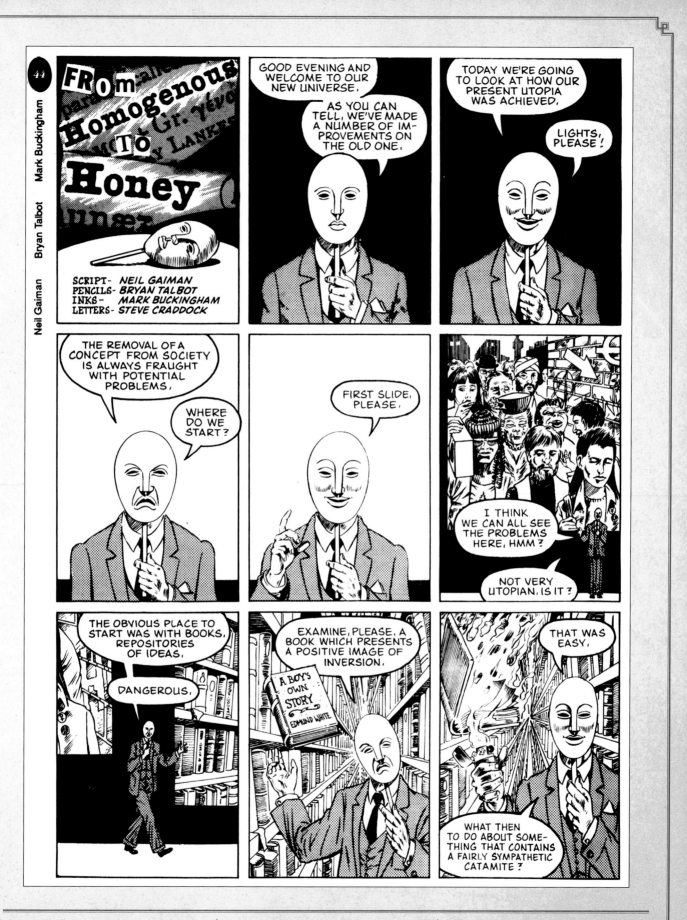

How the Marquis Got his Coat Back.

It was the reason the Marquis de Carabas was chained to a pole in the middle of a circular room far, far underground, and it had over thirty pockets, seven of which were obvious, nineteen of which were hidden, and four of which were more or less impossible to find, even, on occasion, for the Marquis himself. (He had been given — although given might be considered a slight, if justifiable exaggeration — a magnifying glass, by Victoria herself. It was a marvelous piece of work, ornate, gilt with a chain, and tiny cherubs and gargoyles, and ~~it had~~ the lens had the unusual property of rendering transparent

my head since I was about seventeen, and pulled them out, and Richard Mayhew, who I named after Henry Mayhew, author of London Labour and the London Poor. *It seemed very appropriate* (Author's interview).

And I went away and wrote a script, and after a while the BBC commissioned more scripts, and eventually I wrote the whole story. The fun thing with the BBC is that you're not doing a series that will run forever; the idea is you'll do something with a beginning, a middle, and an end. So I wrote it, the BBC started to film it, and really, on the day of filming, I decided it was time to start writing the novel, mainly because I really wanted the power of "because I say so." Which is something that a writer suddenly loses as soon as somebody starts making a TV series, as soon as things start getting filmed. There are a hundred different people making decisions. You're like a general back at base, who's suggested a way of doing something, but there are an awful lot of soldiers in the field, and they all have their own ideas, they all have their own input (Roel, 2007).

The series consisted of six thirty-minute episodes and starred Gary Bakewell as Richard, *Breaking Bad*'s Laura Fraser as Door, *Doctor Who*'s Paterson Joseph as the Marquis, and future Doctor Who Peter Capaldi as the Angel Islington.

It was not very good.

"I remember describing *Neverwhere* the TV show as feeling like I'd written *Sandman* and had Rob Liefeld draw it. And he'd given him a baseball cap."

When asked to pinpoint what was not right about the television series, Gaiman puts his hands over his face, peeps his eyes over the top, and mumbles something about being very embarrassed about a cow.

"There's a thing in *Neverwhere* called The Great Beast of London, and that's based on a real urban legend in London from the seventeenth century about a piglet who ran away in Fleet Street, got

"HOW THE MARQUIS GOT HIS COAT BACK"

IN 2002 GAIMAN BEGAN to solve a mystery for *Neverwhere* fans. "I started writing the new *Neverwhere* novella, 'How the Marquis Got His Coat Back,' in a blank book for writing in that some nice person gave me at some point. It was not a happy experience, as the book turned out to be chichi enough to have little bits of flower petal in the paper, which might be okay if you're writing down your dreams in a thick felt pen, but which combine with a scritchy fountain pen to render the whole thing more or less illegible from the off. Which is rather irritating. I may see if I can find a thicker-nibbed fountain pen and darker ink. Meanwhile, I have learned all about how many pockets the marquis has in his coat, and about the things that got lost in them . . ." A decade later Gaiman finished the story, for publication in the 2014 anthology *Rogues*.

the totally stonking, surprisingly educational, and utterly mindbogging comic relief comic.

Gaiman, Richard Curtis, Peter Hogan, and Grant Morrison edited and held the thing together, and the book featured the work of a host of British comics creators: Jamie Delano, Garth Ennis, Dave Gibbons, Mark Millar, Simon Bisley, Mark Buckingham, Steve Dillon, D'Israeli, Jamie Hewlett, Bryan Talbot, and one uncredited Alan Moore who had refused to work for the publisher Fleetway but secretly helped out on then-girlfriend (now-wife) Melinda Gebbie's pages. Gaiman wrote two pages of "Teenage Mutant Ninja Turtles" to impress his six-year-old-son, Mike, it was published in March 1991, sold out in minutes, and raised over £40,000. "The reason it never went back to press is because DC gave permission to use their characters, but only if they were traced from the Standard Poses that they had, and we couldn't figure out how to do that without looking silly, so we drew the characters in action, figuring DC would realize that we had saved them from embarrassment, but they didn't see it that way."

into the Fleet Ditch—which is what the Fleet River had become—disappeared into the sewers, and grew eating the gubbins, and the excreta and the dead cats and things, whatever he could find in the sewers of London back then, and it grew huge, and they would send in hunting parties after this enormous boar that prowled the sewers under London. I loved this idea; it kind of antedated the whole alligators in the sewers bit, and it seemed like a fun and interesting idea and something that will be nice to play with. So I wrote this thing in, the Great Beast. And after a while, I go off to Australia for a week to be guest of honor at the Australian National Science Fiction Convention, and I come back and they show me the rushes for the first of the Great Beast sequences. And here am I, I've described this pig the size of an elephant, this boar with enormous tusks, with old spears and swords sticking out from the side of it like Moby Dick, and you can imagine my surprise when a large, hairy, and rather amiable-looking highland cow shuffles around through the sewer" (Roel, 1997).

The production team had not been

> *"I remember describing Neverwhere the TV show as feeling like I'd written Sandman and had Rob Liefeld draw it."*

remotely frightened by the boars available, but were very impressed with this cow: a placid thing who stands there in the middle of the shot being nothing but a very happy-looking, contented cow.

The idea was that we'd photograph a wild boar in a way that made it look huge. I'd only agreed to the cow on the grounds that they had a giant facial prosthetic so it wasn't going to look like a cow, and then they had weapons sticking out of its side and

stuff. And I look at the rushes and I say: but what about all that stuff about making up the cow? Giving the cow a prosthetic face so at least it didn't look like a cow? And they said, "Well, it may not look scary now, but when you're standing next to it, it did, and the props department said it wasn't their job, and the make-up department said it certainly wasn't their job, it was props' job, and nobody could agree." So it's just a cow.

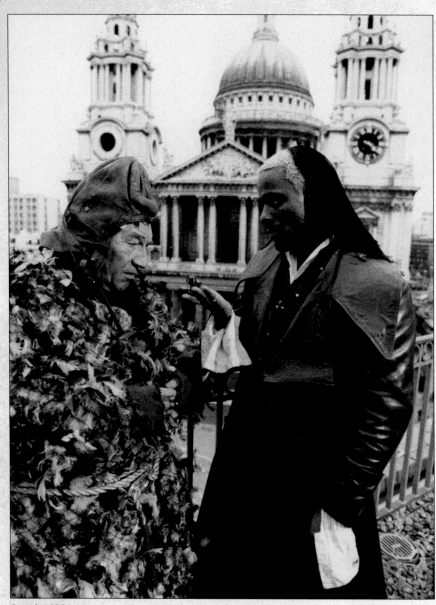

Copyright © BBC

That made me so sad. Because I felt like it was a really good script, and they hadn't made a really good TV show of it. I hadn't wanted to write a novel of Neverwhere. *What I'd been looking forward to was making a terrific TV show and then bringing out a script book with photographs. That was my plan. And then I saw what they were doing with the TV show and suddenly it was like: no, I'm writing the novel.*

Gaiman's first (published) novel *Good Omens* was a collaboration, and while his is the only name on the cover of *Neverwhere*, he still doesn't regard it as his first solo novel. "Even *Neverwhere* felt like a collaboration with the guy who did the scripts. I wasn't doing this thing of starting with a blank piece of paper and putting words down until there was a novel. What I was doing was taking a bunch of drafts of a TV show and finding all the bits I liked and putting them in, fueled with a certain amount of resentment and grumpiness at all of the places where things that I'd asked and things that I'd wanted had been ignored, thrown away, skipped, cut, or whatever. Just frustration because it was stuff that I knew worked." He had complete and total control and a budget far beyond that of the BBC's. The only constraint in a novel is imagination.

What he ended up with was a book infinitely better than the TV series. It's the same story, but it has an entirely different feel to its original version. London itself has the starring role, and Gaiman takes the gray, regular London and makes it magic. Knightsbridge becomes the terrifying Night's Bridge over which not all crossers arrive at the other side, the Blackfriars are real friars, and rumors of abandoned stations are all true and they are still in use in London Below.

"Creating a sort of mythic London was in many ways much easier writing it in places like a hotel room in Galveston, Texas, or sitting around at home in Minneapolis. One could isolate why one wanted to make it mythic, what one was going for. And I love it when people come up to me at signings and say, 'I just got back from London. Before I went, I read *Neverwhere*, and we stayed in Earl's Court and we got to go to Knightsbridge,' and it's as if these places are actually taking on a mythic dimension for them" (*Locus Online*, 1999). ❖

Prologue: Somewhere in the Unreal World.

The cellar was dark and dank and echoed of dust.
The walls oozed slime from time to time: small things
settled in cracks and corners.

A key turns in a lock. Slowly at first, as if the lock
is rusted from disuse, then with a *thunk!* that sends the
little restless back to their holes and webs & patches of
damp. The door opens, and closes again. It has squeaky
hinges.

Footsteps in the dust. A scraping and scratching, then
a candle in the middle of the cellar flickers, gutters
and flames. The candle sits on the floor, in a tin
candle holder thickly covered by the misshapen wax remnants
of it's predecessors. Strange shadows dance across the
walls.

The person who lit the candle stands in the shadows.
Quietly. Waiting. Two tiny reflected flames stare at the
candle; they
are all that can be seen of the face or the figure.
Waiting.

In a far corner droplets of water,
oozing from decaying stonework, mark the passage of time.
(Drip, drip.) The braver scuttling things creep sideways
across the walls, slowly, avoiding the light, staying in the
shadows.

In the flicker of a candle flame a shadow deepens,
distorts. Remains. Where there was one person there are now three

"You have need of our services?" The voice is smooth, oily.
"I do." A gaunt rustling; the
guttering light catches a sheet of parchment
pulled from a cloak, unfolded, passed from one
patch of darkness to the next. "This is the
boy." The voice is as dry as the rustle of parchment.
"You are sure he has the Box?"
"That is my worry. Just bring the boy. You will both
be well rewarded."
A pause. A large lizard, braver than the others
ventures into the small circle of light thrown by
the candle, and looks around.
"I am sure that we will be. Well Rewarded."
"How will you get the boy?"
The lizard darted from one side of

Stardust
BEING A ROMANCE WITHIN THE REALM OF FAERIE

"It's a little epic. I don't know what you call epics that aren't enormous."

STARDUST SPRANG ALL UPSIDE DOWN FROM WALL. IN SEPTEMBER 1987, GAIMAN HAD JUST SIGNED THE CONTRACT FOR *BLACK ORCHID* AND THE AMERICAN *DON'T PANIC* AND COULD AFFORD TO DO SOMETHING THAT HAD NOT BEEN EVEN REMOTELY POSSIBLE IN HIS ENTIRE CAREER AS A JOBBING JOURNALIST: HE COULD AFFORD TO GO ON VACATION.

So my wife Mary and I flew to Ireland, rented a car, and drove around Ireland from landing in Dublin, going down south, around Cork, and down around Bantry. I remember we loved Bantry Bay.

It was on that drive that I remember looking across a field and there was a wall halfway across the field that had a hole in it. Or a gate. I think it was a gate in the middle. And I just thought: Wouldn't it be interesting if the other side of that wall was fairyland. And it was as simple as that. You've got a wall, and you cross it, and now you're in Faerie. And the idea just grew. On the flight over there had been an inflight magazine with a photograph of a little town, and I think it may have been a town in Portugal or in France or Spain or somewhere that was just basically on an outcrop of rock. And I thought I'll borrow that town and I'll put it somewhere in the north of England. And I'll call it Wall. I came up with a story all about this town, and I wrote the first chapter and the introductory pages about Wall as well.

Then he put it away. He had *Sandman* to write.

Time passed and it was now 1991. *The Sandman: Dream Country* was finished, and Kelley Jones was busy drawing *Sandman* in Hell with Lucifer, who's kicking out the last of the demons before he shuts the gate.

THIS SPREAD: Notes for *Stardust*, and artwork for the 2007 DC/Vertigo notecard set.

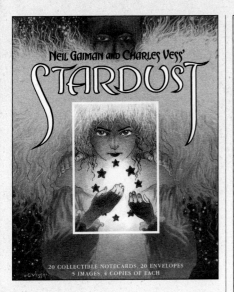

NEIL GAIMAN AND CHARLES VESS'
STARDUST

20 COLLECTIBLE NOTECARDS, 20 ENVELOPES
5 IMAGES, 4 COPIES OF EACH

Sandman is huge.

Gaiman and Charles Vess are in Tucson, Arizona, for the World Fantasy Convention. Their *Sandman* issue, "Midsummer Night's Dream," is nominated for Best Short Story alongside prose stories and wins. "We actually astonished ourselves and everybody else by winning the award" (Murray, 2006). Gaiman and Vess take their statues—busts of H. P. Lovecraft—and try not to lose them or leave them in the bathroom during their various states of inebriation.

That night there's a party being held by Terri Windling. Charles stays back, but I'm at this party. And I'm outside talking to some friends of mine, I'm talking to Teresa Nielsen Hayden and Jane Yolen, and I think Ellen Kushner was there. And I've gone outside probably to have a cigarette, because I smoked then. And I'm wearing a big leather jacket I'm incredibly grateful for because it is so hot during the day but it's so cold, desert cold, at night. And we're out in this little house in the middle of the desert.

And I look up and I see a falling star. And it's like nothing I've ever seen before. In the UK, if you see a meteorite, it's a little pencil line of light across the sky just slashed across the sky with a white pencil. This wasn't that. This was a discrete glinting, burning, shining white thing falling

out of the sky in a slow arc, in the desert where the night sky was velvet black. And I saw it and I thought: Wow, that was such a cool thing to see. Wouldn't it be interesting if I could just go . . . I saw where that thing fell, I could get in a car, I could start walking and I'd go and find it. And then I thought—and it was so bright, it was like a diamond—what if I find it and instead of being just a lump of meteoric rock, it's a huge diamond burning bright. And then I thought: What if it was a girl? And what if somebody had promised his girlfriend, was trying to impress a girl by saying I will bring you back that

Poems for Wall.

Song of the little hairy man.

There's some that goes a wandering
From Zanzibar to Dover
But me, if you were pondering
I'll do much dirges maundering
FOR It's "Sir, how much for yo— ?
I'll walk the wide world over.

And when the night is thundering
I shall not fear the thunder
Nor fear the mammoth's blundering
The bandit and his plundering
For "How much, I was wondering?"
I'll walk the wide world under

be kind of fun for people, going: *Oh my gosh! There are the Hempstocks, and there is the pub, I know what these things are! It'll be fun.*

Books of Magic, Vess and Gaiman's other collaboration, had featured a marketplace in Faerie with a gate between worlds that was very much like the one he had in mind for Wall. Faerie is a world inside Vess's head. There was no one better to draw it.

"I went back to the hotel, found Charlie who was at a different party, hauled him out of the party—holding a bottle of celebratory champagne. I said, 'Okay, let me tell you this story. I think I've come up with something.' I told him everything that was in my head about the story and then at the end he smiled and said, 'I can't wait to draw it'" (Murray, 2006).

Vess, whose beautifully delicate, ethereal style is influenced by the great English book illustrator Arthur Rackham, asked that instead of doing it as a comic, they do it as an illustrated book. "He said: the thing that pisses me off about comics is once I've done a panel, I then have to draw the next panel. Illustrations are at least *things*. And I said sure. So that was what we did."

Gaiman began writing in 1994 while staying at Tori Amos's house in London. *Stardust* came out in four parts through Vertigo in 1997 and 1998 complete with 175 paintings. "A lot of the story was actually pushed into existence by me going, 'Wouldn't it be fun to see Charles drawing so-and-so?' And occasionally he'd draw something and I'd go, 'That's good. I'm going to bring that back'" (Movies. about.com, 2006). A year later—Gaiman's agent, Merrilee Heifetz, having negotiated a deal whereby Neil retained text-only rights—it was published as a novel without the pictures, too. It's a short one—about sixty thousand words. Gaiman says it probably has something to do with how he wrote it: in longhand, using the first fountain pen he had picked up since his schooldays, in big, leather-bound blank volumes.

"*Stardust* has one brief moment of almost Tarantino-esque violence, a couple of gentle sex scenes, and the word 'fuck' printed very, very small once. But apart from that,

fallen star, and winds up with a girl with a broken leg who doesn't want to be dragged anywhere or presented to anybody? And what if I did that weird *39 Steps* thing where they get bound together? That's a story. I like that. And it really was that quick.

And I thought: Wall. I've got that place already, the idea of this little town built up against the wall. What I'll do is I'll set it in Wall and I'll do it as a prequel, so when I come to write Wall, it'll be 170 years later and it'll

it could have been written in 1920. The magic of writing, those things we do to convince ourselves we're doing it the right way. Up until 1986, I wrote everything on a typewriter. From 1986, when I bought my first computer, I did everything on that, except maybe one short story hand-written. Then it came to *Stardust* and I thought, 'OK, I want to write this in 1920.' I went out and bought a fountain pen, which has a lovely sort of arc of closure to it, a feeling of completeness.

"I think it really changed the way I wrote it. You think about the sentence more before you write it. On a computer, it's almost like throwing down a blob of clay and then molding it a bit. But I can't do that with a fountain pen, so I think about it a little more" (*Locus Online*, 1999).

It was written in a voice instantly familiar: stilted and old-fashioned, it feels like something you already know; it feels like coming home. In a piece in *The Guardian* newspaper, Gaiman wrote about how fairy tales began as stories for adults, but with each retelling the bite was taken out; parents who read Grimm's collected tales to their children complained about the adult content, so the Grimms simply took it out. Gaiman wanted to read a fairy tale that was unapologetically for adults, but there weren't any on the shelves so he wrote one instead.

"I wanted to write a fairy story, with the weight and clean lines of a fairy story. I'd just done ten volumes of *Sandman*. Seventy-five issues, 2,000 pages, seven or eight years of my life. It's a story where everything is gray. All the characters are shades of gray. Nothing is wholly black and white, everyone has five different motives for everything they do; little things in one place turn out to be important things in another, and vice versa. And I just wanted to do something simple and elegant" (Howe, 1999).

It is a book with no social agenda, no underlying allegory—something light to make you feel happier, something akin to ice cream. It baffled journalists whose previous contact was with Gaiman's novel *Neverwhere*, which at least had something to say about the homeless. "There seemed to be a general consensus that it was the most inconsequential of my novels.

Fantasy fans, for example, wanted it to be an epic, which it took enormous pleasure in not being" (Gaiman, 2007).

The idea that you could read it the wrong way was a relatively new one. Before the 1940s, before J. R. R. Tolkien, fiction just came out as fiction. Gaiman's *Stardust* harked back to books like Lord Dunsany's *The King of Elfland's Daughter* published in 1924, in which a princess from Elfland is stolen and brought to England, and Hope Mirrlees's *Lud-in-the-Mist*, "a quintessentially English novel of transcendent oddness," which is one of Gaiman's top ten favorite books and set in a town on the borders of Fairyland. These were books about borders between our world and another, before epic fantasy trilogies and bookshelf ghettos.

BeLOW: A drawing of a pirate by Neil.

"I wanted to write a fairy story, with the weight and clean lines of a fairy story."

"*Stardust* was very consciously written, trying to put myself in a pre-Tolkienian mindset. Tolkien changed things. Before him, things weren't published, regarded, or reviewed as fantasy. They were reviewed in *The New York Times* by W. H. Auden. We live in a world where the idea of fantasy as being 'something else' is prevalent, where its success means it has to be replicated to keep it commercial. *Stardust* was intended to be a throwback to the time where a novelist would simply write a fairy tale, and nobody felt it was anything different, it wasn't an aberration, any more than they would look at Dickens and say, 'Ah, it's got a miser and three ghosts in it.'

"The existence of a special fantasy section in a bookshop, somehow different from the rest of the bookshop, is such an astonishingly recent development; it would have been unheard of in the past" (Wagner, 2008). ❖

— Pirate Bill —
Neil Gaiman

STARDUST: THE FILM

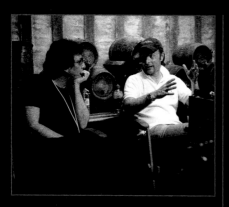

ABOVE: Neil in conference with Matthew Vaughn on set.

OPPOSITE: The flying pirate ship commanded by Robert De Niro's character, Captain Shakespeare, and the theatrical poster.

IN THE MID-2000S, one of the epithets that preceded Gaiman's name in any news story involving movies was "the most-optioned author in Hollywood who has yet to have any of his work translated to the big screen." The saying first appeared in the *Hollywood Reporter* in 2005, and it stuck. *Stardust,* one in a sea of options, was the first to make it out of production purgatory. Before anything went ahead, Gaiman thought about how involved he wanted to get. Much like comics, he looked at how Alan Moore had done it.

"Alan has been my friend for twenty-five years, and his philosophy has always been, they give you a check and it's nothing to do with you and now they can make a film. And the problem is, by the time they did the third film of his work that he wasn't happy with, he distanced himself completely. I think I could have gone that route. But I saw how miserable Alan was. It didn't work to say, 'Go make a film that has nothing to do with me.' Not when every review says, '*League of Extraordinary Gentlemen* is a really bad film made from a really good comic.' Why would you want that to happen? I don't want to live in a world where every review of *Stardust* says, 'This is a really bad film made from a really wonderful illustrated novel.' Because honestly, otherwise you become one of the Raymond Chandlers of the world, who say the only way to survive Hollywood is to shove your money in the trunk and drive off and don't look back. But money can't prevent you from being miserable" (Vineyard, 2007).

In short, Gaiman got involved because he wanted the film to be a good one. "What I really want to have happen is people go: oh, you did that? Oh god you did *Stardust*!

Stardust was so fantastic. I loved the film, it was one of the best two hours I ever spent in the cinema. But I thought the book was a bit better. Because that's really what you want."

At the end of the nineties the option for *Stardust* was at Miramax. When nothing happened before its expiration date, Gaiman was very relieved to have it back.

"I said no to people who wanted to make *Stardust* for four years. Miramax had it for a while, and they hadn't gotten it together. We had a lot of directors ask for it. We had a lot of beautiful young lady actresses who asked to buy the rights for it to be a vehicle for them. But I wasn't comfortable with *Stardust* being a vehicle for anyone. I wanted it to be about the story. So I was very lucky that Claudia Schiffer was both pregnant and had a broken foot—though she wouldn't say *she* was lucky—so she couldn't do much and was doing a lot of reading. And she read *Stardust*. And she said, 'This is just like fairytale stories I read as a kid, except for adults,' and she had [her husband] Matthew read it, and he said, 'I want to make it. I love fairytales, and I love this, and I want to do this'" (Vineyard, 2007).

Matthew Vaughn is an English producer who made his name on East End gangster movies like *Lock, Stock and Two Smoking Barrels*, *Snatch*, and soccer film *Mean Machine*, before debuting as director himself on another gangster flick, *Layer Cake.* At the time his wife suggested he read *Stardust*, he was slated to direct the third *X-Men* film. He bailed during preproduction because they wanted the film made in less time than Vaughn thought he could make a good one. He called Gaiman up, said he wanted to move ahead with *Stardust* instead, and Neil

said yes. "What I did with Matthew was this thing you must never do. Don't do this; it is very, very wrong: I gave him the option for nothing" (Vineyard, 2007).

"But I also trusted him. In Hollywood, lying is something that people do like breathing, but Matthew does what he says he will do and sticks to his word and that meant everything" (Carnevale).

They met up with Terry Gilliam to see if he would direct it, but having just come off *Brothers Grimm*, Gilliam "wasn't going to make another fairy tale for love or money" (Vineyard, 2007). Vaughn became director by default, and offered Neil the option of writing the script. He turned it down, arguing that his vision was in the novel and the film was going to be Vaughn's. But, in light of Moore's experiences, he signed on as producer. He was involved in casting and set locations, but the first thing and the biggest thing he did was put Vaughn in touch with someone who would keep the heart of the film in the right place: he found him a cowriter in Jane Goldman.

He started mentioning writers he was seeing and I thought, "Hang on, all of the writers he's talking to here are boys' writers and Matthew is a boys' director. If the balance here isn't right then it is going to be Lock, Stock and Two Smoking Fairies."

What happened then was I phoned Jonathan Ross. I was doing some work,

I had to finish something—copy editing Anansi Boys, *my last novel—and I went off to Jonathan and Jane's house in Florida. I phoned Jonathan to let him know that I was there safe, and asked what was happening with Jane's current novel. He said, "Oh, I think she really wants to do some screenplays." And suddenly a little electric light went on above my head. I said, "Has she ever read* Stardust?" *And he said, "I don't know. I'll ask her. Jane, have you ever read* Stardust?" *He said, "No, that's the only thing of yours she's not read." I said, "Tell her to read it by Monday.*

We'll talk then."

We talked a few days later and I said, "What to do you think?" She said, "It's brilliant. Why did you want me to read it?" I said, "Would you like to do the script?" She said yes and then I phoned up Matthew and said, "Go meet Jane. See if you like her." And that honestly was my big thing, going, "I think that she'll bring the humanity to it, that she'll get the romance," which I think Matthew on his own might have, self-admittedly, struggled with. That was a big part (Murray, 2006).

Later Gaiman flew to England, stayed with Matthew and Jane at Matthew's "absolutely terrifying" country estate, sat down and acted the entire script through. "At that point I had a fair amount of input in just saying, 'No, don't do that. Change that, lose that. I think what we're trying to do here is this.' At that point they already had a script so all I was really doing was just filing off a few rough edges and encouraging" (Murray, 2006).

The film starred Robert De Niro, Charlie Cox, Claire Danes, and Michelle Pfeiffer. It ended up being a funny, smart, romantic fantasy comedy, the kind of thing you'd file alongside *The Princess Bride* on the shelves in your mind. It did well in the UK box office, less well in the U.S. box office. In the end it was a very good film and got good reviews and was two hours well spent, but the book was a bit better. ❖

american gods

"Gods die. And when they truly die they are unmourned and unremembered. Ideas are more difficult to kill than people, but they can be killed, in the end."

ABOVE: Jacket of the U.S. edition of *American Gods*, 2001.

ALL THROUGH GAIMAN'S CAREER HE REFERS BACK TO THINGS WRITERS SAID WHEN HE WAS INTERVIEWING THEM FOR MAGAZINES IN THE MID-EIGHTIES.

After *Stardust*, Gaiman thought he was going to write a novel called *Time in the Smoke*, a historical fantasy set in restoration London. He didn't write it, because his last three novels had been very English and he had learned, above all, that once you get put in a box you cannot get out of it again. "I would interview bestselling, big gun authors, and I remember realizing—often not during the interview, but afterward, sitting and chatting—that for a lot of the bestselling authors, their success was frustrating and limiting.

"It meant they were in a box. They'd become successful as the person who does 'X,' whether it's spy novels, horror, fantasy, humor, whatever. And I'd hear this refrain over and over, along the lines of: 'I want to do this French Revolution novel, but my publisher won't let me', and I'd be going, but you're so-and-so, what do you mean your publisher won't let you?" (Writeaway.org.uk)

When Gaiman became an author of prose he could very clearly see all the rules and boxes that would be quickly drawn around him were he to do a series of books in the same vein. Following books like *Neverwhere* and *Stardust* with another book like *Neverwhere* or *Stardust* would seal the deal—he would become the English guy who writes those kinds of novels. "In some ways *American Gods* was me saying I needed to draw a very large territory for me to walk within" (Writeaway.org.uk).

American Gods was Gaiman's fourth novel, and one that went on a lot longer than he thought it would.

It was meant to be sort of normal-sized. By the time I had written a normal-sized book it was only half-finished. I figured it was the gods' revenge on me. When I went around doing bookstore signings and readings I'd always say, well, I wrote this and it's 60,000 words and I don't see why books have to be these giant brick-like things that you could stun burglars with, and I would mock very nice people like Tad Williams unmercifully, and say things like, "Tad writes these huge books and look, I just did it in a little one. And it's won all these awards!" I figure somewhere up there the writing gods heard me, and they went "Oh, okay. Right." And so I hit 60,000 words and the book was barely started, and I hit 100,000 words and it was still going (Gaiman Live, 2001).

It ended up somewhere nearer 200,000, a 600-page doorstop, and the first novel Gaiman thought he had truly gone solo on. "It's a very strange book. It's probably the closest thing to *Sandman* I've done since *Sandman*. It has that kind of texture, and that kind of taste. Only a lot more sex" (Gaiman *Live*, 2001).

It started when Gaiman's movie agent, Jon Levin, had mentioned that Robert De Niro was looking for a movie to do, and said to let him know if Gaiman had any ideas for a De Niro vehicle. He didn't, but he started thinking about two characters: one a *Taxi Driver*–era De Niro, the other, Rip Torn, whom Gaiman had encountered in North Carolina while working on a *Good Omens* film script in 1991.

He had these really strange speaking patterns, which actually they pretty

Novel notes:

① Laura - let's talk about her physically and the first time that she and Shadow met - her eyes etc.

② More events of key chapter around - Wednesday, spectral figure there for final thing - Shadow must deal with him then go on to talk to the troops

③ STORM - Big storm battle so unable to distinguish explosions from lightning strikes

much used in The Larry Sanders Show, that's more or less his speech patterns. And I just imagined these two people meeting on a plane (Wagner, 2008).

I was lying in bed one night, and it wasn't actually a dream, it was in that weird little half-state you get into before you actually fall asleep. And in my head there was a man running through an airport, and he'd already had a hell of a day. He'd gone to the wrong airport, the plane had been diverted due to weather, it had landed in the wrong airport. He'd run across, gate to gate, as I often have, trying to get there. When he gets onto the plane there's somebody sitting in his seat. And the stewardess says come on, we have a seat in first class, we have to take off, and she sticks him down in first class. And the man sitting next to him in the seat turns to him and says: "You are late. Now, I want to offer you a job" (Gaiman Live, 2001).

All Gaiman had was a beginning. The characters had no names, there was no Shadow or Mr. Wednesday. The notion lived in his head slowly accumulating ideas like orbiting moons. Added to this was the fact that he'd been living in America for about six years and was finding out that it was weird in ways that nobody had ever told him. He'd spent the pre-move years writing about America for American comics, setting stories within it, but it was an America in his mind—a place made out of bits of films and TV shows by an Englishman living in England. The America he discovered when he moved was something else entirely.

I knew so much more about America before I came here! I remember initially assuming there was an awful lot underneath the surface, then living here for a little while and thinking, "Oh, there's nothing underneath the surface—what you see is what you get." And then, coming through that and deciding, "Yeah, there actually is an awful lot under the surface, but it's not what I was looking

for." England has history; Americans have geography. Which goes back to that joke, "America is a country where 100 years is a long time, and England is a country where 100 miles is a long way." Both of those things are true on many levels. There really isn't a great English road trip tradition, because in three or four days, you've done it all. Whereas in America, the idea of the road trip is this magnificent long slog (Locus Online, 1999).

The novel all snapped into focus in 1998, when Gaiman found himself sleep-deprived in Iceland, where the summer sun never set. "My travel agent had pointed out to me, since I was going to Norway, I could take advantage of a free stopover in Iceland. I flew to Iceland, it was around July the fourth; I left at seven o'clock in the evening, got in around six-thirty in the morning, local time there, and hadn't slept on the plane because it was too quick—you hop over the Pole—and said, 'You know, I'm not going to bed now.' I never did. The room that I was in didn't have curtains, and it was daylight. So, the following afternoon—Sunday, my twenty-four-hour day in Iceland—I hadn't slept in a long time. I wandered into the corridors of this building, I bought a little piece of scrimshaw, and then I saw a little diorama showing the voyages of Leif Ericson across Iceland to Vinland [in North America], and the timeline: This is when they got in, they fought the Indians, they got driven out again. And I just thought, 'I wonder if they left their gods behind'" (Wagner, 2008).

He wrote a letter to his editor, Jennifer Hershey at Avon Books, saying he had an idea for a book and that he was going to call it *American Gods* until he came up with something better. A road-trip novel full of eerie Americana in which the old gods of immigrants are abandoned in favor of the secular gods of technology, a novel tinged with horror, full of stories and myth, and how godlike needs can be satisfied in small ways in human life. "Within a month or two, they sent me a mock-up of the cover, which *was* the cover. This was a really odd thing, and suddenly

Left: Plan for a chapter that never got written.

it was called *American Gods* because that's what it said on the cover. And it had this road heading out, and this lightning bolt, and I thought, 'Okay, this is the book I'm writing'" (Wagner, 2008).

He made sure to put a lightning bolt in the story somewhere.

Going back and looking at *Sandman* in a post–*American Gods* world, some issues feel like pieces of *American Gods* transplanted into the past. One particular point where this is clearest is the part where a grandfather is telling his granddaughter a story from the old country—a tale of gypsy women, forests, and werewolves. The girl is bored and would rather watch TV, and brushes off any reference he drops to being very, very old (in this case centuries), and he only reveals at the end that he is the one

"American Gods was the first thing I'd done which was really lonely."

in the myth, before saying goodnight and abruptly leaving the room.

"*American Gods* was the first thing I'd done which was really lonely . . . it's a very lonely book. It took the best part of two years to write and for the first six months of writing it I went off on my own, I borrowed houses from friends, and I didn't know that I could do this thing. I knew it was going to be a big novel, that in order to work it had to be thick and that I was aiming for a quarter of a million words. It was a strange time; I was in houses I'd borrowed from Tori Amos and Jonathan Ross, and I was just on my own writing, making stuff up and practicing coin tricks. If I get to the point where I need to write something as long as *American Gods* again, I can absolutely see myself doing that again, and it's going to be harder" (Writeaway.org.uk).

For the coin tricks and magic he found help in Jamy Ian Swiss, a renowned stage

magician who specialized in sleight of hand and card tricks. Gaiman met him when he flew to Las Vegas to see Penn and Teller after their appearance on *Babylon 5*. "Jamy and I would have arguments in *American Gods* where I would use the word 'misdirection' and he would say, '*No*, there is no misdirection, there is only direction, what a magician is doing is he's *directing* people's attention.' Stuff like that."

In April 2011, ten years after the book's release, it was announced that *American Gods* was destined to be a television series, produced by Tom Hanks's company, Playtone. Gaiman was going to write the pilot episode. "The overall plan right now is that the first season would essentially be the book, with a few interesting divergences . . . After that, there was always so much more plot: on what happens to Shadow, on what happens in the fallout of *American Gods*, so we're just going to follow it along" (Den of Geek, 2011). In February 2014 the series moved from Playtone to Freemantle Media North America because HBO's option had expired, but the pilot had to stay where it was—tied up in Playtone, and Playtone is exclusively HBO. Says Neil: "I could write another pilot episode but there would be overlap because it's based on the novel, and it would be possible for HBO to be grumpy about it. It is far easier and wiser not to do it." He'll stick around as executive producer.

As of 2014 Gaiman was working on a second *American Gods*, which will likely feed into the TV show. In 2011 he said, "For me, *American Gods* was a way of making sense of America the first time, and I think if I go back and do *American Gods 2*, that will be my way of making sense of what America has become, post-9/11 and post-post-9/11, a peculiar world in which some things have changed, some things are fragment-ing, and some things have normalized. You have the smartphone generation with incredibly short attention spans. The Twitter generation. And a world of immediacy. I'm fascinated by the nature of immediacy. All of that stuff is going in there" (Steel, 2011). But, then, Gaiman is a novelist who doesn't plan—he writes to find out what he thinks about something. Everything can change. ❖

who was far from the
brightest god there was,
but was the best loved.

Thor and his hammer
— a weapon, not a tool —
had defended the home
of the gods against the
Trolls and the Frost
Giants for time out of
mind.

Certainly there were
intelligent gods — Loki
was as smart as a
hundred trolls, each troll
smarter than the smartest
troll there ever had been
or will be, and
no-one was named

after him.

Even Odin, King of the
gods, oldest and wisest
of them all, even he
had no towns or districts
named after him, only
peaks and rivers and mountains,
lonely places you could
see and admire but
would not want to live.

There was a town at
the edge of a Fjord, and
all the young men of that
village went out a-
viking, which is to say,
a-raiding and a-pillaging
of distant towns in
far-off lands, and it

Amgod
MiMiR
computer program?

Gods of the North.

So... either it's Iceland/Norway or
it's Vinland.

We have children who are going to
the old man to hear the tales.
The forbidden tales? — of the gods.

And we learn them as the children
learn — Odin, Thor, Loki, Heimdall
Frey, Tyr and the rest of
them...

The troll tricked into talking
until dawn...

Odin the wanderer...

The time Loki sold Thor's hammer
to the giants — Thor and Loki
sent to get it back — Thor in
drag ---

These are towering, great
figures — majestic, huge (and
the poor giants are huge)

Do the contest of the gods
(Thor vs fire, time etc.)

CORALINE

"Only her skin was as white as paper.
Only she was taller and thinner.
Only her fingers were too long, and they never stopped moving,
and her dark red fingernails were curved and sharp."

The Magical *New York Times* Best-seller

NEIL GAIMAN

Coraline

"Rise to your feet and
applaud: *Coraline* is
the real thing."

—Philip Pullman,
author of
HIS DARK MATERIALS

WITH ILLUSTRATIONS
BY DAVE McKEAN

ABOVE: *Coraline*, first U.S.
paperback cover, 2003, with
Dave McKean artwork.

THERE'S A SHORT STORY BY A BRITISH WRITER CALLED LUCY CLIFFORD, PUBLISHED IN 1882, CALLED "THE NEW MOTHER." AN ANGELIC AND LOVING MOTHER WARNS HER CHILDREN THAT IF THEY ARE NAUGHTY SHE WILL HAVE TO PACK HER BAGS AND GO AWAY FOREVER, AND THAT THEY WILL GET A NEW MOTHER TO REPLACE HER: ONE WITH GLASS EYES AND A WOODEN TAIL THAT DRAGS ALONG THE FLOOR.

Knowing this to be absolutely a true thing that will definitely happen if they are bad, the children are perfectly behaved until they meet a strange girl on the side of the road. She has a little musical box and says there are tiny people inside it who will dance and tell them secrets, but only very bad children are allowed to see it. The children explain the thing about the mother leaving and how they can't possibly be bad, and the girl replies matter-of-factly, "They all threaten that kind of thing. Of course really there are no mothers with glass eyes and wooden tails; they would be much too expensive to make."

It's a Victorian cautionary tale for children, one of those things you read as an adult and feel you should do everything in your power to prevent the book falling into the hands of children, except that children read these stories differently to adults so there's no need. "It's haunting like a nightmare is haunting," says Gaiman (Ouzounian, 2009). His own *Coraline* has that kind of feel; pure Gothic horror, tinged with an *Alice in Wonderland* rabbit-hole wonder. And he did it on purpose. It's a book he wrote for his own little girls.

When she was four, Neil's daughter Holly would come home from kindergarten, crawl up on his lap, and dictate nightmarish stories in which her mother was tied up in the basement and replaced by an evil witch. Neil had his own underlying fear when he was a

boy, frightened that one day his parents would go out and the parents who drove up the driveway a few hours later would only be copies of his real parents, and he'd never see his real ones again. He couldn't find any stories like it on the shelf to read to Holly, so he decided to write her one. The success of the resulting book suggests we're all afraid of the very same thing.

He started it in 1990, when he was still living in a big old house called Littlemead, in East Sussex, and set the story there. "But I took the little door (through which Coraline escapes into her frightening adventures) from the house where I lived as a boy. One door had been bricked up. I was convinced there had to be a way to open it and if I did, it would go down a passageway where strange, wonderful and maybe scary things would happen to me" (Ouzounian, 2009). Originally he thought it would be a short story somewhere around three thousand words, but it kept going. Occasionally he wouldn't know what happened next so he would put the story away, once for as long as four years. It was written in fits and starts, in multi-page chunks or in fifty-word bursts on train journeys, late at night—whenever he knew what happened next. It grew over ten years in spare moments. "You'd think for something written so peculiarly—a 30,000-word novel written over a ten-year period— that it ought to be choppy and bumpy and you should be able to say, 'Gosh, you can see this was written by a thirty-one-year-old living in England, and this was written by a forty-one-year-old living in America.' But there isn't any of that; it has its own voice" (IndieBound).

By the time he had finished it, Holly was nearly grown up. Little Maddy Gaiman, who had arrived after the first chapter had been written, was six. It was always going to be Gaiman's Edward Gorey book, except he finished it three days after Gorey died. It went out into the world with Dave McKean illustrations instead, in 2002, and whatever version of the book you read depends entirely on how old you are. The words are exactly the same.

"When I began it, I remember in 1990 showing the first couple of chapters to a

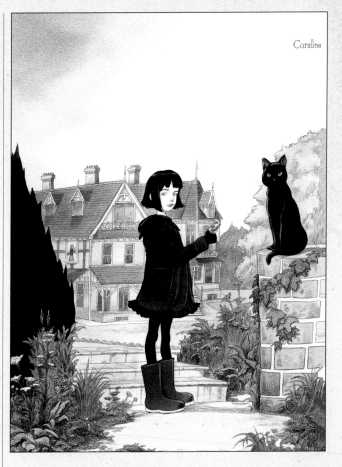

Coraline

Left: Chris Riddell's artwork for the cover of the UK tenth anniversary edition of *Coraline*, 2013.

very-respected, beloved English editor (now dead). He told me he thought it was absolutely brilliant and completely unpublishable. He said, 'There is no way that you can publish something that is a dark fantasy novel for children and adults— aimed at both markets for different reasons—that is essentially a dark and wonderful horror novel'" (IndieBound).

But horror has a way of being self-selecting. Children read it as an adventure story and are never scared because Coraline is never scared, while the adults know just how much danger she is in and read it through the gaps between their fingers.

It grew organically and was written in an entirely mad and unrecommended way, one which Gaiman thinks he will never be able to replicate. *Coraline* is as perfect as she will ever be. "With most of my books I feel much as a craftsman feels about a sculpture or a chair they've made: 'This is a good chair, I like it. It's solid.' Or, 'Well, the legs are a bit wonky, but you can see that

my heart was in the right place.' So, a lot of the time my books and stories are chairs. They're good chairs, chairs I'm proud of. However, with *Coraline* I feel rather like I feel about my children, in that they're wonderful, and I know I was there at their conception, and I know I've had a fairly intimate day-by-day help with their growth, but I look at them at the end of the day and I think, 'You're really cool. How did you get there? Where did you come from and how did you turn out like this?'" (IndieBound).

Ten years later it is a beloved book, a P. Craig Russell comic adaptation, a musical by Stephin Merritt, and a movie by Henry Selick. As a Halloween treat in 2012, each of the thirteen chapters was read on camera by different people—Lemony Snicket, Neil's fairy goddaughter Natashya Hawley, Neal Shusterman, Cassandra Clare, Adam Rex, Melissa Marr, Fairuza Balk, John Hodgman, Holly Black, and R. L. Stine, bookended by Neil. ❖

CORALINE: THE MOVIE

"It's beautiful, it's spooky, it's odd, and he's doing it because I love his work. When I finished writing Coraline, I even had my agent send Henry the book before anyone read it."

THE BRILLIANT stop-motion film director Henry Selick had been on Gaiman's radar long before they actually met. Gaiman had been hearing about him for years from people who thought they should collaborate, and he had seen Selick's *The Nightmare Before Christmas* the week of its release in 1993 and loved it. Selick, a tall thin man who moves like his own Jack Skellington, knew of Gaiman through *Sandman* but was unaware of any of his other work until they were introduced in 2000 by Neil's movie agent, Jon Levin. By this point *Coraline* was only just finished.

Said Selick, "When I read it, it was basically the first draft, and it wouldn't be published, it wouldn't be out for two years. So I got to see it very early. In reading the story, I just felt like I'd found a true collaborator, a lost brother in Neil, with a sensibility. And I come much more from visual storytelling. He's a wordsmith of great talent, and just instant connection. By the time I was halfway through the book, I could see a movie" (Billington, 2009).

Selick wrote a first draft, but it suffered from the same problem as the *Violent Cases* stage play in that it was far too faithful to the original text. He likened it to putting the book into a machine that transformed it into screenplay form, and it just didn't work. "It didn't feel like a movie. It didn't have the right pacing, so I had to tell Neil, 'I'm going to go away. Let's see what happens.' And during that period is when I found my voice" (Billington, 2009). When Selick's option on the film ran out Gaiman let him keep it for free even though Disney were

sniffing around. He wanted this film to be made, and he wanted Selick to make it.

Through Selick's drafts, *Coraline* became a (slightly) less creepy version of the book, more of a Hansel and Gretel seduction scenario. The biggest changes were the introduction of a kid character called Wybie, and Selick set the story in America because he was more comfortable writing in American English. Consequently, the house changed from Littlemead in England to an entirely different one that Gaiman knows just as well: "By some peculiar coincidence inexplicable to the human mind, Henry and his art director managed to set it in my current house near Minneapolis, which they've never seen" (Ouzounian, 2009).

Selick wanted to balance the darkness of the story with the light and color of a classic storybook, so he employed Tadahiro Uesugi as the project's preproduction illustrator, a well-known Japanese artist whose work is heavily influenced by American illustrators of the late fifties and early sixties.

The film took three years to make (about twice as long as a typical live-action film) and required an army of animators, designers, modelers, sketch artists, carpenters, and camera crew to complete it. At its production peak there were 450 people working on the feature simultaneously. Each thing seen on screen—every leaf, every eyebrow, every item—was made by someone and exists somewhere in miniature.

In the lead-up to its release, *Coraline* was the subject of a very inventive promotional campaign. Gaiman filmed an *Alfred Hitchcock Presents*-style monologue about "koumpounophobia" (or the fear of buttons) in his house, and fifty handmade mystery boxes were sent out to selected bloggers all around the world. They ranged from fashion, knitting, and sock-related bloggers to animation ones and Neil himself. Over the weeks they surfaced on the internet, each blogger in turn gleefully rifling through their unique stash of mysteries: weathered letters with wax seals, hands and legs and various anatomical pieces of characters pinned, or sewn, or buttoned into a box.

With a stellar cast including Dakota Fanning, Teri Hatcher, Jennifer Saunders, Dawn French, and John Hodgman, the film

garnered critical acclaim and was nominated for dozens of awards, most notably the Oscar for Best Animated Feature. Gaiman attended the ceremony for which he wrote a fifteen-second sequence where Coraline tells an interviewer what winning an Oscar would do for her. The award would go to Pixar's *Up*.

Said Neil, "We're so proud of it. If it wasn't for the Jonas Brothers spoiling our mojo, we might have been the highest-grossing animated 3D movie ever made. When their film came out, *Coraline* was pulled from some theaters to make space. Two weeks later, when the Jonas Brothers film made no money, we got put back into more of them. But I am so proud of what Henry and everyone did; it also made me feel better about turning my comics into movies" (Thill, 2009). ❖

top: The Other Neil in the "Koumpounophobia" publicity short.

above: Gaiman and Henry Selick on the set of *Coraline*.

opposite: Film stills from *Coraline*.

ANANSI BOYS

"God is dead. Meet the kids."

ANANSI BOYS IS ANOTHER PROJECT THAT WAS ALL LENNY HENRY'S FAULT.

Back in the mid-nineties, Gaiman and Henry were working together on the *Neverwhere* TV show when Henry started grumbling. "I was over at Lenny's house and he was grumbling about the fact there were no black people in horror movies. He said, 'Where? Where are the black people in horror movies? Why aren't there any black people in horror movies?' And I thought: what an incredibly good question. So that was where *Anansi Boys* began. It was just going to be a horror movie with black characters. Except that if I'm thinking of casting Lenny as Fat Charlie, and quite possible as Spider, it's going to be funny. Because Lenny's funny."

Gaiman wrote about three scenes in script form, but says they weren't very good. "It wasn't alive, and I wasn't sure who these characters were. The only one who seemed interesting was Mr. Nancy, and he wasn't much of a character, in that he was going to die before *Anansi Boys* started, or just as it started. So, I put it on the back burner, not really being sure what it was" (Lawless, 2005). In the meantime, Gaiman went off and wrote *Stardust,* and *Coraline,* and ended up borrowing Mr. Nancy for *American Gods.* He fit—he was a spider god—but mostly Gaiman just liked the idea that when *Anansi Boys* eventually did happen we would have met him already. He would have had a chance to live in our heads as a character before we found him singing "What's New Pussycat" and then having a heart attack during "I Am What I Am" and dislodging a woman's breasts from her tube top on his way to the ground.

After playing around with the idea, Gaiman decided it wasn't a movie after all. "Then I had this plan to do a book of three novellas for Jennifer Brehl at HarperCollins and the novellas were going to be: *How the Marquis Got His Coat Back* (for *Neverwhere*), *Hellflyer* (for *Stardust,* which is the one about going to Hell in a hot air balloon), and *Anansi Boys.* It was my first ever real meeting with Jennifer, and we were having lunch in an Orthodox Greek restaurant, which meant that even though this was two or three weeks after the rest of the world had celebrated Easter there was a giant Easter feast going on around us. And when I finished telling Jennifer the story of *Anansi Boys,* she waved her fork at me

OPPOSITE TOP: Neil writes the story of how *Anansi Boys* came to be in a notebook.

OPPOSITE BOTTOM: *Anansi Boys* debuted on the *New York Times* Best Seller list.

Anansi Boys

It was the summer of 1996 supposedly
??? and Billie Henry was learning
to ride a bike. Her father, actor and
comedian Lenny Henry, and I were
following her, and we were talking.
We were talking about comedy, and
about horror, and about ways of
combining the two. Sometimes during
that walk I had a story in my
head, based very loosely on the
way that Lenny, more than anyone I
know, has two sides: a quiet, and ???
scholarly person, and an over the top,
larger than life, funny. And I knew
I had a story to tell about four
people: two brothers, their father, and
a bird woman. And I had a title
for the story, _Anansi Boys_.

I wasn't sure what it was, though.
Perhaps, I thought, it was a film, and
I tried writing an early scene,
as Mr Nancy sang Karaoke, and

another scene, in which the hero,
a sensible young man, was informed
that his father had been the trickster,
the Spider God Anansi. But it
~~had~~ didn't feel like a
movie, so I stopped.

When, in 1999 I came to write
a novel called _American Gods_,
I borrowed Mr Nancy from the story
I had not yet told. Seeing that
he died at the beginning of
Anansi Boys, I felt that he
might enjoy his moment on the
stage.

Time ~~took~~ passed.

I wrote other things: a children's
book called _Coraline_; a graphic
novel called _Endless Nights_. And
then it was time for another
novel for adults.
I had lunch with Jennifer
Brehl.

in a vaguely menacing sort of way and she
said: 'That is a novel.' And I thought oh,
okay. If you say so. I'll go and write it then.
So I went off and I wrote _Anansi Boys_."

The story Gaiman told Brehl that caused
her to waggle a fork at him was about a guy
called Fat Charlie Nancy, who learns at his
father's funeral that Mr. Nancy (Sr.) was
actually the incarnation of the West African
trickster god, Anansi. Now that he's dead,
old Mrs. Higgler figures there's no harm in
Fat Charlie knowing, and he retorts, not
unreasonably, that if he was actually the
son of a god then why doesn't he have any
godlike powers? It turns out his brother
got all of those. Only, Fat Charlie didn't
even know he had a brother. Enter Spider
and a world of trouble in a book about
families and how to survive them, a book
that is partly scary, slightly romantic, a
fraction mythic, hugely thrilling, and
incredibly funny.

The fact that it was a funny book was
one of the reasons it took so long to take

THE NEW YORK TIMES BO[OK]

Best Sellers

This Week	FICTION	Last Week	Weeks On List
1	**ANANSI BOYS,** by Neil Gaiman. (Morrow, $26.95.) After his father dies, Fat Charlie learns that Dad led a secret life as a trickster god.		1
2	**GOODNIGHT NOBODY,** by Jennifer Weiner. (Atria, $26.) An unhappy suburban mother gains her independence by investigating a murder.		1
3	**THE DA VINCI CODE,** by Dan Brown. (Doubleday, $24.95; special illustrated edition, $35.) A murder at the Louvre leads to a trail of clues found in the work of Leonardo and to the discovery of a secret society.	1	132
4	**THE MARCH,** by E. L. Doctorow. (Random House, $25.95.) The story of Sherman's sweep through the South and the lives he left in his wake.		1
5	**ON BEAUTY,** by Zadie Smith. (Penguin Press, $25.95.) Personal and cultural battles between two academic families.	7	2
6*	**THE WIDOW OF THE SOUTH,** by Robert Hicks. (Warner, $24.95.) After the Battle of Franklin in 1864, a Tennessee woman turns over her plantation to Confederate troops for use as a hospital — and also as a cemetery.	6	4
7	**THE HISTORIAN,** by Elizabeth Kostova. (Little,	2	15

This Week	NONF...
1	**THE WO...** rar, Stra... York Tir... policy an...
2	**1776,** by... An accou... Prize-wi... George V...
3*	**FREAKON...** Dubner. ... economi... who chea...
4	**BLINK,** b... The auth... tance of...
5	**THE TE...** $23.95.) ... for whor... come a s...
6	**A MAN W...** (Seven S... observat...

shape. "Since Terry Pratchett has single-handedly colonized such an enormous territory of classic English humor—laying down the streets, the shape of jokes—I didn't feel I could go back to the kind of style the two of us used when we wrote *Good Omens*. So I had to figure out a way to write a funny novel that was not a Terry Pratchett novel. I decided my models were going to be Thorne Smith and P. G. Wodehouse" (*Locus Online*, 2005).

Gaiman sped ahead doing one or two thousand words a day when he suddenly looked up and found that all his characters had started doing things he hadn't expected them to do. He had more plot than he knew what to do with; his original ending, if he used it, would do nothing but fizzle, so he put it in a drawer and let the story compost. "Finishing it was an extremely

> *"I had to figure out a way to write a funny novel that was not a Terry Pratchett novel."*

odd experience, because *Anansi Boys* oscillates between being a funny novel with some scary and disturbing bits, and a disturbing novel with some funny bits, and the second half was, on the whole, fairly dark, and having figured out how to write it funny once again I had to admit that I had no idea at all of what I was doing, and then I had to do it anyway. But eventually it finished itself in zeroth draft (with a lot of help from me)" (*Locus* magazine, 2005).

Like Fat Charlie and Spider, *American Gods* and *Anansi Boys* share genes, but they are completely different entities in completely different worlds: *American Gods* is huge and sprawling and serious, while *Anansi Boys* is joyful and light, more like a 1930s screwball comedy. It shocked Gaiman by winning a British Fantasy Society award because "funny books don't win awards!"

In 2007, two years after its Number One debut on the *New York Times* Best Seller list, *Anansi Boys* was turned into a (heavily condensed and written by someone else) radio play for the BBC World Service. Lenny Henry got to voice Fat Charlie and Spider, two characters whose lives began in a grumpy observation he made in the mid-nineties. Henry also did a stellar job on the audio book, and somehow, through his voice, it becomes more like *Anansi Boys* than *Anansi Boys* the book. Lenny Henry has a whole army of old Jamaican ladies in his head, each with her own individual nuances and personality. ❖

best to edge his way to the front ranks,
without attracting too much attention. Seeing
that by now he was panting like a sheepdog,
dripping with sweat and trod on several
feet as he went by, this proved a failure.

There were glares. Fat Charlie tried to
pretend that he had not noticed. Everyone
was singing a spiritual that Fat Charlie
did not know. He grinned, sheepishly.
Then tried to make it look as if he
was sort of singing, moving his lips in a way
he might have meant he was singing along,
two voce, and might have been muttering a prayer
under his breath, and might just be contem-
-plation.

The casket was a glorious thing, made of what
looked like heavy duty a stainless steel. In the
case of the glorious resurrection, Fat Charlie
felt when Gabriel blows his mighty horn and the
dead escape their coffins, his father was
going to be stuck in his grave, banging away
at the lid, wishing he'd been buried with a
crowbar.

A melodic final Hallelujah faded away.
Charlie could hear someone shouting at the
far end of the Memorial Garden, back where he
had come in.

The Preacher said a prayer. And then
he said, "Now. Does anyone have anything they
want to say in memory of the Dear departed."
It was obvious that several other people
were planning to say things, but

ANANSI BOYS WAS BOUGHT as a movie, with a script by Gaiman, and in August 2010 Gaiman sent off the final draft. He was meant to have started it in March 2009, but then life did that thing where it imitated art. "I went off to New York and got an unexpected phone call saying my father had just died of a suspected heart attack in a business meeting. And when the dust had settled and I opened up the file to write the film script, in which the first thing that happens is that the protagonist's father dies in an unexpected way of a heart attack during karaoke, I found myself thinking, 'I can't do this.' I'd open it up every couple of days and look at the two pages that existed so far and then I'd close it and go and do something else."

Months later, Gaiman was at the Academy Awards to watch *Coraline* go head-to-head with Pixar's *Up*, and went though "a strange, rather mournful, rather odd and depressing day where I felt like I was an alien at the Oscars" (Purcell, 2012). It was two days before the anniversary of his father's death, he was melancholy and wanted to go home and walk with his dogs in the woods. He wrote a piece for *The Guardian* about being invisible on the red carpet (and treading on Rachel McAdams's dress)—it's a thousand beautiful words about being lonely among people, and simply by writing it, something lifted. He went home, wrote the script for *Anansi Boys*, and sent it off. Since then it's transformed into a television show. Before it becomes a television show it might well morph into something else.

ODD AND the frost giants

"It's a book about using your head, I think."

Cover of the U.S. edition,
2009, featuring artwork
by Brett Helquist, and
expanded cover artwork
for the UK edition,
2010, by Adam Stower.

WORLD BOOK DAY IS AN ANNUAL EVENT WITH A STRAIGHT-forward goal: to get kids reading.

A bunch of authors write some books for nothing, the publishers publish them for nothing, and then kids—who have received their World Book Day book coupons—can swap them at the bookshop for a free book of their very own from the World Book Day buffet, which usually consists of about eight titles. Since everybody's doing it for free, it makes for some short reads—even the printer is donating the paper, so they don't want to be putting out *American Gods* bricks or they'd go bankrupt.

Odd and the Frost Giants was Gaiman's World Book Day book in 2008, clocking in at around half the length of *Coraline*. In it, he took pieces of old Norse mythology and put them in the world of a young boy with a bad leg called Odd, who lives in Norway where the winter is never ending and nobody knows why. Treated badly by his stepfather, he leaves the village and escapes to the forest where he meets a bear, a fox, and an eagle who are actually Loki, Odin, and Thor turned into forest animals and cast out of Asgard by the most evil of the Frost Giants, who is also the reason why the spring never comes.

Gaiman is most proud of how he ended the book, which probably would have been very different if there had been more space/words to maneuver: an extra five thousand words might have seen "an awful lot of shouting and running about at the end" (Huff, 2011). Odd can barely walk, uses a crutch to travel through his icy world, and would be useless in a physical fight. Instead he calmly and politely uses his head to win the battle against the Frost Giant. "Having to write a conversation in which a smart kid persuades something a hundred thousand times his size to go home was the challenge. But it wouldn't have happened without that size limitation" (Huff, 2011).

In 2011 Gaiman started work on a second Odd book thinking it was going to be another short one, but having got through the first chapter he realized it would be much bigger than the first. It's got a working title of *Odd's Seachange*, and Neil is sending him on a holiday to Jerusalem, on the same route the Vikings took in the *Orkneyinga Saga*. The third book is set a few years after that one and has something to do with Afghanistan and Iran, where the Vikings got the ingots of crucible steel for the best swords. ❖

"Having to write a conversation in which a smart kid persuades something a hundred thousand times his size to go home was the challenge. But it wouldn't have happened without that size limitation."

INTERWORLD

"All of the stuff that thirteen-year-old boys have no trouble at all understanding made fifty-five-year-old studio executives think we were on crack."

INTERWORLD BEGAN AROUND THE same time as the NEVERWHERE TV SERIES WAS HAPPENING. 1996 SAW THE END OF SANDMAN, BY WHICH POINT THERE WAS A DEFINITE MOVE IN DIRECTIONS NEW AND UNKNOWN, TELEVISION BEING ONE OF THEM.

Gaiman initially met Michael Reaves in 1993 when Reaves was script editor on *Batman: The Animated Series*, and ran into him a year later at the World Fantasy Convention in New Orleans when Reaves had moved on to writing Disney's *Gargoyles*. Reaves had won an Emmy for *Batman*, his career was on the rise, and in 1996 he found himself working at DreamWorks with the option to do a completely original animated series. He called Gaiman, who had never written an animated TV show, and asked if he had any ideas. Gaiman's pitch was *InterWorld*.

> The idea is we have an infinite number of universes and in some of them the multiverse is leading towards magic, and in some of them it's leading towards science, and you now have these huge organizations that are pushing to try and get all of the multiverses to be one thing or the other. And then you have InterWorld, which is just this little thing that is trying to keep things more or less as they are. It's a resistance group, but a resistance group which is trying to hold the status quo. And our hero is a kid who discovers he can walk between these worlds and the superteam that he is going to join are versions of himself from alternate realities.
>
> It came out of this weird fantasy that I used to sometimes have when I was a young man writing Sandman. I used to think there are probably millions of versions of me across millions of multiverse realities. Wouldn't it be nice if sometimes they'd drop in for a coffee? I'd just be sitting there chatting to me, but he'd be the me who would be covered in fur. The sort of werewolf-y one, and over here's a lady-me, and here's a me from a place where everyone's invisible when they're in direct light but they sort of get more visible in shadow. And we'd have coffee, and we'd just sort of talk

of an evening, spend a couple of hours catching up. What are things like on your world, Neil-with-Wings? Well, funny you should ask . . .

Reaves pitched the idea to DreamWorks and got turned down. They pitched it elsewhere and got turned down again. Each time they pitched it they were running into the same problem: the people they were pitching it to were not thirteen-year-old boys. They didn't get it.

What we found was while the likes of [famed screenwriters] Elliott and Rossio would read this thing and have no problems with it, the moment it went to a studio executive everything would get very, very confusing and weird. Because they did not understand the idea that our hero is alternate versions of our hero from different realities. People would read this outline and they'd get confused by us talking about multiverses and multiple versions of our hero—all of the stuff that thirteen-year-old boys have no trouble at all understanding made fifty-five-year-old studio executives think we were on crack. And so Michael and I decided to write the book. We didn't decide to write the book to sell the book, but because it would actually be easier to give someone the book and say, "Here you go, this is the story. This would be the first couple of episodes of a TV show." So we had no particular intention to get it published—the intention was just basically to use the book to get a TV deal, or a film deal.

They wrote the novel in a hotel in snowy Wisconsin in the middle of winter, 1998. "Michael came up and took a hotel room and we just sat next to each other and alternated chapters, or alternated half-chapters. Basically the rule was when you got stuck on the bit you were on, we swapped out." In the end, the book did nothing to convince studio executives of its potential success as a TV series. In 1998 Gaiman had *The Day I Swapped My Dad for Two Goldfish* but wasn't really a children's author, and

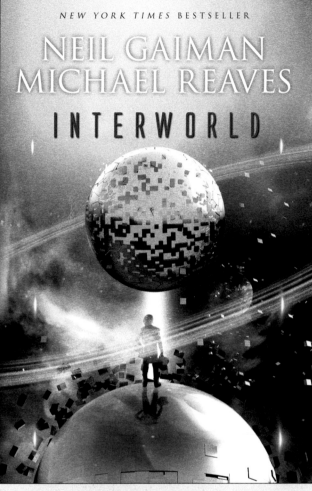

NEW YORK TIMES BESTSELLER

NEIL GAIMAN
MICHAEL REAVES

INTERWORLD

"What are things like on your world, Neil-with-Wings?"

despite writing cartoons for a living, Reaves wasn't a children's author either. Neither knew what to do with the book, so it went into a drawer and stayed there. Then *Coraline* happened.

In the meantime, Reaves's life was not going as well as it had been going. Recently diagnosed with Parkinson's Disease and no longer enjoying the career of the Emmy Award–winning writer of animated TV shows he once had, Reaves asked Gaiman if he would dig out the old book they wrote together and see if it was worth saving. Out of the mothballs it came. They combed its hair and wiped its face and out into the world it went. It was published in 2007, and DreamWorks wound up buying the option to turn it into a film almost a decade after Reaves and Gaiman had stopped trying. "There's a moral there somewhere," said Neil. "But I have no idea what it is."

Then, having originally plotted a huge grand scheme of *InterWorld* stuff back in the days when they'd envisioned it as a television series, there was room for an *InterWorld 2* and *InterWorld 3*. Gaiman recently flew out to LA for plotting sessions with Reaves and his daughter Mallory Reaves, an Eisner Award-nominated writer, and although Gaiman had a huge hand in the plotting and structuring of the books, he left the writing up to the other two. ❖

THE GRAVEYARD BOOK

"Rattle his bones Over the stones
It's only a pauper Who nobody owns."

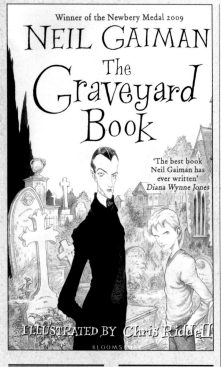

above: Cover of the 2009 UK paperback edition; art by Chris Riddell.

opposite: Limited U.S.-only adult edition of the book with a different cover and interior illustrations by McKean was produced by Subterranean Press.

GAIMAN'S OLD PEACE AND LOVE CORPORATION COHORT KIM NEWMAN SAID THAT GAIMAN'S EARLIER NOVEL *ANANSI BOYS* WAS ONE OF HIS BOOKS FOR GROWN-UPS, "WHICH MEANS THAT IT'S A LOT LESS RUTHLESS THAN THE MATERIAL HE PRODUCES FOR CHILDREN." HIS CHILDREN'S NOVEL *THE GRAVEYARD BOOK* BEGINS WITH A GLOVED HAND IN THE DARK HOLDING A BLOOD-WET KNIFE, AND IT DOESN'T GO ANY EASIER ON THE READER AFTER THAT.

Like Mowgli in Rudyard Kipling's *The Jungle Book* (a book from which Gaiman takes his cues, replacing the creatures from the jungles with ghosts in the graveyard), Nobody "Bod" Owens is an orphan. When we first meet him he is barely a toddler, his family have just been murdered, and he unknowingly escapes the terrible fate himself by sheer curiosity—by clambering over the walls of his crib, sliding down the stairs on his cushioned behind, and venturing out into the night through the open front door. He totters up the hill to the graveyard where he is, after some discussion, adopted and raised by its occupants, a cast of dead people from times very long ago, like the Roman whose headstone was now nothing but a weathered rock, and others not so far back in time. The dead are not the people to be afraid of in this world—it's the living that can hurt you. Mostly living people called Jack.

The Graveyard Book had been gestating for some time before Neil put pen to paper. He had the idea back in 1985 when he was still living in England while watching his two-year-old son Mike play in the graveyard across the road in lieu of the backyard they didn't have. At the time, Gaiman was just twenty-five. Comics and *Sandman* hadn't happened yet, and while he knew it was a good idea, he did not want to screw it up. He thought he'd wait. Every eight years or so he would write two pages of the story to check if he was good enough yet—always the same scene, where the baby enters the gates of the graveyard. Every eight years he would think he wasn't good enough yet and put the idea back in the drawer. Life happened.

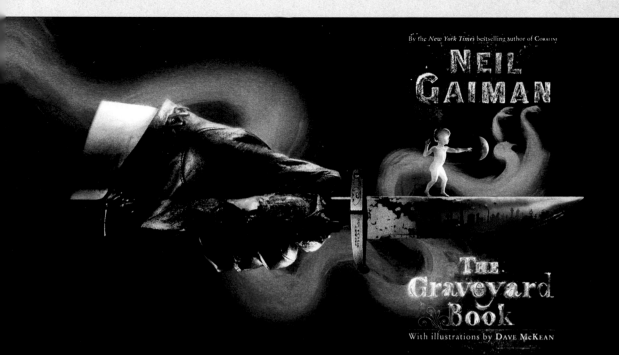

By the *New York Times* bestselling author of CORALINE

NEIL GAIMAN

The Graveyard Book

With illustrations by DAVE McKEAN

By about 2003 two things were becoming obvious to me—one, I wasn't getting any better and was now probably as good a writer as I was ever going to be, so I may as well write the book. And the other was that I'd written Coraline, and it was starting to win awards. So I began to look at strategies for writing the other children's book I had in my head that had been there forever.

I knew the shape of the book in my head—that it was a set of short stories and that the hero would leave when he was about sixteen—and I thought: Why don't I write about when Bod's eight years old [Chapter 4, "The Witch's Headstone"], when he's the protagonist. I wanted him as a person, not a baby, and I wanted to find out what the interactions with the other characters are like.

So I was on holiday on Antigua, and I'm crap at holidays. By day three I'm usually looking for my notebook. Which is what happened this time, and I started writing the opening pages of "Headstone" on the beach; I had just got to the point of stopping, because I thought it was no good,

when my daughter came out of the sea and asked me what I was doing. I told her and she asked me to read it to her, and when I'd finished she wanted to know what happened next. During the holiday [the chapter] got done, and once that existed, the rest of the book spread from it (Writeaway.org.uk).

For years Gaiman had thought the graveyard in his head was a made-up thing—a crumbling old Victorian cemetery with a decaying chapel in the middle of it—but in 2002, during the filming of *A Short Film About John Bolton*, he found Stoke Newington's Abney Park Cemetery in London. It's a place full of winding paths that lead to other paths or nowhere at all, choked with the kind of trees that make the place impenetrable in the spring when they're thick with leaves, and no less dense when the leaves fall. It feels every bit like a cemetery should: cool and quiet and shadowy. Gaiman thought, "This is the cemetery in my story. I thought I'd made it up, but here it is! Because a kid could absolutely live there.

"A year later I was in Glasgow, working on *The Wolves in the Walls* opera for the

National Theatre of Scotland, and I went to the Necropolis. It was much, much, much too tidy, but I loved the hill with the view over the city, so I took Abney Park and put it on a hill like that, reconfigured the topography" (Writeaway.org.uk).

In 2007, when the book was in the last stages of being written, Gaiman went on a research trip at Highgate Cemetery in London with fellow author Audrey Niffenegger. Niffenegger had spent the previous couple of years being an intermittent graveyard guide while working on her own novel set in the graveyard, *Her Fearful Symmetry*. She guided the group through the winding mud paths, past ivy-covered gravestones and the Egyptian Walk. Gaiman brought his note-book, occasionally falling to the back of the group to write down the kinds of strange Victorian names you only find on old weathered tombstones.

Without that tour of the cemetery with Audrey, the last chapter would have been very different. For just an hour to have such a lasting effect on the book gives some sort of idea of how different the whole story would have been had Gaiman written it back when Mike was tiny and toddling around those headstones in 1985.

ABOVE: A sketch of
the graveyard by Neil.

BELOW: Handwritten
Graveyard Book.

"At that point I was the father of a two-year-old son and a two-month-old baby. My experience of kids was from the inside. One of the things that gives *The Graveyard Book* its emotional heft at the end is that it's about the cycle of childhood. It's about leaving and the glorious tragedy of being a parent, which means that there comes a point—if you've done your job right, if you haven't screwed them up, and you have a well-adjusted human being who is capable of going out into the world and being happy—they leave you. If you do your job right you have this person, whom you adore, who is going to go away. And that's right. But that emotional heft is something I couldn't have written about without actually having two kids who've done it" (Writeaway.org.uk).

What he ended up with was a book about the meaning and value of life populated by dead people who can't change anything, who urge Bod to go and do what he can with his short life before coming back and joining them again one day.

When it was finished, he went on a nine-city reading tour, reading a chapter at each stop (splitting the double-length one over two nights). It won both the Newbery and Carnegie Medals, the Hugo Award, a Locus, and a World Fantasy Award, and it stayed on the *New York Times* Best Seller list for a year.

Gaiman says he has more stories to tell, and we have more things to learn from the dead—in particular there's an adult novel in his head about Silas and the Honor Guard—but when asked if there will ever be a sequel he says he worries that *The Graveyard Book* will end up looking like *The Hobbit* to that book's *Lord of the Rings*. Whether it ever happens depends mostly on time, a thing Gaiman always seems to have less and less of.

As for the movie, at time of writing the option is with Walt Disney Pictures with Ron Howard attached to direct. ❖

The man Jack paused on the landing.

ABOVE: The same moment in the book illustrated by Dave McKean and Chris Riddell. "The man Jack paused on the landing."

RIGHT: Drawn in 2008 and scanned before he sent it off, the *Graveyard Book* Christmas Card.

xmas 2008,
with love from
Silas and Bod.
— and more love from —
— Neil —

the Ocean at the End of the Lane

"As pure as a dream,
as delicate as a butterfly's wing,
as dangerous as a knife in the dark."

NONE OF GAIMAN'S CHILD PROTAGONISTS ARE STRICTLY HIM. THERE ARE PIECES OF HIM IN *CORALINE*, IN ODD FROM *ODD AND THE FROST GIANTS*, AND THERE IS A BIT OF HIM IN THE BOD THAT FINDS QUIET PLACES IN THE GRAVEYARD TO READ HIS BOOK UNDISTURBED. BUT THEY ARE NOT HIM. THE BOY IN *THE OCEAN AT THE END OF THE LANE* IS AS CLOSE TO AUTOBIOGRAPHY AS GAIMAN HAS GOT, AND DESPITE THE MAIN CHARACTER BEING A SEVEN-YEAR-OLD BOY, IT IS IN NO WAY A STORY FOR CHILDREN.

It's a novel that started as a short story in 2011, written for his new wife, Amanda Palmer, simply because she wanted to know what he was like as a boy, and it was finished because he was half a world away and missing her. Gaiman summoned the voice of his younger self and stirred up memories of his boyhood home in Sussex for a short story that accidentally became a novel that nobody was waiting for and nobody was expecting. "It was an old manor which had been split into two, and had four or five acres, maybe ten. That house and garden for me were a complete wonderland. I don't know what the guys who were there before us did, but we'd find these strange things in the attic like blocks of marble and bulbs with mercury in. We'd get the mercury out and play with it, and eat it" (*Comics Forum* #1, 1992).

The Ocean at the End of the Lane wasn't even called *The Ocean at the End of the Lane* until about an hour before Gaiman emailed the final draft to his publishers. It had been *Lettie Hempstock's Ocean* and to Neil and those friends who received early, unsure drafts

[Handwritten manuscript notes]

So far: the suicide invoke a sleeping monster, who gave people money — the suicide's last wish. The monster exists on the borders of things guarded by Letty Hempstock & family.

Letty takes our narrator into the monster's world, and tries to subdue it with its name. But she does not know its name. At a crucial moment our narrator lets go of her hand — a worm burrows into his foot. She locks it in to its world. But it's escaped inside she locks it in to its world. But it's escaped inside our narrator. She pulls the worm from his foot, but the monster becomes Ursula Monkton, the kids' new nanny/housekeeper.

It stops our narrator leaving the grounds. It causes his father — or how it has some designs — to try to drown him. ✳

Still to come: as the monster & father make love, our narrator climbs down — disappears in the rain — heads out across the fields. Ursula and Letty reach showdown.

But now the family are trapped with Ursula. The old women are concerned. The reason they keep the fleas at bay is not the fleas — it's the predators. The things that feed on the fleas... and old Mrs Hempstock give Ursula a chance to go quietly. But Ursula is happy, while she is, head filled with big plans. The circling vultures, thousands of them slowly circling and descending and Ursula goes to pieces... And the Hempstocks deal with the predators. The ocean is alive. ~~with the ocean.~~

I went to my room. ~~House of rights~~ ~~It took~~ I was shivery convulsively, and I was wet through, and I was cold. It felt like all my heat had been stolen. The wet clothes clung to my flesh and puddled cold water onto the floor. My ~~shoes~~ sandals made comical squelching noises with every step I took, and water came from the little ~~oozed~~ holes in the top of the sandals. I took all my clothes off, and left them in a ~~soaking~~ dripping heap on the tiles by the little gas-fire. I lit a match, turned on the gas-tap, and lit the gas-flame.

Letty said, "You've had your fill. Now go home."

There were shadows all around us, then. Huge shadows, like the shadows of birds, although there was nothing casting the shadows.

Thoughts: you should, on rewrite, Mr Gaiman, make it so the path in and out is left inside him. So the sequence goes — the hunger birds destroy the hole—path out. Then Ursula grabs Neil. Because he has a little of the hole left inside him. They couldn't get it all out — some of the hole had been creeping up — inside his heart. So Ursula will have to ~~grab~~ tear out his heart to be a way home.

I would have kicked, but there was nothing to kick against. I pulled with my fingers at the limb holding me ~~close~~, but my fingernails dug into writhing cloth, and beneath it, something as hard as bone, and it held me close.

"Let me go!" I ~~said~~ shouted. "Let! Me! Go!"

NO.

"Mummy!" I shouted. "Daddy! Lettie!"

But my parents were not there. Lettie Hempstock stared at me, and shook her head. "Lettie, make her let me go."

Lettie said, "Skarthach. Put the child down. I gave you a choice, before. Sending you home will be hard. But we can do it. I think

in their inboxes it will always remain so. It's dark and haunting and fits into that same corner of fractured memory as *Violent Cases* and *Mr. Punch.*

It is such a weird book because it's the same kind of animal that Violent Cases *is, and that* Mr. Punch *is, and that "How to Talk to Girls at Parties" is, even the bits of "Troll Bridge" are, in that the narrative character is absolutely playing fast and loose with my memories and my identity, and he's kind of me except when he's not. And in the case of* Lettie Hempstock, *I really tried very hard to kind of make him as me as I possibly, possibly could. He came out of conversations with Amanda because she just wanted to know, so I said, I will make you something. I will show you. I was like this kid.*

When people asked about Violent Cases, *I would say it's like a mosaic in which every red square is true. But the red squares aren't the picture. And in* Lettie *it's even weirder. Because it's like:* that's *true,* that's *emotionally* true, *and* that's *a complete lie,* that's *fictional. And then there's an awful lot of me moving things around to get them to work, and me having to sort of go back to being seven again to write it, in my head, and walking around the house that's been knocked down for the best part of forty years.*

I had a wonderful conversation with my younger sister Lizzie, who'd read it, where I had to apologize to her that she doesn't exist in it, because fictionally she couldn't exist in this thing. I couldn't have her. A two-year-old threw everything off, because I would have had to deal with her and account for her at all times. And I was trying to explain that it's absolutely true except whenever it's not.

It begins with a narrator remembering forty years ago when a South African lodger stole the family's car and gassed himself inside it. Somehow the act dislodged something in the structure of the world, and strange powers are set loose in the quiet green countryside of England. We see everything through the eyes of the boy, who is never named and is at the center of the horror, and who has no one to save him but the three Hempstock women who live in a ramshackle farm at the end of the lane. This is the same family to whom Daisy Hempstock of *Stardust* belonged and Liza Hempstock from *The Graveyard Book.* "I had this idea about the Hempstocks who have lived at the end of the lane since the Norman conquest," says Neil. But he hasn't written the Hempstock story yet. He borrows characters for other things occasionally—they are some of the oldest characters in his head.

"I wrote the first five thousand words. We got up to the point where the kid and

THE OCEAN AT THE END OF THE LANE

COMING SUMMER 2013

Lettie had gone out and met this big ragged thing. And in my head it was a short story and all that was going to happen was they were going to go and see this big ragged thing and say, 'Stop doing that,' and it would, and that was that. And when I got to the big ragged thing I went, This isn't how this thing ends. This is the beginning. And I apologized to the nice editor, Jonathan Strahan, in Australia, whom I was writing it for, and sent him a poem instead. And then it just sat there in the notebook."

The notebook went with him to Florida in early 2012 when he was supposed to be working on an *American Gods* sequel, a book which many are waiting for. "But it's always easier to write stuff for me that nobody has any expectations for. Which is one reason why I'm terrible at doing sequels. I always mean to. And then I get distracted because I know that the trouble with sequels is that everybody has expectations, and everybody loved the first one and they want more. And you want to give them that. And you want to give them something like they had last time only better. And then there's part of

"Oh, but I'd much rather do this story that nobody is waiting for."

me that goes, 'Oh, but I'd much rather do this story that nobody is waiting for, and nobody knows they want yet.' Then I went for a jog. And the jogging jogged something in my head and I thought, I know what happens next in that thing I was writing that I don't know what it is, but I think that scary ragged thing is going to turn up as their nanny."

It grew from a short story, into a novelette, into a novella, and then once he had finished the handwritten version Gaiman sent a very apologetic and awkward email to his editor saying that he hadn't written the book he was supposed to write, but he had written this other

thing instead, which wasn't quite a novel and wasn't quite a short story either. *The Ocean at the End of the Lane* is frightening and weird and strange and real. "And I don't really know if it will be a commercial book. Maybe it will hit a nerve. With *The Graveyard Book* I knew what I was doing, I knew it would be a commercial book. With *Lettie* I have no idea what will happen."

The novel went straight to number one on the *New York Times* Best Seller list and stayed on the list for ten weeks. Months before the book was released to bookstores, Playtone acquired the rights to the film for Joe Wright to direct. ❖

PICTURE BOOKS

the day i swapped my dad for two goldfish

"My son looked at me one day when I was saying something horrible and unreasonable to him like, 'Isn't it time you went bed.' He was about eight and he looked up at me and his lower lip trembled and he said, 'I wish I didn't have a dad. He said, 'I wish I had something good, like some goldfish.' He then stomped off to bed angrily. I thought, What a great idea."

IN 1993 NOBODY WAS WAITING FOR A CHILDREN'S PICTURE BOOK BY NEIL GAIMAN. WHAT THEY WERE WAITING FOR WAS THE SECOND EPISODE OF THE *NEVERWHERE* TV SERIES. BUT IT WAS FEBRUARY IN WISCONSIN AND GAIMAN WAS TOO COLD TO THINK. HIS WORLD HAD SHRUNK TO WHAT HE COULD HEAT—HE NEEDED TO GET OUT.

I phoned the travel agent in the little town we were in and I said, "Look, do you have a copy of USA Today with you?" And she said, "Yes." And I said, "Well, right now where we are is blue-y purple. And I would like to go somewhere orange. I don't care where it is unless it's orange." And she said, "Galveston, Texas," and I said, "Great." And I went away for a week. And I stayed in a little hotel on the docks just next to where the shrimp boats come in. And it was the single most productive week of my life, in retrospect.

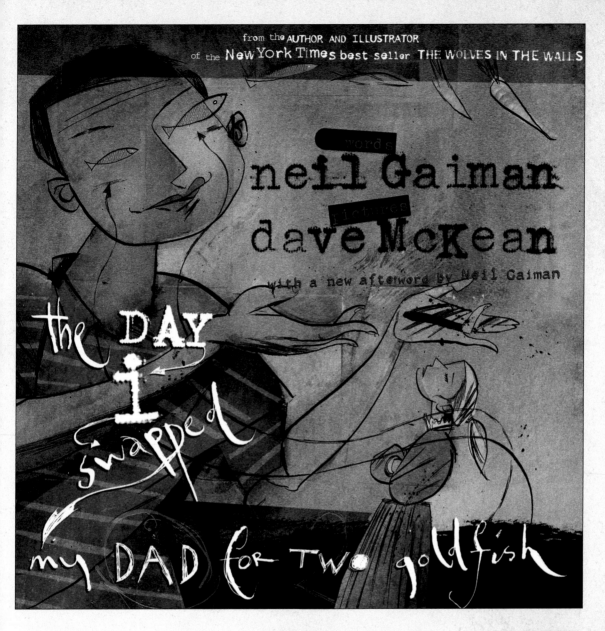

from the **AUTHOR AND ILLUSTRATOR**
of the **New York Times** best seller **THE WOLVES IN THE WALLS**

words
neil Gaiman

pictures
dave McKean

with a new afterword by Neil Gaiman

the **DAY** I swapped my **DAD** for **two** goldfish

On the plane he wrote the start of a short story called "Snow, Glass, Apples," continued it in the bus on the way to the hotel, and finished it in the lobby. But nobody was waiting for a weird sexual Snow White story either. Later, when stuck somewhere halfway through *Neverwhere* episode two, Gaiman went looking through his hard drive for inspiration. He found a document with the first paragraph of something called *The Day I Swapped My Dad for Two Goldfish*. Years had passed since he had started it, but the story had been living in his head ever since: he knew what happened next. Four hours later it was done. When he returned home, after a week in a hotel somewhere warm, Gaiman had two things no one was waiting for, and a fairly sizable chunk of something they were. He was pleased; everybody else was grumpy that he hadn't finished episode two of *Neverwhere*. He named the rabbit in *The Day I Swapped My Dad for Two Goldfish* "Galveston" in the week's honor.

If we don't count the children's book episode of *Miracleman* (some might), *The Day I Swapped My Dad for Two Goldfish* was Gaiman's first book for kids. Partly this came from the fact that his own children were now old enough to say things worth stealing. ❖

ABOVE: Jacket of the 2004 HarperCollins edition. In order to finance Dave while he finished the art for the book, Neil sold the rights to White Wolf, a gaming comany that had a relatively successful publishing imprint. It was their first and only children's book; the rights were later transferred to HarperCollins.

the wolves in the walls

"When the wolves come out of the walls, it's all over."

ABOVE: A photo
of Neil next to the
stage play poster, 2006.

MIKE MAY HAVE ONLY HINTED at swapping his father for a pair of goldfish, but the wolves in the walls were plucked straight from Maddy Gaiman's head. Back in 1998, when Maddy was four, the big Addams Family house was old and in need of some work.

We were living in a house that definitely had things in the walls. I live in that house now, but lots of rebuilding has happened and the inside and the outside are a little more discrete, but back then there were bats in the walls, possibly rats in the walls, definitely mice in the walls. And you would hear them. They would scritch and they would scratch . . .

I went upstairs and I heard crying coming from the bedroom. And at that time she was still sharing a bedroom with me and Mary. She had her own little bed down in the corner of it, but she was asleep in my bed. And she woke up. She was crying. I said "What's wrong?" She said, "The wolves came out of the walls, they took over the house! I had to run away from them" I said, "It's okay, it was just a dream." She said, "It wasn't a dream. I can prove it." And I said, "How will you prove it?" She said, "I can show you the place in the wallpaper they came out from." So she showed me the place in the wallpaper they came out from.

Over the next few days she was still deeply worried about the wolves in the walls. And I would tell her little stories in which she and I would take on the wolves in the walls, and we would win once they came out of the house. They were definitely wolf-battling stories. After a while she stopped worrying that the wolves were going to come out of the walls and I thought, This is such a story. This is so awesome.

The Day I Swapped My Dad for Two Goldfish had come out the previous year, so Gaiman was now a writer of children's books, and he sat down to write what would become *The Wolves in the Walls*. Afterward, he looked at his two thousand words and decided they were "really lifeless and really dull" and contained none of the vibrancy of the thing in his (or Maddy's) head. "So I went away and thought about it a bit. And one day I was walking home and I suddenly thought, 'When the wolves come out of the walls, it's all over.' And I knew the rhythm of that. And knowing that, I thought, Okay, I

Wolves in the Walls Lyrics

There are wolves in the walls
there are creatures in the cracks
There's imaginary monsters
there are shadows in a
 hundred shades of
 black
And all the things you ever
feared
Happen now and
 happen here
Was that rattle just the wind?
That reflection just the moon?
You'll find out soon.

There are wolves in the walls
there are nightmares in the night
there are creatures without feathers
there are things which
 hunt and vanish in the night

And all the things you ever feared
happen now and happen here
was that scuffle just the cat
did it seem to be so near
you'll find out here.

Don't be afraid of the darkness
Or the way a shadow falls
Don't be afraid of the
 imaginary things
only the wolves in the walls.

think I know what the rest of this sounds like. I think I have a tone of voice.

"I do actually know where I stole that from, and I wrote him a letter and told him. He'd told me how much he liked it, and I said, 'Actually, I think I got the key phrase from you.' That was Daniel Pinkwater's book *The Snarkout Boys and the Avocado of Death*; there is a character in it who's the narrator's uncle, and he's a famous wrestler who complains about the terrifying thing about having to wrestle orangutans, and who says words to the effect of, 'you have to watch out when wrestling orangutans that they don't get you by your feet, because when an orangutan gets you by your feet, it's all over.' That phrase just sort of stuck with me, and it just came out right as, 'When the wolves come out of the walls, it's all over'" (Wagner, 2008).

Gaiman wrote it twice more after that, in full, because it was short enough that it was easier just to start from the beginning each time, getting it closer and closer to what it needed to be. The idea had been composting in the back of his head, and he trusted it. Consequently, now he's not sure if it took him seven hours to write or if it was more like three or four years. He sent it over to Dave McKean, who illustrated it with jam and tubas and based the brother and sister on his own brood. He wrestled the pig puppet (a gift from Neil to the newborn Liam McKean, a few years before) off his son long enough to photograph it.

"The only thing that was very strange about Dave's work, which I think is beautiful and perfect in every way but one, is what they discovered in Scotland when they came to put it on stage. They said 'Hang on, the little girl is definitely younger. She's the youngest in the family.' And I said, 'Yeah.' And they said, 'But it's drawn with her being older than the little boy.' And I said, 'That's because Dave's family are his models, and so Yolanda and Liam are the kids in that. And Liam was significantly smaller than Yolanda. So Lucy is bigger than her brother in the book. But actually if you read the story closely, it's very obvious that she is actually meant to be the little one.'"

The National Theatre of Scotland's version of *The Wolves in the Walls* was a "musical pandemonium" provided by Nick Powell (with occasional lyrics by Gaiman), and codirected by Julian Crouch of the Improbable Theatre Company with Vicky Featherstone of the NTS. Crouch is the designer responsible for the incredibly creepy *Shockheaded Peter* and the incredibly funny *Jerry Springer: The Opera*. His design went further than bringing McKean's drawings to life. There are a lot of walls and a lot of wolves, the house spins on an axis, and things flap up and down. When the wolves did come out of the walls, they were bizarre shaggy puppets made of burlap and glue stick with their necks and bodies being things of indeterminate shape worn and draped over the puppeteers, whose faces were visible too, which added to the strangeness. ❖

ABOVE: Pages of unused lyrics from the National Theatre of Scotland production of *The Wolves in the Walls.*

BLueBeRRy GIRL
and
INStRuctIONS

oveR the yeaRs GaImaN has met huNDReDs of aRtIsts who have theN BeeN cauGht up IN the whIRLwIND that Is hIs coLLaBoRatIve LIfe. But theRe Is oNe who Is No ReGuLaR coLLaBoRatoR; she Does Not ILLustRate hIs Books, aND he Does Not wRIte heR soNGs. they steaL fRom each otheR. they feeD off each otheR's aRt. she's LIke a sIsteR he coLLecteD somewheRe oveR tIme.

Gaiman first met Tori Amos when her friend Rantz, who'd been crashing at her apartment, gave Gaiman a demo tape in the signing line at San Diego Comic-Con in 1991. Rantz had left a copy of *The Doll's House* lying around the apartment, and she had ended up writing Neil into a song. "She sings about you in one of the songs," said Rantz. "Don't sue her."

The tape was 50 percent of what ended up being *Little Earthquakes,* and in "Tear in Your Hand," Amos sang about how if you needed her she and Neil would be hanging out with the Dream King. He phoned her and they swiftly became phone pals. He went to see one of her shows about a month later at the Canal Brasserie near Notting Hill in London.

"When I walked in she figured it had to be me and waved. This is less impressive when I tell you that the audience consisted of the publicity lady from East West, one journalist, and a roadie. After a great gig, we wandered off together. We walked down to Notting Hill station and she stood on the platform acting out the entire video for 'Silent All These Years.' I was thinking, 'This is one of the coolest people I've ever met'" (McNair, 1999).

Over the years she wrote him into several more songs, and Neil made her a talking tree in *Stardust.* He wrote short stories for her albums, *Boys for Pele* and *Scarlet's Walk*; letters for tour books; and stories behind each of the characters in *Strange Little Girls.* Amos says that when her music career took off, he would fax her stories all over the world.

But *Blueberry Girl* didn't come into the picture until August 2000. "I was staying in a hotel in Las Vegas, because hotels in Las Vegas are really cheap. Or they were back then. And I had a book to finish—I was working on *American Gods* and I had this idea that I should just go and find a hotel and hole up in it and do nothing but write. . . .

"And the phone rang one day. And it was my friend Tori Amos. And she was calling to tell me that she had her due date for her baby, she had her ultrasound, she knew it was

opposite: Jacket of the U.S. edition, 2009.

a girl. And she said, would I write something for her that was a prayer? And would I write something that was just something that would be small and magical for her daughter to read? And I did. And it was a lovely thing to do in Las Vegas. I suspect most prayers that are uttered in Las Vegas are not about that."

At the time, Amos and her partner were calling the baby the blueberry (later they called her Natashya, and twelve years after that the artist formerly known as Blueberry would read a chapter of *Coraline* for its tenth anniversary video readings). Gaiman wrote her a poem about life and wisdom and hope, a sort of magical benediction from those who had trod before her, a

"She said, would I write something for her that was a prayer?"

vision of aging and growing up and expectations. He gave it to his friend Jon Singer to calligraph. Jon did two copies—one for practice, one for real—and the real one was pinned somewhere near Blueberry's bed, while the practice one was taped to a filing cabinet in Gaiman's office.

"People would come into the office, and they'd stand, and they'd read it. And they'd say, 'Could I have a copy of that?' And I'd say yeah, okay. So I'd make copies of it. And I would do readings. And I would always say, 'Just do me a favor, no mp3s just for this little bit. Don't tape it. This was for Tori and her daughter and let's just keep it private.' And people did, which I think is actually kind of awesome. But after each of these readings people would sidle over and say, 'I have a friend who's very pregnant, could she have a copy?' and I'd always say yes. So I started to turn into somebody whose profession was no longer writing—it was just giving people copies of 'Blueberry Girl.'"

At the Fiddler's Green *Sandman* convention in 2004, Gaiman got talking to Charles Vess, and by the end of it they had decided to turn it into a children's book and to give part of the royalties to RAINN, the rape and incest crisis line charity Tori had founded. He ran the idea past Tori, and she liked it, and Vess spent four years carefully painting each delicate image. The book came out in 2009, Neil got to stop copying out poems for very pregnant ladies, and it spent five weeks on the *New York Times* Best Seller list. Then Gaiman's editor called. During his McFadden Memorial Lecture in 2010, Gaiman said:

She said, "I would love another book from you guys." And Charles and I talked on the phone and I said, "What about Instructions?" And he said, "Yeah, I've always loved that. I will do Instructions." And I thought, That's lovely. That'll come out in oh, 2013. So Charles, of course, having

taken four years on our first book, promptly, with incredible enthusiasm, finished Instructions in like three months. And since then has made everybody, particularly me, promise never to tell anybody because otherwise everybody is going to expect that from him again.

When I wrote it, some years ago, I thought about it as being a set of instructions for navigating and surviving a fairy tale. And that is what I sat down to write. And it was only when I finished it, and I read what I'd written, that I thought, you know, it could also be a set of instructions not just for surviving a fairy tale, but also for surviving life. Because it's about having choices, and it's about what you do.

Trust dreams. And trust your heart. And trust your story. ❖

CRAZY HAIR

NOT THAT LONG AFTER LOCKING HIMSELF AWAY IN A HOTEL IN LAS VEGAS TO FINISH *AMERICAN GODS*, GAIMAN WAS IN FLORIDA DOING THE COPY EDITS ON THE HUGE, FINISHED NOVEL.

All the traveling and work meant that home was rarely seen, and he missed his little girl Maddy who was only about six or seven at the time. They kept in contact by email—sending each other poems or "porys" (that's a poem/story according to Maddy), and Maddy would tell him how many fish she now had (five) and what she had for dinner (fish and sea serpent legs, and also a pirate with legs of pegs), and Neil would reply with his own compositions.

For his fortieth birthday, the Fabulous Lorraine (typist to the youngest author, assistant to the elder) arranged to have the best of Maddy's work collected in a book called *Love, Fishie*. She says in her introduction: "I live and work and love in a world where poems are exchanged nightly and the missing gets a little less, where my small author will shake her head and smile and giggle and call my big one 'Such a silly' over the things that he writes."

Gaiman's hair has a life of its own anyway, but the Florida climate made it go *really* weird.

> I wrote Maddy about the weirdness of being me in Florida. Because my hair, I don't know if you've ever noticed this, is kind of odd.
>
> I went to Florida with hair that looked kind of normal, and I woke up the next morning and it looked like a band of rogue hairdressers had broken in in the night and given me a perm, which they had got halfway through before being disturbed by cops and fleeing through a window. So I had this hair that looked like it was half-permed and half not. Strange, corkscrew curls coming out of my head at peculiar angles that seemed to mean nothing . . .
>
> So I wrote an email to Maddy about my hair. And she wrote a letter back to me and it was addressed to Dear Mr. Crazy Hair. And I thought: what a great line. Crazy hair. I'll just write something funny for Maddy about my hair. So I wrote Crazy Hair in a mediocre sushi restaurant, waiting for the food to come, in pencil in a notebook. I typed it up, emailed it over to Maddy.

The hair became a theme—a shared-world character, a stock member of the Gaiman universe. Days after sending it over to Maddy, Gaiman was a guest at the International Conference of the Fantastic in the Arts, the ICFA, where he did a reading.

OPPOSITE: Jacket of the U.S. edition, 2009.

From the award-winning creators of *The Wolves in the Walls*

CRAZY HAIR

Neil Gaiman
Dave McKean

I had read some powerful passage from American Gods. It was 2001; it hadn't come out yet. And I got to the end and my time had run a little short. I was on my computer, and I was reading from the screen, so I flipped documents and read them Crazy Hair. And at the end of the reading, lots of these academics—the people who go to ICFA are mainly academics—all get into line to talk to me. And I thought they were going to tell me that that little section of American Gods they heard is a work of powering, towering, unimaginable genius; it's brilliant and they think it's going to be a huge success. And instead I had a dozen academics one by one ask if there was any way they could get a print out of that Crazy Hair thing for their grandkids.

He gave it to Dave McKean to draw not that long after, but McKean was just starting to work on their film *MirrorMask* and decided to wait until after he had finished the film, by which point he would have got to grips with some magical computer program that would allow him to make all sorts of crazy hair.

"And there's not much more to tell. It is very silly." ❖

monkey
AND
CHU'S DAY

IN 2007 GAIMAN WENT ON THE FIRST OF THREE RESEARCH TRIPS FOR WHAT HE WOULD MYSTERIOUSLY REFER TO AS "THE NEXT BIG PROJECT" ON HIS BLOG, BEFORE SIGNING OFF, WAVING GOOD-BYE, AND DISAPPEARING BEHIND THE GREAT FIREWALL OF CHINA.

It was going to be his first nonfiction book since *Don't Panic*, and he wanted to do something bigger and weirder than any of the nonfiction he'd done before. He was off to discover the real story behind the sixteenth-century novel *Monkey*, the fictionalized account of the Buddhist monk Xuanzang and his journey to the West—part adventure story, part mythology, and right up Gaiman's street.

He went back two years later to talk with the actor Liu Xiao Ling Tong, who had played Monkey in the Chinese television version of the story, and somehow racked up a $5,000 bill for attempting to use the internet on his phone. So when he went back for a third time in the winter of 2011, he really disappeared. There was no Neil for weeks. He was journeying to the West, with translators and guides, through places like the Xinjiang Province, which he said felt "like walking into *Arabian Nights* in some ways, and like going back in time in others." His visit came after a series of riots in Ürümqi and the government had shut off all communication with the world outside the region. "I had a great guide who was terrified I'd talk politics, and I rapidly discovered that everything except conversations about the spice-sellers in the market or discussion of the pomegranate crop counted as politics. It made my journey even stranger than it might have been already."

All the while Gaiman was researching (and formulating a film adaptation of) the as-yet unwritten next big project. It is still unwritten, but bits of it exist in several different notebooks, which Gaiman says he has to round up and sort out one day. "I think my *Monkey* project will still happen as a book. It is just taking longer than I thought it was.

The biggest trouble with Monkey *is I probably could have written it really, really well if I'd just done a week through China knowing almost nothing. I ran into that big problem that you run into when you actually start doing proper research, of realizing how much you don't know. Suddenly I'd gone from the point where I could fake it*

opposite:
Art from the 2013 U.S. hardcover edition of *Chu's Day* by Adam Rex.

at least one book has definitely come out of the China visit—a picture book called *Chu's Day*. Being an honored foreign guest will get you into many weird and interesting places around the world, and in China that place is Chengdu Panda Reserve. "It's a wonderful thing being an honored foreign guest somewhere like that—you get shown all the cool stuff, get to see pandas, red ones and giant ones, and then find yourself put in a blue disposable smock and gloves (to protect the pandas from you, and not the other way around), and you get a year-old panda placed on your lap. Utter, utter happiness. Better than any number of awards. Makes being a writer completely worthwhile. I suspect that world peace and harmony would come about in weeks if people just got to put pandas on their laps every few months. Honest."

That year-old panda was the inspiration for *Chu*, about a baby panda who sneezes. And when he sneezes, extraordinary, impossible, enormous things happen.

It's illustrated by Adam Rex, who first met Gaiman as a twenty-two-year-old at the San Diego Comic-Con in 1995, when Gaiman was guest of honor. Rex, who was trying to carve out a career doing painted comics, gave Gaiman a piece of *Sandman* artwork which Rex says "he graciously accepted and said was lovely, which it wasn't."

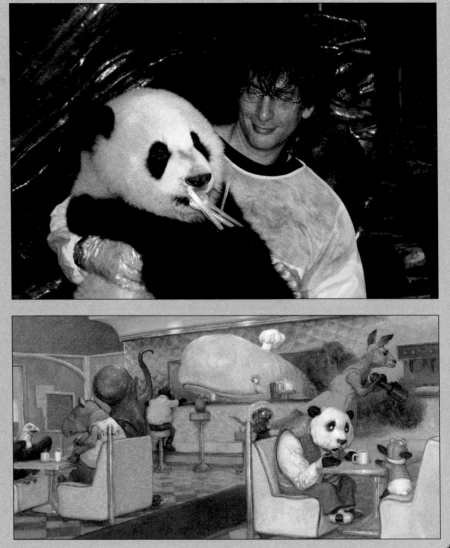

"*One of the things I'm very used to these days is being willing for things to take a long time.*"

convincingly to the point where I actually need to know my stuff. But we'll see. I don't think the Monkey book is dead. One of the things I'm very used to these days is being willing for things to take a long time. Coraline was put away after two years. It came back and took ten years to be finished and published. The Graveyard Book, from idea and writing the first couple of pages and looking at them and going, 'This is crap,' to finishing it was twenty-five years. Maybe twenty-two years. So I'm very sanguine these days about going yeah, that doesn't quite work yet in my head, but it will. So I'll put it away, and I will assume that the little men in my head are off building it while my eyes are closed. ❖

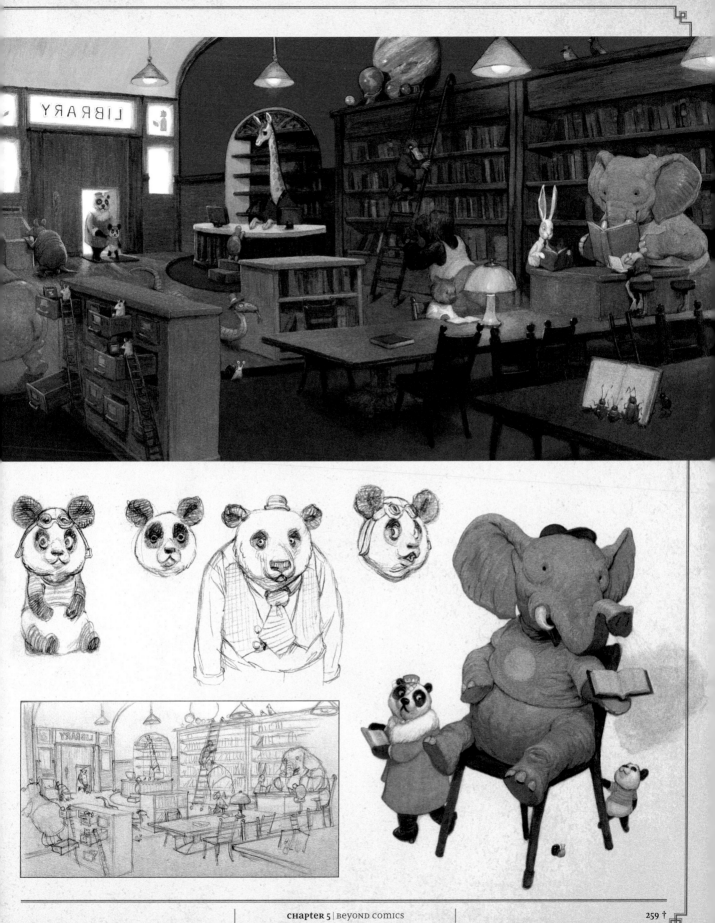

fortunately, the milk

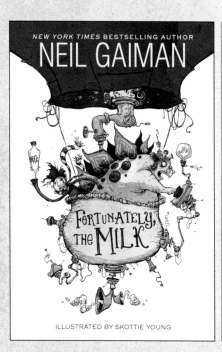

ABOVE: Cover of the 2013
U.S. hardcover edition,
art by Skottie Young.

RIGHT AND OPPOSITE:
Chris Riddell artwork
for the 2013 British
hardcover edition.

THE DAD AT THE BEGINNING of *the day I swapped my dad for two goldfish* DOES NOTHING BUT SIT AND READ THE NEWSPAPER.

Fortunately, the Milk was supposed to be the next Gaiman and McKean book, a sequel to that first one about swapping dads for things that are better than dads. But the book got out of hand and went on too long to be a picture book. It became a short novel for kids, heavily illustrated by Skottie Young in the United States and *The Graveyard Book*'s Chris Riddell in the UK, and the only glimmer of resemblance is the beginning, with a dad being boring and reading the newspaper.

A brother and sister are left under the charge of their distracted dad, who heads off to the corner shop to get some milk. He doesn't come back for ages and ages. The kids think of eating the pickles out of desperation, while their milkless cereal sits in bowls on the breakfast table. The dad arrives home after an indecent amount of time and tells them exactly why he was late, but how fortunately, as they can see, the milk survived despite all the things he'd been through. This time the dad gets to be a hero.

"It took a ridiculous amount of time to write for something that's short and funny and easy (it is a very, very silly book). Because I'd think about it a lot. So it tended to get written in thousand word bursts, but it was a thousand-word burst having thought about the next scene for three weeks." ❖

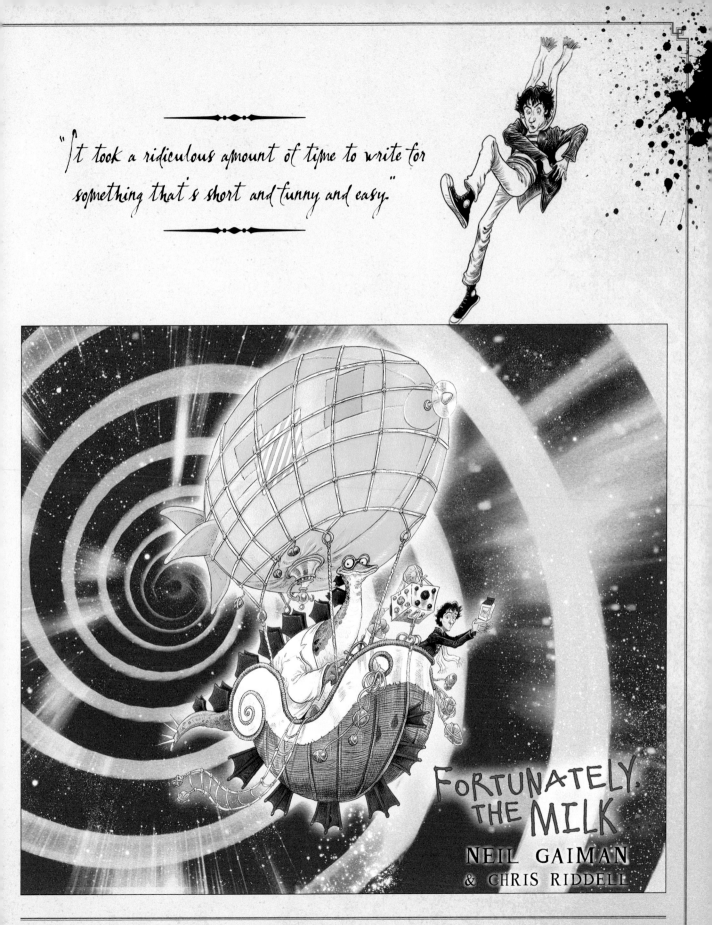

"It took a ridiculous amount of time to write for something that's short and funny and easy."

FORTUNATELY, THE MILK

NEIL GAIMAN & CHRIS RIDDELL

6

silver screens

HOLLYWOOD

"The trouble is, it's not funny. I mean, it's very sad. And I think the only reason it carries on as long as it does is because people always assume, as I've always assumed, all the Hollywood stuff was a joke. I always assumed that when people told their Hollywood stories, they were only kidding, because it wouldn't be that bad. Gradually, you discover that it really is that bad."

FROM VERY EARLY IN HIS CAREER, GAIMAN HAS BEEN DEALING WITH HOLLYWOOD, USUALLY IN THE FORM OF DRINKING SPARKLING WATER WITH SOMEBODY IN AN EXPENSIVE LONDON CLUB AND THEN HAVING NOTHING COME OF IT.

These days films are just as likely to get made as they were back then—they happen unless they don't. In Hollywood things are never dead; occasionally ideas thought long forgotten stir in their graves, some are dug up entirely and live again. Hollywood is, kind of ironically, unpredictable—unpredictable both in terms of what gets made, and in what kind of thing it is once it has been made. When you look closely at the mechanics of how movies are produced and how many people wind up having a hand in it, it's astonishing that any good films get made at all.

"It may just wind up creating art, and it may not. It may be a good movie, and it may not. But the things that will make it a good movie are not necessarily anything to do with me sitting writing my outline, or me writing my script. Which may sound slightly apathetic, but I think it's essentially more practical. One of the things I love about comics, I love about radio plays, I love about short stories and novels: if it works, it's my fault. If it doesn't, it's my fault. And with films, if it works, god knows whose fault it is" (Baker, 2008).

Gaiman's first dealings with the world of movies was *Good Omens*. There had been several companies bidding on the rights with all of them—bar one—stipulating in their conditions that Pratchett and Gaiman be on board to write the script. They both flew over to LA for the meeting.

We were just about to go up to the boardroom for the first actual story meeting, and Terry sidled over to me and said, "If this all goes wrong and we just need to get on a plane home to England we need a codeword. We need some kind of codeword that says This Is Irredeemably Wrong and We Are Walking Out Together." And I said, "Well it'll have to be something neither of us would actually ever say during the course of conversation and something that Americans wouldn't know what it means." And he said, "Yes, have you got any ideas?" and I said, "How about Biggles?" So, he said "Yep, Biggles it is."

And we go into the boardroom, we're waiting, we're talking to the various producers and they're waiting for the executive to come in. And the executive walks in and she says, 'Okay, now Good Omens. *Guys, we love this so much and we've actually been*

"With films, if it works, god knows whose fault it is."

thinking, we've already been, you know, tossing this one around a bit and we think it's going to be a film in which you have your witchfinder—we figure he's probably the Tom Cruise, and the witch girl, whatsername in the book, uh, Anathmawhatever, she's Julia Roberts, and then you've got the kid and he has to decide okay, the witch guy—the witch hunter—he's cool, the witch, *she's cute, you know, and they get to walk in the fields and stuff and the dog . . . ," and I look over at Terry. And we didn't Biggles that time, and looking back on it possibly we should have done, but if we had I wouldn't have got to see the giant mechanism of Hollywood Development Hell in action at such a young age and wouldn't have realized that all of the*

∞ **A Screenplay** ∞

AZIRAPHALE
Certainly. But on one condition. When we find him, you have to permit me to exert my good influence on the boy. Teach him right from wrong. All that.

CROWLEY
But. The boss wants a son he can be proud of. Evil. Like him. Out of the question. I'm not having you messing round with the boy.

AZIRAPHALE
Fine. Well, I'm sure that you can find him easily on your own.

A beat. Then, for the first time in quite a while, CROWLEY grins.

CROWLEY
You know, for an angel, you can be a real bastard sometimes.

AZIRAPHALE gestures. The fallen TABLE rights itself, and the bottles UNSMASH.

CROWLEY
But you've got to promise not to mention a word of this to your head office.

CROWLEY POINTS heavenward as he says this.

AZIRAPHALE
Angel's honour.

The Screen begins to fade into darkness.

CROWLEY
Yeah. All right. it's a deal. After all, with both of us looking for him. Well, how hard can it be?

FADE TO BLACK.

43

ABOVE: A page from the *Good Omens* screenplay.

jokes you hear about Hollywood are true. . . . It is that stupid. It is that nonsensical. It is that strange.

The art form of Hollywood is not the movie, the art form is actually the contract, and every now and then some films get made as a result of this beautiful art form, the contract. Enough of them exist around a project and it actually happens (Grant, 2011).

So embittered was he by the whole *Good Omens* experience in Hollywood that Gaiman came home and wrote "The Goldfish Pool," a bleak story about a writer in LA trying to turn his novel into a script for a bunch of ever-changing movie people who seemingly have never read the novel, nor the blurb, nor the outlines and treatments they keep telling the writer to change, which is precisely what happened forth. Handed it over to them, and get a phone call back saying, 'Well, it's not like the book, is it?' These are like people who order pizza and then complain that it's round and flat and has all this red and yellow stuff on the top. And at that point everybody got fired, and they went off into Chapter 11 and we got the rights back" (*Comics Journal* #155, 1993).

After the *Good Omens* business, Gaiman went home and said no to anyone from movies who came calling. He said no to Bob and Harvey Weinstein and their (potentially life-changing) three-million-dollar offer for the rights to all of his short stories, because he would have no control over what they did to them. He said no to hack script rewrites. He got himself a good, solid Hollywood agent—one who understood what Gaiman was about, and was not trying to turn him upside down and wring

"My friends who were ahead of me, who had walked the minefiled ahead of me, became in some ways my warnings as to what either to do or not to do."

to him. He and Pratchett wrote a first draft of the script for Sovereign Pictures (who did films like *My Left Foot*, *Reversal of Fortune*, and *Hamlet*), and they hated it. "Terry said, 'Fuck this for a game of soldiers. I think I'm going to go and write some novels.' I said, 'I will stick it out for a second draft.' So they flew me out to North Carolina. We had plot discussions, and they basically said, 'Well, we don't want, you know, could you, like, give us another plot?' If that's what you want, okay. So I went away and put together this completely different plot, which intersected *Good Omens* at points but was a different plot and which, whenever the same thing actually did happen, it was for a different reason, and so on and so him out until he was just another burnt-out Hollywood husk. A Hollywood agent who wouldn't mind him saying no to things, who would say no to things too. And in the meantime, Gaiman went off and did *Neverwhere* for the BBC and learned that many of the problems in film and TV are intrinsic to the art form.

Gaiman looked to his friends to see how they had done it. When he first turned up on Douglas Adams's doorstep in Islington in 1983, Adams had just returned from a bad time in Hollywood where they had wanted to turn *The Hitchhiker's Guide to the Galaxy* into "*Star Wars* with jokes" (Gaiman, 1993). He considered the time he spent in Hollywood unhappily missing his friends

and struggling to write screenplays "a lost year," one in which he became more and more depressed and began to lose touch with the things that made him write the way he did. Adams was glad to be home.

My friends who were ahead of me, who had walked the minefield ahead of me, became in some ways my warnings as to what either to do or to not to do. Alan Moore, Clive Barker, and Douglas Adams being the most important three. Because I could look at Alan and I could look at Clive and I could look at Douglas and go okay, you took that *path. And that worked* here *and* here, *but it doesn't really work* there. *And it works for you, but it's not that thing that I want to do.*

Clive embraced Hollywood. Clive slammed Hollywood up against a wall and had enthusiastic carnal knowledge of it. Alan closed his front door and when people called from Hollywood, he told them he was out and not to call back. People would ask why I'd got so involved with Stardust, *or with* Coraline. *And I say, well, lots of reasons. But they say ah, but Alan Moore, he just lets people make films. And I said, well yeah, but then he's always miserable about the films and doesn't see them.*

(As for *Good Omens*, it isn't dead yet. For a while it looked like Terry Gilliam was going to direct it, and as late as 2006 that was still the case. At time of writing Terry Pratchett's own production company, Narrativia, has plans to turn it into either a television series or a film.)

Over the years Gaiman slowly built up a network of people he trusted and wanted to work with, and has since gone on to make amazing movies with them. But it seems like the art form in Hollywood is not movies, but surviving in a system that chews people up.

Unlike movies, Gaiman's Hollywood ending is not finite or perfect. It's bumpy and filled with appearances and disappearances, successes and weirdness. *Princess Mononoke* was weird. ❖

ABOVE: The *Good Omens* screenplay was published as *A Screenplay* in a very limited edition by Hill House in 2004, produced exclusively for subscribers. Title page of *A Screenplay* signed by Terry and Neil.

PRINCESS MONONOKE

"Those were the days of gods and demons."

PRINCESS MONONOKE IS ANOTHER STORY OF HOLLYWOOD MADNESS, BUT A DIFFERENT BRAND TO THE ONE GAIMAN EXPERIENCED WHILE HACKING OUT DRAFTS OF GOOD OMENS.

"I got a phone call from Harvey Weinstein and it was the kind of phone call that begins, 'Please hold for Harvey Weinstein.' I did."

This was in 1997 when Bob and Harvey Weinstein were still at Miramax, the film production company they founded in the late seventies, but which had, for the last few years, been under the control of Walt Disney. Disney had scored a deal with Studio Ghibli for Hayao Miyazaki's glorious animated film *Mononoke Hime,* the highest grossing Japanese movie of all time (five years later Miyazaki would smash box office records again with *Spirited Away*). It's a magical story set in a fourteenth-century Japanese forest, a story about ghouls, beasts, and ancient gods, one in which characters are dealt their death days before it happens and have time to contemplate life and what it means. It's meandering and beautiful, but it's also violent and strange, so Disney thought it better to release the film under the art house Miramax. They handed it down to the Weinsteins with the same deal they had agreed with Studio Ghibli: nothing could be cut. Not one frame.

Miramax had a literal translation of the film's script, but literal translations are artless and cold. Harvey Weinstein asked if Gaiman would come and see the film with an eye to doing an English translation so that it didn't end up sounding like a Saturday morning cartoon.

I said, well, send me a video. And he said no, we're going to fly you to LA. And he flew me to LA, into a huge screening place where it was just me, and I sat and watched the film. And I came away from the film and I thought, I don't know that I want to do this. But I do know that I don't want somebody else to screw it up. I think I can do this, and if I screw it up at least I'll be screwing it up with love.

So I went in for some meetings at Miramax with Harvey Weinstein and Bob Weinstein, who was dealing with the film, and Steve Alpert from Studio Ghibli, who was basically the American at Studio Ghibli and speaker-to-Americans. We got on really well, and I went away and wrote a first draft script. Got notes on it. Got a

second draft script. I was watching the film over and over and over again, frame by frame by frame by frame, trying to make the words fit.

When we get to (I think it was) the third draft, things got really weird. I was very happy with my first draft but people had notes. And then the second draft. By the third draft the notes were getting weird, because I was getting a set of notes in from Studio Ghibli, which could be summed up as, "Can you make it more Japanese, please." And a set of notes from Miramax which could be summed up as, "Can you make it less Japanese, please." And the notes were so specific and so contradictory that I said, There is only one way out of this, and I did draft 4a and 4b and sent them both in and said, "Here is one per the Miramax notes, here is one per the Studio Ghibli notes." And they came back with notes and I did a fifth draft.

What happened next was a bit odd.

Having got to the script in which literally every word of my script had been negotiated and approved because it had to be approved by Miyazaki and it had to be approved by Harvey Weinstein, they handed the approved script to a guy whose job it is to make sure that all the dialogue that I've written works with the mouth flaps of the characters.

I had one conversation with the lip-flappy guy. I was at a convention and he phoned and we had this really weird conversation where he was saying he really liked the subtitles and I was saying, "Trust me, we've negotiated every line in here. If you have to move things around to make them work, obviously do, but why don't you send them to me after that and I'll adjust them?"

Having handed in his script Gaiman was—as is traditional with script writers—cut out of the picture and heard nothing for nine months. In that time, the lip-flappy guy ignored Gaiman's script, went

TOP: A scene from *Princess Mononoke*.

ABOVE: Creating the lyrics for the English-language version of the theme song for *Princess Mononoke*.

back to the original subtitles and rewrote a script of his own based on that. All the lip flaps matched, his job was done, and he handed it over to the director, Jack Fletcher. He and his all-star cast—Billy Crudup, Claire Danes, Minnie Driver, Billy Bob Thornton—went into the recording studio and unwittingly recorded something not written by Gaiman (Gillian Anderson's dialogue, which Neil *had* written, had been recorded earlier) and not approved by either of the Weinsteins or Miyazaki.

Miramax did a midnight test screening of the film with its new English dub under a different title so nobody knew what was being screened. Harvey Weinstein was in the crowd as the film got booed.

"Harvey, I was told, prepared to rip me a new arsehole for delivering such an incredibly crappy script. He called for my script, looked at it, and went, 'This wasn't what we saw last night. This isn't the dialogue that was said, this is something else.' At that point I got brought back into the equation having been very cut out. And I got to hang with Jack Fletcher, the director, and I gave Jack the five drafts of my script he'd never seen before."

Fletcher loved the life and energy of the very first draft and wanted to re-record the actors based on that. Only there was no time to do it. With just one day of recording left per actor, they could not change everything. Together, Gaiman and Fletcher put back as much of the original script as they possibly could, although some notes from Miyazaki that had been carefully worked into Gaiman's script had to fall by the wayside—the guns are still called "rifles" and Ashitaka's girlfriend is still his "little sister."

"There's stuff that was frustrating to me because it was absolutely right and perfect in my original draft, which was approved by everybody including Miyazaki. And then we had to go in and do the very best we could. I felt that we got 90 percent of what we should have got. Maybe 80 percent. The hardest one was Billy Bob Thornton, who needed to re-record all of his lines and was shooting a movie, and his movie had to be shut down for a day while he came and recorded his part in *Princess Mononoke*. I don't think he was terribly

pleased, and I never really felt like we got the Billy Bob Thornton part that we should have done after that. But we had something that was significantly better than the thing that they'd showed that got booed."

But at the point where everybody should be wiping their brows and praising whatever god they like that *Princess Mononoke* was relatively saved, she was not in the clear yet. More Hollywood madness awaited her: Harvey Weinstein wanted to renege on his deal to not touch a frame of Miyazaki's film. At dinner, after a hugely successful screening at the Lincoln

"You have this magical thing that's not like anything else."

Center in New York City attended by the actors, the director, Miyazaki, and his producer, Toshio Suzuki, Weinstein told Gaiman that he wanted to cut the film.

I said Harvey, you've lost that battle. The whole thing—the reason they came on very proudly at the beginning of this—was we have a contract where not a frame can be touched. It is a point of pride for them that not a frame will be touched. He said, "Yeah, yeah, yeah but you know what? They'll let me. It's about twenty-five minutes too long and if I just cut it down it's going to be brilliant." So I said no, I don't want to be there for that conversation, you're on your own. Good luck.

Toward the end of the meal, Mr. Miyazaki and Mr. Suzuki nipped outside for a cigarette, and Harvey went out with them and came back in on his own. There is no Miyazaki and there is no Mr. Suzuki. And there is no more Steve Alpert and there is no more their translator. And I go to Harvey and

I say, "What happened?" And he says "Oh, they've gone. They didn't like the idea. They went back to the hotel. But you know what? You wait till tomorrow. The New York Times review is going to come out, it's going to say it's too long, I will show them that, they'll be on my side, it's going to be great."

The next day the review came out and it said it was lyrical and it said it was magnetic and it called my script poetic and it was a beautiful, wonderful review, and at that moment Harvey kind of dumped Princess Mononoke.

It's a long film. And it is not a fast film, it is a relatively slow film, but it's slow in the way that some of the great Japanese films are slow. I'm not even saying Harvey was wrong for the American audience. He might well have been able to chop Princess Mononoke down to something shorter, and then get behind it and push it to more commercial success, but that feels almost irrelevant. You have this magical thing that's not like anything else.

The bigwigs at Miramax didn't come out to LA for the premiere, and when I discovered that my name had been removed from the poster, it made me sad. It didn't do justice and respect and love to a remarkable film and a beautiful vision.

Miramax released the film with practically no fanfare at all—laying on little to no advertising and only giving the film a very limited run in a small number of theaters, meaning its box office performance was less than spectacular (and Disney was not impressed). It was one of those things that fans found and loved on DVD instead. A Miyazaki film is a treasure, and people will always find him, Hollywood or no. ❖

IN 2007 GAIMAN WENT to Japan for the release of Stardust. "While I was there I went out to Studio Ghibli and really had just expected to go and say hello to Steve Alpert, possibly shake Mr. Miyazaki's hand. And instead he took the day off and showed me around and showed me this wonderful sort of nursery school space that he's built for the little kids in the area. He showed me this magical house that he'd built next door just as a place to go and think about stories, paths through the air and stuff like that. And we talked about Diana Wynne Jones, we talked about life and art, he showed me all of this stuff that was going to be Ponyo."

Here are Miyazaki, Gaiman, and Mr. Suzuki grinning surrounded by drawings by Miyazaki for his 2008 movie, Ponyo.

Beowulf

WHEN *BEOWULF* PREMIERED IN 2007, IT WAS AN ENTIRELY DIFFERENT BEAST TO THE ONE ROGER AVARY HAD IN HIS HEAD IN 1982 WHEN HE SCRIBBLED SOME NOTES ON HOW TO TURN THE EPIC POEM INTO A FEATURE FILM. IT WAS ALSO PRETTY FAR OFF THE SCRIPT HE FIRST DRAFTED WITH GAIMAN UNDER A PALAPA IN A MEXICAN QUINTA.

The saga of the *Beowulf* film started, in a way, with *Sandman*.

In 1996 Avary was sitting in Lorenzo di Bonaventura's office at Warner Bros. being told how brilliant he was by Di Bonaventura, who had loved Avary's *Killing Zoe* so much he was determined to do a film with him, he just didn't know what. He rattled off a list of options for Avary to pick from, and one of them was *Sandman*. Avary, who had been a fan of the comic since 1989, was out-of-his-mind excited at the idea of doing a *Sandman* movie. He had basically already made one in his head when he discovered the series while working in the mailroom of an advertising agency back in the days when *True Romance* was still unmade. One of the executives had a standing mail order for DC Comics, and since they were only for advertising purposes and he never actually wanted them, Avary ended up taking pieces of *The Doll's House* home. In his head Johnny Depp was Dream and Fairuza Balk was Death. He immediately signed on to direct *Sandman*, took the script home, and worked on another draft with its writers, Ted Elliott and Terry Rossio, best known these days for *Pirates of the Caribbean*.

So Avary was on *Sandman*, and then very soon he wasn't. "Roger made the fatal mistake of going in for a meeting and proudly showing them Jan Svankmajer's film *Alice* to demonstrate how he felt the sequences in the Dreaming should look and feel," said Neil, a fact which actually would have clinched the deal for him personally—a man who thinks the Dreaming should look and feel like a strange half stop-motion animation made out of bits of doll, taxidermy rabbits, tiny skulls, sock puppets, and crab claws is at least demonstrating the right kind of thinking—but Warner Bros. balked. In Hollywood it's easier to do your job by saying no to things, because if you say yes to something and you're wrong, you're out on your ear. Eventually, Avary walked. He didn't want to be the guy who ruined *Sandman*. He had also not been paid for a year and a half's worth of work.

As for Gaiman's involvement in any *Sandman* film, he subscribes to the Samuel Goldwyn approach: "Include me out." He said in 1994, "If you get involved, you can get hurt. Quite seriously, this is my baby; it's something I've been living with for seven years. Nobody should be asked to barbecue their own baby, nobody should be asked to cut off its little fingers and marinate them" (Roel, 1994). But he had spoken with Avary while he was working on it, and obviously respected the fact that he would rather walk than bastardize something he loved. He phoned him up a couple of months later simply because he liked him and wanted to see how he was doing.

I liked talking to him, I thought he was funny, I thought he was sharp, I liked Killing Zoe. While we were talking Sandman, we'd talked enough about Pulp Fiction to realize the things that I really liked about Pulp Fiction in terms of the odd plotting were all Roger. It was all the where-the-fuck-did-that-come-from, how-does-a-mind-come-up-with-that stuff—the willingness to just follow an idea as far as it would go.

So Roger and I were talking about what he was working on, and what he had going on. He mentioned that he had a script for Beowulf, and I started saying, "Yeah, you know if I ever did Beowulf, I would love to make Grendel's mum beautiful and scary," and he was saying, "Yeah, that's what I want to do too. I want a Nastassja Kinski kind of Grendel's mum. The only thing I can never figure out is how you get from act two to act three." And I said, "Well, you just make the dragon Beowulf's son." There was a millisecond's hesitation and then he said, "When are you free?

When can we get a week and go off and write this?"

Three months later, in May 1997, Avary and Gaiman flew to Puerto Vallarta (vaguely midway between Avary's California and Gaiman's Wisconsin) and stayed in a borrowed house. They turned the strange old Anglo-Saxon poem, which English lit students have dreaded for years, into a movie a bit like *Monty Python and the Holy Grail* and *Jabberwocky*—or in other words,

aʙᴏᴠᴇ: Beowulf (Ray Winstone) battles a dragon and encounters Grendel's mother (Angelina Jolie).

"an incredibly low budget, relatively irreverent, serious-but-funny-but-serious, sexy Terry Gilliam-esque film in which everybody has been sprayed with dirt.

"It was very much both of us doing it at the same time. We had two computers, we were backing and forthing, cutting stuff between computers, building it up. I was doing stuff, he was doing stuff, I was mucking with his, he was mucking with mine, and at the end of the week we had a script."

They went home, sent their script to people in Hollywood, and waited. The script was sold a few months later to former Hollywood agent Jack Rapke and *Back to the Future* director Robert Zemeckis's company ImageMovers, who were then in cahoots with Steven Spielberg's DreamWorks. It had an immediate green light, and in 1998 if there was one thing that Gaiman was certain of it was that *Beowulf* was going to be made. And then, after a year of rewrites, the green light got turned off. DreamWorks had bought *The 13th Warrior*, which was also *Beowulf*-influenced, and decided they did not want two *Beowulf*-type movies going on at the same time. So Zemeckis and Rapke set the movie up outside of DreamWorks. After another year of working on the film, the option expired, and *Beowulf* lay dormant. Avary was not so much grumpy this time as sad.

In the end, Zemeckis could not get *Beowulf* out of his head. He wanted to direct it himself, and he wanted to use the same performance-capture technique he'd pioneered with *The Polar Express* and use it to create the monsters and world that would be needed for a Viking epic like *Beowulf*. He asked Gaiman, who said it was totally up to Avary. It was Avary's baby and Gaiman would go along with whatever Avary wanted. In 2004 Zemeckis sent in his partner Steve Bing to try to wrench the script off Avary in exchange for whatever he asked for. Avary was so set on directing the film himself he had grown a Viking beard of his own to prove it (and would not shave it until the film was made, and by this point it had reached his nipples). In an attempt to make Zemeckis and Bing go away, he said he'd only part with the project for the moon on a stick. Bing plucked the moon from the sky, made it look like an astonishing amount of money, and Avary took it home and was heartsick. (Neil understands the need to direct your own film. He's been

campaigning for *Death: The High Cost of Living* for roughly a decade.)

"Then we had to rewrite the script a lot over the next eight months to make it something that was no longer a little live-action, Terry Gilliam–esque movie shot on a budget, where we were trying to figure out embarrassing and easy ways to do the golden dragon. Suddenly we were making the golden dragon dive under the water to try and get Beowulf shaken free, he grabs an anchor and he throws it. Very *Raiders of the Lost Ark* kind of stuff. And once the script was rewritten, Bob Zemeckis did his own draft on it which mostly was cutting things. Cutting dialogue, cutting things down."

The European premiere at Leicester Square in London was huge. Massive torches burned on either side of the cinema entrance, men in loincloths beat battle drums on rooftops, and the throng of paparazzi strained over barriers by the red carpet to get pictures of Angelina Jolie, Grendel's beautiful golden mother. It was exciting. It was an event movie.

All media attention was focused on the strange manner in which the film was constructed—one which put the actors in identical Lycra bodysuits with white balls dotted around them. And mostly the strange animation style worked; certainly it had improved tenfold since the slightly creepy dead-eyed children in *The Polar Express*.

The film was definitely, unequivocally not a cartoon for children. Buxom women scrubbed banquet tables as breasts crashed together in waves, rude songs were sung, hideous arms were amputated in slamming doors, and the bloody stumps were gory. But it worked. Beowulf aged in a way that looked far more believable than an actor in a rubber old-man mask. It worked so well that people were mostly just dazzled by the animation and missed the fact that the script was funny (although Roger Ebert noticed). In a film made on no money with actors running around sprayed with dirt, funny becomes more obvious, humor is built into its ramshackle fun.

In November 2007, *Beowulf* was the biggest film in America and internationally, and that means that Gaiman's name is now

Roger B.

TWO MONTHS AFTER THE European premiere of *Beowulf*, Roger Avary was in a car crash in Ojai, California, which seriously injured his wife, Gretchen, and killed passenger Andreas Zedini. Avary was arrested for DUI and sentenced to a year in prison. When he was interviewed for this book, Avary was keen to talk about *Beowulf* and the other work he's done with Gaiman, but mostly he just wanted to talk about Neil's incredible and admirable work ethic. "He isn't hailed enough for that, and also what he told me after my terrible accident when I was in an absolute depression: 'Write, Roger . . . write.' And so I did, and by god it saved my sanity and pulled me out of a kind of hell that I wish others wouldn't ever have to endure, but is a human condition as old as humanity. Neil saved me. Without question. Aside from my wife he is the friend to whom I owe the most." Later, while going through the notebook scans from Neil's attic, this one stood out. Having spoken to Roger, it all makes sense. Look at the name in the top left corner.

When things get really bad I go to the writing place.

big enough in Hollywood that people return his phone calls. But there's part of him that hopes Avary will one day grow his Viking beard again. "In my heart I hope that one day somebody gives Roger Avary not much money, something like five million dollars and his original script back, and he gets to sneak off and make this pirate Terry Gilliam version of *Beowulf*. I'd love to see that." ❖

Post-Beowulf

coLLaborations start Looking Like russian doLLs when you pick apart the pieces, but there are several projects that came from *Beowulf*, all as yet unmade.

ABOVE: Ideas for
Ramayana, written
on hotel notepaper.

OPPOSITE TOP: Pages
from *The Fermata* script.

For DreamWorks in 2000, Gaiman was commissioned to adapt another ancient epic, this time the holy Sanskrit text, *Ramayana*. He was at the DreamWorks offices talking to Jeffrey Katzenberg, head of animation, about something else entirely when Katzenberg started telling him about some pictorial representations of the story of Rama and Sita he'd seen, while walking through a temple in Thailand. It struck him that it would make a great animated film, and he wanted Neil to write it.

> I had read the Ramayana *as a young man in my battered Penguin Classics edition and just remembered it as a stonking good story. And I said yes, I'd love to look at it. So I went away, re-read the Valmiki version, read any other versions that I could find—a lovely book on the many* Ramayana, *and picture books and comics, and just sort of steeped myself in it and in ways that it had been told. And then I sat down and did my best to do a fairly compressed version, in that you need to decide where your story begins and where your story ends. And for a Hollywood story, I thought the best place for it to begin is just before he meets Sita and the best place for it to end is with him having rescued Sita and they're on their way back. And then to just try and shape the story and try and tell it fairly and honestly.*
>
> *And you obviously have all the elements of classic animation here including the magically powered cheerful god-but-he-isn't-really-but-he-is-really monkey sidekick of Hanuman, you have wonderful demons, you have a golden bow, you have somebody who has a destiny, and you have true love. And I thought, what more do you need?* (Gaiman, 2008)

While drafting the many versions of his own *Ramayana* (about five all told), the story in Gaiman's head looked very much like the work of *2000 AD* artist Brendan McCarthy, who had illustrated a comic by Gaiman's fellow British Invasion writer Peter Milligan called *Rogan Gosh*, back in the early 1990s. McCarthy is known for his wild colors and strange artwork, and *Rogan Gosh* was one of the wildest. "Brendan had his sort of Road to Damascus moment where he ran into a pile of comics in India and went: I love this. There's art stuff here that I've never seen in the West and [he] started doing stuff and playing with it, using that imagery. Brendan burned in my head through every version of the *Ramayana*. That comic was one of the most interesting moments of fusion between Indian and British and American comics culture" (Gaiman, 2008). Years later, after the *Ramayana* movie quietly sank, Gaiman thought about doing it as a comic simply because the story is so visually rich.

CONTINUED:

Arno snaps his fingers. Time stops. He heads over to her table.

> ARNO (cont'd)
> Hi. My names's Arno Strine and I
> think you're wonderful. *[handwritten: Love the way you lick you ... ra for ... finger. It affected us on a very deep + erotic level.]*

She's frozen in time and says nothing.

> ARNO (cont'd)
> So. What are you reading?

He looks at the cover of the book. Then he looks down at the notebook. He flips to the beginning, sees her name and address written there.

> ARNO (cont'd)
> Hello Rhoda. Nice name. Not really
> a nice name, but it suits you. I
> mean, I can't imagine you as a
> Sandra.

He flips through her notebook. There are little notations made on various pages, in her handwriting. One of them says -- and we focus in on it: *Sexiness of men who take their wristwatches off in public.*

INT. BOOKSTORE NEXT DOOR. DAY

Time is still frozen. Arno is in the bookstore. He picks a solid-looking Victorian novel -- Dickens' Bleak House -- off a shelf.

Arno puts down thirteen dollars into an open cash register, paperclipped to a note saying "For Dickens' Bleak House"

INT. THAI RESTAURANT. DAY

Time starts: Arno is back in his seat in the restaurant. He reaches down into his bag and pulls out the Dickens book, puts it up on the table, ostentatiously *not* looking at Rhody, who takes her first sip of tea. Her attention is caught by the book...

Then, filmed as if it's half-way between a striptease and one of those documentaries about the sex-lives of insects, we watch a very strange courting ritual...

As Arno starts to PLAY WITH HIS WRISTWATCH STRAP, while reading.

This almost immediately catches Rhody's attention.

Arno PUSHES his watchband up and down his wrist, unconsciously (although he knows exactly what he's doing). He TWISTS it around his wrist.

Rhody licks her lips.

Then Arno turns a page, and when he puts his hand back on his watchstrap, he gives it a tug, and slowly -- maddeningly slowly -- he UNDOES IT, and PEELS IT from his now naked wrist.

Rhody's nostrils are flared. We can hear her breathing. Arno rubs the place where his watchstrap was.

It's almost orgasmic.

> ARNO (V.O.)
> Okay. Now. We don't rush this. We
> wait and we watch... *[handwritten: Arno looks at ties]*

INT. DEPARTMENT STORE -DAY

We follow Rhody around, as she walks through a Department store. *[handwritten: "Hi Rhody!" corrects clerk "Miss"]*

We catch glimpses of Arno behind her, but they are never more than almost subliminal moments.

Then, in the lingerie counter, she walks into the changing room, with a bunch of stuff.

Arno's just sitting in a chair nearby. *[handwritten: Innocent NOT Stalking]*

INT. RESTAURANT. NIGHT

Arno's explaining -- *[handwritten: to Frozen Bar scene / After Two days of surveillance I'd learned the following things.]*

> ARNO
> No boyfriend. She's smart.
> She's really smart. Okay. And she's
> not Rhoda. She's Rhody. Miss
> Right. Right? So I put into effect
> Operation Say Hello. *[handwritten: Ext Apt.mnt.]*

INT. RHODY'S BEDROOM. DAY

Arno in Rhody's bedroom, with a notebook out. He's picking up books, jotting down titles.

Now he looks at the CDs beside the CD player - Patti Smith, Bowie, Vivaldi. He writes these down.

[handwritten: Basque. Handcuffs. "Hello Kitty" vibrator.]

[handwritten: ARNO / I want you.]

the fermata

AROUND 2002, BEFORE *BEOWULF* had been revived, Gaiman was working on a film adaptation of Nicholson Baker's novel *The Fermata* for Robert Zemeckis. *The Fermata* is a book about a guy called Arno Strine who can stop time, or "drop into the Fold." In that time he is alive and ambulatory and thinking and looking, while the rest of the world is stopped or paused. He doesn't use that time to rob a bank, but he does use it to undress the frozen women in the office he's temping at and to write his demented autobiography on a Casio typewriter. It's an incredibly funny book that, had it been very faithfully adapted, "would be an incredibly long film with some really peculiarly tedious masturbatory bits." Over the five drafts Gaiman wrote, he turned it into something else.

The first time that Bob [Zemeckis] asked me to adapt The Fermata *I said no. Because I just didn't see how you could do it as a movie. And then he came back and said, Please. And I went and I reread the book and I said, Well, okay, you've got a book which is basically about a guy who cannot emotionally contact women, so his solution is essentially a twelve-year-old's fantasy, which is to stop time, undress them, and masturbate. Which is very much the fantasy of somebody who can't quite cope with the idea of actually talking to the opposite sex and so forth. What if we just push it one degree over and do the Woody Allen thing of a person who really cannot communicate with women, but actually give him a little more? Let him stop time, undress them, and paint them. So that was where we took it: as if it were sort of the* Annie Hall*-period Woody Allen, which is all about nebbishes who cannot really communicate with women. He stops time and undresses them. But at least then it's slightly less scuzzy.*

After *The Fermata* drafts, Zemeckis went and spent years working on motion-capture films, but now that he's back in the world of live action, Gaiman has asked him if he wants to dig out the old script and give it life.

> "I have to bear in mind while I'm writing this that this is not just a myth. It is a holy story."

MODESTY BLAISE -- I, LUCIFER outline. Gaiman
Page 1

Modesty Blaise in I, Lucifer.

An Outline.

"Why, this is Hell, nor am I out of it."
Marlowe, Doctor Faustus, Act I sc. 3

INITIAL THOUGHTS

What makes I, Lucifer special?

Firstly the sensibility: it's an action film for people who don't like action films. It's funny (although its humour comes naturally from the story -- there aren't any jokes. Well, except for Willie Garvin's), it's scary, it's exciting, it's strange. It exists in the slippery territory between Pulp Fiction and the X-Files, between Goldfinger and Hellraiser.

We should enjoy our time spent with Modesty and Willie. She is brilliant and beautiful and funny and smart, competent and dangerous. He is irreverent and lethal. Together, they make the perfect partnership. We see them from many different perspectives: Steve Collier's, Rene Vaubois, Tarrant's, and, of course, the Bad Guys'.

Seff is the ultimate villain: he's a puppeteer; a Hannibal Lector, a Napoleon of crime, who gets other people to do his dirty work for him. He ought to be genuinely scary.

Unique to 'I, Lucifer' is the world seen from Lucifer's point of view: not just the glimpses we get of Hell and the Damned, but also the events of the story with the protagonists seen as

The problem with the movie was not (totally) lack of money as is usually the case, but a misunderstanding between holy myth and Hollywood story. Gaiman could see the difference, but the Hollywood executives could not.

One of the weirdest conversations I had was with one of these very, very top executives where I said, "You do understand I cannot do the stuff you would like me to do without changing things so fundamentally that people would get offended. This is a live religion." And he said, "No, no, no, no I've spoken with my advisors. It's just a story, it's a myth; you can do what you want with it."

When I was trying to tell it initially as an animated thing, I found myself looking at it and going, you know, I have to bear in mind while I'm writing this that this is not just a myth. It is a holy story. For hundreds of millions of people it is a story of holiness that people get killed, that riots happen, that things get burned down, that tempers flare, that screwing up the story of Rama could be perceived by a number of people as a deeply offensive blasphemy. Which is not true when you're playing around with something like Beowulf. *You play around with* Beowulf, *you may have some Anglo-Saxon scholars who go, No, this is blasphemous! But they aren't going to burn you, and you know that you won't actually be hurting them to the core of their being. Well, you may do, actually. Ango-Saxon scholars are funny things" (Gaiman, 2008).*

By the last draft the story it had been turned into a futuristic Western and was so bent and changed that Gaiman was calling it "the *Ramayana*-ish project" for DreamWorks, who said that they didn't see a future for traditional two-dimensional animation that didn't prominently feature TV comedians. Said Gaiman in the post-*Shrek* world of 2003, "So I think we can assume that's dead." ❖

modesty blaise

THE BERROW BROTHERS (Duran Duran's managers back in the day, fact fans) and Marcello Anciano (together they were Wandering Star Media) got in touch with Peter O'Donnell, the creator and writer of the *Modesty Blaise* newspaper comic strip and novel series, and acquired the film rights to the character. Within a week they had done a deal with the Weinsteins at Miramax. Thanks to John Travolta's bathroom reading in *Pulp Fiction*, Miramax knew Quentin Tarantino was a fan of the series so hatched a plan in which Tarantino wrote the first in a double-bill of *Modesty* films, Gaiman wrote the second, and Luc Besson directed both. Tarantino chose the first novel, while Gaiman skipped one and settled on the third, *I, Lucifer.* "I thought it was filmic, I could imagine it in my head," said Neil. "It was the one that was most like a weird horror/fantasy novel and least like a standard spy novel. It feels like a classic *Avengers* episode.

"I did an outline, which I think everybody liked and wrote a few scenes of script to go with it so you could get a feel of what kind of thing it would be. Quentin was ridiculously busy. I set aside six months to do *Modesty Blaise* (I think also to work on *Death* or something) and wound up with six dead months because I was simply waiting for a word to come down from Miramax that never came. At the end of that six months it was obvious the thing had expired."

Finally, in 2003 Miramax put out a direct-to-DVD half-baked B-movie called *My Name is Modesty* as a way of extending the rights they were about to lose.

The best part of all this, according to Gaiman, is he got to have lunch with Peter O'Donnell, whose work he had discovered and loved at the age of seven in the form of the second *Modesty* novel, *Sabre-Tooth* (1966).

Black Hole

IN early 2006, when *Beowulf* was still being made, Avary and Gaiman were working on another movie together. This time is was an adaptation of fellow *Taboo* alumnus Charles Burns's brilliantly weird graphic novel, *Black Hole*, a horror movie pastiche about a sexually transmitted teen plague in 1974, which manifests itself in grotesque mutations, like tails and scales. Said Gaiman on his blog in late 2006, "The script for *Black Hole* is starting to feel like a real movie script, I think. Roger and I bought a bunch of CDs with names like *CHARTBUSTERS from 1974!* and have them playing in the background a lot of the time. Oddly enough, the intervening thirty-two years haven't erased how much

I didn't ever want to hear 'Billy Don't Be a Hero' again."

The movie was broken up into three acts with the first to be written by Avary, the second by Gaiman, and the third by both, although Gaiman ended up doing the last one himself, because Avary was up to his eyeballs in other work. They handed it in, and it immediately got picked up by David Fincher of *Fight Club* fame.

I got a phone call from Roger the day David Fincher signed on saying, "We will be fired now. I've worked with Fincher. We failed to do a movie together. I know his method of working, which involves getting someone to do draft after draft. He will want nine to twelve drafts. And our deal is such that they couldn't afford to do that. So we will be fired and somebody young who will do them draft after draft for Writers' Guild minimum will be on the film within three weeks. And then David will never make it."

So a few weeks later, we were fired. Nobody actually fired us to our faces.

But we got fired. Nobody was ever going to call us again on that. And then we heard that David Fincher had brought in a young guy, and we heard that they were doing draft after draft after draft of the script. And indeed the years have passed, and David Fincher has not made it. And the last conversation I had with Black Hole *was with a director in Hollywood whose star was rising, who was telling me how much he had loved our original draft of the script, and how much he had not loved any of the Fincher ones and was wondering if he should go and talk to Paramount or whoever on the scripts because he'd very much like to make it. So anything could happen.*

There was also that idea where Avary was going to rope Gaiman in to play a surrealist artist in a movie about Salvador Dali. But *Gala Dali* has not yet happened and remains here at the bottom of the page, like a footnote.

BABYLON 5 AND THE ROAD TO EN-DOR

IN THE LATE 1980S, BACK BEFORE *BABYLON 5* EXISTED, FORMER JOURNALIST J. MICHAEL STRACZYNSKI TOOK OVER HARLAN ELLISON'S SPOT AS HOST OF A MIDNIGHT SCI-FI RADIO SHOW CALLED *HOUR 25*. GAIMAN WAS AN OCCASIONAL GUEST, STOPPING BY EVEN IN THE POST-JMS YEARS TO TALK ABOUT THE COMIC BOOK LEGAL DEFENSE FUND WHILE ON HIS *LAST ANGEL* TOUR.

Years later, when Straczynski went on to write his televisual space opera *Babylon 5*, he introduced a species of alien that wears a kind of World War II–era gas mask that looks strikingly similar to the helm of Morpheus in *Sandman* (they breathe methane, not oxygen, hence the mask). He named them the Gaim.

For years Straczynski hounded Gaiman to write an episode of *Babylon 5*, and eventually in 1997, after five years of solid hounding, Gaiman had a gap in his schedule. "I said 'Okay, I can do it!' I said, 'I've got an idea,' and I told him my idea. And he said, 'Hm, I like that. Let me run it by the producers.' He rang me back the next day and he said, 'I ran it by the producers. They like it.' And I said, 'Okay, great. Shall I write you an outline now?' And there was a pause. Joe said, 'Do you *like* writing outlines?' And I said, 'No.' And he said, 'Neither do I.' And I said, 'In which case, I have one question.' And he said, 'Forty-three pages,' without missing a beat" (Farrell, 2008).

Gaiman's episode was the only one written by anyone other than Straczynski so late in the show's life. It was an out-of-continuity oddity called "Day of the Dead," in which characters were visited by deceased people from their past, including the famous entertainers Rebo and Zooty, played by the equally famous magicians Penn and Teller. Teller remains typically silent for the whole thing, but occasional strange lines are delivered by machine (voiced by Harlan Ellison).

I was a huge fan of Penn and Teller. I'd first said hello to both of them I think in about 1991. Off Broadway. I think it was the Penn and Teller Rot in Hell tour. Then they were in Bab 5 and I went along to the shooting for a day and I met them. I was going from there to Las Vegas to some kind of big computer show where CompuServe were paying my travel and putting me up to have me come in and do a one-hour signing

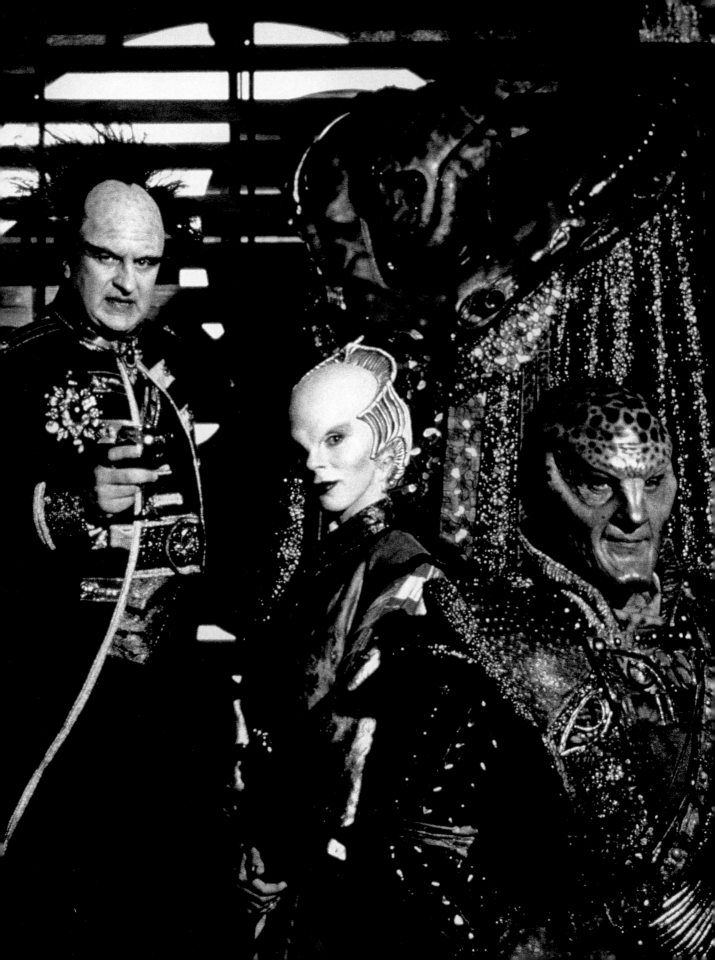

ABOVE: The mask worn by the Gaim—noticeably similar to the helm of Morpheus in *Sandman*.

OPPOSITE: *Lyonesse* notes from a notebook circa 1998.

on their stand. Since they'd also agreed to fly me into LA and put me up there for a night, it meant that I was going to see Babylon 5 and then going to Las Vegas. And I met Penn and Teller, and I discovered that they were actually flying in every night—they were still doing their Las Vegas shows, they were just commuting. I said I'll be in Las Vegas tomorrow and they said, "Come along to the show," so I did, and we hung out. I spent a very long

evening with Penn and Teller and Jamy Ian Swiss, and by the end of it we were friends. I was friends with both of them very individually, and Jamy wound up being my magic consultant for American Gods.

Then Penn and I were emailing each other, and I do not remember in what context, but Penn made a blanket pronouncement that never in the history of humanity had the tricks of crooked medium shit ever been used

for good. And I said well, what about The Road to En-dor?

The Road to En-dor *was a book published in 1919 by Welshman E. H. Jones, a former lieutenant in the Indian Army who ingeniously escaped a prisoner of war camp in Turkey during World War I by convincing his captors that he and his fellow prisoner, an Australian called C. W. Hill, were mediums who could communicate with the "Spook" and read minds. He wrote the book soon after his escape to explain what happened.*

I had read The Road to En-dor *because they had it in my school library at Ardingly when I was ten. And I'd read it and I'd loved it, and I'd loved it as much because it had an amazing how-to-read-minds fold-out diagram set of instructions as anything else. And I learned how you do mind-reading tricks. But I also loved the story, and how it went right, and how it went wrong, and how they would organize things and it would be brilliant, and then the English would come in and screw them over. The English kept screwing them over.*
I mentioned this to Penn, and Penn just quietly ordered a copy from AbeBooks, told Teller about it, and they both read it and came back and said, "This is amazing. It should be a screenplay. Would you write it with me?" I said sure. So then we spent several years trying to find out who owned the rights and eventually we found Hilary.

In a strange turn of happenstance, the owner of the rights to *En-dor* turned out to be Hilary Bevan Jones, an Emmy Award–winning British film and television producer who counts TV shows like *Cracker*, *Red Dwarf*, and *Blackadder* in her filmography. The production company she founded in 1994, Endor Productions, was named after her grandfather's book. Bevan Jones flew out to Las Vegas to meet Gaiman and Penn, and plans were afoot: they were going to team up like the Three Musketeers and make

IDEA FOR IMAGINE
— LYONESSE —

Between Ireland and US, in the Atlantic is Lyonesse. (Sailor castaways?)

Regency - King long gone.

Two houses, both alike in infamy -

Romeo + Juliet affair between the two houses.

Scheming regent. Old king gone.

Sailor cast ashore onto Lyonesse.

It's very 16th/17th C.

The evil regent is also a magician. But the real magicians are further inland.

Think Twin Peaks pilot - meet people.

1, Claudius + MacBeth.

Prophecy says king come again.

appearance of the [?]

this film happen. It wasn't until about 2006 that Penn and Gaiman actually sat down to write the script, eight years after Penn had sent the email that set off the dominoes. They held a reading, did a rewrite, and did another reading in London with Bill Nighy as one of the leads, along with Andrew Scott and Dan Bittner. The last bit of news on the film was back in 2008 when Bevan Jones was in discussion with potential directors. But, says Neil, "'That is not dead which can eternal lie, yet with strange aeons even death may die . . .' as nice Mr. Lovecraft said about giant octopus-faced things that come out of the ocean and destroy the world. Films are like that. Films are like giant octopus-faced people who sleep in R'lyeh. You think they're dead. And then they turn out not to be dead."

Gaiman was working on another project with Bevan Jones called *Lyonesse*, a fantasy series set somewhere that looked like the strange islands of Scotland with swords and magic. "I'd originally plotted *Lyonesse* in about 1996 when there was no fantasy at all around. And definitely no sort of sword and sorcery. Right now you've got *Game of Thrones*, and you've got a lot of knock-offs of *Game of Thrones*. I think it is probably healthy if *Game of Thrones* runs its course and knock-offs of *Games of Thrones* run their course, and *Lyonesse* will still be around, because otherwise people will see it as one of them. So I put that on hold. I really like *Lyonesse*, and I have a pilot episode script more or less finished." ❖

a short film about john bolton

ABOVE: In these unknown waters, film director Terry Gilliam has served as a sort of mentor. In his notebook Gaiman mentions having lunch with Gilliam at some point during filming, who told him that directing was most hard on the feet. "The secret to directing," he said, "is the shoes." A sad and almost illegible scribble beneath the quote says that had Gilliam revealed this a week previous, Gaiman would have thought he was joking.

This was the short film that Gaiman wrote and directed as a way of proving he could. He needed a practice run for *Death: The High Cost of Living*, a film he still wants to direct himself if it ever happens, so he wrote the script, grew a beard, and *A Short Film About John Bolton* happened. It's a half-hour investigation into the question anyone who's ever been at a Q&A will know is at the top of every fan's list: "Where do you get your ideas?"

> *I'd just decided one day that I was going to write a script for myself. I ran mentally through all of my short stories and the thing that the boys in the backroom offered up was, of all things, an introduction to a book of John Bolton paintings that I'd done. And it was just this weird little thing where I'd described John Bolton, and I'd made up a completely fictional John Bolton mostly inspired by the fact that he used to paint himself wearing a gasmask. I was feeling very like, "I don't want to do another introduction that's just another bloody 'this is how I met John Bolton and this is why I like John Bolton and this is why his paintings are interesting.'" So I wrote this completely fictional thing about a painter called John Bolton who happened to have painted the paintings in John's book. And then I thought: that would be a really good thing for a short film. I loved* Thirty-Two Short Films About Glenn Gould, *so I'll call it* A Short Film About John Bolton *(really stupid idea).*

John Bolton is a British artist famous for his photorealistic paintings of dangerously sexy vampiric women. While not strictly limited to the realm of horror (he was Gaiman's first artist on *The Books of Magic*), he is most well known in these parts thanks to working with Clive Barker on things such as the *Hellraiser* comic adaptation. The idea for the film also finds

its roots in the short story by H. P. Lovecraft, "Pickman's Model," in which an artist painted not from the diseased and rotting corners of his imagination but was actually visited by the beasts in his studio and drew them from life. "The subjects of my paintings come to me," says the quiet and reserved John Bolton in the film. "I really don't have any imagination." In one Bolton interview scene he is seated in front of a small portrait of Richard Dadd, Victorian artist and lunatic (Gaiman wrote about him for *The Economist* in 2013).

"These days, with things like *The Office* and so forth, people now understand all of the conventions of faux straight-faced comedy documentary stuff. When we did it, it was still weird and hovery. I just wanted to do something that tasted halfway between *Spinal Tap* and *Blair Witch*, so it just felt like a documentary crew. I remember giving my film crew a really hard time, because I was saying, 'No, I would actually like you caught in the shot. I want it slightly awkward. I want you caught in reflections, I'm very happy for an occasional mic to go into shot or whatever. The whole idea is it's a documentary.'"

A Short Film About John Bolton opens in a London gallery, where the latest exhibition by the artist has just been hung in its classy, clean surrounds: disturbingly lifelike portraits of beautiful undead women slithering over tombstones, staring straight out from the canvas in blues and blacks. English comedian Marcus Brigstocke plays the interviewer, wearing a suede jacket and slightly too-tight jeans—the kind of clothes TV hosts wear that render them "a social outcast in any possible situation." He talks to real-life talk show host Jonathan Ross, who has turned up to buy another painting by the great Bolton to add to his collection. Ross, a longtime friend of Gaiman's, is just one of the many cameos throughout the film; even the real John Bolton is one of the guests on opening night talking about the art of John Bolton, played by John O'Mahony, who spends the opening night party looking detached and uncomfortable. Gaiman populated the rest of the party with pals such as Colin Greenland and Steve Jones, and got Dave McKean to shoot some footage (of which only a few seconds were used in the final cut). He says they didn't need to act all that hard on account of the wine being real.

The highlight of the film is when the interviewer is invited for a rare visit to Bolton's studio, the exterior of which is the ruined church in the center of Stoke Newington's Abney Park Cemetery, later used in *The Graveyard Book*. It's the first time Bolton has let anyone see how the paintings are created, and Brigstocke looks genuinely unnerved. Gaiman tried to keep the color red divorced from the filmic palette; as the tension heightens and Brigstocke shoots more pained looks at the camera, the red is deliberately boosted very subtly and effectively. A smattering of red leaves, red bushes, and a red door tell us we are not in the safe confines of the cold gallery anymore, but somewhere alive and full of portent.

But more than anything, it's very funny. It premiered at San Diego Comic-Con in July 2003. ❖

тне film was sнот in London in a cold November in 2002. Brigstocke said the only time he was actually warm was in Bolton's studio, a scene shot in the same disused hotel in St. Pancras featured in *Neverwhere*, using only candlelight and a low shutter speed. Gaiman's notebook from the set is mostly concerned not with shots or notes for the actors, but soup. The two naked actresses who turn up in the grand finale (those zebra stripes are tattooed by the way) were never far from a bowl of tomato and lentil or chunky vegetable.

BELOW: Marcus Brigstocke wearing the jeans.

WHO KILLED AMANDA PALMER
AND
statuesque

THE SECOND SHORT FILM GAIMAN DIRECTED WAS *statuesque*, ONE OF TWELVE SILENT FILMS TO BE SCREENED ON SKY IN THE TWELVE DAYS BEFORE CHRISTMAS 2009.

In early June of that year, Hilary Bevan Jones had asked him if he wanted to do one of her *Ten Minute Tales*, and Gaiman had said he would, as long as he got an idea. That night, while on stage with Amanda Palmer at New York's Housing Works, he did. It was an event put together by *Spin* magazine, an evening of music and literature in which Gaiman did a reading and Amanda Palmer sang some songs, the general point of which was to highlight the mutual effects they have on each other, as well as being a sort of launch party for her book, *Who Killed Amanda Palmer*.

The *Who Killed Amanda Palmer* photo book had begun a couple of years before. Palmer's and Gaiman's lives were colliding, through friends and art, before they had ever met each other. Palmer had been asked to contribute to an anthology of songs about Gaiman's work; the Dresden Dolls' "Jeep Song" had been one of Gaiman's favorite songs since it came out in 2003. On long overnight flights and in lonely empty houses, they would email each other, as relative strangers, from different ends of the earth. Then Palmer, whose world is a collaborative frenzy much like Gaiman's, asked him if he would contribute to some mad idea she had for an alternate reality game called *Who Killed Amanda Palmer*.

She wanted to do something cool and strange and interactive—a game, a book, and some videos—with the idea that the book would flesh out the stories hinted at in the game. And then it got simpler: she asked him if he would write some short stories to accompany a series of photos in which she was dead.

A year later at the *Spin* launch, Palmer sang Gaiman's "I Google You" and was in the middle of singing "Perfect Fit," a Dresden Dolls song inspired by her time as a human statue in Harvard Square, when Gaiman dug out his notebook and scribbled something down. He had an idea for his silent film: a man documenting human statues the way bird-watchers check off rare species. It was a variation of a short story Gaiman had written in 2007 for an anthology called *Four Letter Word: New Love Letters*, in which

he wrote a quietly creepy letter from a human statue to the woman with the long red hair who passed him every day and never noticed.

You have walked past me and looked at me and smiled, and you have walked past me and other times you barely noticed me as anything other than an object. Truly, it is remarkable how little regard you, or any human, give to something that remains completely motionless. You have woken in the night, got up, walked to the little toilet, micturated, walked back to your bed, slept once more, peacefully. You would not notice something perfectly still, would you? Something in the shadows?

For Amanda, an appreciation.
(After Christopher Smart. Sort of.)

For I shall enumerate my lady's charms, although they are numberless

For FIRSTLY she has a smile like a beam of sunlight breaking through a cloud in a medieval painting
For SECONDLY she moves like cats and Panthers and also she can stand still
For THIRDLY she has eyes of a colour that no two people can agree on, which I remember when I close my eyes
For FOURTHLY she laughs at my jokes, sings unconcerned on the sidewalk and gives money to buskers as a religious act
For FIFTHLY she fucks like wildcats in thunderstorms
For SIXTHLY her kisses are gentle
For SEVENTHLY I would follow her, or walk behind her, or in front of her wherever she wished to go, and being with her would ease my mind
For EIGHTHLY I dream of her and I am comforted
For NINTHLY there is NO-ONE like her. Not that I've ever met, and I have met so many people. No-one at all.

"For lastly she squeaks when I say "waste-paper basket" and also in the mornings, eyebrowless and waking, she always looks so perfectly SURPRISED.

Neil Gaiman

(for the fireflies)

ABOVE: "I went out to stay at Amanda's place to work on these photos, because I knew that the only way I'd get this stuff written for her is if I was there. Because otherwise I'd do things for everybody else that they needed. So I went and I stayed at the Cloud Club and hung with her. It was her and me and Kyle Cassidy as this little mad team."

Left: A slightly rude poem Neil wrote for Amanda and read aloud at the Sydney Opera House in 2011 during her show.

ABOVE: Amanda and
Neil pictured during the
filming of *Who Killed
Amanda Palmer*.

OPPOSITE:
Statuesque script.

The film was shot in September that year, in Watford, North London, starring Bill Nighy as Mr. Jellaby, jam sandwich enthusiast, who takes a packed lunch every day and sits and watches the human statues in the town square. Palmer, a particularly unloved and ignored sort of human statue (unloved even by Dave McKean's son, Liam, in a small cameo), falls in love with Jellaby and decides to gently stalk him. Always frozen, always painted. It's a classic tale of unrequited love and has a twist ending not unlike Gaiman's *Harlequin Valentine*. Its temporary soundtrack of the Velvet Underground, Owls, Rasputina, David Bowie, Steeleye Span, Béla Fleck, Kate Bush, and Louis Armstrong was replaced by a real score by musician Sxip Shirey, and the film was broadcast on Christmas Day.

As for whether or not Gaiman still has a taste for directing after his two attempts, he has this to say:

I enjoy directing. I love the process. I've loved it each time I've done it, which isn't very often. But I think I get spoiled as a writer by being actually quite good at it. I would never look at a book of mine and go, "Oh, I wish I was so-and-so, I would have done this so much better." Whereas occasionally I get offered full-scale films to direct, and maybe one day one of those films will come along and I'll go, "Yeah, I'll do you," but mostly I look at it and I think somebody else will do this better, and so I say no. I loved doing Statuesque, *because it was nine minutes and it was a three-day shoot and two weeks prep and a week cutting it. It was a nice little chunk of my life. But to do a full-scale film I'd really need to want to say, Okay, this is a year of my life, and I'm the best possible person for it.* ❖

STATUESQUE BY NEIL GAIMAN - SHOOTING SCRIPT 4.9.09

1 INT. MR JELLABY'S KITCHEN - DAY 1 1

Jam Sandwiches are being made with white bread.

PULL BACK: A man is carefully making sandwiches in a
small suburban kitchen. The sandwiches go into a
tupperware box.

He fills his thermos flask with a few spoons of instant
coffee, hot water and a splash of evaporated milk from
a tin.

This is MR JELLABY. He lives alone. He is a
businessman.

 CUT TO:

2 INT. MR JELLABY'S FRONT HALL - DAY 1 2

There is a hat-stand, with a bowler hat on it, and a
brown trilby. A black umbrella in the umbrella-stand.

The post arrives.

Mr Jellaby gets it, opens an envelope.

He takes out a hole-punched sheet of paper from the
envelope, puts it into a spiral-bound notebook.

He checks that he has everything: the spiral-bound
notebook of photocopied pages; pens of different
colours; binoculars (two pairs); a camera; a folding
chair; a blanket. He does.

He smiles with nervous satisfaction. Then he puts on
the trilby hat and his coat.

 CUT TO:

3 EXT. MR JELLABY'S HOUSE - DAY 1 3

A car is parked. It is a very small car, but it does
have a back seat.

He loads all the things he has assembled into his car.
He drives away.

 CUT TO:

4A EXT. THE SQUARE - DAY 1 4A

Day 1

"I enjoy directing. I love the process. I've loved it each time I've done it, which isn't very often."

GAIMAN AND MUSICIANS

GAIMAN AND PALMER HAVE gone on to do several projects together, though they try to keep it to a minimum. "We actually work relatively well together, but I think both of us treasure coming home and having somebody who's not involved in what's going on to talk about it with. It's the one thing we lose whenever we work together. We can't go, oh god, this is happening. Because it's happening with the other one too.

"Also there's an awkwardness in our sometimes working together because we are both completely used to having our own way. It's not that we don't play well with others, because we do, but we normally play well with others in context of we have the last word. You can't have two last words. Although we have both tried to have two last words."

They toured America in 2011 with "An Evening with Neil Gaiman and Amanda Palmer," a combination of spoken word, songs, chats, and stories. Part of the idea of this came from the fact that neither Gaiman nor Palmer is good at vacations—by doing a combined tour they got to spend time together while still technically working. She's taken to dragging Gaiman up on stage to sing: four years ago it was Derek and Clive's "Jump," and lately it's been Leon Payne's "Psycho" accompanied by a sawchestra (and at a London show at Koko he was upstaged only by surprise guest Richard O'Brien doing the "Time Warp" in peach tights and pearls). Occasionally Gaiman will serve as her support band, reading a story alone on the stage.

WORDS and MUSIC

sins: "tomorrow's supergroup, today."

Sonnett

I don't think that the were
Atteh I liked a few folk
with engh

ABOVE: The beginnings of what would become "Dark Sonnet" by Lorraine a' Malena.

OPPOSITE: Written on the London Underground in December 2002, during the week Gaiman was shooting *A Short Film About John Bolton.* The beginnings of another song for Lorraine's band, as well as another piece of "Dark Sonnet."

ON APRIL 25, 2011, PALMER MADE GAIMAN JOIN HER BAND. IT WAS FOR AN EXPERIMENT SHORTLY BEFORE THE RETHINK MUSIC CONFERENCE, AN EVENT THAT BROUGHT TOGETHER LEGAL, BUSINESS, AND ACADEMIC EXPERTS TO DISCUSS NEW MODELS FOR CREATING AND DISTRIBUTING MUSIC.

As Palmer had not so long ago ditched her record company in favor of self-management, she was invited to be a speaker, and the idea for 8in8 grew from that. It was Ben Folds's (of Ben Folds Five) idea: instead of a talk, Palmer and her assembled supergroup would perform a record they made in a day: eight songs in eight hours, distributed over the internet just hours after it was made. They were opening up the process of making a record to fans, webcasting the whole thing to show how art is made or would be made if it was done by locking three musicians and an author in a recording studio. It was also, for the purposes of Rethink Music, an exercise in timing and distribution—showing what can be done with next to no money, showing what's possible at the other end of the spectrum from Lady Gaga. Her group was Ben Folds on drums and piano and vocals, Damian Kulash of OK Go on vocals and various, and Neil Gaiman on lyrics.

The band was set up and recorded live in the studio like an old jazz session, a desk for Gaiman in the corner where he churned out lyrics like he was dashing out copy for a front-page exclusive. Suggestions for song subjects were crowdsourced from Twitter, and for some reason, in response to a request for a famous person to write about, the most suggested was the inventor Nikola Tesla. Said Amanda, "He just started riffing on the idea of Nikola Tesla as a love song, you know, a girl falling in love with Nikola Tesla, and he just scratched out the first verse and the first few lines. 'I met Nikola Tesla in a diner in New York, he was eating cotton candy in the dark.' He'd start telling me what he was doing and I'd guide a little, I'd give him some ideas for the shape of the song. Being Amanda Palmer and very lovelorn of course I want this to be a sad, yearning one-sided relationship with Nikola Tesla, The Man Who Would Never Love. And so as soon as he had two verses cranked out he printed them out, I grabbed the page, I ran into a little isolation-booth with a piano set up, and I started with the first melody that came to my head and said whatever it is, that's what it's going to be. Let's not be precious about it" (*The Story*, 2011).

[Handwritten notebook, left page]

Now there's smiles in the eyes of the tigers
And they roar like the voice of the world
And although they're adoring
the pictures are Dorian.
~~Other~~ your name's on their lips
But it's better out loud
And you're proud
And you ~~so~~ sails to ruin
~~But God knows had to be free~~
and isn't it ~~real~~

There's a slim dome
A forbidden book
reeks of brimstone
And ~~that's~~ not the hook
that you swallow
It's the butterfly road
~~that~~ you follow, there it's hollow

The deal as always was faustian
like three cards to shuffle and fool
or the liquor ~~that~~ souped up
Remember ~~poor Faustus~~
Who got in the pot
co, he taught it a poet
And was cool with his head in the loop
And the next thing he knew he was soup...

[Right page, top]

sonnet

I really don't know that
I think "I love you" means.
alone." it means "don't leave me here

Lisbeth Zwerger — poss.
artist for Crazy Hair?

Witold Gombrowicz
Ferdydurke —
taught ~~a~~ Argentinian girlfriend "Polish"
for 2 yrs — imaginary
language

There is a cliché of the French as who all men
who gesticulate with cigarettes and
fragrant women in unfeasibly tight
skirts. In reality, not all Frenchmen
smoke, many of them shave, and some are
sardine who wear pants; but...

Gaiman sang the last song, "The Problem with Saints," with Ben Folds on piano, because he hadn't yet had a go on vocals and everybody else had, and also because the story needed an English accent and nobody else can sing a line like, "And the people that she hated will be neatly bifurcated and the English will no longer rule the world" quite like Neil can. Gaiman can't really sing, despite being the front man of the Ex-Execs back in 1977. "I rapidly figured out that neither could Lou Reed or Bob Geldof or those guys. But I could certainly put across a song. It was storytelling, and I could do that. And I still can. The *New York Times* said I sing 'like a novelist.' And I thought yes! I fucking do!"

In the end they discovered that a song takes at least two hours to write and record. They got six songs in twelve hours and bailed at four a.m. They called the album *Nighty Night*. It was a sort of twenty-four-hour comic but for music, another Noble Failure Variant.

Other non-Palmer songs, such as "Post-Mortem on Our Love," "A Girl Needs a Knife," and "Yeti," were written over the years mostly for bands involving folk musician Lorraine Garland (also known as the Fabulous Lorraine, Gaiman's former assistant) in the form of the Flash Girls with science fiction writer Emma Bull, and the Folk UnderGround. When Lorraine teamed up with Malena (Lorraine à Malena), Neil's buxom Vampira-esque horror presenter assistant for Fox Movie Channel's *13 Nights of Fright* (in which he got to introduce scary films in the lead-up to Halloween), he dragged out "Just Me and Eve" for them, a song about being chucked out of the Garden of Eden. "Like anyone else who has ever loved Gilbert and Sullivan I suspect, once in a while the urge to write a Gilbertian patter song wells up unbidden in the auctorial breast, and some years ago, I succumbed. I wrote the song for the Flash Girls, but Emma didn't like the subject matter, so it went back to a drawer and was forgotten. When Lorraine and Malena started making music, I pulled it out of mothballs and handed it over to them (luckily Lorraine still had the back of the envelope on which I'd jotted down the chords all those years ago)."

There was also One Ring Zero's *As Smart as We Are* album, their critically acclaimed project in which they enlisted a bunch of famous authors to write their lyrics, and a one-off for singer-songwriter Olga Nunes called *A Dream of Gardens*. And then there were rude ones in early drafts of *Beowulf*, songs about screwing virgins and nailing balls to walls, which he'd probably sing himself if you asked him nicely. ❖

mirrormask

above: Gaiman and McKean during filming.

opposite: Gina McKee as the Queen of Shadows.

IT'S HARD TO BELIEVE THAT WHEN JIM HENSON'S *LABYRINTH* WAS RELEASED, IT WASN'T CONSIDERED A SUCCESS.

The Dark Crystal had topped the charts four years before it, but *Labyrinth* was so disappointing at the box office that Henson never directed another film again. Had he not died four years later, he would have seen the love for *Labyrinth* grow to cult status with the onset of the home video—the Jim Henson Company certainly did.

In 1999, while looking back at their DVD sales figures, they saw that both *The Dark Crystal* and *Labyrinth* were hugely popular with pretty much no effort at all on their part. Generation after generation rediscovered them, and over time they had become classics. The Henson Company wondered if they could make another one, a direct-to-DVD movie, like a prequel to *Dark Crystal* or a sequel to *Labyrinth*. Ultimately they decided to make something entirely new but that contained the same spirit as those old puppet films.

Gaiman already had ties to the Jim Henson Company since they the owned the film and television rights to *Neverwhere*. But even so, CEO Lisa Henson thought there was no way they would be able to get a Neil Gaiman script. They simply couldn't afford it: Sony was putting up just four million dollars for the project, which sounds like a lot of money to regular folk but is a pittance in movieland. But she'd seen Dave McKean's movies and knew what he was capable of on little-to-no-budget. She phoned Gaiman. "She said, 'I've seen McKean's films that he made in his mother's barn. Do you think he could do it?' I don't know, but I think I can ask him. 'I know we couldn't afford you to write it, but do you think you could come up with a story?' I said if Dave says yes to directing it, I'm going to write it. Why should I lose the fun?" (Khouri, 2005).

Having dealt with Hollywood executives for more than a decade, continually bending and breaking ideas to fit their mold, Gaiman and McKean were given a new kind of freedom at Henson. "That was the joy of *MirrorMask*. I wrote it for Writers' Guild TV basic, which was technically I think one one-thirtieth of my quote in Hollywood at the point I wrote it. But the Henson Company was able to offer us an incredibly simple deal that was very straightforward, which was: 'You get four million dollars to make a fantasy movie. We can pay you absolutely nothing, you'll be working for basic, but nobody is going to tell you what to do. If we like the script, we sign off on it, and you make your movie. We want a film like *Labyrinth*, like *The Dark Crystal*, like the Henson films we made back in the eighties. We think it would be a good thing to make a family fantasy movie now. Those films cost forty million dollars back in the eighties. We have four million dollars now. All we can offer you is you will never have to sit there at a table while a bunch of people in suits tell you how you're going to change your script. Write us a script, we'll sign off on it, and we'll be in business'" (Khouri, 2005). As for McKean, he loved the budget. He loves a ceiling, and he loves having bars to push against. It was, if nothing else, a challenge.

They were put up in the Henson house in London to get their script done. They had two weeks to do it in, had brought along heads full of ideas: Gaiman with a *Prince and the Pauper* variation, an idea about a girl who was part of a traveling theater who had a sick mom, while McKean envisioned a circus and masks and two mothers. But once they got to the house and sat down to work, a strange thing happened. Despite being close collaborators since 1986, they had never actually worked in the same room together. They discovered they couldn't do it.

> It had never occurred to either of us we couldn't work in the same room, because we'd never tried. We'd work very happily in separate offices and be on the phone every night. It was only when we came to work on MirrorMask *that we discovered we had completely opposite writing methods. And completely opposite creating methods. Dave wanted to do everything with little cards before* he started writing the script. And I wanted to know enough about the story to know it had a beginning, a middle, and an end, and just start writing and see what happened. Start making stuff up, having fun.
>
> We also discovered that what we wanted in a place to work was absolutely different. So I went down to the basement, which was a kitchen. It was warm, it was dark, and I could have Radio 4 playing in the background and then tune it out. And I would sit and work. Which Dave thought was absolutely the weirdest thing that he had ever seen, and he went up to the third floor where there was a grand piano, and he had the best time playing the grand piano. And we'd meet in lounge in the middle.

Over a few nights they watched the three-hour first cut of *Labyrinth* together, which featured many scenes the editor had later trimmed, and a lot of things they'd changed. "I liked it better, although

I understood why everything had been cut. I think Dave Goelz voiced Sir Didymus, so Sir Didymus sounded a lot like the Great Gonzo in the version I saw." It fed back into what they were writing during the day— sections of *Labyrinth* DNA spliced into *MirrorMask*.

"We both talked about what we liked about *Labyrinth*, and one of the things we both really responded to as parents of daughters was the fact that it's about a girl who's at that point in life where you have girlhood on one side and young womanhood on the other, and you're making a bunch of decisions and sort of internally processing a bunch of stuff about who you are, what you are, and whether that's what you want to be. For me, the key to Helena's identity was just that line right at the beginning where her mom says all these kids would love to run off and join the circus and Helena says, 'Great! I want to run away and join real life'" (Khouri, 2005).

"It had never occured to either of us we couldn't work in the same room."

In their script, teenager Helena Campbell (Stephanie Leonidas in the film) has a fight with her mother. Later her mother collapses, is taken off in an ambulance, and guilt consumes our hero.

"What was fun was when we handed in the script, the immediate response from the Sony people was, 'We don't quite get Helena because sometimes in the script she's reacting like a kid and sometimes she's reacting as a young woman.' That's the whole point when you've got a fourteen/fifteen-year-old, even a ten/eleven-year-old, there are points where they're twenty-five and points when they're six! There are points when they're young women, and there are points when they need a

hug. I loved the idea of concretizing that metaphor; making this all happen at that cusp moment where she's really under the gun and under an incredible amount of pressure" (Khouri, 2005).

On the night of her mother's operation, Helena dreams she is in an alternate world, a strange collaged dreamplace populated by analogues of people she knows. The actress Gina McKee is sick in a hospital bed, or in Helena's dreamworld she is a queen on her bed in the City of Light, which is slowly being swallowed by shadows. Find the charm, wake the queen, save the world.

It's a world that is creepy and dark and golden, one where clockwork dolls sing a broken music box version of Burt Bacharach's "Close to You." A librarian played by Stephen Fry presides over a room full of flying books that get captured in butterfly nets and molt pages when depressed. Every frame looks like Dave McKean artwork simply because that is what it is: most of it exists only as animation, a drawing brought to life. The green room actors are adrift in a world of McKean's own making. Instead of Henson's puppets, there are endless papier-mâché masks. McKean says that even with a budget ten times the size of *MirrorMask* the film wouldn't have looked any different—he wasn't interested in making things that looked photo real, and that's generally where the money goes. He wanted it to have the painterly, handmade look from the beginning, a direct human communication rather than computers and corporations. "I was interested in having it look like an individual made it," he said (Khouri, 2005).

The story of keys and charms and passageways is accompanied by an equally strange score courtesy of Iain Ballamy, who had worked with McKean previously on the *Signal to Noise* radio play in 1996. It is haunting in the same way a solo violin in an empty tunnel is haunting.

Although the film was originally slated to be straight-to-DVD, it received such an enthusiastic reaction at the Sundance Film Festival that it was given a small theatrical release in September 2005 in the United States. ❖

tam Lin

Before Dave McKean was officially the sole designer and director of *MirrorMask*, Brian Froud, the primary concept artist on both *Labyrinth* and *The Dark Crystal*, was loosely part of the plan. The idea was that McKean would direct and Froud would design, but in the end everybody realized that if McKean was going to direct something it was going to be McKean's vision, and Froud was pushed out.

But it wasn't the only time Gaiman was all set to work with Froud on a movie and it didn't happen. In February 2003, Gaiman met with Sony and Brian and his wife, Wendy Froud, to talk about doing a film loosely based on the old Celtic folk ballad "Tam Lin," in which Tam Lin is rescued by his true love from the queen of the fairies. Gaiman wrote an outline or two and then the project was "eaten by meningitis." He slowly recovered, and "in the summer was told by the Sony people that *I definitely had not been fired* and I called my agent and asked if that meant I'd been fired, and he said yes."

DOCTOR WHO

BEFORE HE WAS WORRYING ABOUT *BATMAN*'S WEEKLY DEATH TRAP, GAIMAN WAS WORRYING ABOUT THE PARTICULARS OF *DOCTOR WHO*. THEY GO WAY BACK.

"I was the kind of fan that cared. I was the kind of fan who obsessed over the show. When I was six, my most treasured possession was a copy of *The Dalek World* annual. I used to try to figure out how it was that you could have red Daleks when, according to the annual, Daleks could not see the color red. Were these Daleks going, 'Bugger me, there are Dalek bumps floating around in the air? Oh my God! Stealth Daleks! Why is it everybody else can see our invisible stealth Daleks?' I'd actually worry about this stuff.

"I was the kind of fan that watched every episode I could, between the ages of three and about fourteen, fifteen—which takes us from William Hartnell to Tom Baker, which is not a bad stretch. Somewhere mid–Tom Baker, I got interested in girls, and punk rock, and . . . well, that was mostly it, actually—girls and punk rock—and I drifted away" (*Doctor Who Magazine* #448, 2012).

But nobody ever totally drifts away from *Doctor Who*. The show is sticky. At twenty-three, in his interview with Douglas Adams for *Knave*, Gaiman talks about Adams reaching the "awe-inspiring heights of scriptwriter on *Doctor Who*." When *Don't Panic* came out in 1988, *Doctor Who* only had a year or so left before it was canceled. It's a kind of Holy Grail for sci-fi fans in England, but by the time Gaiman's career was underway, the show was gone. Unsurprisingly, from the minute Russell T. Davies revived the program in 2005, fans have been quite vocally campaigning for Gaiman to write a *Doctor Who* script. Then, one day, he did.

He wrote it when he should have been writing the *Anansi Boys* film adaptation. His father had died, and on the plane back to America after the memorial service in England, Gaiman was in the kind of intense, strange emotional state that comes from trying to keep everything together when everything is falling to bits. He took out his notebook and he wrote.

For me, going into that episode was probably the most escapist thing I've ever done. The universe was kind of intolerable, and I'd been going for a week, I hadn't stopped, I hadn't cried, I hadn't had a chance to do anything, because I had to keep going for everybody, for the family, and just keep this thing running. I sat down and started to write and I remember being really irritated when we were coming into land, because I had to leave this place. About three weeks later, I thought, "I should take a look at the notes that I made on the plane"—and I'd actually written about 80% of the episode. All the dialogue. It needed some tidying, there were bits that were missing, but the first

OPPOSITE: Promotional image for "Nightmare in Silver."

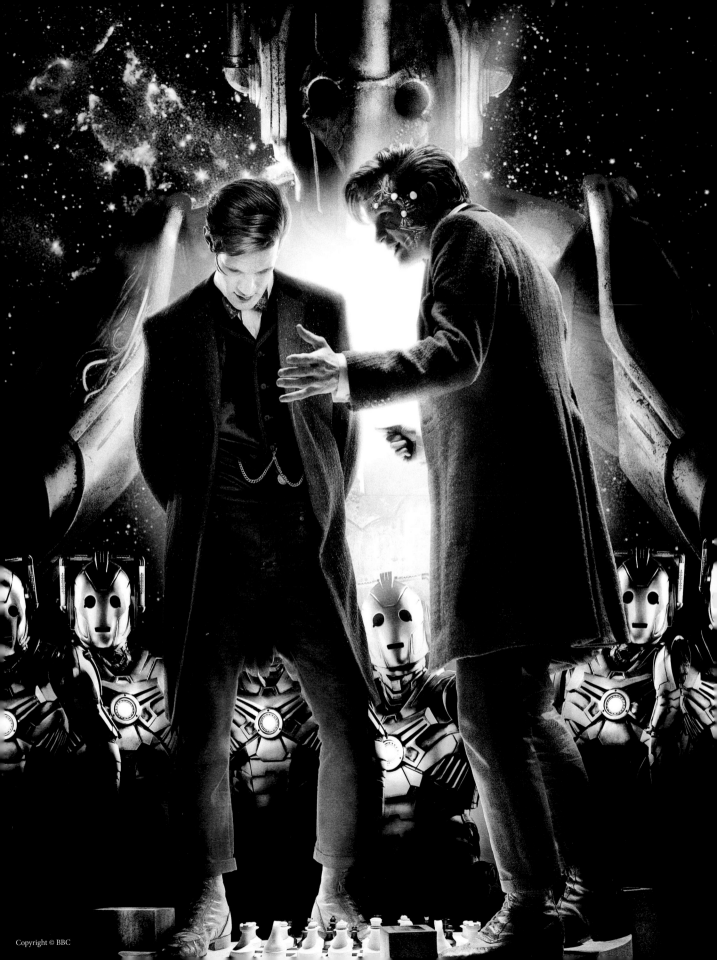

"Captain Incredible wished his dog would talk about something other than his favourite T.V. Programmes"

Neil Gaiman
Jan 26 2012

draft pretty much existed—and I didn't really remember actually writing it. I remember going to that place and being on this planet, in this junkyard with the Doctor, but not in the kind of way that I normally remember writing (Doctor Who Magazine #448, 2012).

The episode sees the Doctor and his companions receive a distress call from a living Time Lord—a strange thing given that our Doctor is supposed to be the last surviving member of his race—and in following it, he ends up trapped on an asteroid planet.

"It has a lot to do with my personal love of the *Doctor Who* mythology and the fact that it all started in a junkyard, so I thought I'd set this episode in a junkyard. In a tiny little pocket universe that only contains an asteroid with a junkyard on it."

Lured there by a sentient being called House who exists only by consuming the energy it extracts from the TARDISes it lures there, the Doctor and his companions are unable to escape. House takes control of the TARDIS and uses it to leave the asteroid after realizing there will be no more Time Lords after this one. The junkyard comes into play when they have to build a new TARDIS out of bits of junk strewn around the surface of the planet.

As for the Doctor's TARDIS? We get to meet her. Before House leaves, it transfers the TARDIS matrix into the dead body of a lady called Idris, played by Suranne Jones. "The central idea of the story was what would happen if the Doctor and the TARDIS actually got to talk. She's every bit as smart as he is, in her own way. But her own way is very different to his way; she exists across space and time. All of space and time simultaneously," Gaiman said on *Doctor Who Confidential*. Idris is the TARDIS personified, which had never been done before in the history of *Doctor Who* and which, if ever attempted again, will be an echo of what Gaiman built. The TARDIS gets forty-two minutes of life. She is "The Doctor's Wife."

Gaiman's episode was filmed in the autumn of 2010 and was the most hotly anticipated episode in years. It was supposed to be filmed in 2009 for the 2010 series but got pushed back for budgetary reasons—Gaiman's episode needed a bit more money than the BBC had. "They really were taking other episodes out behind the bike sheds, beating them up, and taking their lunch money in order to pay for mine, which was the promise that they made when they bounced me from one season to the next" (*Doctor Who Magazine* #448, 2012).

He visited the set himself and met the cast, but mostly he got to fulfill a lifelong dream of getting to stand at the control deck of the TARDIS, where he looked exceptionally like Doctor Who himself with his mop of unruly hair. In an episode of *Doctor Who Confidential*, Gaiman stood in that same place and read from his script like a novelist reading a novel.

That never happens in *Doctor Who.*

The rough cut was fifty-six minutes long and scenes were inevitably lost, but Gaiman didn't feel like he'd been let down in the same way that had caused him to go and write the *Neverwhere* novel. And although he did toy with the idea of doing a novelization, he says he's probably not capable of writing "anything that's going to break your heart more than Suranne Jones saying hello to the Doctor before she dies" (*Doctor Who Magazine* #448, 2012). He watched the final cut of "The Doctor's Wife" where he had

first written the original notes: on a plane, up in the sky and hurtling through space. But he wasn't watching it like a story—he was seeing which bits made it in, which bits got cut, how the pieces all fit together, and what the special effects looked like. When he got home, he thought he hadn't done it right. That night he turned to the friends he was with and said that if everybody promised absolute secrecy, he would like to show them his *Doctor Who*. He wanted to watch it with people around.

"So I put it on, and my friends and I are sitting there watching it, and there was a point three-quarters of the way through or so, and I looked around and realized that a bunch of people are watching it and they have wet cheeks. Glistening tears on their cheeks. And they haven't stopped, and they aren't getting out tissues or anything, they're just watching. And it was this amazing feeling of: this has worked. This is actually doing what I hoped it would do. And it's doing it even more than that" (Gaiman, 2011).

The episode aired on the May 14, 2011, with more than six million viewers. It won Gaiman a Ray Bradbury award for Outstanding Dramatic Presentation, and in September 2012 it won a Hugo. In his acceptance speech Gaiman said that, having succeeded in making an episode that everybody seems to have loved, and then having gone and won everything, only a madman or a fool would tempt fate by doing it again.

He told the crowd he was already on his third draft of his second episode.

Two months before the announcement, Gaiman had a last-minute meeting in Wales with show runner Steven Moffat and his team, the first one since sending in his draft of "Nightmare in Silver." They had liked it enormously. Moffat's brief was that he wanted Gaiman to make Cybermen scary again. They had, in recent times, become a bit pathetic. "I'm going back to what scared me when I was a kid. I didn't know what was under there. They definitely didn't clank. And probably going back to the original face of the Cybermen. Not the original original one, which was kind of cloth. But the next model."

That was in July. After numerous rewrites and changes, as with the first episode, the final script was sent over in November, polished while staying in London. A week later, a copy of the script was left in the back of a cab by an absent-minded actress and sparked an unprecedented act of morality by the fandom. A non-*Doctor Who* fan found it, uploaded a photo of it on her Facebook page, and a friend of hers (a *Who* fan) posted it on the social news site Reddit.

In an unlikely turn of events, instead of pleading that the contents be scanned and spread around the world for curious fans to consume early, everybody insisted that the script be returned to the BBC Wales offices unleaked. Collectively, they eschewed an inside scoop in favor of an unspoiled story. Within a few days it was back in the right hands, and the fan was just pleased to have been a part of *Doctor Who* in some small way. ❖

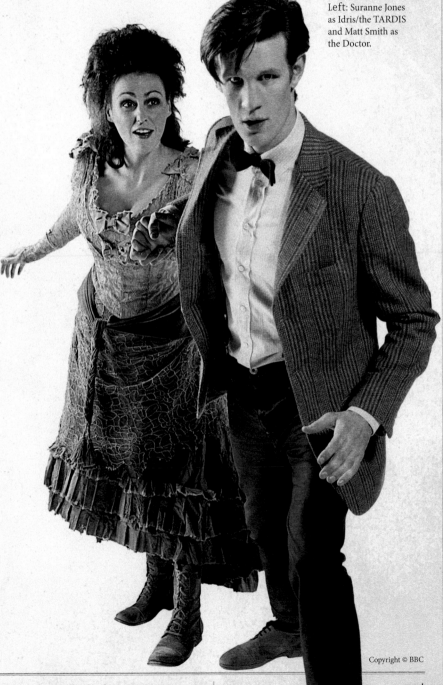

Left: Suranne Jones as Idris/the TARDIS and Matt Smith as the Doctor.

chapter

Reflections

7

RADIO PLAYS

"Radio plays are, if not my favorite medium, at least one of my favorite media. It's like filmmaking without the waiting about, and with its own special magic."

HAVING SPENT DECADES TRYING HIS HAND at a multitude of media, GAIMAN IS ALLOWED to have a favorite.

Probably where Gaiman learned the most about the joys of radio plays versus anything else was in Douglas Adams's flat in Islington. *Hitchhiker's Guide to the Galaxy* had been adapted from a radio play into a novel and into a TV show into a movie, and Gaiman got to hear the ins and outs of all of it. Adams always favored radio, too.

Over Gaiman's career various stories have been adapted for the radio—"Murder Mysteries" and "Snow, Glass, Apples," *Anansi Boys* and *Signal to Noise* and *Mr. Punch*—and most recently he played the part of a nameless fop in a *Neverwhere* adaptation by Dirk Maggs, who did the last three *Hitchhiker's Guide* radio adaptations. (The play has an all-star cast: James McAvoy, Benedict Cumberbatch, Anthony Head, Bernard Cribbins, Andrew Sachs, Johnny Vegas, and "Christopher Lee saying lines I wrote. This makes me happier than I have any right to be.") He says radio is a wonderful, vital force, which allows you to do things cheaper and quicker: a scene in a film in which a character needs to appear geographically distant would require half a day of setups and relighting and moving the camera and moving the people . . . but in radio, you just take three steps away from the microphone. It takes no time at all.

Why does radio beat the novel, the comic, the film, and the short story? Gaiman has by this point had a go at basically everything; if anyone would know, it's him.

We absorb fiction in absolutely different ways. The experience of reading a book and the experience of watching a play, and the experience of watching a movie, are absolutely different. And by their fundamental nature, with a book you are being given a set of letters and punctuation marks. In English, you've got half a dozen punctuation marks, maybe a dozen at most. Twenty-six letters. And you are going to assemble these in your head and build a world. Fundamentally, it's as if there is an act of sub-creation going on. You are the creator. The author is the creator, but the reader is the sub-creator. The

PREVIOUS SPREAD: Kelley Jones art from the *Sandman* sketchbook, 1992.

OPPOSITE: The all-star cast of the 2013 radio version of *Neverwhere*. From left: Benedict Cumberbatch (Islington), James McAvoy (Richard), Natalie Dormer (Door), Sophie Okonedo (Hunter), and David Harewood (Marquis).

analogy I used when I've been trying to explain it to people over the years is fifty million people have read The Catcher in the Rye and there are fifty million Holden Caulfields wandering around in people's heads. They all look different. Some of the readers will actually come up with a full character, and they could tell you what his hair looks like. It's a nice example because there's no picture on the cover, so everybody has that pure experience of creating their own Holden Caulfield.

With a comic, you can't do that. A comic is giving you a visual. But that's part of the power of the thing. Part of the power is everybody who experiences Death, or Superman, or Batman, or Morpheus, or the Fantastic Four knows exactly what they look like, and the place that the acts of sub-creation occur are in the weird Scott McCloud, Eddie Campbell voids between panels. It's Eddie, it's Scott, showing a man standing behind a woman with a knife and then cutting to outside of a skyscraper and a scream. The author didn't kill her. You just killed her. It was an act of sub-creation.

A film gives you very, very little room. Normally, I have to be sort of careful when I say things like this, because otherwise my inbox will fill up with people saying, "I do not think you have carefully enough considered the films of Robert Altman." But film tends to make you less of a sub-creator and more of an observer.

Stage plays are peculiar, because the act of sub-creation tends to occur in the interstices of the suspension of disbelief. In a movie, somebody gets their hand chopped off and you know their hand just got chopped off. In theater the hand can be chopped off and what's held up is red ribbons, but it has the same impact. You as a member of the audience are sub-creating in a peculiar way because you provide the scenery, you provide the world in which something happens. Somebody can say, "I am flying," and they are flying. By knowing these impossibilities

Copyright © BBC

you are also on some weird level a sub-creator. You are not a sub-creator with film, on the whole. You are an observer. But film has these amazing powers because it's occurring in real time, it's really *happening* on some level.

Radio plays I love, and find them incredibly close to comics. Comics have everything except an audio track. Everything is coming in through the eyes. And when you're writing comics, you're working really, really hard—or I am, always—to try and fool the mind of the person reading into somehow hearing something. It was something that I was always obsessed by when I was writing comics; I would put fragments of songs, I would try and write noises in, it was something that fascinated me in the work of Will Eisner, what he'd do with sound effects and drawing shapes and things that indicated sound effects and the plip, plip, plip of water or whatever because you're going: this is the one thing we don't have. So we try to compensate.

What I love about radio is it's an inversion of comics, because you don't have a visual track, all you have is an

audio track. You have really good actors and you have stuff occurring in real time, so it's not the comics experience or the book experience where you can take as long over a page or as short over a page as you want, you can examine it, you can read it, you can cut it up in your head, you can go back a few pages and come forward again. You're experiencing it in real time. Yet even though you're experiencing it in that way, you're still creating things. The easiest, most obvious example is, for me, Douglas Adams's line: "Ford, you're turning into an infinite number of penguins." Which is something that they tried and failed to show on the TV show, and then in the movie they didn't even attempt it. And when you hear it, it makes you try to turn somebody into an infinite number of penguins. In your head. And I love that. I love that good radio is engaging you. Good radio is making you part of the thing. It's similar engines to the engines of a novel, where you get to walk around Narnia, Middle-earth, or whatever, before there was a movie, and build these places in your head from whatever cues you have, whatever cues you can get. ❖

as for how he does it all...

THE SHEER HEFT OF THIS BOOK GIVES YOU SOME IDEA OF HOW MUCH NEIL HAS ACCOMPLISHED OVER THE YEARS. SO HOW DOES HE DO IT ALL? SOMETIMES HE DISAPPEARS INTO THE WOODS FOR WEEKS TO WRITE. HE STOPS SHAVING AND LIVES IN HIS BATHROBE. HE SEES NO ONE BUT MAYBE SOME SHEEP. OTHER TIMES HE STAYS UP LATE IN OTHER PEOPLE'S HOUSES AND FALLS ASLEEP WHERE HE SITS.

"Going off the grid is always good, for me. It's the way that I've started books and finished books and gotten myself out of deadline dooms and things. I used to be somebody who did his best work at night. And would wake up about midday, faff around until about nine o'clock at night and then crank up, and then at 1 o'clock in the morning I'm really buzzing. There's this weirdness of looking around and going: I'm not that person anymore. Now I can't actually count on being able to do great work at night. Probably what I'll do is fall asleep. But the main thing, with all of this, is writing stuff that excites you, writing stuff that interests you, writing stuff that gets you happy" (Steel, 2011).

To Neil, the process of writing is an accumulation of things and an exploration of thoughts—he doesn't plan as strictly as a lot of index card writers, which infuriates editors. It's also a constant effort to outwit the process of *not* writing. He unplugs from the internet. He flies to different countries or states to stay in sad hotels where he'll get things done simply because there is nothing else to do but write. Then there are the collaborations: the films, the TV shows, the radio plays, the other swing of the pendulum:

"I have maintained my sanity over the years, whatever sanity I have, in a weird sort of pendulum swing of doing collaborative stuff, and that will drive me mad in the way that collaborative stuff does, and then I'll be so sick of that I will say, 'Right, now I'm going to go off and write a novel,' and I will disappear for a year. By the end of that year, I won't have spoken to anybody in six months. I will be this wild-haired person who has lost all social skills and feels rather awkward talking to other human beings—but every word of that novel is there because I want it to be. At that point, what I'm craving is some kind of human contact and doing things with other people. So, for me, you go back and forth" (*Doctor Who Magazine* #448, 2012). ❖

NEIL'S
WORK-
-IN-
-PROGRESS
BOOK

or,

the terror of making marks on paper

afterword

IN 2010 IT WAS NEIL'S FIFTIETH BIRTHDAY. ON NOVEMBER 10, SEVERAL HOTELS IN NEW ORLEANS WERE PACKED WITH PEOPLE FROM HIS LIFE—FAMILY, FRIENDS, COLLEAGUES—AND AT SOME POINT OVER THE DAYS A HIGH PERCENTAGE OF US PURCHASED HATS.

Fellow Gaiman people could be spotted on the other side of town looking like tourists who had just bought hats. We would wave at each other from underneath our bowlers with whatever hand wasn't holding a beignet. Sometimes we swapped hats, other times we accidentally sat on them, sometimes we left them in cabs.

When the party was all over, the nibbles had all been eaten, and the presents had been driven to Wisconsin, I went back to the Addams Family house with Neil to go through his attic for this book. I wrote the following while I was there. I slept through my first Midwestern snow storm. We wore different hats then.

✛

It is during the days after Neil's fiftieth birthday party in New Orleans. I was there. Now I'm sitting on the floor, in his house in Wisconsin. It's snowing outside and there are dogs by our feet, and Neil is unwrapping presents. As he opens them he tells me how long he has known that person, how he knows them, and why he loves them, truly loves them, in a way that is not Hollywood and fake.

There are so many people. There are the people who published his first graphic novel. There are the artists from *Sandman*, and *Sweeney Todd*, and *Mr. Punch*. There are writers: science fiction, horror, a Pulitzer Prize-winner. He gets a tiny meteor from his old bandmate Geoff Notkin, now a Meteor Man. There's the voice of the dad in *Coraline*. It was a party that spanned a lifetime of friendships, career, and random encounters in Chinese restaurants. He has done so much, had a finger in so many pies, that it's hard to count them. "Is there anything you haven't written?" asks the girl in *Arthur*, the American children's television show on which Neil did a special appearance.

"Cookbooks. I've never written a cookbook. Might be fun to try!"

He unwraps a palm-sized box, opens the lid and removes the tissue paper. Nestled in the middle is a miniature beehive made of lead or pewter, honey yellow in color and about the size of a thumbnail.

"This. This is going in the Incredibly Cool Things Cupboard."

He gets up and strides out of the room, two white dogs in tow, past the Charles Addams original and over to a glass cabinet full of awards and miscellaneous things. There's another miniature—a half-submerged Japanese lady in a bathtub, one hand visible above the water. Tip her over and her other hand is revealed to be somewhere rude.

"It used to be the cabinet where we kept all the awards. But there are so many awards and a lot of them are so ugly. So this is where I keep my Incredibly Cool Things."

He places the beehive next to the Japanese lady, a purchase he and Amanda Palmer made, and says, "You know what I like? Mostly Amanda Palmer. Would you like to see if Wobbly Pins would like a walk?"

We put on our coats and our fluorescent-orange gnome hats to match the dogs' capes so the hunters know we're not bears. Lola is missing hers, having caught it on a barbed wire fence during that afternoon's walk, resulting in a trapped, crying dog and a rescue mission for Neil. (He crossed the river by balancing on a fallen tree and made his way up the embankment, by which point Lola had gnawed her way free and left an orange flag flapping in the breeze. She galumphed down the slope to meet her master with the remains of the cape flapping about her chest like a cravat. Having completed his mission, Neil turned back to go the way he had come, but the tree that he had so swiftly scaled now revealed itself to be covered in the slipperiest of green moss, suspended over the iciest of Midwestern country streams. Blinded by the need to save his pup he had noticed none of this in the first crossing.)

Cabal and Lola are jostling at the door. We head out into the pitch-black countryside with a flashlight. Flickers of light turn the white German Shepherds into ghost-like apparitions on old reels of film. Lola bounds ahead; Cabal wobbles on his pins.

ABOVE: At Meyer the Hatter in New Orleans. In the foreground is Jason Webley, who would have himself ordained just to marry Neil and Amanda. Jon Singer, calligrapher of *Blueberry Girl*, is behind the smiley man in the top hat.

"It's Alan Moore's birthday today," says Neil.

"How old is he?" I ask.

"I guess he's about fifty-seven. I think he's about seven years ahead of me. It sounds about right. He's older than me but still firmly planted in my generation."

"I don't think of him as being part of your generation."

"Or anyone's generation. He exists outside of time like some sort of godlike wonder."

"Something like that. And also you just seem kind of younger."

"[If] I don't do another cool thing for the rest of my life, I can still point at the mountain of cool stuff I've already done."

"You know, I have a bit of an idea about aging and time, and I really should do something with it—stick it in a story or something—because it really is kind of good. When you're a kid you see adults as adults, you don't see them as people who used to be kids. They are an age, and they have always been that age. Even at your age, twenty-something, the adults you knew when you were a kid are still more or less how they always were. I'm the same Neil to you now as I was to you then. But I'm not really. You haven't yet watched people age over the course of twenty, thirty, forty years, and it's weird. Really weird."

"Yeah. I think there's nothing sadder than the passage of time. I get so low at birthdays. Holly had to deal with me on this year's birthday, couldn't understand why I didn't want a birthday party. Turning twenty-four was the first birthday I've ever

had that really hit me properly. By that age my mom had already had me, was married and heading back to Australia. Not that I want a baby or a marriage, but at twenty-four I'm an adult. I didn't get that at twenty-one at all despite everyone saying, 'Oh you're an adult now.'"

"Exactly. Did you read what I said on my blog about twenty-four?"

"No."

"I said I'd liked being younger than twenty-four. Anything cool I did, people would say, 'And he's so *young*,' and that felt good. And then suddenly I was twenty-four and I felt like I couldn't be a boy wonder any longer, and the world had become level."

"That's kind of what I was getting at, but you've put it better."

"Turning fifty was a big one: I can't be a promising young writer any longer. For the last decade, I've hated getting Lifetime Achievement awards, they'd make me feel squirmy and awkward, and now I'm going to have to accept them with good grace."

"Is it a bit like them turning the music on when you're halfway through your Oscar acceptance speech?"

"A bit like that, yes. But I've done a lot of stuff. If I don't do another cool thing for the rest of my life, I can still point at the mountain of cool stuff I've already done. And I'm happy."

Lola emerges from the corn field with an antler in her mouth. She drops it at my feet.

"If we hang around a bit longer maybe he'll poop."

Cabal looks embarrassed.

"Neil, don't say 'poop.' I can't say 'poop.'"

"I can now," says Neil. "I've lived here for twelve years. I can no longer say 'defecate.' I live in a country where the past tense of shit is 'shit.' 'That dude, he juss shit on my head.' And the past tense of spit is 'spit.' 'He juss spit on me.'"

"It's 'shat.'"

"Exactly."

And we stood around in our pointy orange hats waiting for a dog to poop in the dark. ❖

OPPOSITE: On a boat somewhere in Scotland in 2010.

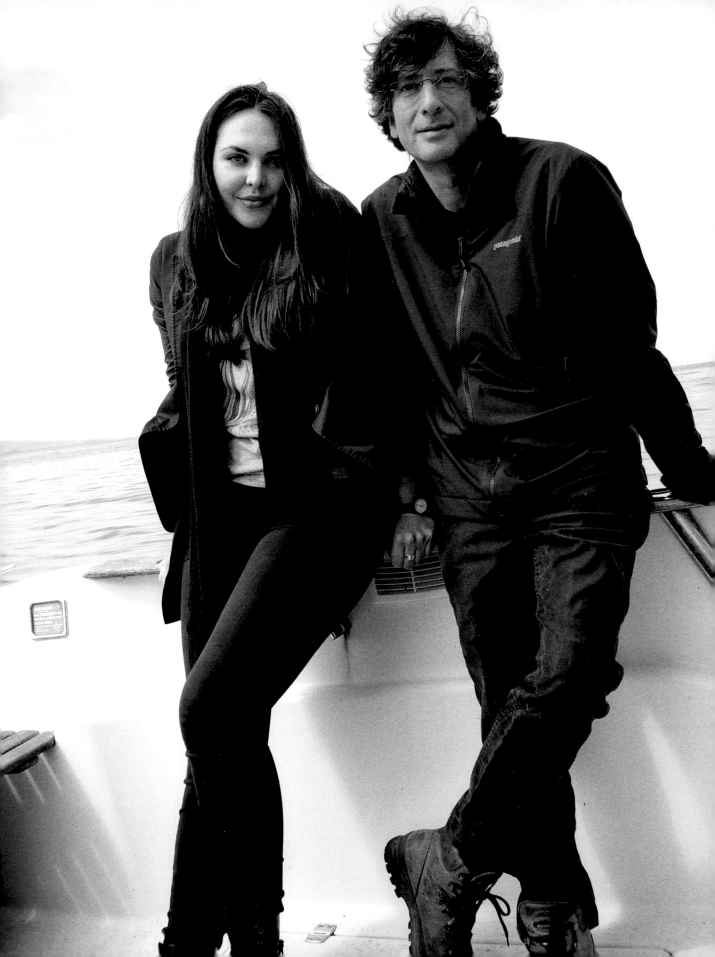

NEIL GAIMAN BIBLIOGRAPHY

ART, DOODLES, AND PHOTOGRAPHS

But I Digress; Cover art: *But I Digress* by Peter David, Krause Publications, 1994

Death Is; Sketch: *Faces Of Death Print*, 1994

Dirtbag #3; Cover art: *Dirtbag #3*, Twist And Shout Comics, 1994

Lorraine Garland; Photograph: *Lorraine A' Malena—Mirror Mirror*, Aranya Records, 2005

Gazebo; Photograph: *Shedworking* by Alex Johnson, Frances Lincoln, 2010

Dave McKean; Photograph: *Black Orchid* collection, DC, 1991

Mr. Gaiman And Friend; Drawing: *The Sandman Book X: The Wake* collection, Vertigo/DC, 1997

The Murders On The Rue Morgue; Comic written by Alan Moore: *Negative Burn* #13, Caliber, 1994

Amanda Palmer; Photographs: *The Grand Theft Art Companion*, self published, 2012

Portrait Of Gris Grimly: *The Dangerous Alphabet* by Neil Gaiman and Gris Grimly, HarperCollins, 2008

Rat; Drawing: *The Book Of Twilight*, Caliber, 1994

Satan; Drawing: *SATAN 1.X* software

Self Portrait With Reflections; Drawing: *Guest of Honor Neil Gaiman*, Chicago Comicon, 1993

Spider; Drawing: *Anansi Boys Chapbook* by Neil Gaiman, William Morrow, 2005

Sunday; Drawing: *Sunday Print*, Comic Book Legal Defense Fund, 2003

Ultimate Spider-Man #100 cover art: *The Ultimate Spider-Man 100 Project*, The Hero Initiative/Marvel, 2007

Watchdogs; Drawing: *Watching The Watchmen* by Dave Gibbons, Titan, 2008

ARTICLES

"$1M a Minute to Film? No Problem": *The Guardian*, March 3, 2006

"Douglas Adams": *Time Out* #948 (October 19–26, 1988)

"The Comics Explosion": *Time Out* #839 (September 17–24, 1986)

"Discworld Leaves Its Black Hole": *Financial Times*, July 12, 2002

"Dresden Dolls": Spin.com, 2010

"Fantasytime at the New Imperial": *Prince Of Stories* by Hank Wagner, Christopher Golden, and Stephen R. Bissette, St. Martin's Press, 2008

"Filmmaker's Diary: Neil Gaiman": *Look* #145 (Spring 2005)

"Neil Gaiman's Fantasy Painting": *Intelligent Life* July/August, 2013

"Ghosts in the Machines": *New York Times* Op-Ed, October 31, 2006 (illustrated by Sam Weber)

"Gumshoe": *Punch* Vol. 297, #7749 (July 21, 1989)

"Happily Ever After": *The Guardian*, October 13, 2007

"James Herbert: Growing Up Public": *Gaslight & Ghosts* edited by Stephen Jones and Jo Fletcher, 1988 World Fantasy Convention/Robinson, 1988

"King Of The Gory Tellers": *Today*, October 19, 1986

"Looking to a Horizon of Greys": *Heartbreak Hotel* #2: *Samizdat*, Willyprods, 1988

"The Myth of Superman" (with Adam Rogers): *Wired* V. 14 #6 (June 2006)

"Nobody's Guide to the Oscars": *The Guardian*, March 25, 2010

"Nourishing the Spirit": *The Washington Post*, December 2, 2001

"The Perils of Parasailing": *Busted* V. 2 #8, Comic Book Legal Defense Fund, May 2000

"Lou Reed": *The Guardian*, October 28, 2013

"Six to Six": *Time Out* (1990)

"Something About Collaborating with Artists": *Locus* #510 V. 51 No. 1 (July 2003)

"Sweet Fang": *20/20* #1 (April 1989)

"Gene Wolfe": *The Guardian*, May 14, 2011

AUDIO RECORDINGS

"Broken Heart Stew"; Performed by Neil Gaiman and Amanda Palmer: *An Evening with Neil Gaiman and Amanda Palmer*, self published, 2011

"Creepy Doll"; Performed by Jonathan Coultan and Neil Gaiman: *An Evening with Neil Gaiman and Amanda Palmer*, self published, 2011

The Dark; Read by Neil Gaiman: Audible.com, 2013

Neil Gaiman Presents…; Series of audio books picked and with introductions by Neil Gaiman: Audible.com, 2011–present

"Jump"; Performed by Neil Gaiman and Amanda Palmer: *An Evening with Neil Gaiman and Amanda Palmer*, self published, 2011

The Last Temptation by Alice Cooper; Concept co-development and additional lyrics by Neil Gaiman: Alice Cooper—*The Last Temptation*, Epic Records, 1994

"Liverpool Street"; Anecdote by Neil Gaiman: *The Moth Audience Favorites* V. 5, Storyville Center For The Spoken Word, 2008

"Makin' Whoopee"; Performed by Neil Gaiman and Amanda Palmer: *An Evening with Neil Gaiman and Amanda Palmer*, self published, 2011

"My Space"; Song by Evelyn Evelyn with guest vocals by Neil Gaiman among others: *Evelyn Evelyn*, 11 Records/8ft. Records, 2010

"Psycho"; Performed by Neil Gaiman and Amanda Palmer: *An Evening with Neil Gaiman and Amanda Palmer*, self published, 2011

The Right Book; Lemony Snicket book read by Neil Gaiman: *With a Little Help* by Cory Doctorow, Lulu.com, 2010

The Witches Of Lublin; voice acting by Neil Gaiman: *The Witches Of Lublin*, SueMedia Productions, 2011

BOOKS

Adventures In The Dream Trade by Neil Gaiman, NESFA, 2002

American Gods by Neil Gaiman, William Morrow, 2001

Anansi Boys by Neil Gaiman, William Morrow/Headline, 2005

Angels and Visitations by Neil Gaiman, Illustrations by Michael Zulli, Charles Vess, Steve Bissette, Bill Sienkiewicz, Jill Karla Schwarz, and P. Craig Russell, Dreamhaven, 1993

Beowulf: The Script Book by Neil Gaiman and Roger Avary, Harper Entertainment, 2007

The Best American Comics 2010 edited by Jessica Abel, Matt Madden, and Neil Gaiman, Houghton Miflin Harcourt, 2010

Blueberry Girl by Neil Gaiman, illustrated by Charles Vess, HarperCollins, 2009

A Calendar of Tales by Neil Gaiman and You, illustrated by Niam, Kenneth Rodriguez, Roland Hausheer, Paul Francis, Kit Seaton, George Doutsiopoulos, Svetlana Fictionalfriend, Caia Matheson, Gracjana Zielinska, Maria Surducanh, Grace Hansen, and Shezah Salam, Blackberry, 2013

Chu's Day by Neil Gaiman, illustrated by Adam Rex, Harper, 2013

Coraline by Neil Gaiman, illustrated by Dave McKean, HarperCollins, 2002

Crazy Hair by Neil Gaiman, illustrated by Dave McKean, HarperCollins, 2009

The Dangerous Alphabet by Neil Gaiman, illustrated by Gris Grimly, HarperCollins, 2008

The Day I Swapped My Dad for Two Goldfish by Neil Gaiman, illustrated by Dave McKean, Borealis/White Wolf, 1997

Day of the Dead by Neil Gaiman, DreamHaven, 1998

Don't Panic by Neil Gaiman, Titan, 1988 (Updated by David K. Dickson in 1993, M.J. Simpson in 2002, and Guy Adams in 2009)

Duran Duran: The First Four Years of the Fab Five by Neil Gaiman, Proteus, 1984

Euro Temps devised by Alex Stewart and Neil Gaiman, edited by Alex Stewart, Roc, 1992

Fortunately, The Milk by Neil Gaiman, illustrated by Scottie Young or Chris Riddell, Harper/Bloomsbury, 2013

Fragile Things by Neil Gaiman, William Morrow, 2006

Ghastly Beyond Belief by Neil Gaiman and Kim Newman, Arrow Books, 1985

Good Omens by Neil Gaiman and Terry Pratchett, Victor Gollancz, 1990

The Graveyard Book by Neil Gaiman, illustrated by Dave McKean, HarperCollins, 2008

Instructions by Neil Gaiman, illustrated by Charles Vess, HarperCollins, 2010

InterWorld by Neil Gaiman and Michael Reaves, Eos/HarperCollins, 2007

A Little Gold Book of Ghastly Stuff by Neil Gaiman, Borderlands Press, 2011

Neil Gaiman's "Make Good Art" Speech by Neil Gaiman, designed by Chipp Kidd, William Morrow/Headline, 2013

MirrorMask by Neil Gaiman, illustrated by Dave McKean, HarperCollins/Bloomsbury, 2005

MirrorMask: The Illustrated Film Script Of The Motion Picture from the Jim Henson Company by Neil Gaiman and Dave McKean, William Morrow, 2005

M Is for Magic by Neil Gaiman, illustrated by Teddy Kristiansen, HarperCollins, 2007

Murder Mysteries (Radio play script) by Neil Gaiman, illustrated by George Walker, Biting Dog Press, 2001

Neverwhere by Neil Gaiman, BBC Books, 2006

Now We Are Sick edited by Neil Gaiman and Stephen Jones, illustrated by Andrew Smith and Clive Barker, DreamHaven, 1991

The Ocean at the End of the Lane by Neil Gaiman, William Morrow/Headline, 2013

Odd And The Frost Giants by Neil Gaiman, illustrated by Mark Buckingham, Bloomsbury, 2008

The Quotable Sandman by Neil Gaiman, Vertigo/DC, 2000

The Sandman Book of Dreams edited by Neil Gaiman and Ed Kramer, Harper Prism, 1996

A Screenplay by Neil Gaiman, Hill House Press, 2004

The Silver Dream by Michael Reaves and Mallory Reaves, story by Neil Gaiman and Michael Reaves, Harper Teen, 2013

Smoke and Mirrors by Neil Gaiman, Avon, 1998

Snow Glass Apples (Radio play script) by Neil Gaiman, illustrated by George Walker, Biting Dog Press, 2002

Stardust by Neil Gaiman, illustrated by Charles Vess, Vertigo/DC, 1997; Text-only version Spike/Avon, 1999

Stories edited by Neil Gaiman and Al Sarrantonio, William Morrow/Headline, 2010

Temps devised by Neil Gaiman and Alex Stewart, Roc, 1991

Unnatural Creatures edited by Neil Gaiman and Maria Dahvana Headley, Harper, 2013

Villains created by Mary Gentle and Neil Gaiman, edited by Mary Gentle and Roz Kaveney, Roc, 1992

A Walking Tour of the Shambles by Neil Gaiman and Gene Wolfe, illustrated by Randy Broecker and Earl Geier, American Fantasy Press, 2002

Weerde Book 1 devised by Neil Gaiman, Mary Gentle, and Roz Kaveney, Roc, 1992

Weerde Book 2 devised by Neil Gaiman, Mary Gentle, and Roz Kaveney, edited by Mary Gentle and Roz Kaveney, Roc, 1993

Who Killed Amanda Palmer by Neil Gaiman and Amanda Palmer, photos primarily by Kyle Cassidy, Beth Hommel, Eight Foot Books, 2009

The Wolves in the Walls by Neil Gaiman, illustrated by Dave McKean, HarperCollins, 2003

COMICS

w=Writer; *s*=Story; *a*=Artist; *p*=Penciller; *i*=Inker; *l*=Letterer; *c*=Colorer; *sep*=Separations

"Angela"; *a*=Todd McFarlane, *l*=Tom Orzechowski, *c*=Steve Oliff, Reuben Rude, and Olyoptics: *Spawn* #9, Image, 1993

Angela (*Angela's Hunt*); *p*=Greg Capullo, *i*=Mark Pennington and Greg Capullo, *l*=Tom Orzechowski, *c*=Todd Broeker and Fierce Colorgraphics, Steve Oliff and Olyoptics: *Angela* #1–3, Image, 1994–1995

"Babycakes"; *a*=Michael Zulli, *l*=Steve Bissette: *Taboo* #4, SpiderBaby Grafix, 1990

"Being an Account of the Life and Death of the Emperor Heliogabolus"; *a*=Neil Gaiman: *Being an Account of the Life and Death of The Emperor Heliogabolus*, self published, 1992

"A Black and White World"; *a*=Simon Bisley, *l*=John Costanza: *Batman Black and White* #2, DC, 1996

Black Orchid; *a*=Dave McKean, *l*=Todd Klein: *Black Orchid* #1–3, DC, 1988–1989

"Blood Monster"; *a*=Nancy O'Connor, *l*=M. Kelleher: *Taboo* #6, SpiderBaby Grafix, 1992

"The Book Of Judges"; *a*=Mike Matthews: *Outrageous Tales from the Old Testament*, Knockabout, 1987

The Books of Magic; *a*=John Bolton, Scott Hampton, Charles Vess, and Paul Johnson, *l*=Todd Klein: *The Books of Magic* #1–4, DC, 1990–1991

The Books of Magick: Life During Wartime; *w*=Si Spencer, *s*=Neil Gaiman and Si Spencer, *a*=Dean Ormston, Duncan Fegredo, Steve Yeowell, and Sean Philips, *c*=Fiona Stephenson, *l*=Todd Klein: *The Books of Magick: Life During Wartime* #1–15, Vertigo/DC, 2004–2005

"Brothers"; *p*=Richard Piers Rayner and Mike Hoffman, *i*=Kim De Mulder, *c*=Tatjana Wood, *l*=Tim Harkins: *Swamp Thing Annual* #5, DC, 1989

"Celebrity Rare Bit Fiends"; *a*=Rick Veitch: *Rare Bit Fiends* #2–3, King Hell, 1994

The Children's Crusade; *w*=Neil Gaiman, Alisa Kwitney, and Jaime Delano, *a*=Chris Bachalo and Peter Snejbjerg, *i*=Mike Barreiro, *c*=Daniel Vozzo, *l*=John Costanza: *The Children's Crusade* #1–2, Vertigo/DC, 1993–1994

"The Cigarette Ad"; *a*=Mark Buckingham: *The Truth* #6 (March 17 1988)

"Comix Ecsperience"; *a*=Neil Gaiman: *Comix Experience 5th Anniversary Ashcan*, Comix Experience, 1994

"Conversation Piece"; a=David Wyatt, l=Tom Frame: *2000 AD* #489, IPC, 1986

"The Court"; a=Warren Pleece: *It's Dark in London*, Serpent's Tail, 1996

"Cover Story"; a=Kelley Jones: *A1* #5, Atomeka Press, 1991

"The Dark"; s=Todd McFarlane, a=Todd McFarlane and Greg Capullo, l=Tom Orzechowski, c=Steve Oliff and Olyoptics, partial script by Neil Gaiman (uncredited until 2010): *Spawn* #26, Image, 1994

"Deady and I"; a=Voltaire: *Deady* Volume 3, Sirius, 2004

Death: The High Cost of Living; p=Chris Bachalo, i=Mark Buckingham, l=Todd Klein, c=Steve Oliff and Olyoptics: *Death: The High Cost of Living* #1–3, Vertigo/DC, 1993

"Death Talks About Life"; a=Dave McKean, l=Todd Klein: *The Sandman* #46, Vertigo/DC, 1993

Death: The Time of Your Life; p=Chris Bachalo and Mark Buckingham, i=Mark Buckingham and Mark Pennington, c=Matt Hollingsworth, l=Todd Klein: *Death: The Time of Your Life* #1–3, Vertigo/DC, 1996

"Death: A Winter's Tale"; a=Jeff Jones: *Vertigo: Winter's Edge* #2, Vertigo/DC, 1999

"Down Among the Dead Men"; a=Les Edwards: *Zombie Apocalypse! Fightback*, Robinson, 2012

Eternals; p=John Romita Jr., i=Danny Miki, Tim Townsend, Tom Palmer, Delperdand, and Janson, c= Matt Hollingsworth, Dean White, and Paul Mounts, l=Todd Klein: *Eternals* #1–7, Marvel, 2006–2007

"The Eternals—What It Is And How It Came To Be…"; p=John Romita Jr., i=Danny Miki, l=Todd Klein: *Entertainment Weekly* #884/885 (June 30/July 7, 2006)

"The False Knight on the Road"; a=Charles Vess: *The Book of Ballads and Sagas* #1, Green Man Press, 1995

"Feeders and Eaters"; a=Mark Buckingham, l=Annie Parkhouse (Original release), l=Vickie Williams (Subsequent releases): *Revolver: The Horror Special* #1, Fleetway, 1990

"The Flowers of Romance"; a=John Bolton, l=Todd Klein: *Vertigo: Winter's Edge* #1, Vertigo/DC, 1998

"Fragments"; p=SMS, l=Jack McArdle, Everything Else by Fox: *Redfox* #20, Valkyrie Press, 1989

"From Homogenous to Honey"; p=Bryan Talbot, i=Mark Buckingham, l=Steve Craddock: *AARGH*, Mad Love, 1988

"The Great Cool Challenge"; a=Shane Oakley: *BLAAM* #1, Willyprods, 1988

"Harlan & Me…"; a=Neil Gaiman: *Guest of Honor Harlan Ellison*, Chicago Comicon, 1994

"Hold Me"; a=Dave McKean, l=Todd Klein, c=Dave McKean and Danny Vozzo: *Hellblazer* #27, DC, 1990

"How They Met Themselves"; a=Michael Zulli, l=Todd Klein, c=Daniel Vozzo, sep=Jamison: *Vertigo: Winter's Edge* #3, Vertigo/DC, 2000

"I'm A Believer"; a=M. Belardinelli, l=Tom Frame: *2000 AD* #536, Fleetway, 1987

"The Innkeeper's Soul"; a=Larry Welz: *Cherry Deluxe* #1, Cherry Comics, 1994

"It Was a Dark and Silly Night"; a=Gahan Wilson: *Little Lit V. 3: It Was a Dark and Silly Night…*, Raw Junior Book/ HarperCollins, 2003

"Jack in the Green"; a=Steve Bissette and John Totelben, c=Tatjana Wood, sep=Digital Chameleon, l=John Costanza: *Neil Gaiman's Midnight Days*, Vertigo/DC, 1999

"Jael and Sisera"; a=Julie Hollings: *Outrageous Tales from the Old Testament*, Knockabout, 1987

"Jephthah and His Daughter"; a=Peter Rigg: *Outrageous Tales from the Old Testament*, Knockabout, 1987

"Journey to Bethlehem"; a=Steve Gibson: *Outrageous Tales from the Old Testament*, Knockabout, 1987

"The Last Sandman Story"; a=Dave McKean: *Dustcovers: The Collected Sandman Covers 1989–1997*, Vertigo/DC, 1997

The Last Temptation; a=Michael Zulli, l=Todd Klein, c=John Kalisz and Bernie Mireault: *Alice Cooper: The Last Temptation* #1–3, Marvel Music, 1994

Legend of the Green Flame; a=Eddie Campbell, Mark Buckingham, John Totelben, Matt Wagner, Jim Aparo, Kevin Nowlan, and Jason Little, p=Eric Shanower and Mike Allred, i=Arthur Adams and Terry Austin, l=Todd Klein, c=Matt Hollingsworth and Kevin Nowlan: *Green Lantern*Superman: Legend of the Green Flame*, DC, 2000

"The Light Brigade"; w=Neil Gaiman and Nigel Kitching, a=Nigel Kitching: *Trident* #1, Trident, 1989

Marvel 1602; a=Andy Kubert, l=Todd Klein, Digital painting by Richard Isanove: *Marvel 1602* #1–8, Marvel, 2003–2004

Melinda; a=Dagmara Matuszak: *Melinda*, Hill House Publishing, 2004

"Metamorpho the Element Man"; a=Michael Allred, c=Laura Allred, l=Blambot's Nate Piekos: *Wednesday Comics* #1–12, DC, 2009

"Miracleman: The Library of Olympus"; a=Mark Buckingham, l=Wayne Truman, c=Digital Chameleon: *Miracleman: Apocrypha* #1–3, Eclipse, 1991–1992

Miracleman: The Golden Age; a=Mark Buckingham and Gail Pople, l=Wayne Truman, Painted by Sam Parsons and D'Israeli: *Miracleman* #17–22, Eclipse, 1990–1991

"Miracleman: Retrieval"; a=Mark Buckingham: *Miracleman* #17–22, Eclipse, 1990–1991

"Miracleman: Screaming"; a=Mark Buckingham, l=Elitta Fell, c=Sam Parsons: *Total Eclipse* #4, Eclipse, 1989

Miracleman: The Silver Age; a=Mark Buckingham, l=Wayne Truman, Painted by D'Israeli: *Miracleman* #23–24, Eclipse, 1992–1993

"Mister X: Heartsprings & Watchstops"; a=Dave McKean: *A1* #1, Atomeka Press, 1989

"My Dream"; a=Neil Gaiman: *Chicago Comicon 1993 Souvenir Book*

"My Last Landlady"; a=Sam Kieth and Mike Dringenberg: *Hero Comics 2011*, IDW, 2011

"100 Words"; a=Jim Lee, l=Jimmy Betancourt: *Liberty Comics* #2, Image, 2009

"On the Stairs"; a=Teddy Kristiansen, l=Rob Leigh: *Solo* #8, DC, 2006

"Original Sins"; p=Mike Hoffman, i=Kevin Nowlan, c=Tom McCraw, l=Todd Klein: *Secret Origins Special* #1, DC, 1989

'Orrible Murders!; plot=Neil Gaiman; w=Nick Vince, Hilary Robinson, Dave Stone, and Dave Jackson; a=Mark Buckingham, Sean Philips, Duncan Fegreado, Paul Johnson, Steve Martin, Richard Weston, Lee Brimmicombe-Wood, Steve Whitaker, Rich Holden, Pete Mastin, Dave King, Ian Ellery, Brad Brooks, Roger Langridge, Dylan Horrocks, Andy Roberts, David Lloyd, Matt Brooker, Al Davison, and Andrew Robottom: 'Orrible Murders!, Comics Creators Guild, 1992

"Pavane"; a=Mark Buckingham, l=Agustin Mas, c=Nansi Hodlanan: *Secret Origins* #36, DC, 1989

"Planet of the Rain Gods"; a=Mark Buckingham, l=Todd Klein, c=Charlie Kirchoff: *Dr.Who: The Brilliant Book 2012*, BBC Books, 2011

"The Prophet Who Came to Dinner"; a=Dave McKean: *Outrageous Tales from the Old Testament*, Knockabout, 1987

"Romita—Space Knight!"; a=Hilary Barta, c=Michelle Madsen, l=Todd Klein: *John Romita Jr 30th Anniversary Special*, Marvel, 2006

The Sandman Book I: Preludes And Nocturnes; p=Sam Kieth and Mike Dringenberg, i=Mike Dringenberg and Malcolm Jones III, c=Robbie Busch, c=Daniel Vozzo (*Absolute* editions), l=Todd Klein: *The Sandman* #1–8, DC, 1989

The Sandman Book II: The Doll's House; p=Mike Dringenberg, Chris Bachalo, Michael Zulli, and Sam Kieth, i=Malcolm Jones III and Steve Parkhouse, c=Robbie Busch, c=Daniel Vozzo (*Absolute* editions), l=Todd Klein and John Costanza: *The Sandman* #9–16, DC, 1989–1990

The Sandman Book III: Dream Country; p=Kelley Jones and Colleen Doran, i=Malcolm Jones III, a=Charles Vess, c=Robbie Busch and Steve Oliff, c=Daniel Vozzo (*Absolute* editions), l=Todd Klein: *The Sandman* #17–20, DC, 1990

The Sandman Book IV: Season of Mists; p=Mike Dringenberg, Kelley Jones, and Matt Wagner, i=Malcolm Jones III, P. Craig Russell, George Pratt, and Dick Giordano, c=Steve Oliff and Daniel Vozzo, l=Todd Klein: *The Sandman* #21–28, DC, 1990–1991

The Sandman Book V: A Game of You; p=Shawn McManus, Colleen Doran, and Bryan Talbot, i=Shawn McManus, George Pratt, Dick Giordano and Stan Woch, c=Daniel Vozzo, l=Todd Klein: *The Sandman* #32–37, DC, 1991–1992

The Sandman Book VI: Fables and Reflections; p=Stan Woch, Duncan Eagleson, Bryan Talbot, and Jill Thompson, i=Dick Giordano, Vince Locke, Stan Woch, and Mark Buckingham, a=Kent Williams, Shawn McManus, John Watkiss, and P. Craig Russell, c=Sherilyn Van Valkenburgh, Daniel Vozzo, and Lovern Kindzierski and Digital Chameleon, l=Todd Klein: *The Sandman* #29–31, 38–40, 50, *Special* #1, Vertigo/ DC, 1991–1993

The Sandman Book VII: Brief Lives; p=Jill Thompson, i=Vince Locke and Dick Giordano, c=Daniel Vozzo, l=Todd Klein: *The Sandman* #41–49, Vertigo/DC, 1992–1993

The Sandman Book VIII: World's End; p=Bryan Talbot, Michael Zulli, Shea Anton Pensa, and Gary Amano, i=Mark Buckingham, Dick Giordano, Vince Locke, Bryan Talbot, Steve Leialoha, and Tony Harris, a=Alec Stevens, John Watkiss, and Michael Allred, c=Daniel Vozzo, sep=Android Images and Digital Chameleon, l=Todd Klein: *The Sandman* #51–56, Vertigo/DC, 1993

The Sandman Book IX: The Kindly Ones; p=Marc Hempel, Dean Ormston, and Richard Case, i=Marc Hempel, D'Israeli, and Richard Case, a=Glyn Dillon, Charles Vess, and Teddy Kristiansen, c=Daniel Vozzo, l=Todd Klein: *The Sandman* #57–69, Vertigo/DC, 1994–1995

The Sandman Book X: The Wake; a=Michael Zulli, Jon J. Muth, Charles Vess, Bryan Talbot, and John Ridgway, c=Daniel Vozzo and Jon J. Muth, l=Todd Klein: *The Sandman* #70–75, Vertigo/DC, 1995–1996

The Sandman: The Dream Hunters; a=Yoshitaka Amano: *The Sandman: The Dream Hunters*, Vertigo/DC, 1999

The Sandman: Endless Nights; a=P. Craig Russell, Milo Manara, Miguelanxo Prado, Barron Storey, Bill Sienkiewicz, Glenn Fabry, and Frank Quitely, c=Lovern Kindzierski and Chris Chuckry, l=Todd Klein: *The Sandman: Endless Nights*, Vertigo/DC, 2003

Sandman Midnight Theatre; w=Neil Gaiman, Plotted by Matt Wagner, s=Matt Wagner and Neil Gaiman, a=Teddy Kristiansen, l=Todd Klein: *Sandman Midnight Theatre*, Vertigo/DC, 1995

The Sandman: Overture; a=J.H.Williams, c=Dave Stewart, l=Todd Klein: *The Sandman: Overture* #1–6, Vertigo/DC, 2013–2014

"Shaggy God Stories"; a=Mike Mignola, c=Tatjana Wood, l=Tim Harkins: *Swamp Thing Annual* #5, DC, 1989

Signal to Noise; a=Dave McKean: *The Face* V. 2 #9–15 (June–December 1989)

"Sloth"; a=Bryan Talbot: *Seven Deadly Sins*, Knockabout, 1989

"The Spirit: The Return of Mink Stole"; a=Eddie Campbell, c=Steve Oliff, sep=Tracey Anderson, l=Tracey H. Munsey and Chris Sadoian: *The Spirit: The New Adventures* #2, Kitchen Sink Press, 1998

"Sweat and Tears"; s=Neil Gaiman and Faye Perozich, w=Faye Perozich, a=Yanick Paquette and Michael Lacombe, c=Scott Rockwell, l=Faye Perozich: *Blood Childe* #4, Millennium, 1995

Sweeney Todd the Demon Barber of Fleet Street; a=Michael Zulli: *Taboo* #7, SpiderBaby Grafix, 1992

The Totally Stonking, Surprisingly Educational and Utterly Mindboggling Comic Relief Comic; Plot by Richard Curtis, Neil Gaiman, and Grant Morrison, Edited By Richard Curtis, Neil Gaiman, and Peter K. Hogan, w=Various including Neil Gaiman, a=Various, l=Ellie de Ville, Eliza, Tom Frame, Bambos Georgiou, Ian Nicholson, Annie Parkhouse, and Woodrow Phoenix: *The Totally Stonking, Surprisingly Educational and Utterly Mindboggling Comic Relief Comic*, Fleetway, 1991

The Tragical Comedy or Comical Tragedy of Mr. Punch; a=Dave McKean: *The Tragical Comedy or Comical Tragedy of Mr. Punch*, Victor Gollancz, 1994

"The Tribe Of Benjamin"; a=Mike Matthews: *Outrageous Tales from the Old Testament*, Knockabout, 1987

"True Things"; a=Mark Buckingham, l=Todd Klein: *The Extraordinary Works of Alan Moore* by George Khoury, TwoMorrows Publications, 2003

"Vier Mauern"; a=Dave McKean: *Breakthrough*, Catalan Communications, 1990

"Villanelle"; a=Dave McKean: *The Adventures of Luther Arkwright*: ARKeology, Valkyrie Press, 1989

Violent Cases; a=Dave McKean: *Violent Cases*, Escape/Titan, 1987

Welcome Back to…The House Of Mystery; a=Sergio Aragones, l=Todd Klein, c=Tom Ziuko: *Welcome Back to…The House Of Mystery* #1, Vertigo/DC, 1998

Whatever Happened to the Caped Crusader?; p=Andy Kubert, i=Scott Williams, c=Alex Sinclair, l=Jared K. Fletcher: *Batman* #686, DC, 2009; *Batman Legends* #33, Titan/DC, 2009; *Detective Comics* #853, DC, 2009

"What's in a Name?"; a=Steve Yeowell, l=Jack Potter: *2000 AD* #538, Fleetway, 1987

"The Wheel"; a=Chris Bachalo, l=Todd Klein, c=Rob Ro and Alex Bleyaert: *9-11 Volume 2*, DC, 2002

Wheel of Worlds; s: Neil Gaiman and John Ney Reiber, w=C.J. Henderson, James Vance, Rick Veitch, John Ney Reiber, p=Mike Netzer, Ted Slampyak, Bryan Talbot, Shea Anton Pensa, i=Mike Netzer, Art Nichols, Kelly Krantz, l=Richard Starkings, John Workman, c=Alan Craddock, Angus McKie: *Neil Gaiman's Wheel Of Worlds* #0, Tekno Comix, 1995

"When Is a Door"; p=Bernie Mireault, i=Matt Wagner, c=Joe Matt, l=ABCD: *Secret Origins Special* #1, DC, 1989

"Wordsworth"; a=Dave McKean: *Hellraiser* #20, Epic, 1993

"You're Never Alone with a Phone;" a=John Hicklenton, l=Tom Frame: *2000 AD* #488, IPC, 1986

essays, speeches, and tributes

"All Books Have Genders": BN.com and Powells.com

"Banging the Drum for Harlan Ellison": *Readercon 11 Souvenir Book*, 1999

"Batman: *The Dark Knight Returns* by Frank Miller": *Foundation* #38 (1987)

Robert Bloch Tribute: Appreciations of the Master edited by Richard Matheson and Ricia Mainhardt, Tor, 1995

"Bone Notes": *Jeff Smith: Bone and Beyond* by Lucy Shelton and David Filipi, Wexner Center for the Arts, 2008

"Anthony Boucher—*The Compleat Werewolf, and Other Stories Of Fantasy And SF*": *Horror 100 Best Books* edited by Stephen Jones and Kim Newman, Xanadu, 1988

"*The Bride of Frankenstein*": *Cinema Macabre* edited by Mark Morris, PS Publishing, 2006

"Peter Crowther: The Awful Truth": *Travellers In Darkness* edited by Stephen Jones, World Horror Convention 2007

"Will Eisner Tribute": *Will Eisner: A Spirited Life* by Bob Andelman, M Press, 2005

"Entitlement Issues": Neilgaiman.com

"Essay for Beth": *Dark Dreamers* by Beth Gwinn and Stanley Wiater, Cemetery Dance, 2001

"Essay for Patti": *The Faces of Fantasy* by Patti Perret, Tor, 1996

"Jo Fletcher: A Concurrence": *Brighton Shock!* Edited by Stephen Jones, PS Publishing, 2010

"Footfall Review": *Foundation* #36 (Summer 1986)

"Four Poems": *Brothers and Beasts* edited by Kate Bernheimer, Wayne State University Press, 2007

"Free Speech & The CBLDF": *Fiddler's Green: A Sandman Convention Book*, 2004

"Ghosts in the Machines": *New York Times*, October 31, 2006

"The Golden Age": *The Uncanny Dave Cockrum…A Tribute* edited by Clifford Meth, Aardwolf Publishing, 2004

"Good Comics and Why You Should Sell Them": *Gods & Tulips*, Westhampton House, 1999

"Hanukkah With Bells On": *Independent*, December 21, 2008

"Here's How I Became a Doctor Who Fan": *Behind The Sofa: Celebrity Memories of Doctor Who* edited by Steve Berry, Matador, 2012

"How Dare You": *Inside Borders*, August 2001

"How To Read Gene Wolfe": *Fantasy and Science Fiction* V. 112 #4 (April 2007)

"In Which An Entablature of Salamanders Performs a Myoclonic Can-Can, and Mary Livingstone Is Discussed": *Polder* edited by Farah Mendlesohn, Old Earth Books, 2006

"A Modest Proposal": *Free Speeches*, Oni Press, 1998

"The Mystery of Father Brown": *100 Great Detectives* edited by Maxim Jakubowski, Xanadu, 1991

"Mythcon 35 Author Guest of Honor Speech": *Mythprint* V. 41 #10/#271 (October 2004)

"Nebula Medal Acceptance Speech": *A Little Gold Book of Ghastly Stuff* by Neil Gaiman, Borderlands Press, 2011

"The Newberry Medal Acceptance Speech": *The Graveyard Book* by Neil Gaiman, Harper, 2010

"Notebook Thoughts from Abroad": *Guillermo del Toro: Cabinet Of Curiosities* by Guillermo del Toro, Harper Design, 2013

"Notes From A Successful Crossover Author": *Writers' and Artists' Yearbook 2009*, A&C Black, 2008

"Notes Towards a Vegetable Theology": *Prince of Stories* by Hank Wagner, Christopher Golden, and Stephen R. Bissette, St. Martin's Press, 2008

"Once Upon a Time": *The Guardian*, October 13, 2007

"On Cities": *SimCity 2000*, Maxis, 1993

"On Discovering Diana Wynne Jones": *Boskone 32 Program Book*, 1995

"On Signings": *Gods & Tulips*, Westhampton House, 1999

"Pro Guest of Honor Terry Pratchett: An Appreciation": *Noreascon 4 Book*, 2004

"Quorn Versus the Microwave Popcorn!": *Concatenation* #4, 1990

"Reflections on Myth (With Digressions into Gardening, Comics and Fairy Tales)": *Columbia: A Journal of Literature and Art* #31 (Winter 1999)

"Several Things About Charles Vess": *Tropicon XVII Book*, 1998

"They Were Probably Just Being Polite": *World Fantasy Convention 2002 Book: Gods and Monsters*, 2002

"The View from the Cheap Seats": *The Guardian*, March 25, 2010

"300 Good Reasons to Resent Dave Sim": *Comics Buyer's Guide* #977 (August 7, 1992)

"2006 SFWA Grand Master Award: Harlan Ellison": *On the Road* Volume 6, Shag Records, 2012

"Where Do You Get Your Ideas": Neilgaiman.com

"Where I Write": *Anticipation: The 67th World Science Fiction Convention Book*, 2009

"Why Books Are Dangerous": *Guys Write for Guys Read* edited by Jon Scieszka, Viking, 2005

"Why Defend Freedom of Icky Speech": Neilgaiman.com

"Gene Wolfe: Be Willing to Learn": *World Horror Convention 2002 Book*

"Writing (The PRO/con Speech)": *Gods & Tulips*, Westhampton House, 1999; *Magian Line* V. 3.2 (July 1997)

"Writing and Werewolfing": *Waterstone's Guide to Science Fiction, Fantasy & Horror* edited by Paul Wake, Steve Andrews, and Ariel, Waterstone's Booksellers Ltd, 1998

"You Never Forget Your First Time": *Batman Cover to Cover*, DC, 2005

films

Archangel Thunderbird; directed by Kevin Davies, written by Alan Grant and Tony Luke; voice of Baal by Neil Gaiman; broadcast 1998

Arthur: "Falafelosophy"; directed by Greg Bailey, written by David Steven Cohen and Peter K. Hirsch; appearance by Neil Gaiman; broadcast October 25, 2010

Babylon 5: "Day of the Dead"; directed by Doug Leler, written by Neil Gaiman; broadcast March 11, 1998

Beowulf; directed by Roger Zemeckis, written by Neil Gaiman and Roger Avary; release date November 5, 2007

Coraline; directed by Henry Selick, written by Henry Selick based on a book by Neil Gaiman; release date February 5, 2009

Doctor Who: "The Doctor's Wife"; directed by Richard Clark, written by Neil Gaiman; broadcast May 14, 2011

Doctor Who: "Nightmare in Silver"; directed by Stephen Woolfenden, written by Neil Gaiman; broadcast May 11, 2013

Doctor Who: "Rain Gods"; director uncredited, written by Neil Gaiman; release date September 24, 2013

Dragon's World; directed by Justin Hardy, written by David McNab, Justin Hardy, and Charlie Foley; Neil Gaiman is creative consultant; broadcast 2004

Dreams With Sharp Teeth; directed by Erik Nelson; Neil Gaiman is interviewee; release date May 2008

The Guild: "Downturn"; directed by Sean Becker, written by Felecia Day; appearance by Neil Gaiman; air date September 6, 2011

It Was a Dark and Silly Night; adapted and directed by Steven-Charles Jaffe based on a comic written by Neil Gaiman; release date October 18, 2008

Jay and Silent Bob's Super Groovy Cartoon Movie; directed by Steve Stark, written by Kevin Smith; voice of Albert the Manservant by Neil Gaiman; release date April 20, 2013

Life, The Universe, and Douglas Adams; written and directed by Rick Mueller; narrated by Neil Gaiman; release date 2003

Live at the Aladdin; director uncredited, recording of live reading by Neil Gaiman; recorded October 2000

MirrorMask; directed by Dave McKean, written by Neil Gaiman, story by Neil Gaiman and Dave McKean; release date January 25, 2005 (Sundance debut), September 30, 2005 (national)

Neverwhere; directed by Dewi Humphreys, written by Neil Gaiman; broadcast September 12–October 17, 1996

Notes from the Underground; interview with Neil Gaiman by Louis Broome; broadcast April 9, 1998

On the Wall; directed by Lisa Nelson, written by Neil Gaiman; release date 2005

Princess Mononoke—English release; directed by Hayao Miyazaki, translated from the original Japanese by Steve Alpert, Haruyo Moriyoshi, and Ian MacDougal, adapted from translation by Neil Gaiman; release date October 1999

A Short Film About John Bolton; directed by Neil Gaiman, written by Neil Gaiman; release date January 24, 2003

The Simpsons: "The Book Job"; directed by Bob Anderson, written by Dan Vebber; appearance by Neil Gaiman; air date November 20, 2011

Stardust; directed by Matthew Vaughn, written by Jane Goldman and Matthew Vaughn based on the comic by Neil Gaiman and Charles Vess; release date August 10, 2007

Statuesque; written and directed by Neil Gaiman; air date December 25, 2009

interviews

Douglas Adams; "Douglas Adams": *Knave* V. 16 #4 (1984)

Douglas Adams; "Words": *English Penthouse* V. 19 #5 (May 1984)

Douglas Adams; "The Hitch-Hikers Guide To Douglas Adams": *Fantasy Empire* #13 (September 1984)

Douglas Adams; "Douglas Adams the Universe and Everything": *Space Voyager* #13 (February/March 1985)

Brian Aldiss; "A Writer For All Seasons": *Space Voyager* #16 (August/September 1985)

Clive Barker; "Words": *Penthouse* (UK) V. 20 #5 (May 1985)

Steven Berkoff; "The Steven Berkoff Interview—He Ain't Heavy…": *Knave* V. 17 #6 (1985)

George Best; "George Best—The Best of All Worlds": *Knave* V. 18 #4 (1986)

Martin Brest; "Martin Brest—Coming Back in Style": *Knave* V. 17 #4 (1985)

Ramsey Campbell; "Words": *Penthouse* (UK) V. 20 #5 (May 1985)

Arthur C. Clarke; "Stranger Than Fiction": *Space Voyager* #17 (October/November 1985)

John Cooper Clarke; "John Cooper Clarke: The Man Behind the Glasses": *Knave* V. 16 #3 (1984)

Divine; "The Knave Interview: Divine": *Knave* V. 18 #5 (1986)

William Donaldson; "Going Back To His Roots": *Knave* V. 17 #11 (1985)

John Dowie; "John Dowie—Humour Therapy": *Knave* V. 16 #7 (1984)

Adrian Edmonson; "The Knave Interview: Adrian Edmondson": *Knave* V. 19 #2 (1987)

Denholm Elliott; "The Face Fits…": *Knave* V. 17 #7 (1985)

Fish; "Fish Swimming Against The Tide": *Knave* V. 16 #12 (1984)

Mark Gabor; "Club Portrait: Mark Gabor": *Club International* (UK) V. 15 #2 (1986)

Ray Galton and Alan Simpson; "Comedy Playwrights": *Knave* V. 17 #5 (1985)

William Gibson; "The Knave Interview: William Gibson": *Knave* V. 18 #7 (1986)

William Gibson; "Loving The Alien": *Time Out* #928 (June 1–8, 1988)

Gary Glitter; "Glittering Prizes": *Knave* V. 17 #3 (1985)

Gorillaz; "Keeping It (Un)Real": *Wired* V. 13 #7 (July 2005)

Harry Harrison; "West of Eden": *Knave* V. 16 #8 (1984)

Frank Herbert; "Dune Is Busting Out All Over": *Knave* V. 17 #2 (1985)

Frank Herbert; "Duniverse": *Space Voyager* #14 (April/May 1985)

James Herbert; "…East End Boy Writes Good": *The Best of Knave* (1986), *Knave* V. 16 #10 (1984)

James Herbert; "The Craft": *James Herbert by Horror Haunted* edited by Stephen Jones, New English Library, 1992

The Hernandez Brothers; "The Hernandez Brothers": *The Comics Journal* #178 (July 1995)

Lucy Irvine; "From 'Runaway' to 'Castaway'": *Knave* V. 19 #6 (1987)

Terry Jones; "…And Now for Something Completely Terry": *Knave* V. 16 #6 (1984)

Terry Jones; "Terry Jones Of Monty Python Is Turning The World Upside Down": *Fantasy Empire* #14 (November 1984)

Kambriel; "Kambriel": *Tome Volume One: Vampirism*, 44 Flood, 2013

Stephen King; "The King And I": *Cemetery Dance* #67 (2012)

Patrick Macnee; "Patrick Macnee Avenger With a View to Kill": *Knave* V. 17 #10 (1985)

Rik Mayall; "Waiting For Gogol": *The Best of Knave* V. 5 (1986), *Knave* V. 17 #1 (1985)

Alan Moore; "The British Invasion: Alan Moore": *American Fantasy* V. 2 #2 (Winter 1987)

Alan Moore; "The Knave Interview: Moore About Comics": *Knave* V. 18 #3 (1986)

Alan Moore and Dave Gibbons (as moderator of panel); "A Portal to Another Dimension": *The Comics Journal* #116 (July 1987)

Grant Morrison; "So One Comic-Book Legend Said To The Other…": *Entertainment Weekly* #1165 (July 29, 2011)

Richard O'Brien; "The Knave Interview: Richard O'Brien": *Knave* V. 20 #2 (1988)

Bill Oddie; "Bill Oddie: The Goodies, The Birdies, and the Toilet Book": *Knave* V. 16 Christmas Issue (1984)

Tuppy Owens; "The Shy Sex Expert": *Knave* V. 18 Christmas Issue (1986)

Terry Pratchett; "The Colour Of Pratchett": *Space Voyager* #15 (June/July 1985)

Terry Pratchett; "Deeply Weird": *Time Out* #949 (October 26–November 2, 1988)

Terry Pratchett; "Sweet Fantasy—25 Years Of Terry Pratchett's Discworld": *Books Quarterly* #29 (2008)

David Rappaport; "The Knave Interview: David Rappaport": *Knave* V. 18 #2 (1986)

Lou Reed; "Lou Reed: Waiting for the Man": *Reflex* #26 (July 28, 1992)

Gilbert Shelton; "Gilbert Shelton": *Knave* V. 16 #5 (1984)

Robert Silverberg; "Science Fiction Seer": *English Penthouse* V. 19 #3 (1984)

Peter Tinniswood; "Peter Tinniswood Tales from a Long Room—in Kilburn": *Knave* V. 16 #11 (1984)

Edmund White; "The Knave Interview: Edmund White": *Knave* V. 18 #9 (1986)

Gene Wolfe; "The Knight At The Door": *The New York Review of Science Fiction* #186 V. 16 No. 6 (February 2004)

Introductions, afterwords, and forewords

"About Kim Newman, with Notes on the Creation and Eventual Dissolution of the Peace and Love Corporation": *The Original Dr. Shade & Other Stories* by Kim Newman, Pocket Books, 1994

"A Brief Introduction": *The Animal Bridegroom* by Sandra Kasturi, Tightrope Books, 2007

"After They've Brought on the Dancing Girls: Some Thoughts On Friendship, Healthcare, Cats and Sex": *Images of Omaha* #1, Kitchen Sink Press, 1992

Afterword: *Evelyen Evelyn—A Tragic Tale in Two Tomes* by Amanda Palmer, Jason Webley, and Cynthia Von Buhler, Dark Horse, 2011

Afterword: *Nameless Sins* by Nancy A. Collins, Gauntlet, 1994

Afterword: *Lord Of The Fantastic* edited by Martin H. Greenberg, Avon/Eos, 1998

Afterword: *Peace* by Gene Wolfe, Orb, 2012

Afterword: "A Book Review, Issued in the Form of a Circulating Document, Amplified and Enhanced with Observations from Life and Several Precepts for the Wise By Ilen, a Magian": *The Lord of Castle Black* by Steven Brust, Tor, 2003

"The Amano Conundrum": *Biten* by Yoshitaka Amano, Asahi Sonorama, 1999

"The Books of Magic: An Introduction": *Books of Magic 1: The Invitation* by Carla Jablonski, Eos/HarperCollins, 2003

"Breathtaker: An Introduction": *Breathtaker*, Vertigo/DC, 1994

"A Brief Encounter Before the Real One": *Harlan 101: Encountering Ellison* by Harlan Ellison, Edgeworks Abbey, 2011

"But What Has That to Do with Bacchus?": *Deadface: Immortality Isn't Forever*, Dark Horse, 1990

"The Cartoonist": *The Cartoonist* #1, Sirius, 1997

"Concerning Dreams and Nightmares": *The Dream Cycle of H. P. Lovecraft*, Del Rey, 1995

"Dinosaur Shadows: Why I Lomo, And on Real Film At That": *Lomo Life*, Thames and Hudson, 2012

"A Distant Soil: An Introduction": *A Distant Soil: The Gathering*, Image, 1997

"Dori Seda: An Introduction": *Dori Stories*, Last Gasp, 1999

"Drawn in Darkness": *Haunted Shadows* by John Bolton, Halloween Artworks, 1998

"Will Eisner's New York: An Introduction": *Will Eisner's New York* by Will Eisner, Norton, 2006

"Harlan Ellison's Loose Cannon: An Introduction": *Amazing Stories* #603 (September 2004)

"England's Dreaming": *Albion*, Wildstorm Productions, 2007

Foreword: *100 Graphic Novels for Public Libraries* by Steven Weiner, Kitchen Sink Press, 1996

Foreword: *The Beast That Shouted Love at the Heart of the World* by Harlan Ellison, Borderlands Press, 1994

Foreword: *Best Friend for Life* by Anne Bobby, Black Dog And Leventhal Publishers, 2008

Foreword: *The Complete Bone Adventures*, Volume 2, Cartoon Books, 1994

Foreword: *Dimensions Behind the Twilight Zone* by Stewart T. Stanyard, ECW Press, 2007

Foreword: *The Einstein Intersection* by Samuel R. Delany, Wesleyan University Press, 1998

Foreword: *Elric in the Dream Realms* by Michael Moorcock, Del Rey/Ballantine, 2009

Foreword: *God Bless You, Dr. Kevorkian* by Kurt Vonnegut, Seven Stories Press, 2010

Foreword: *The Greenwood Encyclopedia of Science Fiction And Fantasy* V. 1 edited by Gary Westfahl, Greenwood Press, 2005

Foreword: *Lucifer: Devil In The Gateway*, Vertigo/DC, 2001

Foreword: *Myth, Symbol And Meaning in Mary Poppins*, Routledge, 2006

Foreword: *Reflections on the Magic Of Writing* by Diana Wynne Jones, David Flicking Books, 2012

Foreword: *Rising Stars* #1, Top Cow/Image, 1999

Foreword: *The Science of Fiction and the Fiction of Science* by Frank McConnell, McFarland & Company, 2009

Foreword: *Solomon Kane Sketchbook* by Gary Gianni, Wandering Star, 1997

Foreword: *Vertigo Encyclopedia* by Alex Irvine, DK Publishing, 2008

Foreword: *The Aesthetics of Invention: Art & Artifice* by Jim Steinmeyer, Carrol & Graf, 2006

Foreword: "Just an Introduction": *Just a Geek* by Wil Wheaton, O'Reilly, 2004

Foreword: "Remembering Douglas": *Hitchhiker* by M.J. Simpson, Justin Charles & Co., 2003

"From the Days of Future Past": *The Country of the Blind and Other Selected Short Stories* by H. G. Wells, Penguin Classics, 2007

"Neil Gaiman in an Exciting Introduction with the Daleks": *Doctor Who and the Daleks* by David Whitaker, BBC Books, 2011

"Goreword": *Tales from the Crypt Calendar* 2006, Workman Publishing, 2005

"Hi By the Way": *Tori Amos Under the Pink Tour Book*: Pink Tour, 1994

"'How Do You Baffle a Vegetable?' and Other God Jokes": *Swamp Thing Volume Eight*, Titan, 1988

"In Re: Pansy Smith and Violet Jones": *The Flash Girls— The Return of Pansy Smith and Violet Jones*, Spin Art, 1993

Introduction: *The 13 Clocks* by James Thurber, The New York Review Children's Collection, 2008

Introduction: *The Adventures of Professor Thintwhistle and His Incredible Aether Flyer*, Fantagraphics, 1991

Introduction: *Amano's Hero Exhibition Flyer* (1999)

Introduction: *Tori Amos to Venus and Back Tour Book: To Venus and Back*, 1999

Introduction: *The Arbitrary Placement of Walls* by Martha Soukup, DreamHaven, 1997

Introduction: *The Art of Bryan Talbot*, NBM, 2007

Introduction: *Astro City: Confession*, Homage, 1997

Introduction: *Blake's 7: The Inside Story* by Joe Nazzaro and Sheelagh Wells, Virgin, 1997

Introduction: *Bratpack*, King Hell, 1992

Introduction: *Comic Book Tattoo* edited by Rantz A. Hoseley, Image, 2008

Introduction: *Dogsbody* by Diana Wynne Jones, Firebird/Penguin, 2012

Introduction: *Faeries: A Musical Companion to the Art Of Brian Froud*, RCA/BMG, 2002

Introduction: *Fahrenheit 451 60th Anniversary Edition* by Ray Bradbury, Simon and Schuster, 2013

Introduction: *The Good Fairies Of New York* by Martin Millar, Soft Skull Press, 2006

Introduction: *Hokusai: Demons* by Al Davison, The Astral Gypsy, 2009

Introduction: *Hothouse* by Brian Aldiss, Penguin Books, 2008

Introduction: *The Jungle Book* by Rudyard Kipling, Random House, 2012

Introduction: *The King Of Elfland's Daughter* by Lord Dunsany, Del Rey Impact/Ballantine, 1999

Introduction: *Kirby King of Comics* by Mark Evanier, Abrams, 2008

Introduction: *The Knight and Knave of Swords* by Fritz Leiber, Audible.com, 2008

Introduction: *Fritz Leiber Selected Stories* edited by Jonathan Strahan and Charles N. Brown, Night Shade Books, 2010

Introduction: *Lenore—Cooties* by Roman Dirge, Titan Books, 2010

Introduction: *Jack Kirby's The Losers*, DC, 2009

Introduction: *Lud-in-the-Mist* by Hope Mirrlees, Millennium/Victor Gollancz, 2000

Introduction: *The Machineries of Joy* by Ray Bradbury, PS Publishing, 2010

Introduction: *Mark of the Beast* by Rudyard Kipling, Gollancz, 2007

Introduction: *Modern Masters V. 22: Mark Buckingham*, TwoMorrows, 2010

Introduction: *The New Annotated Dracula* by Bram Stoker, edited by Leslie S. Klinger, W. W. Norton and Company, 2008

Introduction: *The Tundra Sketchbook Series Volume Three: Noodles*, Tundra, 1991

Introduction: *The Collected Omaha the Cat Dancer Volume Five*, Kitchen Sink Press, 1993

Introduction: *Portable Childhoods* by Ellen Klages, Tachyon, 2007

Introduction: *Rockstar* by Geoffrey Notkin, Stanegate Press, 2012

Introduction: *The Savior Book One*, Trident, 1990

Introduction: *Scholars & Soldiers* by Mary Gentle, MacDonald, 1989

Introduction: *Shadows of Light and Dark* by Jo Fletcher, Airgedlamh Publications/Alchemy Press, 1998

Introduction: *Sonovawitch! And Other Tales of Supernatural Law*, Exhibit A Press, 2000

"An Introduction": *Starchild: Crossroads*, Coppervale Press, 1998

Introduction: *Superheroes* edited by Steve Saffel, Titan, 2010

Introduction: *Superman: The Man of Tomorrow*, Titan, 1988

Introduction: *Swords Against Death* by Fritz Leiber, Audible.com, 2008

Introduction: *Swords Against Wizardry* by Fritz Leiber, Audible.com, 2008

Introduction: *Swords and Deviltry* by Fritz Leiber, Audible.com, 2008

Introduction: *Swords and Ice Magic* by Fritz Leiber, Audible.com, 2008

Introduction: *Swords in the Mist* by Fritz Leiber, Audible.com, 2008

Introduction: *The Tale of One Bad Rat* #1, Dark Horse, 1994

Introduction: *Tantrum* by Jules Feiffer, Fantagraphics, 1997

Introduction: *The Umbrella Academy: Dallas*, Dark Horse, 2009

Introduction: *The Vertigo Tarot*, Vertigo/DC, 1995

Introduction: *Voice of the Fire* by Alan Moore, Top Shelf, 2003

Introduction: *Gahan Wilson: 50 Years Of Playboy Cartoons* by Gahan Wilson, Fantagraphics, 2010

Introduction: *World Walkthrough: Fas Ferox*, Lulu.com, 2006

Introduction: *The Year's Best Graphic Novels, Comics, & Manga* edited by Byron Preiss and Howard Zimmerman, St. Martin's Griffin, 2005

"An Introduction by Famous Author Neil Gaiman": *Tales of Mirth and Woe* by Alistair Coleman, Publish And Be Damned, 2006

"Introduction Concerning Speculative Engineering, with Notes on Exploration, the Scattered Oeuvre of John M. Ford, and an Unreliable and Vaguely Scatological Anecdote About Freud or Someone Like That": *Adventures in the Dream Trade; From the End of the Twentieth Century* by John M. Ford, NESFA, 1997

Introduction: "Four Bookshops": *Shelf Life* edited by Greg Ketter, DreamHaven, 2002

"Intro from the Heart": *Hearts of Africa*, Slave Labor Graphics, 1994

"Denis Kitchen: The Awful Truth": *The Oddly Compelling Art of Denis Kitchen*, Dark Horse, 2010

"Love and Death: Overture": *Swamp Thing: Love and Death*, DC, 1990

"Me and My Dadd and Mark Chadbourn": *The Fairy Feller's Master Stroke* by Mark Chadbourn, PS Publishing, 2002

"The Nature of the Infection: Doctor Who Novellas": *The Eye Of The Tyger* by Paul McAuley, Telos, 2003

"Of Blood and Bad Craziness…": *Swamp Thing Volume Two*, Titan, 1987

"Of Meetings and Partings": *The Collected Stories of Roger Zelazny V. 3: This Mortal Mountain* edited by David G. Grubbs, Christopher S. Kovacs, and Ann Crimmins, NESFA Press, 2009

"Of Time, and Gully Foyle": *The Stars My Destination* by Alfred Bester, Vintage Books/Random House, 1996

"On Barron Storey": *W.A.T.C.H. 1996 Annual*, Vanguard, 1996

"One of the Brotherhood": *World Fantasy Convention 2002 Book: Gods and Monsters*

"On Spares—A Short, Formal Introduction, with Additional Theory": *Spares Special Edition* by Michael Marshall Smith, Overlook Connection Press, 1998

"On *Viriconium*: Some Notes Towards an Introduction": *Viriconium* by M. John Harrison, Bantam Spectra, 2005

"Original Synners—An Introduction to the Tenth Anniversary Edition": *Synners* by Pat Cadigan, Four Walls Eight Windows, 2001

"Orphee": *Orphee* (CD), Projekt, 2000

Preface: *The Arthur C. Clarke Award: A Critical Anthology* edited by Paul Kincaid with Andrew M. Butler, Serendip Foundation, 2006

Preface: *Hope-in-the-Mist* by Michael Swanwick, Temporary Culture, 2009

Preface: *Blood Suckers: The Vampire Archives* edited by Otto Penzler, Vintage Crime/Black Lizard, 2009

"A Recognition": *Echoes: The Drawings of Michael William Kaluta* by Michael William Kaluta, Vanguard, 2000

"Screwtape Letters": *The Screwtape Letters*, Marvel, 1994

"Shameful Secrets of Comics Retailing: The Lingerie Collection": *How To Get Girls (Into Your Store)*, Friends of Lulu, 1997

"Some Strangeness in the Proportion: The Exquisite Beauties of Edgar Allan Poe": *Edgar Allan Poe: Selected Poems and Tales* by Edgar Allan Poe, Barnes And Noble, 2004

"The Spirit: An Introduction": *The Best of the Spirit*, DC, 2005

"The Swords of Lankhmar": *Return to Lankhmar* by Fritz Leiber, White Wolf, 1997

"The Thing of It Is": *Jonathan Strange and Mr. Norrell* by Susanna Clarke, Bloomsbury, 2009

"Triffles Light as Air and Otherwise": *Swamp Thing Volume Four*, Titan, 1987

"True Stories: The Secret Life of Kelli Bickman": *What I Thought I Saw* by Kelli Bickman, Yatra Publications, 1996

"A Very Foxy Introduction": *Redfox Book II: The Demon Queen*, Valkyrie Press/Harrier, 1988

"What This Book Is Really About": *The Worm*, Slab-O-Concrete Publications, 1999

"What Was He Like, Douglas Adams?": *The Ultimate Hitchhiker's Guide to the Galaxy* by Douglas Adams, Del Rey/Ballantine, 2002

"Who Killed Amanda Palmer": Amanda Palmer—*Who Killed Amanda Palmer*, Roadrunner Records, 2008

"Why Dead Birds Move and Flowers Go to Hell": *Swamp Thing Volume Three*, Titan, 1987

"The Wound That Never Heals: An Introduction": *The Man in the Maze* by Robert Silverberg, ibooks, 2002

poems and songs

"All Purpose Folk Song (Child Ballad #1)": *Magian Line* V. 1.4 (February 1994)

"The [Backspace] Merchants": *Gateways* edited by Elizabeth Anne Hull, Tor, 2010

"Banshee": *Magian Line* V. 2.2 (October 1994)

"Bay Wolf": *Dark Detectives* edited by Stephen Jones, Fedogan & Bremer, 1999

"Before You Read This": *Before You Read This Print*, Todd Klein, 2008

"Bloody Sunrise": *The Lifted Brow* #4 (January 17, 2009)

"Boys and Girls Together": *Black Heart, Ivory Bones* edited by Ellen Datlow and Terri Windling, Avon, 2000

"The Butterfly Road": Folk Underground—*Buried Things*, Happyfun Records, 2003

"Cold Colours": *The Time Out Book of London Short Stories* edited by Maria Lexton, Penguin, 1993

"Conjunctions": *Mythic Delirium* #20 (Winter/Spring 2009)

"Dark Sonnet": Lorraine A' Malena—*Mirror Mirror*, Aranya Records, 2005;

"The Day the Saucers Came": spiderwords.com (2006)

"Death": *British Fantasy Society 2006 Calendar*, British Fantasy Society, 2005

"Eaten (Scenes From a Moving Picture)": *Off Limits* edited by Ellen Datlow, St. Martin Press, 1996

"8in8": *Nighty Night* album with Amanda Palmer, Ben Folds, and Damian Kulash: eightineight.com

"The Empty Chambers": *Outsiders* edited by Nancy Holder and Nancy Kilpatrick, Roc, 2005

"The Faery Reel": *The Faery Reel* edited by Ellen Datlow and Terri Windling, Viking, 2004

"Folk Underground": Folk Underground—*Buried Things*, Happyfun Records, 2003

"A Girl Needs a Knife": The Flash Girls—*Maurice and I*, Fabulous Records, 1995

"Going Wodwo": *Green Man* edited by Ellen Datlow and Terri Windling, Viking, 2002

"The Herring Song": The Flash Girls—*The Return of Pansy Smith and Violet Jones*, Spin Art, 1993

"Holes": *The Jane Austen Argument—Holes*, self published, 2011

"House": Tor.com

"How to Write Longfellow's Hiawatha": *Adventures in the Dream Trade* by Neil Gaiman, NESFA, 2002

"If I Apologized…": *MirrorMask Original Motion Picture Soundtrack*, La-La-Land Records, 2005

"I Google You": Amanda Palmer—*Who Killed Amanda Palmer*, Roadrunner Records, 2008 (CD—website preorder free MP3 only)

"In Relig Oran": *In Relig Oran* Print, 2010

"Instructions": Holiday print from Neil Gaiman (1999)

"Inventing Aladdin": *Swan Sister* edited by Ellen Datlow and Terri Windling, Simon & Schuster Books For Young Readers, 2003

"It's Just Me and Eve": Lorraine A' Malena—*Mirror Mirror*, Aranya Records, 2005

"I Will Write in Words of Fire: *An Evening with Neil Gaiman and Amanda Palmer*, self published, 2011

"Locks": *Silver Birch, Blood Moon* edited by Ellen Datlow and Terri Windling, Avon, 1999

"Making a Chair": Holiday print from Neil Gaiman (2011)

"A Meaningful Dialogue": The Flash Girls—*Play Each Morning Wild Queen*, Fabulous Records, 2001

"My Last Landlady": *Off the Coastal Path* edited by Jo Fletcher, StanZa, 2010

"Neil's Thankyou Poem": *Magian Line* V. 2.2 (October 1994)

"Observing the Formalities": *Troll's Eye View* edited by Ellen Datlow and Terri Windling, Viking, 2009

"Ode to Wm. Messner-Loebs": *Heroes and Villains* edited by Clifford Meth and Neal Adams, TwoMorrows, 2005

"The Old Warlock's Reverie": *Once Upon a Midnight…* edited by Jame A. Riley, Michael N. Langford, and Thomas E. Fuller, Unnameable Press, 1995

"On the Wall": One Ring Zero—*As Smart As We Are*, Soft Skull Press, 2004

"Personal Thing": The Flash Girls—*Play Each Morning Wild Queen*, Fabulous Records, 2001

"Poem": spiderwords.com (2006)

"Poem for Amanda": *An Evening with Neil Gaiman and Amanda Palmer*, self published, 2011

"Post Mortem of Our Love": The Flash Girls—*The Return of Pansy Smith and Violet Jones*, Spin Art, 1993

"The Queen of Knives": *Tombs* edited by Peter Crowther and Edward E. Kramer, White Wolf, 1994

"Reading the Entrails: A Rondel": *The Fortune Teller* edited by Lawrence Schimel and Martin H. Greenberg, Daw, 1997

"The Rhyme Maidens": *An Evening with Neil Gaiman and Amanda Palmer*, self published, 2011

"Riding the Flame/Little Beggarman": The Flash Girls—*The Return of Pansy Smith and Violet Jones*, Spin Art, 1993

"The Scorpio Boys in the City of Lux Sing Their Strange Songs": *Alan Moore: Portrait of an Extraordinary Gentleman* edited by Smoky Man and Gary Spencer Millidge, Abiogenesis Press, 2003

"The Sea Change": *Overstreet's Fan* #6 (November 1995)

"Septimus' Triolet": *A Fall of Stardust*, Green Man Press, 1999

"The Sky at Night": *The Sky at Night Print*, 1998

"The Song of the Audience": *Angels and Visitations* by Neil Gaiman, DreamHaven Books, 1993

"Song of the Little Hairy Man": *A Fall of Stardust*, Green Man Press, 1999

"The Song of the Lost": *Heroes*, Marvel, 2001

"Song of the Song": *Welcome to Bordertown* edited by Holly Black and Ellen Kushner, Random House, 2011

"Sonnet": *Adventures in the Dream Trade* by Neil Gaiman, NESFA, 2002

"Sonnet in the Dark": The Flash Girls—*The Return of Pansy Smith and Violet Jones*, Spin Art, 1993

"Tea and Corpses": The Flash Girls—*The Return of Pansy Smith and Violet Jones*, Spin Art, 1993

"Vampire Sestina": *Fantasy Tales* V. 10 #2 (Spring 1989)

"Virus": *Digital Dreams* edited by David V. Barrett, New English Library, 1990

"The White Road": *Ruby Slippers, Golden Tears* edited by Ellen Datlow and Terri Windling, AvoNova/William Morrow, 1995

"The Winter Gardens": *An Evening with Neil Gaiman and Amanda Palmer*, self published, 2011

"Witch Work": *Under My Hat* edited by Jonathan Strahan, Random House, 2012

"A Writer's Prayer": Holiday print from Neil Gaiman (1999)

"Yeti": The Flash Girls—*Maurice and I*, Fabulous Records, 1995

short stories

"Adventure Story": *McSweeney's Forty* edited by Dave Eggers, McSweeney's Books, 2012

"And Weep Like Alexander": *Fables from the Fountain* edited by Ian Whates, Newcon Press, 2011

"Being an Experiment Upon Strictly Scientific Lines Assisted byy Unwins LTD, Wine Merchants (Uckfield)": *20/20* #11 (February 1990)

"Bitter Grounds": *Mojo Conjure Stories* edited by Nalo Hopkinson, Aspect/Warner Books, 2003

"The Case of Death and Honey": *A Study in Sherlock* edited by Laurie R. King and Leslie Klinger, Poisoned Pen Press, 2011

"Case of the Four and Twenty Blackbirds": *Knave* V. 16 #9 (1984)

"Changes": *Crossing the Border* edited by Lisa Tuttle, Indigo, 1998

"Chivalry": *Grails: Quests, Visitations and Other Occurrences* edited by Richard Gilliam, Martin H. Greenberg, and Edward E. Kramer, Unnameable Press, 1992

"Cinnamon": *Overstreet's Fan* #4 (September 1995)

"Click-Clack the Rattlebag": Audible.com (2012)

"Closing Time": *McSweeney's #10: McSweeney's Mammoth Treasury of Thrilling Tales* edited by Michael Chabon, McSweeney's Books, 2002

"Daughter of Owls": *Overstreet's Fan* #9 (February 1996)

"December 7, 1995": *Tori Amos Boys for Pele Tour Book: 1996–1997 Tour*, 1996

"Desert Wind": Robin Adnan Anders—*Omaiyo* CD, Rykodisc, 1998

"Diseasemaker's Croup": *The Thackery T. Lambshead Pocket Guide to Eccentric & Discredited Diseases* edited by Jeff Vandermeer and Mark Roberts, Night Shade Books, 2003

"Don't Ask Jack": *Overstreet's Fan* #3 (August 1995)

"The Facts in the Case of the Departure Of Miss Finch": *Frank Frazetta Illustrated* #3 (Fall 1998)

"Featherquest": *Imagine* #14 (May 1984)

"Feeders and Eaters": *Keep Out the Night* edited by Stephen Jones, PS Publishing, 2002

"Feminine Endings": *Four Letter Word* edited by Joshua Knelman and Rosalind Porter, Chatto and Windus, 2007

"Fifteen Painted Cards from a Vampire Tarot": *The Art Of Vampire the Masquerade* edited by Ken Cliffe and Carl Bowen, White Wolf, 1998

"The Flints of Memory Lane": *Dancing with the Dark* edited by Stephen Jones, Vista, 1997

"Forbidden Brides of the Faceless Slaves in the Nameless House of the Night of Dread Desire": *Gothic* edited by Deborah Noyes, Candlewick Press, 2004

"Foreign Parts": *Words Without Pictures* edited by Steve Niles, Arcane/Eclipse, 1990

"The Goldfish Pool and Other Stories": *David Copperfield's Beyond Imagination* edited by David Copperfield and Janet Berliner, HarperPrism, 1996

"Goliath": *The Matrix Comics*, Burlyman Entertainment, 2003

"Good Boys Deserve Favours": *Overstreet's Fan* #5 (October 1995)

"Halloween": *Time Out* #1367 (October 30–November 6, 1996)

"Harlequin Valentine": *World Horror Convention 1999 Book*

"How Do You Think it Feels?": *In the Shadow of the Gargoyle* edited by Nancy Kilpatrick and Thomas S. Roche, Ace, 1998

"How to Sell the Ponti Bridge": *Imagine* #24 (March 1985) (illustrated by Keith Cooper)

"How to Talk to Girls at Parties": *Fantasy & Science Fiction* V. 112 #1 (January 2007)

"I Cthulhu: Or What's a Tentacle-Faced Thing Like Me Doing in a Sunken City Like This (Latitude 47° 9' S, Longitude 126° 43' W)?": *Dagon* #16–17 (January/February–April/May 1987)

"In the End": *Strange Kaddish* edited by Clifford Lawrence Meth and Ricia Mainhardt, Aardwolf Publishing, 1996

"An Invocation of Incuriosity": *Songs of the Dying Earth* edited by George R. R. Martin and Gardner Dozois, Subterranean Press, 2009

"Jerusalem": BBC Radio 4 (2007)

"Keepsakes and Treasures: A Love Story": *999* edited by Al Sarrantonio, Hill House Publishers/Cemetery Dance Publications, 1999

"A Longer and Stranger History": *Sandman Statue: The Sandman Statue (1991)* designed by Randy Bowen, DC/Graphitti Designs, 1991

"Looking for the Girl": *Penthouse* (UK) V.2 0 #10 (October 1985)

"A Lunar Labyrinth": *Shadows of the New Sun* edited by J. E. Mooney and Bill Fawcett, Tor, 2013

"Manuscript Found in a Milkbottle": *Knave* V. 17 #8 (1985)

"The Man Who Forgot Ray Bradbury": Neil Gaiman and Amanda Palmer: *An Evening with Neil Gaiman and Amanda Palmer*, self-published, 2011

"The Mapmaker": Holiday print from Neil Gaiman (2000)

"Megafauna": *Going Down Swinging* #32 edited by Jessica Friedman and Geoff Lemon, Going Down Swinging Inc, 2011

"The Monarch of the Glen": *Legends II* edited by Robert Silverberg, Voyager/HarperCollins, 2003

"The Mouse": *Touch Wood* edited by Peter Crowther, Little, Brown and Company, 1993

"Murder Mysteries": *Midnight Graffiti* edited by Jessica Horsting and James Van Hise, Warner, 1992

"My Life": *Sock Monkeys (200 Out Of 1863)* by Arne Svenson and Ron Warren, Ideal World Books, 2002

"Mythical Creatures": *Mythical Creatures Presentation Pack*, Royal Mail, 2009

sources

"Nicholas Was…": Holiday print from Neil Gaiman (1989)

"Nothing O'Clock": Puffin.co.uk, 2013

"October in the Chair": *Conjunctions: 39 The New Wave Fabulists* edited by Peter Straub, Bard, 2002

"One Life, Furnished in Early Moorcock": *Michael Moorcock's Elric: Tales of The White Wolf* edited by Edward E. Kramer and Richard Gilliam, White Wolf, 1994

"Only the End of the World Again": *Shadows Over Innsmouth* edited by Stephen Jones, Fedogan & Bremer, 1994

"Orange": *The Starry Rift* edited by Jonathan Strahan, Viking, 2008

"Other People": *Fantasy & Science Fiction* V. 101 #4–5 (October/November 2001)

"Pages from a Journal Found in a Shoebox Left in a Greyhound Bus Somewhere Between Tulsa, Oklahoma, And Louisville, Kentucky": *Tori Amos Scarlet's Walk Tour Book: Scarlet's Walk*, 2002

"The Price": *Dark Terrors 3* edited by Stephen Jones and David Sutton, Victor Gollancz, 1997

"The Problem of Susan": *Flights* edited by Al Sarrantonio, Roc, 2004

"The Return of the Thin White Duke": *V* #29 (Summer 2004)

"The Shadow": *Half-Minute Horrors* edited by Susan Rich, Harper, 2009

"Shoggoth's Old Peculiar": *The Mammoth Book of Comic Fantasy* edited by Mike Ashley, Robinson, 1998

"Sir Gawain and the Green Knight: May" (tale told in 12 parts, each by different author): *British Fantasy Society 2005 Calendar*, British Fantasy Society, 2004

"The Sleeper and the Spindle": *Rags and Bones* edited by Melissa Marr and Tim Pratt, Little Brown, 2013

"Snow, Glass, Apples": *Snow, Glass, Apples Chapbook*, DreamHaven, 1994

"The Spirit of Seventy Five": *Guest of Honor Will Eisner*, Chicago Comicon, 1996

"Strange Little Girls": *Tori Amos Strange Little Girls Tour Book: Strange Days*, 2001

"A Study in Emerald": *Shadows Over Baker Street* edited by Michael Reaves and John Pelan, Del Rey, 2003

"Sunbird": *Noisy Outlaws, Unfriendly Blobs, and Some Other Things that Aren't as Scary, Maybe, Depending on How You Feel about Lost Lands, Stray Cellphones, Creatures from the Sky, Parents Who Disappear in Peru, a Man Named Lars Farf, and One Other Story We Couldn't Finish, so Maybe You Could Help Us Out* edited by Ted Thompson with Eli Horowitz, McSweeney's Books, 2005

"Sweeper of Dreams": *Overstreet's Fan* #8 (January 1996)

"Sweet Justice": *Judge Dredd Annual 1988*, IPC, 1987

"Tastings": *Sirens and Other Daemon Lovers* edited by Ellen Datlow and Terri Windling, HarperPrism, 1998; SM

"The Thing About Cassandra": *Songs of Love and Death* edited by George R. R. Martin and Gardner Dozois, Gallery Books, 2010

"Troll Bridge": *Snow White, Blood Red* edited by Ellen Datlow and Terri Windling, AvoNova/William Morrow, 1993

"The Truth is a Cave in the Black Mountains": *Stories* edited by Neil Gaiman and Al Sarrantonio, William Morrow, 2010

"Very Short Story": *Wired* V. 14 #11 (November 2006)

"Wall: A Prologue": *A Fall of Stardust*, Green Man Press, 1999

"Webs": *More Tales from the Forbidden Planet* edited by Roz Kaveney, Titan, 1990

"We Can Get Them for You Wholesale": *Knave* V. 16 #7 (1984)

"The Wedding Present": *Dark Terrors 4* edited by Stephen Jones and David Sutton, Victor Gollancz, 1998

"What's Your Story": *What's Your Story? The Postcard Collection*, Waterstone's, 2008

"When We Went to See the End of the World by Dawnie Morningside, Age 11 1/4": *Smoke and Mirrors* by Neil Gaiman, Avon, 1998

Roel, Dave. "Interview with Neil Gaiman and Dave McKean." December 10, 1994. http://daveroel.comyr.com/ng1.htm

Roel, Dave. "Interview with Neil Gaiman." June 27, 1997. http://daveroel.comyr.com/ng2.htm

Roel, Dave. "Interview with Neil Gaiman." February 11, 1998. http://daveroel.comyr.com/ng3.htm

Goodyear, Dana. "Kid Goth: Neil Gaiman's Fantasies." *The New Yorker*. January 25, 2010. http://www.newyorker.com/reporting/2010/01/25/100125fa_fact_goodyear#ixzz1SBzl98Fz

Farrell, Shaun. "Adventures in Sci-Fi Publishing Podcast #57." July 30, 2008. http://www.adventuresinscifipublishing.com/2008/07/aisfp-57-neil-gaiman/

Anderson, Porter. "Neil Gaiman: 'I enjoy not being famous.'" CNN.com. July 30, 2001. http://edition.cnn.com/2001/CAREER/jobenvy/07/29/neil.gaiman.focus/index.html

Murphy, Peter. "Enter Mr. Sandman." Accessed September 22, 2013. http://www.laurahird.com/newreview/neilgaimaninterview.html

Gaiman, Neil and Mike Richardson. *Neil Gaiman: Live at the Aladdin*. DVD. 2001.

Crispin, Jessa. "An Interview with Neil Gaiman." Bookslut. October 2006. http://www.bookslut.com/features/2006_10_010057.php

Gaiman, Neil. "Addams Thing." Journal (blog), October 22, 2005. http://journal.neilgaiman.com/2005/10/addams-thing.html

Gaiman, Neil. "Ray Bradbury." Journal (blog). June 6, 2012. http://journal.neilgaiman.com/2012/06/ray-bradbury.html

Wagner, Hank, Christopher Golden, and Stephen R. Bissette. *Prince of Stories: The Many Worlds of Neil Gaiman*. New York: St. Martin's Press, 2008.

Vince, Nicholas. "The Luggage in the Crypt." *Skeleton Crew*. November 1990. http://www.nicholasvince.com/works/luggage-in-the-crypt/

Henderson, Susan. "LitPark Interview: Neil Gaiman." The Nervous Breakdown (blog). November 29, 2009. http://www.thenervousbreakdown.com/shenderson/2009/11/neil-gaiman/

Gaiman, Neil. Address to the University of the Arts Graduating Class 2012. Transcribed from a video.

Comics Forum: The Quarterly Journal of the Society for Strip Illustration #1. Spring 1992.

Lawley, Guy. "'I like *Hate* and I hate everything else': The influence of punk on comics." In *Punk Rock: So What?: The Cultural History of Punk*, edited by Roger Sabin. New York: Routledge, 1991.

Steel, Sharon. "The Hot Seat: Neil Gaiman." *Time Out*. June 13, 2011. http://newyork.timeout.com/arts-culture/1550483/the-hot-seat-neil-gaiman

Baker, Bill. *Neil Gaiman on His Work and Career: A Conversation with Bill Baker*. New York: Rosen Publishing Group, 2007.

Gaiman, Neil. "peace and love and all that stuff . . ." Journal (blog). October 18, 2006. http://journal.neilgaiman.com/2006/10/peace-and-love-and-all-that-stuff.html

Locus Online. "Neil Gaiman: Different Kinds of Pleasure." February 2005. http://www.locusmag.com/2005/Issues/02Gaiman.html

Richards, Linda. "January Interview: Neil Gaiman." *January Magazine*. August 2001. http://januarymagazine.com/profiles/gaiman.html

Masters, Tim. "Neil Gaiman: 'Short stories are like vampires.'" BBC. June 11, 2010. http://www.bbc.co.uk/news/10277014

Huddleston, Kathie. "Neil Gaiman hitchhikes through Douglas Adams' hilarious galaxy." SciFi.com. http://www.scifi.com/sfw/advance/24_interview.html (via the Wayback Machine, February 16, 2004)

Gaiman, Neil. "Remembering Douglas." May 15, 2003. http://www.neilgaiman.com/p/Cool_Stuff/Essays/Introductions/Remembering_Douglas

Rudden, Liam. "Interview: Neil Gaiman, of The Hitchhiker's Guide to the Galaxy Live." *Edinburgh Evening News*. July 19, 2012. http://www.scotsman.com/edinburgh-evening-news/latest-news/interview-neil-gaiman-of-the-hitchhiker-s-guide-to-the-galaxy-live-1-2421785

Gaiman, Neil. "Neil Gaiman and Terry Pratchett at EosCon IV." NeilGaiman.com. 2001. http://www.neilgaiman.com/p/Cool_Stuff/Essays/Essays_By_Neil/Neil_Gaiman_and_Terry_Pratchett_at_EosCon_IV

Locus Online. "Gaiman & Pratchett, Together Again… Almost." February 2006 (1991). http://www.locusmag.com/2006/Issues/1991_Gaiman_Pratchett.html

Locus Online. "A Conversation With Neil Gaiman & Terry Pratchett." February 2006. http://www.locusmag.com/2006/Issues/02GaimanPratchett.html

The Comics Journal #155 (January 1, 1993).

Kraft, David Anthony. *Comics Interview Super Special: Sandman*. Fictioneer Books, 1993.

Gaiman, Neil. The Official Neil Gaiman Tumblr. August 21, 2012. http://neil-gaiman.tumblr.com/post/29881421158/nothingbutthedreams-i-just-rediscovered-how

Hibbs, Brian. "Interview with Neil Gaiman." 26 October, 1989. http://thedreaming.holycow.com/2008/08/05/gaiman-interview-with-brian-hibbs/

Fantasy Advertiser #109 (January 1989).

Howe, David. "Neil Gaiman: Stardust Memories." Prism 23.6 (November/December 1999). http://www.britishfantasysociety.co.uk/bfs/stardust-memories-neil-gaiman/

Gaiman, Neil. "From Before He Was a Wizard…." Journal (blog). February 25, 2009. http://journal.neilgaiman.com/2009/02/from-before-he-was-wizard.html

Gaiman, Neil. "FAQ." NeilGaiman.com. http://www.neilgaiman.com/p/FAQs/Books,_Short_Stories,_and_Films

Gaiman, Neil. Blog. "Dragged screaming from the vaults…." Journal (blog). February 25, 2009. http://journal.neilgaiman.com/2009/02/dragged-screaming-from-vaults.html

Speakeasy #79 (October 1987).

Gravett, Paul. "Dave McKean: Mixed Media." November 13, 2005. http://www.paulgravett.com/index.php/articles/article/dave_mckean/

Comics Forum: The Quarterly Journal of the Society for Strip Illustration #1 (Spring 1992).

Comics Forum: The Quarterly Journal of the Society for Strip Illustration #2 (Summer 1992).

"Graphic Festival Part 3: The Evolution of the Idea." Transcribed from http://www.youtube.com/watch?v=Vx85OPnWIVI

Sanderson, Peter. "Gaiman's Sandman at 20." *PW Comics Week*. November 11, 2008. http://www.publishersweekly.com/pw/by-topic/new-titles/adult-announcements/article/17596-gaiman-s-sandman-at-20.html

Salisbury, Mark. *Writers on Comics Scriptwriting*. London: Titan Books, 1999.

Asbury Park Press. December 19, 1993.

Comic World #12.

Previews: Comics, Games, Trading Cards, and More! Vol. III, no. 8 (August 1993).

WIRED, "Exclusive Interview: Amanda Palmer and Neil Gaiman." December 27, 2012. Transcribed from video: http://www.youtube.com/watch?v=QDgFhwI9fqQ

McKean, Dave. Introduction to *Signal to Noise*, by Neil Gaiman and Dave McKean. Milwaukie, OR: Dark Horse, 2007.

Amazing Heroes Preview Special #2 (1986).

Amazing Heroes Preview Special #5 (Summer 1987).

Amado, Alex. "Following His Dream: Neil Gaiman Talks About His Past, Present and Future as a Storyteller." March 11, 1991. http://www.maths.tcd.ie/~afarrell/things/interview.html

Khoury, George. *Kimota! The Miracleman Companion*. Raleigh, NC: Twomorrows Publishing, 2001.

It #1 (September 1994).

Cavna, Michael. "LONG 'SPAWN' DISPUTE SETTLED: Neil Gaiman says case is good for creators, 'incredibly good' for copyright." *The Washington Post*. January 30, 2012. http://www.washingtonpost.com/blogs/comic-riffs/post/long-spawn-dispute-settled-neil-gaiman-says-case-is-good-for-creators-incredibly-good-for-copyright/2012/01/30/gIQAyoTvdQ_blog.html

Weiland, Jonah. "Marvel to Publish New Project by Neil Gaiman." Comic Books Resources. October 24, 2001. http://www.comic bookresources.com/?page=article&old=1&id=566

Gaiman, Neil. Afterword to *Marvel 1602*. New York: Marvel, 2006.

Weiland, Jonah. "Marvel's '1602' Press Conference." Comic Books Resources. June 27, 2003. http://www.comic bookresources.com/?page=article&old=1&id=2406

Gaiman, Neil. Cover letter to Andy Kubert, *Marvel 1602 #1*. October 29, 2003.

Newsarama. "Know Your Eternals." 2006. http://web.archive.org/web/20070417084439/http://www.newsarama.com/marvelnew/Eternals/GaimanEternals.html

Bissette, Stephen R. Myrant (blog). August 29, 2005. http://srbissette.blogspot.co.uk/2005/08/ok-heres-scoop-from-noon-to-noon.html

The Comics Journal #144 (January 1993).

Comics Buyer's Guide (July 3, 1992).

The Comics Journal #185 (March 1995). "The Steve Bissette Interview."

CosForums. "The Trades Interview." http://www.cosforums.com/showthread.php?t=121049&page=4

Hogan, Peter. "Feature Focus on *Mr. Punch*." *Previews: Comics, Games, Trading Cards, and More!* 1994.

Gaiman, Neil. Twitter photo. http://www.whosay.com/neilgaiman/photos/44511

Comics Forum: The Quarterly Journal of the Society for Strip Illustration #7, Autumn 1994.

Thill, Scott. "Neil Gaiman Write a Final 'Love Letter to Batman.'" *WIRED*. April, 21, 2009. http://www.wired.com/underwire/2009/04/a-love-letter-t/

Graphic festival, 2012. Neil Gaiman talks about killing Batman. Transcribed from a YouTube video. http://www.youtube.com/watch?v=NgmygRpVt10&feature=share&list=UUwBRJ0M9XbyG10lAoNmVMVQ&index=27

Gaiman, Neil. Introduction to *Batman: Whatever Happened to the Caped Crusader?* New York: DC Comics, 2010.

Gaiman, Neil. "Why defend freedom of icky speech?" Journal (blog). December 1, 2008. http://journal.neilgaiman.com/2008/12/why-defend-freedom-of-icky-speech.html

Gordon, Joe. "Knocking about with Tony Bennet." Forbidden Plant International (blog). December 13, 2006. http://forbiddenplanet.co.uk/blog/2006/knocking-about-with-tony-bennett/#

Gaiman, Neil. Introduction to "Locks" in *Fragile Things*. New York: William Morrow, 2006.

Huff, Ryan. "Interview: The Luckiest Boy in the World, Neil Gaiman." Geek of Oz. January 2011. http://www.geekofoz.com/2011/01/interview-luckiest-boy-in-world-neil.html

Gaiman, Neil. "The Truth is a Cave in the Black Mountains." Graphic Festival interview. Transcribed from a YouTube video. http://www.youtube.com/watch?v=Hyqt9ZFsacY&feature=share&list=UUwBRJ0M9XbyG10lAoNmVMVQ&index=39

Locus Online. "Neil Gaiman: Of Monsters and Miracles." April 1999. http://www.locusmag.com/1999/Issues/04/Gaiman.html

Gaiman, Neil. Journal (blog). September 8, 2002. http://journal.neilgaiman.com/2002/09/hello-you-probably-know-this-already.asp

Rave magazine interview. Jody McGregor. Macgregor, Jody. "A Pinch of Stardust." Attention Conservation Notices (blog). July 23, 2012. http://jodymacgregor.tumblr.com/post/27808211455/neil-gaiman-stardust-interview

Murray, Rebecca. "Behind the Scenes of the *Stardust* Movie with Neil Gaiman and Charles Vess." About.com. July, 2006. http://movies.about.com/od/stardust/a/stardust080106.htm

Gaiman, Neil. "Happily Ever After." *The Guardian*. October 13, 2007. http://www.guardian.co.uk/books/2007/oct/13/film.fiction

McIntyre, Gina. "All the Rules Are Turned Upside Down." *The Hollywood Reporter*. September 2005. http://www.neilgaiman.com/p/About_Neil/Interviews/Neil_Gaiman:_'All_the_rules_are_turned_upside_down.'_by_Gina_McIntyre,_The_Hollywood_Reporter_(September_2005)

Vineyard, Jennifer. "'Stardust' Author Neil Gaiman Tells Why He Turns Down Most Adaptations—But Not This One." Mtv.com. August 10, 2007. http://www.mtv.com/news/articles/1566862/neil-gaiman-makes-his-stardust.jhtml

Carnevale, Rob. "*Stardust*: Matthew Vaughn and Neil Gaiman Interview." IndieLondon. http://www.indielondon.co.uk/Film-Review/stardust-matthew-vaughn-and-neil-gaiman-interview

Gaiman, Neil. *American Gods*. New York: William Morrow, June 2001 (Page 65).

http://www.writeaway.org.uk/node/1267623117

Transcribed from an MTV news video.

Den of Geek. "Casting Neil Gaiman's American Gods." July 17, 2011. http://www.denofgeek.com/television/982327/casting_neil_gaimans_american_gods.html

Ouzounian, Richard. "Author Returns to 'First Girlfriend.'" *The Star*. February 7, 2009. http://www.thestar.com/Entertainment/article/583129

Grant, Gavin J. "Neil Gaiman." IndieBound. http://www.indiebound.org/author-interviews/gaimanneil

Billington, Alex. "Interview: *Coraline* Writer and Director Henry Selick." FirstShowing.net. 2009. http://www.firstshowing.net/2009/interview-coraline-writer-and-director-henry-selick/

Lawless, Andrew. "Using Genre to Effect: Neil Gaiman." Three Monkeys Online. August 1, 2005. http://www.threemonkeysonline.com/using-genre-to-effect-neil-gaiman/2/

Purcell, Charles. "Comics Genius." *The Sydney Morning Herald*. August 3, 2012. http://www.smh.com.au/entertainment/books/comics-genius-20100803-114ez.html#ixzz2BpQCDIR7

Gaiman, Neil. "Bet you thought I was…oh hang on, I used that one already." Journal (blog). September 28, 2009. http://journal.neilgaiman.com/2009/09/bet-you-thought-i-was-oh-hang-on-i-used.html

Gaiman, Neil. "News and musing." Journal (blog). June 16, 2007. http://journal.neilgaiman.com/2007/06/news-and-musing.html

White, Claire E. "A Conversation with Neil Gaiman." Writers Write. March 1999. http://www.writerswrite.com/journal/mar99/gaiman.htm

McNair, James. "How We Met: Tori Amos and Neil Gaiman." *The Independent*. October 10, 1999. http://www.independent.co.uk/arts-entertainment/music/news/how-we-met-tori-amos--neil-gaiman-743901.html

Gaiman, Neil, discussing writing *Blueberry Girl* at Books of Wonder, New York. March 7, 2009. Transcribed from a YouTube video. http://www.youtube.com/watch?v=9I5gHkzZeFo

Gaiman, Neil. MacFadden Memorial Lecture in Indianapolis. April 2010. Transcribed from a YouTube video. http://www.youtube.com/watch?v=5UPfj8-Qsgg

Gaiman, Neil. "The Author Comes Home, and displays many photographs of his travels." Journal (blog). November 4, 2009. http://journal.neilgaiman.com/2009/11/author-comes-home-and-displays-many.html

Gaiman, Neil. "Long Post, I'm Afraid…." Journal (blog). August 29, 2007. http://journal.neilgaiman.com/2007/08/long-post-im-afraid.html

Rex, Adam. E-mail with the author.

The Dreaming. "Neil Gaiman: A Man for All Seasons." August 5, 2008. thedreaming.holycow.com/dreaming/lore/interview/neil-gaiman-a-man-for-all-seasons/

Grant, Richard E. *Development Hell*. BBC Radio. June 6, 2011. Transcript.

Gaiman, Neil. *Don't Panic: Douglas Adams and the Hitch Hiker's Guide to the Galaxy*. London: Titan Books, 1993.

Avery, Roger. Foreword to *Beowulf: The Script Book*, by Neil Gaiman and Roger Avery. London: HarperEntertainment, 2007.

Gaiman, Neil. "The Ramayana." Recorded on March 25, 2008 at the British Library.

Gaiman, Neil. Journal (blog). Januray 1, 2003. http://journal.neilgaiman.com/2003/01/lets-see_01.asp

Gaiman, Neil. "Old friends…" Journal (blog). April 29, 2006. http://journal.neilgaiman.com/2006/04/old-friends.html

Gaiman, Neil. *A Short Film About John Bolton*, DVD. Director's commentary. New Video Group, 2004.

The Story podcast. 22nd July, 2011. Transcribed.

Gaiman, Neil. "Just me and Eve." Journal (blog). October 15, 2005. http://journal.neilgaiman.com/2005/10/just-me-and-eve.html

Khouri, Andy. "The 'Mirrormask' Interviews: Neil Gaiman and Dave McKean." Comic Book Resources. September 15, 2005. http://www.comic bookresources.com/?page=article&id=5661

Cook, Benjamin. "Interview with Neil Gaiman." *Doctor Who Magazine* #448. June 27, 2012.

Gaiman, Neil. "The Hitch-hiker's Guide to Douglas Adams." *Knave*, vol. 16, no. 4.

Doctor Who Confidential, transcribed from *The Doctor's Wife* episode.

Gaiman, Neil. "You see the Doctor do things he's never done before." Digital Spy. May 9, 2011. Transcribed from a YouTube video. http://www.youtube.com/watch?v=2NX3KPU7pg0&feature=related

Gaiman, Neil. "News from the Dead Room." Journal (blog). November 28, 2004. http://journal.neilgaiman.com/2004/11/news-from-dead-room.asp

Gaiman, Neil. "Author meets world." Journal (blog). November 28, 2012. http://journal.neilgaiman.com/2012/11/author-meets-world.html

picture credits

Every effort has been made to credit the copyright holders of the images reproduced in this book. We apologize for any omissions, which will be corrected in future editions, but must hereby disclaim any liability.

pp. 2–3: NG Archive Images Copyright © Neil Gaiman

foreword
p. 7 Copyright © Chris Close

introduction
p. 9: Copyright © Christian Ward
pp. 10–12: NG Archive Images Copyright © Neil Gaiman
p. 13: NG Archive Image Copyright © Neil Gaiman/Jill Thompson
p. 14: NG Archive Image Copyright © Neil Gaiman
p. 15 Copyright © Allan Amato
pp. 16–18: NG Archive Images Copyright © Neil Gaiman
p. 19: Top left ™ & © DC Comics. Used with Permission; right NG Archive Images Copyright © Neil Gaiman

chapter 1
p. 21 Copyright © Nick Harman
pp. 22–25: NG Archive Images Copyright © Neil Gaiman
p. 27: ™ & © DC Comics. Used with Permission.
p. 29: NG Archive Image Copyright © Neil Gaiman
pp. 30–32: All images Copyright © Nick Harman
p. 33: Left Copyright © Nick Harman; right NG Archive Image Copyright © Neil Gaiman
p. 34: From *Sideburns #1*, 1977
pp. 35–37: NG Archive Images Copyright © Neil Gaiman
pp. 38–39: All images Copyright © Galaxy Publications

INDEX

acknowledgments

Big love and thanks to:

Joel Golby and Bill Stiteler for being the first to read it, and editors Nick Jones and Tim Pilcher for putting me up to it. My Dad, Eddie Campbell, for not even allowing me to consider the possibility of not doing it, and for giving me that copy of *Sandman* #18 all those years ago. Mick Evans, for giving me the rest.

Pádraig Ó Méalóid, for endless help and answers (he has written an entire book on the history of Miracleman although it is, at this point, still looking for a publisher). Daniel Best, Sean Michael Wilson, everyone else in The Really Very Serious Alan Moore Scholar's Group who opened up their archives and their scanner lids for me, along with Russell Willis from Panel Nine.

Steve Bissette for doing *Prince of Stories* (with Hank Wagner and Christopher Golden) so I had something to steal from, plus sending a box of Taboo in the post.

Kim Newman, who let me come round and eat biscuits and look at old '80s porn magazines in his DVD dungeon. Ian Pemble for beer and for filling in the bits of history for which there are no records, only stories in pubs. Shield Bonnichsen for assembling the bibliography and providing images. Oscar Zarate, Faith Brooker, Eugene Byrne, Roz Kaveney, Mark Buckingham, Dave McKean, Steve Whitaker (I never got to meet him but he asked the questions I didn't), Stephen L. Holland at Page 45, Chris Breach, Martin Hand, Simon Russell, Ellie Wilson at Ilex, Adam Rex, Martin Griffiths, and my mum. The Fabulous Lorraine for dinner and scans and caffeine. And Sarah McIntyre and Audrey Niffenegger for letting me rant.

Ossie Hirst, Nat Metcalfe, and everyone at Gosh! Comics in London.

And Neil. Thanks for letting me go through your stuff. I put it all back just the way I found it. Unlike Kim's.

- sweet dreams -

They're human. Either Ikaris is insane. Or something's wrong.
But the Eternal places aren't there either.
Ikaris gets his memory back. Gets enough of the
stray Eternals to form a proto-unimind.

He also knows the clue to what
happened & somewhere in the past — in
Eternal loyalties & betrayals — only it isn't.

It's Sprite. 12 years old. Smarter and trickier
than any of them. Who only wanted to Age. She
wanted to grow up.

He accessed something (the Uni-mind again?) or
uncovered secrets of the Eternals (eg that some ?
them have died? Kept in stasis in Celestial
machines?)

The story of Ikaris regaining his memory (aided by
someone?) and restoring the Eternals. Gives them
something to do.

Biggest problem with Eternals is why to do.
So now the game becomes rounding up the
old Eternals, scattered and memory-wiped.
Uni-mind (+ Dreaming Celestial — or just Celestial
giggles) reconfigured reality + wiped them out.
& to Olympia — why there. It's all gone.

DIkaris ② it gets worse. Makkari, Thena, Sprite — film star?
(Avengers?) sees Uni-Mind — Sprite in California — only the
Dreaming Celestial. ④ Eternals vs. Sprite v Dreaming Celestial.
⑤ Rebuilding — restoration. ⑥ Rounding up Eternals..? What T$ are
boy there?

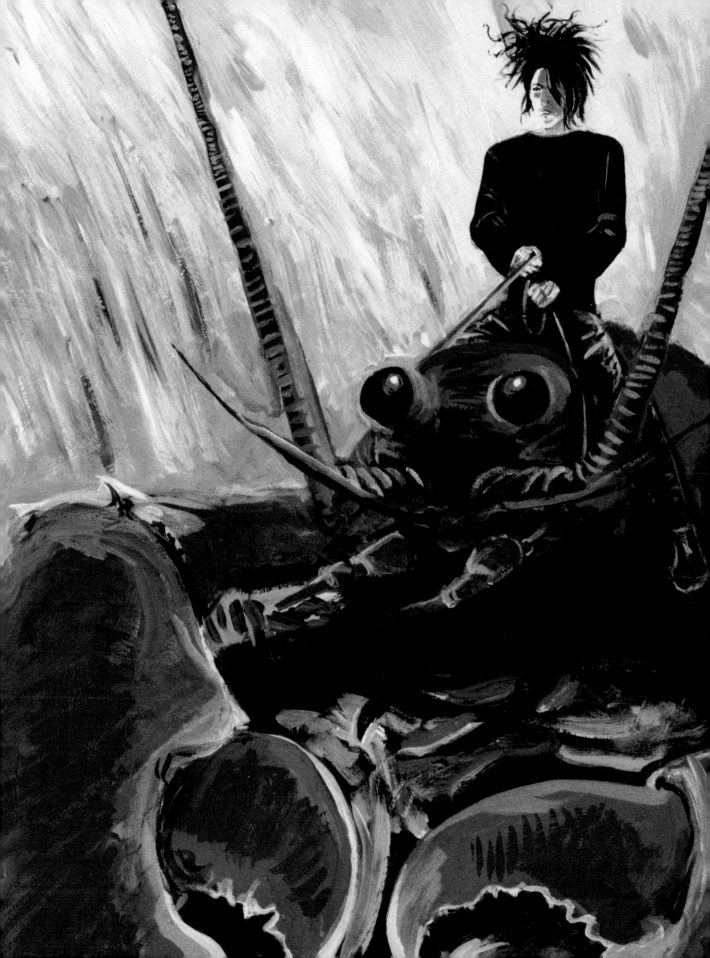

BLacK ORCHID

"There are two Black Orchids. One is the one in my head, and the other is the one that hit the paper. I'm still terribly proud of the one in my head. When I see the comic or the book, I'm reminded that that isn't the one the world got."

ABOVE: Gaiman in
December 1988.

OPPOSITE:
Black Orchid #1, 1988.

mOST AmERICAN SUPERHERO COmICS BY THE MID-1980S HAD BECOME HIDEBOUND; THEY READ AT BEST LIKE A MIXTURE OF WHAT HAD COME BEFORE, AND AT WORST THEY WERE LIKE BLURRED PHOTOCOPIES OF A PHOTOCOPY.

Compared to Alan Moore's groundbreaking work on *Swamp Thing* and *Watchmen*, they were boring and uninspiring—and America took notice. Since Britain had produced one Alan Moore, DC Comics wondered if there might be more where he came from. So DC Comics editors Dick Giordano and Karen Berger flew to London on a mission. They were applying the Beatles principle to comics.

At the previous year's UKCAC in September 1986, Gaiman had given Berger his "Jack in the Green" script that he'd written as a tryout for Moore. By the end of February, *Violent Cases* was still unfinished but almost there, and Gaiman heard that the DC scouts were in town. He rang Titan's Nick Landau and found out where they were staying. He got them on the phone and managed to set up a meeting.

"So I phoned Dave and said, 'We're going to see Dick Giordano,' and Dave says, 'They don't want to see us.' I practically put a gun to his back, forced him to bring his portfolio up. (A few months earlier, Dave had gone over to New York and shown his stuff to Marvel and DC and Continuity and everybody had said, 'Yes, we'll get back to you,' and nobody ever had.)" (*Fantasy Advertiser* #109, 1989).

If you talk to people who have worked with Gaiman, or who have had stories pitched to them by Gaiman, a lot of them have no idea how it happened. People accidentally agree to do things and then suddenly they're doing things they had no idea they were going to do two minutes ago. "It's weird. I had all these great survival skills I almost never use anymore. Every now and then I have to pull them out—these days I'll pull them out during giant Hollywood meetings, but they were how I survived in the eighties. It was like rewriting the world. Poor Dave was just walking around behind me going, 'They

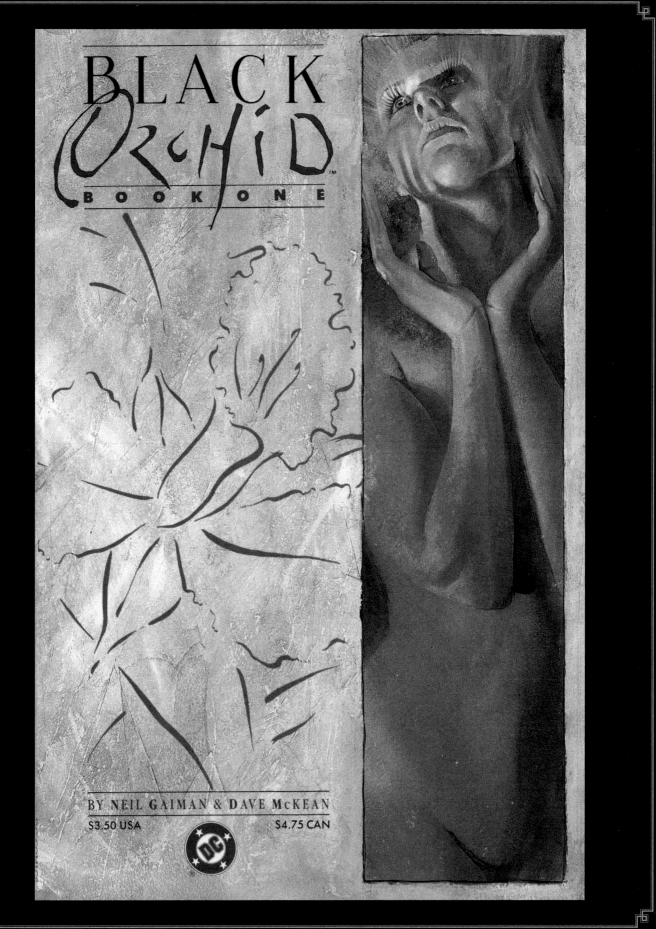

Gaiman was writing sequences not that much further along than what McKean was drawing. His art at the beginning of the book wound up feeding back into the story at the end of it. "There were also things like solutions to problems becoming motifs. Like, there is a point at page thirteen of *Black Orchid* #1—which, bear in mind, I wrote in about May 1987. I rung Dave saying, 'We aren't going to have any sound effects, are we?' and he said no. I wanted a sequence where we got a tap dripping, and the solution to getting that effect was to use the space between the panels, pulling the panels apart to use space between them, that actually wound up becoming a technique that was used through the rest of the books. They stop being gutters and start being further pieces of information" (*Fantasy Advertiser* #109, 1989).

don't mean it.' I'm going, 'Sshhhh. Don't look down. We're okay.' He went through that entire first meeting with DC Comics just baffled. 'I think they're just saying this to be polite.' No, they think we're great. We're doing this. I was very good at it. And I don't think anybody minded." Without that ability to bullshit, possibly none of this would have happened.

"We went into the room and Karen was there; she was pleased to see me. She went, 'Oh, Neil! I was going to try and get in touch with you! I read your "Jack in the Green" story on the plane coming over, I really liked it.' So I did my pitch for *Phantom Stranger*, and they said, 'Weirdly enough, Grant Morrison was in this morning, he did a pitch for *Phantom Stranger* too. Yours is really

good, his is really good—unfortunately we've got this Paul Kupperberg piece, which is not very good but it is what it is. So you can't do that.' Then they looked at Dave's art and suddenly Dick Giordano took us very, very seriously. So we had Dave's art, we had the fact that she liked my 'Jack in the Green' story, and we had the fact they liked the first pitch. Then Dick said: 'What do you want to do?'"

Gaiman rattled off a list of characters he had jotted down, going further and further down the list until he was ransacking the bottom of the DC bins for stuff that nobody was going to pick. The Phantom Stranger, Cain and Abel, Nightmaster, Black Canary, Green Arrow, John Constantine, Hawk and Dove, and Klarion the Witch Boy. He even

pitched Sandman, although that character (the original incarnation) was already spoken for in the Justice Society of America. Deadman, the Demon, the Forever People…

"And then I said: Black Orchid? And Karen, famously and to her embarrassment even to this day, said, 'Black Hawk Kid? Who's he?' And Dick said, 'Oh Black Orchid. I remember her, great costume. Yeah, do a Black Orchid proposal for us.'"

Black Orchid was a character created in 1973 who had appeared only sporadically since her creation, languishing in backups and cameos in various DC titles. She was essentially only an idea, appearing so infrequently that she remained a character with no secret identity and no official origin story. She was a vague mix of Superman and Batman in pinky-purple spandex. A superheroic detective with a black orchid calling card.

"We went down to the bar, and Dave looked up at me and said, 'I'm going to have to draw cheesecake. Oh god this is awful, I don't want to do this,' and I said, 'Well, what do you want to do?' He said, 'I prefer the "Jack in the Green" idea you had, we could do something like Amazonian rain forests, the destruction of the rain forests and that kind of thing,' and I said, 'Yes, don't worry, it will work. Trust me.' I was lying. I didn't know what I was doing" (*Fantasy Advertiser* #109, 1989).

Gaiman plotted *Black Orchid* on the train home to Sussex. By the time the train pulled in an hour or so later, he had outlined the first thirty pages of something that was definitely not cheesecake. The story gave Black Orchid an overhaul and an origin: instead of an anchorless superhero, she became a plant-hybrid with ties to the Green and everybody in it, the mythic universe of Alan Moore's *Swamp Thing*.

Gaiman wanted it to be a film noir story influenced by E. E. Cummings, a pacifist fable in which violence happened but was deeply unpleasant, in which meditation and beauty played an important part. Most of all he wanted to do a comic for people who actually read comics, unlike *Violent Cases*. Gaiman phoned McKean at his art school dormitory the next morning and told him the entire plot in a phone call so

Left: "Black Orchid was the hardest character to write. That's why I talk about E. E. Cummings, because he was where I ended up going to try to get how to express her thought processes, to try to use the imagery for her. I'm still not sure she works. I hope she does" (*Fantasy Advertiser* #109, 1989).

long that other students thought McKean was staging a piece of performance art.

It was about forty-five minutes on the payphone in his college; thirty people were lining up behind him in the hallway waiting to use the phone. And he didn't say a word.

I got to the end and he said, "Alright." And he went away and he painted six paintings of Black Orchid. *Just beautiful. On the Saturday night, DC held a dinner party in some Soho restaurant, and we were invited. But the following morning, Dave and I went to their hotel and we dropped off my outline and Dave's drawings. Years later Karen told me that the reason*

we got the job, the reason they took us seriously even though neither of us had any credits actually, in any real terms, was because we met them on Thursday, and on Sunday morning before they went back to America they had the pitch. They had the paintings and they had the outline, even though I didn't really have an ending for the story. I never really had an ending for Black Orchid. *But it was basically the first two parts.*

The pitch brought in other characters from the DC Universe—Lex Luthor, Batman, a trip to Arkham Asylum to meet Poison Ivy—which Gaiman says was a combination of the thrill of being let loose

Left: *Black Orchid* #1. Gaiman said: "I suggested we do natural things in bright colors, and dead things sort of monochromatic, and there was a progression through the book, from the cities to wildlife, from these tight little panels to the full bleeds. Dave took that one step further, and did the world outside in black and white, with natural things in full color. Also, it would bounce backwards and forwards, because by the time I was halfway through part two, I had seen the paintings that Dave had done for part one, so then I took some of those things and put them back into part two" (Kraft, 1993).

Vegetable Theology,' which was meant to be in *Black Orchid* but only gets glanced on. Basically they asked me to work out a whole system, how to do all the vegetable characters correctly, and that's the kind of thing I get a real kick out of, designing religions and designing systems and so on" (*Fantasy Advertiser* #109, 1989).

Having seen what kind of material Gaiman and McKean were capable of, DC Comics decided against releasing *Black Orchid* in the normal six-issue miniseries they had originally billed it for. Frank Miller's *Batman: The Dark Knight Returns* had done well the previous year in their new Prestige Format—square-bound comics with longer extents, better quality paper, and cardstock covers—so they phoned Gaiman and said that's what they were doing. "I was going, the *Dark Knight* format? The only thing they've done is the *Dark Knight*? Aaah!" While it was a vote of confidence (and not just a little bit terrifying in that anything following *Dark Knight* would then be compared to *Dark Knight*), it did require a bit of a rethink in the writing. Gaiman wound up doing two issues of the original plot in each double-sized issue—which was "a slight change in pacing, especially because it didn't fit" (*Fantasy Advertiser* #109, 1989).

in the sweet shop and also a commercial decision on his part. "It wasn't a commercial decision from the viewpoint of selling it to the public, but rather to sell it to DC. That was why we didn't come up with something that was ours and try to sell it to DC. What we did was take an old DC character and say, 'You'll own the project, and we're going to have these DC characters running through it'" (Kraft, 1993).

Not only did Gaiman tie Black Orchid to the Green for the purpose of a single story, he wrote a whole essay about the mythology and placed her in a plant-based family with Floronic Man and Poison Ivy: "I wrote an article called 'Notes Towards a

"And then halfway through issue two they got cold feet."

Gaiman was told later, by editor Paul Levitz, that DC originally saw *Black Orchid* as a non-commercial but arty and prestigious book, something that they would be proud to publish alongside the comics they usually published but not something they expected to be a big commercial hit. Having now actually seen the comic, they realized it could feasibly wind up being a financial success, except for one thing: nobody had ever heard of Neil Gaiman or Dave McKean.

I got a phone call from Karen saying, "Look, you're two guys nobody's ever heard of, doing a character that nobody's ever heard of, and it's a female character and female characters don't sell. So we're all kind of worried. What we've decided to do is give Dave a Batman script by Grant Morrison. He wrote the annual, but we think Dave can do it as a whole book called Arkham Asylum. *And we'd like to give you a monthly comic, and we'll build you guys up a bit before we bring out* Black Orchid."

This did not sit well with Dave, because Dave was already sick of the style he was doing Black Orchid *in, it was a mistake, it was wrong, he'd seen Bill Sienkiewicz's* Stray Toasters *and that was the future of comics. The joy of working with Dave, which was also the pain in the arse of working with Dave, is that he was always in search of the correct way to do it. The right way. I never thought there was a right way to do anything, I was just throwing mud at a wall—you hope some of it sticks. But Dave was always looking for the right way to do comics, so halfway through* Black Orchid *he was pretty sure that* Black Orchid *was not the right way to draw comics. Then by the time he was halfway through* Arkham Asylum *he knew that was not the right way to draw comics, but he had to keep going. Dave was really grumpy because he did not want* Arkham Asylum *to come out before*

Black Orchid, *because he felt that the entire comics world would feel that he had taken a huge step back as an artist if it happened.*

In the end, and more to the point, DC was not prepared to sit on 120 pages of fully painted comics for an extra year and a half given that they'd paid lots of money for it to be done.

The Sandman #1, although it had a cover date for January 1989, was released in October 1988, one month before the first issue of *Black Orchid,* which arrived on the shelves in three Prestige parts in November, December, and January. Gaiman worried that people would be wondering who this Gaiman guy was, whom they had never heard of last week, and who this week had flooded their new release shelves (it wasn't really a fair point given that it was a year and a half's worth of work arriving at the door at once). But for all this worrying about *Black Orchid's* commercial viability, Gaiman got to do *The Sandman.*

"I figured that *Sandman* would be this little horror comic that no one would notice, and *Black Orchid* would come out and everyone would go gosh, wow, and jaws would drop and we'd be famous. As it was, *Orchid* had all the impact of rose petals falling onto the surface of a pond" (*Comics Forum* #2, 1992). ❖

> "The joy of working with Dave, which was also the pain in the arse of working with Dave, is that he was always in search of the correct way to do it."

POSTSCRIPT:
Probably of equal importance to his coming career is what the royalty check from *Black Orchid* bought him. With the first real money he'd ever made in comics, Gaiman bought a foot-high Groucho Marx statue. "For the first time pretty much in my life, I was in the black, and I had some money and I thought I can just go out and buy this thing. So I did. I bought myself Groucho and he sits up on my book shelf and he looks down at me, and it's very hard to take yourself too seriously. I mean, it's the occupational hazard of writers. Everything else: the broken marriages, the ruinous addiction, the living in penury, the lower back pain—all these you feed back into your work. Take yourself too seriously and you're lost. You'll wind up teaching creative writing somewhere. So, Groucho helps me on that. When I take myself too seriously I look up and there's this tacky Groucho Marx statue staring down at me holding his cigar" (Vince, 1990).

SANDMAN

"I started Sandman in a state of absolute delirious terror. I'd written some fiction, not much. But I'd never come up with one story every month."

WITH *BLACK ORCHID* IN A STATE OF SUSPENDED ANIMATION, GAIMAN NEEDED TO COME UP WITH AN IDEA FOR AN ONGOING COMIC THAT WOULD MAKE A NAME FOR HIM, THAT WOULD GIVE *BLACK ORCHID* SOME CHANCE OF NOT DYING BEFORE WAKING.

He tossed a few ideas at Karen Berger. "The one I'd really wanted to do was the Phantom Stranger. And she said she'd talked to Dick and the Phantom Stranger just wasn't heroic enough. 'But what about that Sandman idea you were talking about over dinner?'"

In the first draft of *Black Orchid*, Gaiman had included a restaurant scene in a dream sequence in which some old characters from the DC dreamworld—Cain and Abel and Sandman—turned up as waiters. He wound up taking it out of the second draft, but the idea was still floating around in his head when Berger and Jenette Kahn, then-president of DC Comics, came over for another editorial meeting early on in *Black Orchid*'s creation.

Comic book characters go through so many changes and reinventions that there is a word to describe the act of pretending the current incarnation was always so: "retcon," or retroactive continuity. It makes for a messy world. But the Sandman has been through so many overhauls in his lifetime that they are basically entirely new characters every time. Created in 1939 by Gardner Fox and Bert Christman for *Adventure Comics* #40, Wesley Dodds was a pulp noir mystery man sporting a green business suit, fedora, and gas mask who used a gun emitting sleeping gas to sedate criminals. He was good at hand-to-hand combat, but had no superheroic powers barring the ability to see the future in his dreams. In 1941 the character was rejigged by Mort Weisinger and artist Paul Norris, who put him in a yellow and purple costume and gave him a sidekick called Sandy the Golden Boy. He carried a pouch of dream dust and his main aim was to protect sleeping children from the monsters in their heads. This was the version that Joe Simon and Jack Kirby took over later that year, and then in 1974 created an entirely new Sandman for another short-lived series.

"SANDMAN IS INTENTIONALLY AN attempt to create a—hopefully valid—mythic structure, and one that is inclusive. Partly that is because I have the DC Universe to play with but also . . . one of the things I wanted to specifically look at was, what does the twentieth century do with, to, and about myth? Thus you'll get something like *Dream Country*, which is basically a series of four essays on influence that forgotten myths still have. Death has a line at the end where she says, 'Myths and legends live on in a kind of Dream Country.' And that's what it's about. You know, myths, and legends still have power; they get buried and forgotten, but they're like landmines."

OPPOSITE: *The Sandman* #1, January 1989, based on Bauhaus singer Peter Murphy.

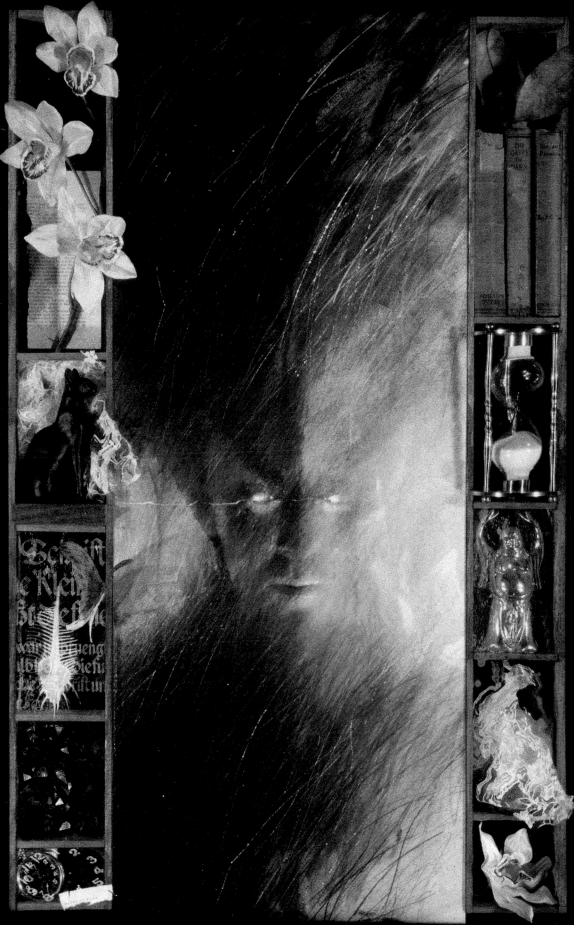

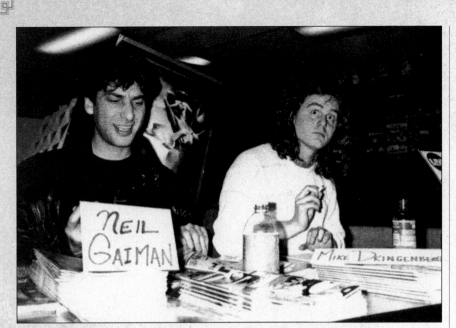

"I'd been thinking about the Sandman a lot, not the original but the Kirby and Simon guy who lives in the dream-dome thing. And I had this idea that was basically: what if that was just how this one kid saw him, as a big yellow and purple superhero? What if he was someone else for different people who saw him? And I was really, really attracted by the idea of somebody who lives in dreams." *Black Orchid* was very linear, very prosaic, a story that was very much grounded in reality, partly because they had tried to give the book a filmic quality by basing a lot of imagery on photographic references. If there is one thing that characterizes Gaiman as a writer (and McKean as an artist, for that matter), it's that he likes to keep moving on, a habit that was no doubt born during his time as a journalist and seeing writers being trapped in boxes from which they can never escape. He wanted to do something as far away from *Black Orchid* as he could and had floated the idea of doing a stand-alone Sandman graphic novel to Kahn and Berger long

SANDMAN
MODEL SHEET No 10
11-10-87

THIS IS THE FIRST NON-BOWIE
VERSION AND, WHILST IT HAS
A HARDER EDGE TO IT I THINK
IT PROVES TO BE TO MASCULINE.
IT ALSO INTRODUCES THE
CONCEPT OF IMAGERY APPEARING
AMONGST THE 'FLAMES'
OF HIS ROBE.

SANDMAN
MODEL SHEET No. 9
11-10-87.

ABOVE: Neil and Mike Dringenberg doing a signing at Jim Hanley's Universe comic shop for *Sandman* #1 in Staten Island. Neil has said only six or seven people showed up to get their books signed that day.

RIGHT: Early designs for Morpheus by Leigh Baulch, 1987.

OPPOSITE: Sam Kieth's Morpheus design, 1987.

before everyone lost their nerve over *Black Orchid*.

Berger thought there was something in the Sandman idea. Roy Thomas was already doing something with the 1970s Sandman, so she told Gaiman to just make up his own version: keep the name, but come up with something entirely new. It was the fifteenth of October, and he was just starting to think about an outline for the series when the Great Storm of 1987 hit England, a hurricane of such ferocity that it famously left London's Sevenoaks with just one oak. "In some ways the hurricane was the best thing for Sandman. Because I was trapped. In my house."

At this point Gaiman was living in Nutley, a small village in East Sussex, in a big old house called Littlemead that he later immortalized in *Coraline*.

I woke up the next morning and the village was cut off. An hour after I came down the road, all of the trees came down. People had been killed, and we had no power. And I couldn't

"I WILL SHOW YOU FEAR IN A HANDFULL OF DUST."
T.S. ELIOT

Neil: Anyway, Borderline didn't actually come out. But on Borderline I met Dave McKean.
Steve: You were sort of the Renaissance Man at Borderline, doing three features, and they all looked pretty interesting. There was 'The End of the Third Form' with Martin Griffiths, you were working with Nige Kitching...
Neil: On The Light Brigade which I have given to him for Trident.
Steve: And Old Magic, which at the time was your favourite, you were very keen on it.
Neil: Old Magic was nice, I was going to do some good things for that.
Steve: Is that ever going to come out?
Neil: No, I don't even have a copy of the script. End of the Third Form is really the only one I'd like to go back to.
Steve: Is there any plan for that seeing the light of day?
Neil: I don't know. Howard Stangroom asked me if I would do it for one of the Harrier titles and I really wanted to but I just didn't have the time.
Steve: It's not completed then?
Neil: No, it's one episode and plotted. It's such a nice story. Paul Gravett once described it as Billy Bunter liquidised with Night of the Living Dead.
Steve: I was thinking that it's a little bit like Lindsay Anderson's 'If', something like George Romero.
Neil: 'If' was using public schools as symblematic of what was happening at the end of the '60s, and I wanted to use the monster and horror traditions as a metaphor for school.
Steve: You mean all the waiting and seething, waiting to be released, all that manic energy?
Neil: Yes, the manic energy and the acts of violence and the oppression and so on that occurs in school. You have got somebody who is just as worried about the fact that he hasn't finished his geography homework as he is that he is turning into a werewolf and his best friend has just been killed, that kind of thing, which is fun. Anyway, so Paul Gravett comes along as he's doing some interviews about Borderline, and he sees what I'm doing and he likes it, and he sees what Dave's doing and likes that, and he says "Would you two be interested in doing somethi-

Gates of horn and ivory.
Brother to Death.
Sleep covers a man all over, like a cloak.
sands in an hourglass -- marking off a man's life.
"Some dreams we have are nothing else but dreams/ unnatural and full of contradictions."
"After midnight dreams are true."

The DC Horror hosts?

The dreamtime.

Some indians and aborigines who make no distinction between dreams and reality. People who interface.

Ramsey's book -- Incarnate, with the dream-house imagery in there.

Gods of sleep and dreams.

Three brothers: death, sleep and ?

I like the dreamstream. Dump the kiddy protector side of things-- yes or no? Favour yes.

More notes about the Sandamn (hmm damn sand?) Sandman.

The Dark Fantastic.

What I don't want this to be:

A crappy Sword and sorcery book.
or even A fairly good sword and sorcery/ fantasy book.

It has to be fairly heavily rooted in the real world.

Dreams are contiguous. Dream stuff can be interpreted on many levels. It can be used and shaped by the people who dream.

There are things in dreams. Dreams give access to other worlds-- and things can get to people through their dreams. And sometmes things can get out into the real world through dreams.

It is not that everything in dreams is real. But never underestimate the reality of things in dreams.

The Dream Stream (cruddy name) I think I prefer the Dream Time or the Dreamtime is also to some extent a doorway into other dimensions.

...ndman ought to have personal experience (of sort of ... in the world. He knows who people are. He knows who Gods ... goddesses. He knows many of the monsters etc.

...am Place is somewhere you can get most places from: ...nd, other dimensions, etc.

...t the only Sandman. Other worlds and other places have ... although it is quite possible that they are all the ...son. (put them all together and there's only one person

...dream and what is reality?

... level, of course, he is a right brain contruct.

... speaking, if you (as a god or whatever) wished to ...e someone to something in a dream you'd go through him.

...e is not real time: things happen faster.

...ic Organisation

...have in all naivety forgotten that beneath our ...d of reason another world lies buried. I do not ... what humanity will still have to undergo before it ... to admit this." Carl Jung.

...now you fear in a handful of dust." TS Eliot.

...has been imprisoned, a number of dreams have escaped ...eal world, where they have begun independant lives.

26

|| Neil's original computer notes for his Sandman project ||

FA
109
JAN 89
BRITAIN'S PREMIERE COMICS FANZINE
65p $3.00 CAN
$2.25 US

NEIL GAIMAN
GRANT MORRISON

ABOVE: Original computer notes from *FA* #109. Predates the October 1987 hurricane but only slightly.

OPPOSITE TOP: Neil draws Delirium.

OPPOSITE BOTTOM: Gaiman draws Dream.

turn on the computer, and I couldn't work. So I just walked around and thought a lot. It was too dark even to handwrite. The lights were still off.

The phones worked, so I remember having a long phone call with Rick Veitch telling him about the Season of Mists storyline and him telling me that I couldn't do it because he was going to do a similar story in which Lucifer quit, called King Hell. He was writing Swamp Thing at the time. I

was kind of sad about that because I really was looking forward to doing my Lucifer quitting story. Then I was setting up with somebody in London to go and stay at their place where they had power, I think it was Mike Lake, once they'd cleared the roads, but they still didn't have the power lines up. And then suddenly the power came on. The first thing I did was I went to the computer, turned it on, typed "The Sandman" and wrote a paragraph and a half.

Gaiman says that one of the seeds of the whole Sandman idea was that the word "dream" has more than one meaning: it can be the scenes that play in our sleeping heads, our hopes and aspirations, or the stories we tell ourselves to make sense of the world. His original computer notes, printed out on an old dot matrix printer, predate the finished proposal he sent to Berger. The early notes are Neil thinking aloud on paper, a stream of consciousness— half sentences and ideas about dreams, what they are, where they come from, where or when they become true. He floats the idea of there being three brothers ("Sleep, Dream, and ?"), he quotes T. S. Eliot and Carl Jung. There are glimmers of what *Sandman* would become, but barely. There are no Endless; there is no Dreaming.

Gaiman then wrote an eight-issue outline and gave it to McKean and Leigh Baulch for character designs to send along to Berger. McKean based his version of Dream on stills from a U2 video, while Baulch's sketches were more of a white-faced, black-haired version of David Bowie's *Aladdin Sane*. Berger liked the concept but wasn't sure Gaiman had the writing chops to pull it off without it becoming kind of conventional, so put it aside to think about it. Meanwhile, Kahn and Giordano asked to see the outline and ended up liking it so much that *Sandman* was a go whether Gaiman could pull it off or not.

Dave McKean was on board to do the covers—work so gorgeous they are collected in a book of their very own—but was busy doing *Arkham Asylum*, the thing

that was supposed to put him on reader-radars before *Black Orchid* turned up. Leigh Baulch, who had previously worked with Gaiman on *2000 AD*, was not keen on drawing anything beyond his original character designs. "His drawings of Morpheus were a little more David Bowie than I was happy with, but he was brilliant at them. He had this beautiful sort of Barry Smith–influenced style, and that was why I did that 'Sweet Justice' story for him. But he also had a wife and a mortgage and a good job at Titan. And he was very slow. So what Leigh really wanted to do was a few spot illustrations here and there. He did not want to drop everything and draw comics." Gaiman needed an artist.

"Karen, Dave, and I went out for the worst meal that I've ever had in Soho. It was one of those things where you just walk in and go, 'Oh, this looks nice.' And it was just as bad as anything could possibly be. The food was awful, and it was depressing, and we got back to her hotel room, and Karen and I were sitting there just trying to think of artists. I think I suggested Tom Yeates because I'd liked some of his *Swamp Thing* stuff. And she said, 'Sam Kieth?' I'd seen some Sam Kieth—I'd seen his inks on *Mage*, which I'd really liked, and I think I'd seen a two-page story he'd done for Fantagraphics called *Wandering Stars*, which again, I really liked." Kieth is an American artist who was at this point in his mid-twenties and whose first comics work had appeared

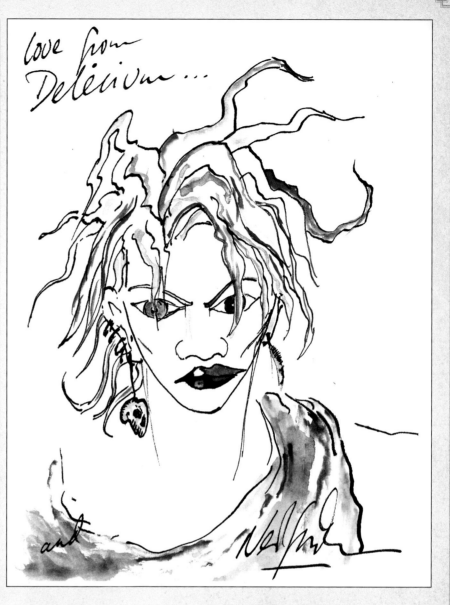

love from Delirium . . .

and

— sweet dreams —

"*Karen, Dave, and I went out for the worst meal that I've ever had in Soho. It was one of those things where you just walk in and go, 'Oh, this looks nice.' And it was just as bad as anything could possibly be.*"

Dreambook

A bus stops for me in a small town.
I get on and realise many of the
passengers are subdued. There's
seat for me. I start to realise these
people are being taken to the madhouse.
It reaches the [...] anytime at the
end swing open – the bus is inside
a holding cell. People get out. A sign
on the wall says "Script Doctor." I
affect a calm unconcern, and
get into the office, where I see my
computer has finally made a wireless
connection & got my e-mail?

Later, I'm at a school. Nick is
a comics convention and I
am putting together a curriculum on
Fear. It becomes an award
ceremony. From Nick I duck out
to listen to a writer explain the
encyclopedia she's working on...
She's prejudiced against [...]
6 Oct 04.

in 1984. There wasn't all that much to see so far.

"Karen had his number, so we phoned him up. It was something like 11.30 p.m. He answered the phone, and I just remember Karen saying, 'Hi Sam, it's Karen Berger, DC Comics. Got a writer with me, Neil Gaiman, and he's got a comic, *Sandman*, and we want to know if you'd like to draw it. Yes of course I know who you are Sam, that's why I called you. No, no this isn't a joke. No Sam, nobody's turned it down.'

"He's doing that thing where he's going, 'Well, who turned it down before? Did lots of people say no? Is that why you're calling me?' We had to convince him that we knew who he was, and we had seen his stuff. I was listing all of the things I've seen by him. 'So are they making you have me?' 'No, I thought you'd be really good.' Then he suggested Mike Dringenberg as inker, who came on board and the ship lumbered off. Sam got progressively more and more miserable and after issue #3, he quit. And cheered up a little. As he said to me: 'I feel like Jimi Hendrix in the Beatles, I am in the wrong band. This is not what I want to be doing.'"

last night I dreamed the
Harlan Ellison stories I'd be
edited, a [...] in corridor.
[...] sharp demons tall [...]-covered
in cats' [...] [...] had forgotten
to explains roles to [...] who came to
[...] to a black
other dream was dedicated to Dan [...] his bidding-
Knight, perhaps ironically, and though [...] 3 [...]
I remember little of the story, [...] the view
the time [...] That sail line inside he
was numbered – I thought it's [...] after
experimental, but on waking I realised [...] how deeply
they were just page proofs. [...] Harrison Ford
[...] myth [...]
the guy's family – in his head
his wife, her new husband, the kids
are nightmarish. Then we
realise that he's the nightmare
one & they're trying to cope
with him...

HARBOR HOUSE
AT PIER 21

My death dream,
in which I'm driving,
weaving in out of traffic.
They without [...] I slam
the car into the back of
a red van – heard,
immediate, no slowing of time.
I'm dead.
Awake, heart pounding...

N⁰ 28 · PIER 21 · GALVESTON, TEXAS 77550
TELEPHONE 1·409·763·3321 · FAX 1·409·765·6421

Looking back at his artwork with twenty-five years' hindsight, you can't help agreeing with Kieth. His inks were perfectly suited to Matt Wagner's *Mage*, but *The Sandman* was a different beast. The seventies horror comic style—in which the ugliness of everything is exaggerated, the faces are drawn, and the mouths are sunken—was not where Gaiman was going with the series. In later issues, even when Morpheus went to Hell, it was beautiful.

There is an incredibly sweet phone interview by Kieth with Gaiman in *Comics Interview Super Special*, published in 1993. Time enough had passed for the dust to settle. It really was a case of musical differences, not of any pushing and shoving

"Sam said to me, 'I feel like Jimi Hendrix in the Beatles.'"

or bad blood. Gaiman always knows who's going to be illustrating a story—he will not begin writing a story until he knows who is going to be drawing it. He plays to his own strengths, but he also plays to the strengths of his collaborators and everyone comes out looking good. Every script is a letter to the artist. He asks them what they like to draw, what they *want* to draw, and builds a story around the stuff they're good at. But aside from a couple of things, Gaiman didn't really know the work of Sam Kieth, and they'd never met—*Sandman* #1 was almost written in a vacuum. "The first issue was probably, for both of us, the furthest away from what we would have wanted it to be, what either of us would have really wanted," said Gaiman. "You have this sort of platonic ideal in your head of what a comic could be like . . ." And Kieth added, "And then there's #1" (Kraft, 1993).

In terms of script, the first three issues were largely set in stone, but come #4, Gaiman wrote an issue entirely for Kieth, who still had two issues to do after handing in his notice. "It was: let's do stuff that Sam will actually enjoy doing. Which is why we got that double-page spread of demons from horizon to horizon, and Lucifer's Tower and all that kind of stuff" (Kraft, 1993). Even though Kieth's artwork references the style of Bernie Wrightson and comic book horrors, there was a moment in issue #5, Kieth's last, that gave him pause. Escaped Arkham Asylum–patient Dr. Destiny has jumped into a car driven by a nice lady called Rosemary who, even with a gun to her head, suggests that her new terrifying and naked companion make use of the coat on the backseat so he doesn't get cold. Later, he shoots her point-blank in the face.

Kieth's problem with the whole thing was that he'd grown fond of the character, that in a universe of abstracts and fantasies Rosemary was the first three-dimensional average kind of character to enter the

THIS SPREAD:
A handful of Neil's dream diaries from a box in the attic.

followed it, you'll get the other kind too: "Just little life-affirming stories that are a little heartwarming. You have to have both sides" (Kraft, 1993).

Kieth felt he was at odds with the universe Gaiman was creating, and thought Dringenberg was outclassing him at the time as an illustrator, so suggested that he take over. With *The Sandman* #6 Dringenberg became penciler and Malcolm Jones III, whose work Gaiman had seen and liked on *The Question*, was on ink duties. The sixth issue is the first time the artist and the writer feel like they're on the same page. It is also kind of a watershed moment in the history of *The Sandman* and where it was going, not in terms of content, but in terms of emotional scope, change, and all-out weirdness: twenty-four hours in a diner in which customers are puppeteered and ultimately murdered by a madman. Proper horror show. "All of the characters in the diner in issue #6, some of them are nice people, some of them *aren't* nice people, but they're *real* people. And I think that's what hurts. But one of the nice things about having done #6 is if I want to do something offbeat now, it's sort of like #6 established that I was going to go beyond anything that anybody had previously done in comics, or in mainstream comics. So, after that, I've been pretty much left alone" (Kraft, 1993).

Largely, those kinds of stories were a minority. But just the fact that he could do them meant that Gaiman was changing the rules and expectations of comics all over again, much in the same way Moore had done back on *Swamp Thing*.

From the beginning, Gaiman was thinking of endings. *The Sandman* was, in his head, a finite story with a definite ending, albeit an ending that was a long way off. He didn't know if the series would ever get there; he figured he'd get what most other people else got: twelve issues and nothing more.

Early on, like in the 1960s and 1970s, if DC felt something wasn't selling, they'd just stop it. In the seventies, when they really got into this canceling idea there'd be comics that would come out for one issue and

picture. He didn't realize that Gaiman had merely created her just to kill her off a few pages later. "I like the idea that I have this huge territory in which Sandman stories take place. You can't see me gesturing with my arms," said Gaiman down the phone to Kieth. "But I have this *huge* territory. And part of it is sheer black horror." But for every horror story, like the one with Rosemary, or the one set in the diner that

be gone. Which is really crazy because how can you cancel something after one issue? You're canceling it before you've actually got the sales report back. There were a lot of comics, things that Jack Kirby did, that would run for three issues. There were these weird little comics that would just sort of come and go.

But by 1986/1987, the way that they would do it is that things ran for twelve issues. Bob Rozakis, 'Mazing Man, twelve issues. The stuff that people like Cam Kennedy were doing, these comics would run for twelve issues. And what would actually happen is they'd figure they'd run it for a year, so everyone's under contract for a year. Round about issue eight, you would know whether you were for the chop or not. But they'd still run you to issue twelve because then it's not a failure.

So I plotted eight issues, because I figured at eight issues I'll get the phone call saying: minor critical success, absolute commercial failure. And I will shrug, and that will be that, and then I'll do four short stories and we'll close out. And that'll be Sandman. And for the first four issues we were on line for that.

"Wake up, sir. We're here."

The Sandman #1 sold better than any commensurate DC horror title, which Gaiman puts down to the Dave McKean cover and the advertising campaign with the adapted T. S. Eliot line. ("'I will show you fear in a handful of dust' was suddenly 'I will show you terror in a handful of dust.' They were terrified the T. S. Eliot estate would come after us.") But mostly he has no idea. "I don't know. It was just weird. Swamp Thing had been selling in the twenty thousands, and Alan had gradually taken it up to the forties. I think his last issue was about fifty thousand and that was thought to be as good as a horror title could get. Then Sandman #1 came out—double-sized issue—and it did I think eighty or ninety thousand copies."

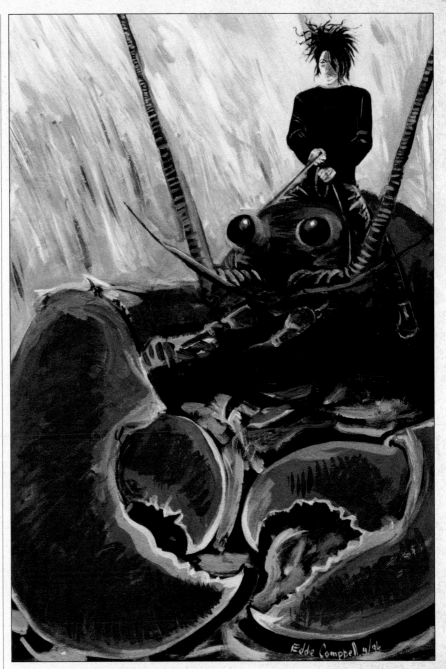

Issue four was the lowest point for sales. "It was something like forty thousand copies. I think they had a forty-thousand-copy royalty cut off—if you sold below forty thousand you didn't get any royalties. And we never got below that point, but with #4 we were close—it was only about $300 royalties. And then #5 picked up a little bit. And then #6 picked up a little bit. And then #7 picked up a bit. We were picking up 500–600 people a month.

ᴀʙᴏᴠᴇ: Dream on a Lobster, from the *Sandman Gallery*, by Eddie Campbell, 1994.

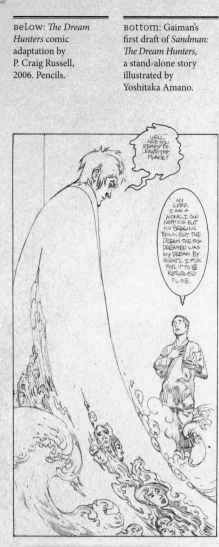

"Issue #8 was this one where DC actually had enough confidence and they wanted to give *Sandman* a push. So I went out and got quotes from people who were friends of mine and who were horror people saying this is good, and I wrote the telling-the-story-so-far thing, and DC overprinted by a third. They sent the comics out unordered to stores, and told them they could do what they wanted with them. They just said: here you go. Some stores sold them, but the smart stores gave them away." Some of them went back to DC and asked for more.

Instead of making two dollars off a comic once, DC were expanding the readership, getting people to try something new for absolutely nothing. They were teaching them to fish. Brian Hibbs at San Francisco's Comix Experience put labels with the shop's name and address on the free comics and then left them at barbershops and on buses and ended up gaining about 100 readers for the 400 copies he dropped around the city. They came back, they bought *Sandman*, and they bought lots of other comics, too.

"I walk with her, and I hear the gentle beating of mighty wings."

Up until the eighth issue it's fairly easy to see whose style Gaiman was writing in.

Much like *My Great Aunt Ermintrude,* he was putting on voices and sometimes they fit awkwardly like a borrowed jacket with the sleeves a little too short: there was Dennis Wheatley in the first issue, whose occult novels had a big influence on nine-year-old Neil; old EC comics in the second; Ramsey Campbell and Clive Barker for the third, and the fourth issue was *Unknown Worlds,* the science fiction magazine edited by John W. Campbell. "In my mind, it owes a lot to Heinlein's *Magic, Inc.* where I shamelessly stole the idea of lining up every demon in Hell and finding the one causing trouble" (Wagner, 2008). He built the beginning of *Sandman* using Alan Moore's *Swamp Thing* arc *American Gothic* as his model: they are all short stories except for the last three.

But somewhere between the twenty-four hours in the diner of #6 and *The Sandman*'s eighth issue, he stopped trying to be anybody else. It was no longer Neil Gaiman playing in the DC sandpit, it was Neil Gaiman's *Sandman* with its own little world and rules and people. It's palpable from the first page. *The Sandman* is ultimately a story about family, but you really don't get that until you meet them. The issue was called "The Sound of Her Wings," and in it we finally got to meet Dream's older sister, Death.

She turned up after seven issues of Dream running around trying to retrieve things stolen from him during his imprisonment—his helm, his ruby, his pouch of sand, all sold on or passed on to mortals who haven't the power to deal with them—in a storyline that was basically a straight fantasy quest novel about revenge and getting stuff back. In the end we find Dream moping in Washington Square Park in New York, feeding the pigeons. The preceding issues felt made up; when Death arrives, the characters feel alive and real. They are grounded in the real world, not in a world of horror or fantasy, of revenge or violence, but pigeons and people kicking balls around in a park. Death quotes from *Mary Poppins,* does a Dick Van Dyke-doing-a-terrible-Cockney-accent impression, is cute and smiley and everyone falls in love with her. In issue #8

we realize what *Sandman* is all about: it's a story about life and death, people and love. With Death, Dream visits hospital rooms, cribs, and underpasses, watching her do her job. He muses on humanity's attitude to his sister, gives us verses to a song singing Death's praises, a forgotten poet who understood her gifts like no other. It's beautiful and poetic and quiet. It's the beginning of Dream's personal story, the one that will ultimately leave us in tears sixty issues later. It feels like something we've not seen before. Also, it's the first time the sun comes out.

By #8 I don't know what we were selling. We were suddenly selling sixty thousand a month. Or fifty thousand a month. We climbed and we climbed and we climbed with real readers who were staying. That was fascinating. So I didn't get canceled, but I was expecting it. And then once I knew that I wasn't going to be canceled, which was every-thing after #8, it was just like: okay. Nobody's going to stop me. Nobody knows what I'm doing now. I'm not even sure what I'm doing but I've got all this stuff in my head.

I sat down and took a look at what I had done so far, and what I wanted to do with the rest of it. That was interesting, because there were a lot of things the fans obviously liked about the first eight issues and I thought I had two alternatives: either I could go back and do a lot more of the stuff the fans liked about the first eight issues, bringing in the DC characters, what are Mr. Miracle's dreams like or Batman's dreams, and that kind of thing, or I could go off and do the kind of things that I wanted to do at that point which was stuff like The Doll's House. *I decided I wanted to keep moving, and if nobody likes it, they'll go away and fine, we'll go down the tubes. In the meantime, what the hell? This is my comic, and I'll take it where I want to take it. That was what I did, and what*

cont. page 110

vertigo

Karen Berger's talent scouting trip in 1987 landed her with a collection of British writers (Gaiman, Grant Morrison, Jamie Delano, Peter Milligan) who did things differently. As Gaiman said in 1993: "The flak that the English used to get, and occasionally still do, from mainstream writers who say things like, 'Gee, look what these guys are doing. They can get away with it in mainstream comics because they're English.' And you turn around and you say, 'Well, have *you* ever tried anything like that?' And they say, 'Of course not. I know exactly what management would say if . . .' There is definitely an idea in America that you can't do interesting stuff within the mainstream because They Will Stop You. I've never worried about that. With me, there is very, very little compromise that goes into *Sandman* these days. And there's been less and less compromise as the years have gone on. I do what I do" (*Comics Journal* #155, 1993).

In 1993 she gave the Brits a room of their own: a DC imprint called Vertigo, a ship she captained right up to 2013. She took post-Moore *Swamp Thing* and *Hellblazer* with her. *The Sandman* #47 was the first in the series to go out on the shelves with Vertigo emblazoned on its cover. And as for its exciting launch title, Gaiman took care of that too: *Death: The High Cost of Living*. Death was the canary in the cage. She chirped.

"This is my comic, and I'll take it where I want to take it."

Left: Gaiman's notes on a hotel notepad for *Sandman* #63 (September 1994, above) in which Lyta Hall talks to the Furies.

SANDMAN COVERS

ONE OF THE THINGS that set *The Sandman* apart from every other comic on the shelf was the Dave McKean covers. While the artists and design on the inside changed frequently, the covers were always McKean, every month. He defined the look of *Sandman* for those who read it and those who didn't. "I remember having the argument, way, way back, about whether or not we were going to put the title character on the cover," said Neil. "It was a very strange argument to me, but it was a make-or-break argument with Sandman—whether he was going to be on the cover of every single comic. And at some point somebody actually said, 'How will they know that he's in it?' We said, 'Well, the comic will say Sandman at the top. In large letters. And it will have a number.' We assume a certain level of intelligence and literacy, which we seem to have been proved right on. The same thing with redesigning the comic completely. 'Oh, won't people think it's a completely different comic?' 'No, they're really bright—it says Sandman on the cover'" (*Comics Journal* #155, 1993).

The first eight were designed as a gallery of portraits, with each portrait bordered by shelves with things on them—things scavenged by both Neil and McKean in Covent Garden: an hourglass, a Buddha, a black cat. They look like something out of a Peter Greenaway film. After the eighth issue, McKean did away with the borders and stuff got weird in different ways every single time. He used his friends and wife and dead spiders as models, and sometimes even Neil.

LEFT. *The Sandman* #1, April 1989.
OPPOSITE: The cover to *The Sandman* #16, June 1990, featuring Neil sitting in McKean's living room.

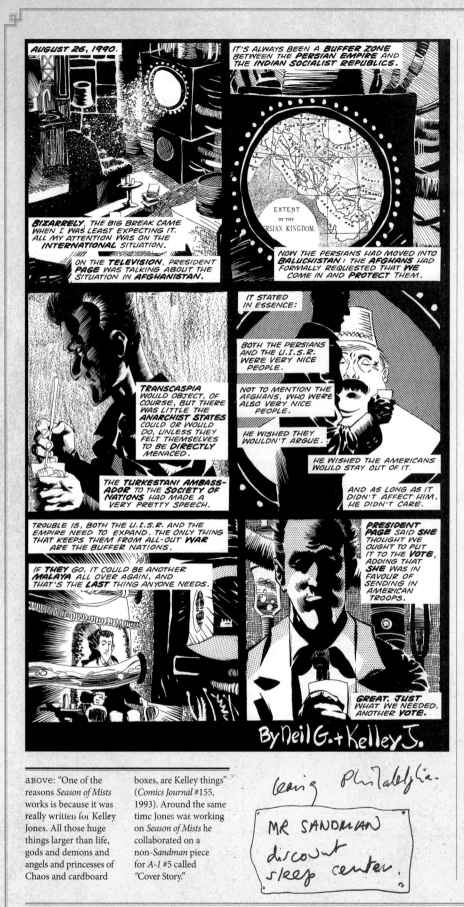

By Neil G. + Kelley J.

leaving Philadelphia.

MR SANDMAN discount sleep center.

ABOVE: "One of the reasons *Season of Mists* works is because it was really written for Kelley Jones. All those huge things larger than life, gods and demons and angels and princesses of Chaos and cardboard boxes, are Kelley things" (*Comics Journal* #155, 1993). Around the same time Jones was working on *Season of Mists* he collaborated on a non-*Sandman* piece for *A-1* #5 called "Cover Story."

happened was that we lost a few readers at the point where we started The Doll's House. *Sales dropped, but then they also picked up. It was like we were losing some of the younger readers, but as we lost them, the older readers came in* (Kraft, 1993).

The Sandman was there on the shelves every month, more or less, from January 1989 to March 1996, which, combined with the other work he was doing at the same time, set a grueling pace that meant Gaiman spent a lot of time writing while he was traveling. "I would write in hotel rooms. I still write in hotel rooms. Not quite as much because now they have internet so I do emails in hotel rooms as much as I write. And I was much more driven than I am now. I could do the thing of being at a convention and having four pages to write, and realizing I wasn't due on a panel for X-amount of hours, and go up to my room, sit down, write those four pages, or write those three-and-a-half pages and head back a bit early or whatever, and did. I was very, very good at doing that kind of thing. I think some of that came from having to write in offices. I'd write surrounded by people, like what I was doing on *Penthouse*. It's not like I had my quiet little office—I was in a big room filled with people and I was turning out the copy, going chunketychunketychunketychunk-cling! Chunketychunketychunketychunk-cling! Wrrr. Put it down. Mark it up."

He said in 1993: "I can do it because it does have a finite end. I can always somehow tell myself even at the worst moments, 'This too will pass. You will not do this forever. I will get to the end of the story.' And then I'm damned if I will ever do a monthly comics for a period of more than six months or whatever again in my life" (*Comics Journal* #155, 1993).

Working at such a speed, Gaiman was transcribing things straight from his subconscious without much of a filter—

RIGHT: Dave McKean's artwork for *The Sandman: The Doll's House* trade paperback, 1991.

the CHILDREN'S CRUSADE

IN DECEMBER 1993, THE two dead schoolboys from *Sandman* #25 were brought back in *The Children's Crusade*, a seven-issue crossover series bookended by Gaiman and *Sandman* editor and novelist Alisa Kwitney, with art by *Sandman* and *Death: The High Cost of Living*'s Chris Bachalo. It was the first time a big crossover was attempted by Karen Berger's then-new Vertigo imprint, and didn't go so well. In fact, the walls and demarcations of the Vertigo universe were retooled in such a way that it never happened again.

❦

thousands of ideas poured into *Sandman*'s pages. In his attic there are tubs full of notes ripped from the backs of envelopes, off hotel notepads, Post-it notes with decades of fluff collected on their once-sticky backs. They contain the kind of insane scrawls you scribble in the half-light, roll over and

forget you did, so one can be forgiven for asking if any of the stories in *The Sandman* come from his dreams.

"Made of? They're just dreams . . ."

When I was writing Sandman I would occasionally steal imagery from my dreams, almost never got plots, but occasionally images were incredibly useful. And to this day if there's a dream that's just sort of affecting emotionally, I'll write it down. Which was something I learned to do while I was doing Sandman.

I used to have real nightmares and they used to worry me. In my teen years and my early twenties I had nightmares such that I was scared to go to sleep. Full-on bad stuff. And then I did Sandman and I needed scary, horrible imagery. When it turned up I would wake up and go, "Oh my god! I just had a horrible nightmare! Being pursued through endless corridors by a guy with spaghetti for a face! That's brilliant!" So I would write them down partly because you'd never know what was going to be useful in retrospect, or what might be important in retrospect.

Which isn't to say that I ever went back and reread them, but it is to say some of the time the action of writing stuff down moves it from this weird box in your head of stuff that will evaporate . . . it moves it from being written in melting snow, to being written onto paper. In terms of the boxes of your mind things are in, it's changed. The scary thing about that was that after a few times of doing that, the nightmares pretty much stopped completely. I would joke that the people who were doing them were so deeply put out by my reaction to them, which was not what was expected when sending somebody horrible nightmares.

In *A Game of You,* in Hazel's dream, where she's on a train, and she goes into the basement of the train, which is really weird, because she didn't know trains had basements. There's a dead baby that looks like it's already undergone an autopsy, and she picks it up, and then it sort of starts attacking her with sharp teeth, and it's a real thing—that was straight out of my head. That was like standard-issue "Neil Nightmares" (Wagner, 2008).

"—Swift as a shadow, short as any dream—"

One particular story in *Dream Country* deals directly with this same sort of question, the one that usually comes from either an uninventive interviewer or a wide-eyed fan with a notebook and pencil in their lap, waiting to capture the secret: "Where do you get your ideas?" Gaiman's usual answer—"I make them up. Out of my head."—which is often coupled with a shrug, makes it sound so infuriatingly simple that probably there are writers having to buy new shirts all the time having torn theirs in Gaiman-induced rages. He uses the concept in "Calliope," *Sandman #17*: a blocked writer, Richard Madoc, nine months past deadline and still unable to deliver the promised follow-up to his successful first novel, makes a deal with an older and infinitely more successful writer in exchange for the Greek muse he keeps locked in his house. He rapes her on a cold and musty bed, and then the ideas start to flow. Gaiman charts Madoc's meteoric rise: his appearances on bestseller lists and talk shows, his plays, his Oscar-winning films. He will not let her go because without her, he has no ideas. When Morpheus intervenes, he pours endless ideas into the writer's head, so many that pages cannot hold them, and he scratches them onto the walls of his room with the bloodied ends of his fingers. Finally, for peace of mind, he lets her go. Some *Sandman* fans have taken these premises, babbled from the crazed and desperate writer, and turned them into stories and poems of their own.

"Writers are liars."

If you are a writer, you tend to have sort of a magpie head. You store

> "When I was writing Sandman I would occasionally steal imagery from my dreams, almost never got plots, but occasionally images were incredibly useful."

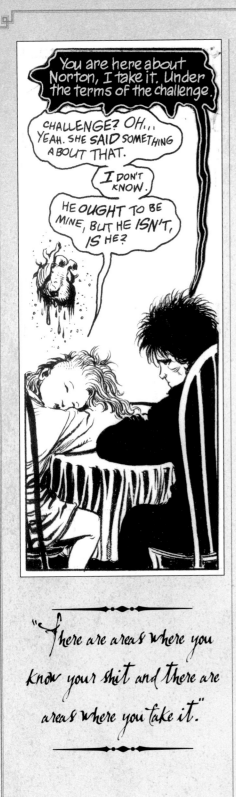

"There are areas where you know your shit and there are areas where you fake it."

above: A panel from "Three Septembers and a January," in *The Sandman* #31, October 1991. Art by Shawn McManus.

opposite: A page from the story "Façade" featuring Element Girl, *The Sandman* #20, October 1990. Art by Colleen Doran.

away all sorts of weird and wonderful trivia, which pops out when you need it. A lot of the mythology stuff, maybe ninety-five percent of it, I know fairly well and I'm interested in. And then there's stuff that you'll read for pleasure. I remember this book called *Funeral Customs Around the World.* It was wonderful. I picked it up on a whim and started reading and got completely fascinated by the different ways different cultures—based on different environments—have of disposing unwanted corpses. There are cultures in which you can't bury them, so what do you do? Sometimes you drop them in a river to be eaten by crocodiles. In Tibet, where they don't have any wood to burn them with, and don't have any rivers to throw them in, and the ground is too hard and rocky to bury them, they wind up grinding them up and feeding them to the birds mixed with a little corn as a way of getting rid of them. It's called sky burial. I remember reading that and going, 'That's an issue of Sandman,' and doing my funeral issue set in a necropolis, with this huge graveyard where all the different burial methods get demonstrated and discussed, just because I thought it was cool.

There are areas where you know your shit and there are areas where you fake it. The art of writing is the same as the art of convincing a teacher that you really did do your homework or you studied something that you didn't. It's the art of lying convincingly and it's amazing how much you can learn from a little (Salisbury, 1999).

Sometimes, a lot of the time, structure will give me the shape of the story. And, sometimes, I even wind up abandoning the structure. Sandman #6, "24 Hours"—the horrible one set in the diner—came from a desire at the point, going, "You know, I'm in a twenty-four-page comic; wouldn't it be cool to do a story called '24 Hours' in which I do one hour per page?"

And then, of course, I wound up abandoning that structure slightly, because I needed six pages to set up the first hour, and many of the later hours were done in half pages. But that was the idea. I just liked the idea of doing these beats, hour by hour, through a story. And the story it generated was this nightmarish, monstrous story that probably wouldn't have existed if I hadn't thought of the structure (Wagner, 2008).

From where we are now, it looks like Gaiman knew what he was doing all along. But if you ask him outright he'll look at you wide-eyed, astonished it ever worked and that he got away with it. He likens the process of writing a monthly comic to being a little like jumping out of a plane and trying to knit yourself a parachute as you fall. "If you're writing a novel, you can be halfway through it or more before you know what it's about or how it's going to work. You get to the end and you realize how the end fits together, and you go back to chapter one and you plant all the clues that make it obvious how it's going to end. When you're working on a monthly comic, that's not feasible because apart from anything else, when you get to the part where you realize what it's all about and how it ends, the parts have already been printed, everybody's read them, and you can't go back and change them now. By the time I got to the end of *The Doll's House* I was writing the second-to-last episode, and I suddenly realized I didn't have a clue about what was going to happen in the last one" (Kraft, 1993).

To add to the pressure of not knowing what was going to happen next, Gaiman was about to become the linchpin in a major shift in comics publishing, and in comics finding their way into regular bookshops. Nowadays, a trade paperback collection is the way many people buy comics, rather than in weekly or monthly installments—it arrives not long after the last issue in a storyline and usually contains about six to eight issues. Lots of people choose them over collecting the

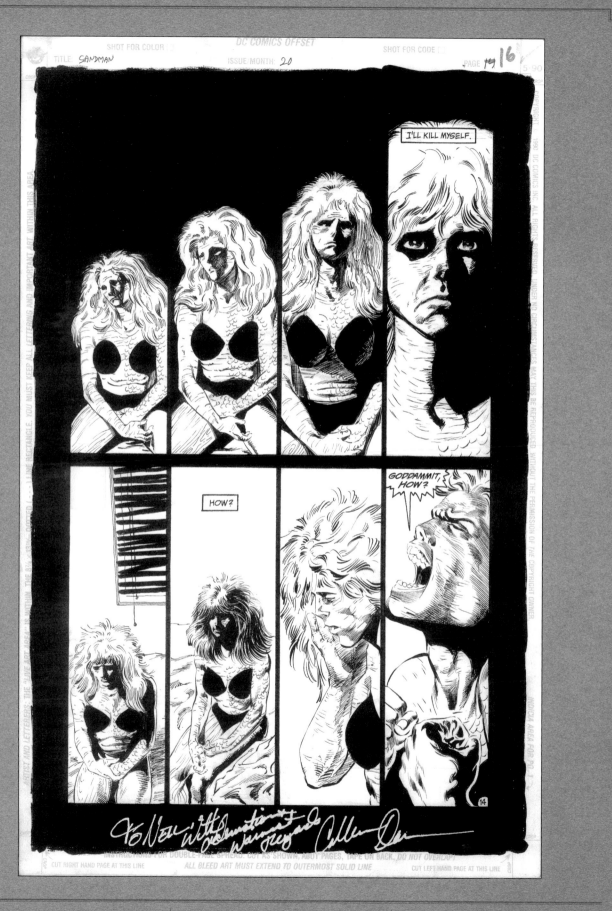

Sandman 60 notes:
plot areas in motion

1) Lyta stays at the oorgon's house, and
becomes slightly gaga...
 possibly in reality she's been picked up by
Thessaly / Larissa. (sandman tries to get her...
 she's my guest.)
 Tales

2) Rose and Jed and Wanda. chantal's death. —
 going to the deathbed. Wanda. (old dungeon best.)
 Wanda dying.

3) Wanda's crazy & horny and thin.
 Life has pissed all over her — lost the house, lost
 Chantal, lost her spider collection.

3) Nuala at Home ~ bold and voluptuous and virginal.
 Her castle on the borders of Faerie.
 implication that Titania made gave her way because
 Nuala was the beauty.

4) New Corinthian. — Wants to know what the last
 corinthian was like. Matthew won't talk
 win, just stares + croaks + flies away...

5) Carla and the police.

6) Rose and the UK — she leaves.

Rose encounter with Endless

 62 —
 Rose → UK.

Sandman 61 — thoughts
Sandman 62 — Rose goes to England. Old lady —
 the house tells her the "flying children"
 story, as a metaphor for age, screaming
 at the women & hurry... meets
Paul (?) downstairs. Alexander 30 yrs, old age ?
upstairs. sly unity left for her? A letter?
letter Unity left after she died.

Holi life = fresh and
 food.

paperbacks did not usually happen. They happened sometimes for big ambitious books like *Watchmen* and *The Dark Knight Returns,* but it was in no way expected. At least, not by Neil: "We had no idea that anything was going to be collected at that point. If we had, *Dream Country* would have been five, maybe six issues rather than four" (Wagner, 2008). Every story arc from there was collected in a way that was viable for bookshops. It was an important piece in the construction of the graphic novel outside of comic shops.

It was one of those things that if you look back on it, you think, "My God. Wasn't Gaiman a brilliant career strategist," but the way it happened was that DC had heard that in Rolling Stone's "Hot Issue" of 1989, they had picked Sandman *as the hot comic. Bruce Bristow [vice president of sales and marketing at DC Comics] decided to take out an ad. The economics of taking out an ad meant they had to have something to sell. The sudden idea was, we're going to do a graphic novel collection of* The Doll's House, *the book we were already on. Which meant that suddenly, issue sixteen was hitting the stands and* The Doll's House *collection was coming out at exactly the same time, looking like it had been designed over a couple of days. Which is exactly what happened, because they only had two days to put it together, no corrections really of any kind at that point got made. We were bugging out. Bristow was convinced it was an enormous failure, because only a dozen people called the number off the ad to order it, and he wasted fifty thousand dollars of DC's money, or whatever, except because we had this book, actually, it seemed to be selling, and Bruce wanted to stand behind this thing, and he and Bob Wayne [DC Comics' retail promotions manager] had the idea of* Sandman *Month because now we had the book after and the book before—we had* Preludes & Nocturnes *and we had* Dream Country. *They came up with various*

individual issues in teetering piles in the corners of rooms—they say things like "I'll wait for the trade" and wander out of the shop, a vision of their bookshelf in their head, complete with perfect matching spines. Back in 1989 when the last issue of *The Doll's House* was about to land, trade

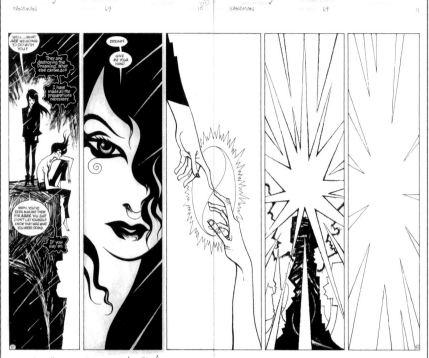

TO NEIL — with my eternal thanks for a great gig! *Marc Hempel*

things: a poster, and a watch, and a T-shirt, and I was the one going, "Why are you guys trying to bring all this stuff out in one month? For God's sake, spread it out!" They said, "No, no, no, it's going to be Sandman *Month!*"

I thought they were stupid. And they did it, and it went huge. It worked, and I had to apologize. Statues! It was the first statue. Suddenly, we had a little line of books, and part of Sandman *Month* was that you got a slipcase (Wagner, 2008).

The timing was exactly right, and *The Sandman* was propelled to a new level. Neil even talked DC into releasing the fourth volume, *Season of Mists*, in hardcover. "It made things happen, in terms of the way we were looked at, and we got Norman Mailer to give us a quote" (Wagner, 2008).

When Gaiman started writing *The Sandman* ("in a state of absolute delirious terror") it took him about a week-and-a-half to two weeks to write a complete script for a single issue, slower at the start and picking up as he went along. "When you start a story, or anything, there are an infinite number of ways that it can go. And that's the delight of it for me. When you get to the end there is one way that it *had to* go. That's why it can take me five or six days to write the first five or six pages of a *Sandman*. I will normally do the last eight pages in a night. By the time you get to page seventeen, the rest of it has defined itself. The branching paths are getting fewer and fewer with each decision that you make. It then goes off and it's graven in stone. Which is what the writing of fiction is all about. Unless you're into 'Choose Your Own Adventure' games. Even then, all they do is give you the illusion of being able to follow paths and make choices. I don't think one should be able to follow *every* path. I think one of the great things about fiction is that it takes the chaos of life and feeds it back to one in a form that is emotionally satisfying" (Vince, 1990).

In a rare occurrence, he'd get lucky and end up doing the whole thing in a weekend—like "Dream of a Thousand Cats," which was written in just a couple of

agent in place

A YOUNG LITERARY AGENT called Merrilee Heifetz flew into Gaiman's orbit when Titan Books asked her to handle the U.S. rights to *Don't Panic*. Having bagged a $50,000 deal that saw the book become a bestseller, a stunned Neil Gaiman wanted to meet this woman. One month after *Sandman* #1 hit the shelves in October 1988, Gaiman met Heifetz to talk about his future. Says Heifetz:

"He showed me his comics and said he needed an agent to negotiate his next deal with DC, but said he would be writing novels in the near future. Back then, no one published graphic novels. This was not considered to be an interesting or lucrative area of publishing—and the comics business wasn't actually considered to be publishing at all. But even though I wasn't a comic book reader per se, I was completely beguiled by the writing and the story, and I knew Neil Gaiman was unquestionably the real deal. And I just thought, 'I really want to work with this guy because if he really does write novels someday they will probably be incredible.' So I agreed to negotiate his long, impenetrable DC contracts for relatively small advances simply because he was just that good. But no one had an agent for comics at that point. There were big comic book writers, Alan Moore for instance, but no one got into this business for the money and nobody needed an agent. DC hated having to deal with me."

Heifetz is still his agent today and negotiated the deal for the book you're holding now.

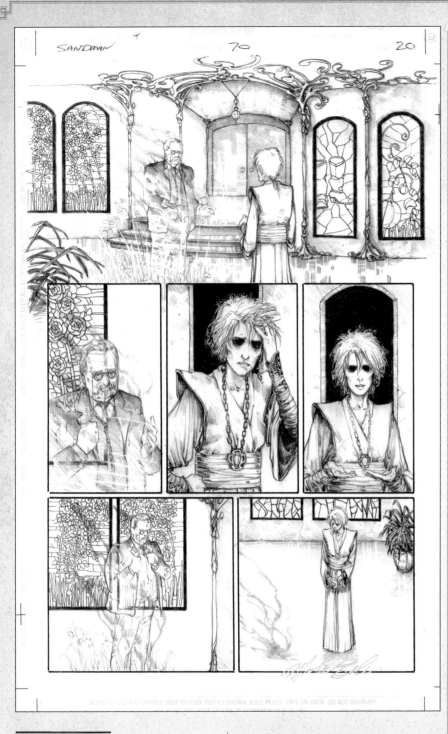

ABOVE AND OPPOSITE:
Michael Zulli's pencils
for *The Wake, The
Sandman* #70,
August 1995.

a month to one script, making a little folded-up, scribbly version of the comic as he went. "I'd take twelve pieces of paper and fold them over so you have the cover, and everything including the ads. I'd irritate DC because I'd want to know where the ads were going to be placed. They hated that, but it's kind of useful" (Salisbury, 1999).

With Dave McKean, Gaiman very rarely writes a full script, but then Gaiman and McKean have a weird sort of telepathic connection. With all these new people on board, nothing could be left to chance. He worked out every panel progression; every line where any character is standing is all in the script. "There's nothing accidental in *Sandman*, and if something is there, it's because I want it to be there. I am a benevolent dictator as far as *Sandman* is concerned. Those are the terms that it's done on. If you want to do an issue of *Sandman*, you're going to get forty-eight pages of closely-written script from me" (Kraft, 1993).

Sandman artists—and there were many—came into the fold in various ways. Initially, the ideal was to do the thing that Siegel and Shuster did, where the writer and artist team sticks together for eternity. But then Sam Kieth bailed.

And when Sam bailed, we figured it would be me, Mike Dringenberg, and Malcolm for eternity. Only, Mike Dringenberg was a little bit slow. So we'd occasionally need fill-ins, and also sometimes I'd write a double-length issue, so we'd need fill-ins. So that was where I went and got Chris Bachalo and Michael Zulli. And then Mike Dringenberg was meant to do Books of Magic #2. *So he needed four months to do that. So I wrote* The Dream Country *stories for individual artists while Mike went off and did* Books of Magic. *(But he never did it, he just never quite got to it. Which got a bit awkward.)*

So then he did the intro story and the out-story for Season of Mists *but Kelley Jones became the artist for that storyline. And then having done that,*

days following a drive down a narrow country road outside of London. "I saw a large cat sitting on the side of the road, very big, and very, very black, just looking like a little patch of night. And I thought: You know, if the Sandman was a cat, *that's* what the character would look like" (Baker, 2007). That was *The Sandman* #18 in the bag, as it were. But mostly he'd devote half

Mike Dringenberg left, because Mike was miserable on deadlines and was not set out for deadlines, and everybody was happier, including Mike. Suddenly we realized that we had this new weird world. And the new weird world was one in which we may as well get lots of different artists to do short stories, and I could sometimes audition people for a longer storyline—just try and find the right artist. That was really interesting, trying to find the right artist for the right storyline. Going okay, I love Shawn McManus but I love it when he does this. So I wonder if I can get him to do this."

Of all the artists, Jill Thompson of *Scary Godmother* fame has the best origin story.

I didn't have an artist for Brief Lives. I was at San Diego and somebody came over with a drawing of Death naked that he'd just had done as a convention sketch. And I said: "This is really brilliant. Who did this?" And he said: Jill Thompson. And that afternoon Jill Thompson was in my signing line. She said, "Hello, I'm Jill Thompson." And I said: "You! *You drew Death naked!*" She turned bright red and started apologizing and going "Sorry, sorry, it was this guy! He asked for a naked Death! I'm sorry!" I said: "No, no, no, I think you're really good. Do you want to draw a whole Sandman storyline?" I think she was doing Wonder Woman at that point. And she's like: "Yeah!" And that's how Jill came on board.

Marc Hempel was meant to be [Hellboy *creator*] Mike Mignola. For The Kindly Ones I knew I wanted somebody whose art style was very blocky and filled with shadows and shapes and just sort of dark, and flames. I also knew that I wanted to follow that with something very, very detailed and realistic, so The Wake would be such a contrast. But having said that, that was also at the point

where I thought The Kindly Ones was going to be maybe a five-issue arc. I did not expect it to be thirteen or whatever. It just never stopped.

Marc Hempel's art came as a shock to the system for many readers who were buying *Sandman* every month, especially to anyone who had been reading regular comics alongside *The Kindly Ones*. His angular and cartoony artwork clashed with everything, including the artists on the issues preceding it—artists like Mike Allred and John Watkiss doing short stories in *World's End*. But this was only as it was coming out. *The Kindly Ones* was fixed by time.

The Kindly Ones *has the best rating of any of the individual* Sandman *books on Amazon.com. You may spend an issue or twenty pages going argh, I'm not sure about this Marc Hempel, and then you forget about it. And then you're drawn into it. And then Marc's storytelling style takes over. I think when people read it as a whole, and if you don't have to reacclimatize yourself to Marc and to this sort of slightly cartoon-y, very powerful, very simplistic, very design-oriented style every month, I think it works a lot better.*

And also, by The Kindly Ones, *it was the only time I was writing it absolutely and completely for the graphic novel. By* The Kindly Ones *I genuinely, for the only time, did not care about the reviews, because I knew the monthly comic was coming out, I knew it was going to work, I knew people were going to buy it. I knew I was going to get to the end. I also knew, by that point, that the thing that was going to last would be the graphic novel. All of these graphic novels existed, all of them were going to continue to exist. So I was able to do things that I honestly would never have done earlier in* Sandman's *run just in terms of not recapping. In everything else I recap, and I recap really well and I hide recaps. So you*

I am healing you. Creating you. Giving you life.

I am bringing you back from the dead.

TOP: Dream speaks in white on black because Neil wanted him to be distinctive. Dream should sound like the voice in the back of your head.

ABOVE: Final issue of *The Sandman*, March 1996.

OPPOSITE: The last *Sandman* story, printed in *Dustcovers*, 1997—Neil's anecdotal, personal coda to the series, in which he glimpses Morpheus in the night.

don't even know that you're being recapped. Nobody ever says "the story so far," but somewhere in the first three pages I've tried to plant enough information that if this is the first copy of Sandman you've ever picked up, you can pretty much follow what's going on. And with The Kindly Ones, I didn't really bother. It was like: if you're lost, this is okay. This is being written for the graphic novel people.

People who were picking up *The Kindly Ones* on a monthly basis were also only getting pieces of story—the issues were not self-contained shorts—so readers would miss the immediacy of the story. "If you're reading it over seven or eight months, you get one episode of it that is pure out-and-out horror, followed a month later by one episode that is pure, out-and-out fantasy, and it's sort of as if somebody's saying, 'Well, I'm making a sandwich here, and the first thing we have is one piece of rye bread.' And you wait a month and they say, 'And we've got peanut butter.' And you wait another month and they say, 'And we've got cucumbers.' What? Huh? This is too weird. But when you're just handed it as a sandwich, it works fine" (Kraft, 1993).

The story that followed *The Kindly Ones* was to be the last. Michael Zulli's softly colored pencils gave a quiet respect to the somber tone of the book. And it was always going to be that way.

"The real problem with stories—if you keep them going long enough, they always end in death."

I floated my little trial balloon along about issue twenty-two, twenty-three. We'd been doing this for a couple of years, and I remember saying to Karen somewhere in there, "I think I'm going to want Sandman to stop when I stop." And she said, "You know that will never happen," and so on.

A few months later, I was having dinner with Jenette Kahn, and during the course of the dinner, I said, "I think I'm going to want Sandman to stop when I stop," and she said, "Oh, sweetie, you know, that's not the way we do things in comics," and so on. And I said, "Okay, not a problem."

And I just carried on with my grand plan, and everything kept going. And then people started asking me in interviews what I'm going to be doing, and how it's going to work once Sandman stops. And I said, "DC will stop Sandman when I'm done, which I would really like, or they'll carry on, and I would not do any further work ever for DC. If they stop it when I stop it, I will maintain a very cheerful business relationship with DC." And that's basically what they did.

Whether those interview quotes did any good or not, I don't know, but it is very true that around issue sixty-ish, well over two years away from the end of Sandman, I remember Karen just saying to me at some point, "We really aren't going to be able to continue this when you're done, are we? We should just end this," and I said, "Yes." And it was never more complicated or big or grandiose than that. Years had gone by, and honestly, now it was obvious.

The problem I think I managed to avoid by stopping Sandman after ten years was that I was no longer the twenty-six-year-old who began Sandman. When I ended, I was still more or less him. I can write things that are cooler or smarter, but I can't write them with the sheer sense of exuberance, the sense that I was breaking new ground, that he did (Wagner, 2008).

And that was *Sandman*.

"You woke up." ❖

Now, understand, I was a child who believed all he was told. My parents told me true things.

Our car was stolen once, and Churchill died. I knew this, because they told me. I looked out of the window, when the snow was on the ground, and saw an animal sliding through the snow, and learned from them that it was a stoat (in its winter coat, an ermine).

My parents taught me my wooden letters. I painted the consonants blue, with paint, the vowels in red, with nail lacquer. Even today red nail polish smells to me like vowels.

So I believed in the Sandman, when I was three. Ask me if I still do...

Alan Moore encountered John Constantine in a restaurant in South London, after he had been writing him for several years. They did not talk. I dreamed once of Morpheus. I knew what it felt like to be him, to look out of his eyes. (Which are not eyes. That was the strangest part of it. They were not eyes at all.)
When Holly, my oldest daughter, was four or five she would come to me at night, complaining she could not sleep, and I would tell her of the Sandman, and his pouch of magic sand, which would send her to dreamland.
I told her I had some of that sand. Only a pinch, but it was enough.
I would blow imaginary sand into her eyes, and she would smile, satisfied.
Then she would return to her bed, and sleep easily, and I would return to writing.
I wrote all the night, in those days. Every word was written in the dark.
I have never encountered Morpheus in reality, have had no encounters with the Sandman, except, perhaps, for one, which I will come to in time.

AND THEN THERE IS . . .
DEATH

"People are used to the idea of Death with a sickle and a cape. I wanted to do a Death that would challenge people's conception. I wanted to do the kind of Death that I would want to meet when I die."

AS SOON AS SHE WALKED INTO THE CITY SQUARE ON PAGE THREE OF "THE SOUND OF HER WINGS" AND BOUNCED A BAGUETTE OFF HER MOPING BROTHER'S TEASED HAIR, FANS FELL IN LOVE WITH HER.

Nobody could help it; Death stole the show. The idea that at the end of your life you get to walk off holding the hand of a girl like that was somehow life-affirming, like everything would turn out all right in the end. Gaiman thinks one of the reasons she became so instantly popular was due to the fact that she was simply very nice in a time when there were very few nice people in comics. Characters were largely colorless or full of angst. "She's sensible, not naive, but innocent. She has the innocence of one who has been there and done that and come out the other side. It's almost a sort of holy innocence. She's the kind of person you'd like to meet and spend a day with."

Death is the peacekeeper among the Endless, likes hot dogs, parties, books with happy endings, and Disney films. She dresses entirely in black, wears too much eyeliner, and was about as far away from comic book characters as you could get. You could see Death in the street, and after *Sandman*, you frequently did. It was kind of Neil's fault—he got a lot of women to read comics.

The point that I realized that was happening was about year two or year three, and I'd be going to places like the San Diego comic book convention. Fat, unwashed gentlemen in stained T-shirts would come up to me and extend their hands in gratitude and say, "Let me shake your hand! You brought women into my store." And there was a part of me that always wanted to go, "If you sweep it, they'll come back!"

What was great about Sandman *was you had a comic that guys would hand to their girlfriends and say, "Look, read this." And the girlfriends would read it and*

ABOVE: *Death: The High Cost of Living* notes.

say, "Have you got any more?" When the relationship would collapse, the girls would take the Sandmans, and they would hand them to their next boyfriend or their next girlfriend. Slowly, they became this sexually transmitted thing. Sandman spread. I was incredibly proud of that. It had always seemed to me just peculiar that half the human race didn't read comics. I was writing a comic for everybody, trying to keep a gender balance of the characters and trying to write something that wasn't the preadolescent male power fantasy (Steel, 2011).

"Sandman was a comic that guys would hand to their girlfriends."

Young gothy women wearing ankhs and eyeliner would drop in at the comic shop, pick up an issue of *Sandman*, and walk straight out. A lot of them bought other things of course, but there were those who were simply there for Morpheus and his sister.

Gaiman had been thinking about giving Death her very own miniseries for a while, until Karen Berger phoned in 1991 and gave him a reason to actually do it.

Death and Doowop.

4 AUG 93

Left: Death and doo-wop, by Neil.

Death 2 -- lettering draft
Page 1

Death -- The High Cost of Living.

Part 2.

 "Death is nature's way of telling you to sit down and shut up." Old
 saying I just made up.

Hi Chris,

well, I'm on a plane on my way to Lincoln Nebraska. Yesterday I did a signing
in Boulder Colorado that was meant to start at 4:00 and finish at 7:00, and
wound up going from 3:30 to 10:00 am -- hundreds and hundreds and hundreds of
people. Somehow there doesn't seem to be any correlation between town size and
signing size. I'm kind of squished into my seat by the bulk of the gentleman
in the seat next to me, who is sitting reading a digest-sized porno mag and is
not a thin person. There's a cute baby in the seat ahead of me trying to play
peekaboo. It's like every commercial you've ever seen of how rotten air travel
can be.

Anyway, I was meant to give you some pages of DEATH when I saw you on Saturday
(I'm sorry we didn't get any chance to talk, by the way. Next time I do a
signing tour I'll not even assume there's any possibility of doing anything
else along the way. But as I told you, there hadn't been a chance to finish
it. Well, to start it. Sigh. But I've got the fully-finished Sandman 44 in my
bag, so Death is, by definition, next.

I'm in a rotten mood currently, which has quite a bit to do with Eclipse.
Strange people.

Anyway. Death. The Second part of an almost-definitely 3 part story. This one
is I think 27 pages long, but we need to check it.

Death: The High Cost of Living.

Part Two: A Night to Remember.

Written by Neil Gaiman
Pencilled by Chris Bachalo
Inked by Mark Buckingham
lettered by Todd Klein
Coloured by Mayor Oliff and his Merrie Band
Edited by Karen Berger

(And the last part will probably be THE HEART OF THE MATTER)

....

Right: First page. I think we want to do a slow pan in on Death and Sexton
walking along a street in Death's neighbourhood. It's early on a summer's
evening: means that it's still light, even though here and there neon signs
and house-lights are going on. Maybe somewhere there's a flicker of fireflies
(because Steve Oliff and his team -- mayor Oliff I should say -- can deal with
this stuff). She's walking a little ahead of him, looking around all the time,
bright and perky. She's dressed more eccentrically than she was last time, in
her hat and probably some kind of really neat, ripped-looking dress with
little lacy bits. He's got his hands in his pockets (spiritually, if not
actually, because he's wearing jeans) and is walking around behind her, kind
of more or less weirded out.

ABOVE: Letter from Neil to Chris Bachalo preceding the script to issue two of *High Cost of Living*, late 1992. Every script is a letter to the artist (not just a script to nobody) and this one mentions the problems with Eclipse relating to *Miracleman*.

TOP RIGHT: *Death: The Time of Your Life* promotional art.

RIGHT: *Death: The High Cost of Living* tiny comic by Neil, 1992.

Before the whole summer convention season, I got a phone call from Karen— and I'd been talking, actually, mainly with Mike Dringenberg about doing a Death miniseries for a while—and she said, "Well, we're just about to do a poll, and we're going to put a load of DC supporting characters into this poll for the summer convention season and let the people at the cons just vote for who they want to see." And I said, "So?" And she said, "Well, we were thinking of putting Death on." And I said, "Okay, and . . . ?" And she said,

"The thing is, if we put Death on, she'll win. So basically, do you want to do the series now? You know, do you want to do it within a year? If you don't want to do it within a year, we won't put her on the list."

So I thought about it and I figured, okay, it was a nice excuse to actually get me to turn the story from a nice idea and something I wanted to do one day, into something I was definitely going to do. So I said, sure, put her on the list. And she won. The fans voted for Death (Kraft, 1993).

outside my window it's dark.
When I was younger I used to
write little stories.
I'm kind of freaked about the
cost of the plane.
I'm kind of freaked about the
cost.
At last accounting I was
about 1.3 million dollars in
debt to the
record company.
But I've got half a million
dollars in a publishing account
which pays for the Beverly Hills
house

9882 Little Santa Monica Boulevard, Beverly Hills, California 90212, U.S.A.
Tel: (310) 551 2888 Fax: (310) 788 2319

THE PENINSULA
BEVERLY HILLS

Pays for Hazel and Alvie,
And somewhere to stay when
I'm home
And taxes
But I haven't been home
too much, have I?
For the hundredth time
I pick up the phone
& call home. I call the
house number & the office
number & I even call the
number # that only Larry
had.

9882 Little Santa Monica Boulevard, Beverly Hills, California 90212, U.S.A.
Tel: (310) 551 2888 Fax: (310) 788 2319

Just look at me
I'm having the time
of my life or
something just like it

– E. Costello
Contains Brilliant Parade.
(nice idea –
pleasant version of...)

top: Notes for two pages of *Death: The Time of Your Life*, in which Foxglove is falling asleep on a plane.

Left: How the above looked in the finished comic, 1996.

above: Elvis Costello's thoughts on death, scribbled down by Neil.

DEATH: THE HIGH COST OF LIVING
A treatment, by Neil Gaiman

- It's about a young man who wishes he were dead.

- It's about a girl who claims to be Death -- on her first day off for 100 years.

- It's about the day they meet. About one, glorious, crazy, dangerous day in New York in which each of them has the time of their life...

- And in which they both, in their own way, learn the Cost of Living -- and the value of life.

DEATH: THE HIGH COST OF LIVING -- would be based on the Graphic Novel, 'DEATH: THE HIGH COST OF LIVING' -- the best-selling comic 'for mature readers' of all time.

It's an upbeat, cool, delightful story about a teen romance that never quite happens -- a magical story with scary and weird bits in it.

It's a film that exists somewhere in the space between *Repo Man* and *The Fisher King*, between *Sense and Sensibility* and *On The Town*. It's about what it means to be alive. It's about having reasons to live. It's about a day in Manhattan in summer, which gives a young man a reason to keep living, and about Death -- the coolest, nicest, most beautiful Death you could ever wish to meet.

It features:

DIDI -- she's an utterly charming girl in her teens: masses of dark hair, dressed in a black tee shirt and black skirt, wearing a silver ankh on a chain. In every way except -- possibly -- one. She's a very happy, bright, pretty, funny, utterly together character.

She believes that she is Death.

She says that, once every hundred years, Death takes on human form, for one day, in order to understand what life is, and to appreciate the value of life and the end of life.

If you point out to her that sh... re killed ...erse's

22.

CONTINUED: (2)

 SEXTON
 Can't you do anything?

And Didi comes into our frame, looking down at Sexton.

 DIDI
 Okay. I can see the problem. You've
 got a fridge on top of you.

 SEXTON
 Okay. Let's not panic here. Can you
 get it off me?

 DIDI
 Maybe. You know, this is a dumb *it's a garbage dump.*
 place to go poking about. I mean,
 it's not safe.

 SEXTON
 Yeah? And who asked for your
 opinion?

 DIDI *Nobody asked for it.*
 ~~Nope.~~ You're right. ~~You didn't.~~
 Sorry. Well, nice meeting you. Good
 luck getting out from under ~~there.~~ *your fridge.*

She moves out of shot.

 SEXTON
 Hey! Come back! Um. Yeah, look, I'm
 sorry, it was a dumb thing to do,
 and -- hey! ARe you still there?

A beat. Has she gone? Then she leans back into shot, and says,

 DIDI
 Still here. Okay, I'm going to try
 and push it off you. Breathe in and
 don't move.

On the garbage mound: She puts her shoulder against the fridge and pushes. It's heavy... But it gives, tumbling down the side of the mountain of garbage with a crash.

 DIDI (cont'd)
 Take my hand.
 ... and she pulls him up. Then she

Death: The High Cost of Living came out in three monthly parts from March 1993. Chris Bachalo, whose first professional comics job was on *Sandman* #12 in *The Doll's House,* where he got to draw old Bronze Age Sandman, jumped at the chance to do pencils. Mark Buckingham took on the inking duties. "What's interesting is it doesn't actually look like Chris Bachalo and it doesn't look like Mark Buckingham. I'm not sure who it actually does look like, it's sort of like a punk Brian Bolland or something" (Kraft, 1993).

> "It is genuinely terribly funny. It's got this kind of Catcher in the Rye-ish feel to it."

The basic premise is much like *Death Takes a Holiday,* the old 1934 film starring Fredric March: Death takes on a physical form for one day every 100 years to better understand what it's like to be mortal. She spends her day eating things and getting stuff for free, and "wandering around with a young man by the name of Sexton Furnival, who's about sixteen and considers life unfair, not least because he got called Sexton Furnival." From Sexton's point of view, Didi is just some sixteen-year-old girl who *thinks* she's Death, figuring that anybody who claims to be the incarnation of death is probably nuts. And the thing is, she might well be just that. There's an element of doubt in the story in which it is "perfectly possibly that she really is just

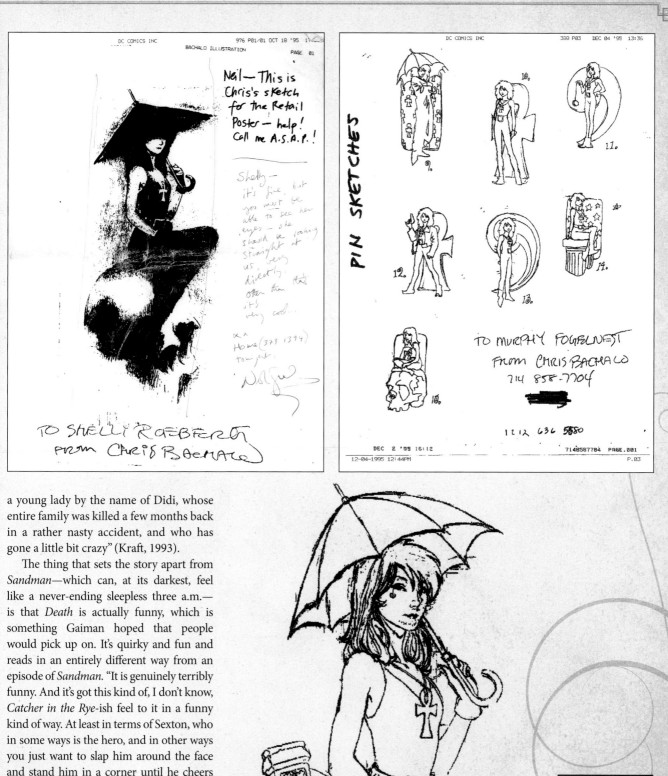

a young lady by the name of Didi, whose entire family was killed a few months back in a rather nasty accident, and who has gone a little bit crazy" (Kraft, 1993).

The thing that sets the story apart from *Sandman*—which can, at its darkest, feel like a never-ending sleepless three a.m.—is that *Death* is actually funny, which is something Gaiman hoped that people would pick up on. It's quirky and fun and reads in an entirely different way from an episode of *Sandman*. "It is genuinely terribly funny. And it's got this kind of, I don't know, *Catcher in the Rye*-ish feel to it in a funny kind of way. At least in terms of Sexton, who in some ways is the hero, and in other ways you just want to slap him around the face and stand him in a corner until he cheers up. You know, 'What have you got to be weltschmertz-y about'" (Kraft, 1993)?

Didi, on the other hand, is so cheery she doesn't even get upset with old Mad Hettie who harasses her all day—the one day she's allowed to wander around like a

ABOVE LEFT AND LEFT: Death statue design by Chris Bachalo, 1995. Versions one and two.

ABOVE: Death merchandise designs by Bachalo, 1995.

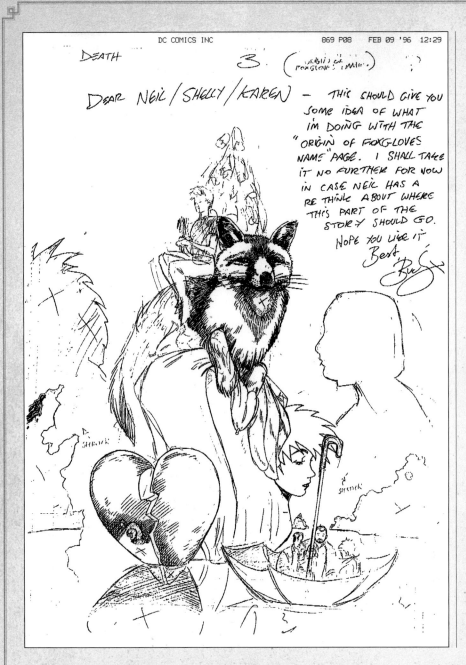

DC COMICS INC 869 P08 FEB 09 '96 12:29

DEATH 3. (ORIGIN OF FOXGLOVE'S NAME.)

DEAR NEIL / SHELLY / KAREN — THIS SHOULD GIVE YOU SOME IDEA OF WHAT I'M DOING WITH THE "ORIGIN OF FOXGLOVES NAME" PAGE. I SHALL TAKE IT NO FURTHER FOR NOW IN CASE NEIL HAS A RE THINK ABOUT WHERE THIS PART OF THE STORY SHOULD GO.
HOPE YOU LIKE IT
BEST
BUCKY

regular person—because, as she explains to Sexton: "If you know someone really well, it's hard to stay mad at them for very long. I know everybody really well."

The film adaptation has been floating around since the mid-nineties, occasionally being kicked around different production companies, kicked back to the same production companies, greenlit, then extinguished, and then greenlit again. Said Neil: "*Death: The High Cost of Living* has been in development heck, which is like development hell but slightly more encouraging" (Sanderson, 2008). He has written several drafts and would like to direct himself. He hung out with Guillermo del Toro on the set of *Hellboy 2* to learn how to make a film. But plans for *Death* change all the time. "It will happen unless it doesn't."

In 1997 the same creative team put together another miniseries called *Death: The Time of Your Life*, which brought back the lesbian couple Foxglove and Hazel from the *Sandman* arc *A Game of You*. ❖

Left: Fax from Mark Buckingham, 1996.

opposite: Death promotional counter standee, 1993.

beLow: Fan mail, sent to Neil through channels at DC, forwarded on by Berger, 1997. "This book saved my life. I was thinking (seriously) of committing suicide before I read this book, I realised how percious (sic) just one day of life is. More importantly I'm not really afraid of death anymore."

Forwarded message:
Subj: Vertigo
Date: 97-05-23 15:59:58 EDT
From: ▓▓▓▓▓▓▓▓
To: DCOVE2MAIL

Field 4 = Death : the High Cost of Living

Field 6 = This book saved my life. I was thinking (seriously) of committing suicide before I read this book , I realized how percious just one day of life is. More importantly I'm not really afraid of death anymore.

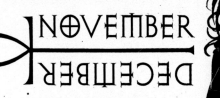

NOVEMBER
DECEMBER

DEATH GALLERY
DEATH: THE HIGH COST
OF LIVING *hardcover*
DEATH TALKS ABOUT LIFE
DEATH WATCH
DEATH T-SHIRT

DEATH™

DEATH GALLERY

BELOW: Buckingham sent in two drawings for the *Death Gallery* in 1993. This was the second.

SAID GAIMAN IN 1993: "We did *Death: The High Cost of Living*, which, categorically and with absolutely no contenders, was the bestselling mature readers comic there's ever been. Everybody would love more Death. And Chris Bachalo has set aside time toward the end of 1994 to begin drawing another Death story. But in the meantime, everybody seems to want more Death stuff, and we don't have another story for them. So it's like, what are we going to do here? The *Superman Gallery* and the *Batman Gallery* were very well received, and they primarily consisted of reprint material. So with this one, we thought, let's do a *Death Gallery*. I know she's one of the favorite characters for convention sketches, booklets, so okay, let's give people a chance to draw her. And let's assemble a great cast of artists to do it" (*Previews*, 1993).

The *Death Gallery* was released as a comic and had a run in a comic book art gallery in New York City's SoHo. It included pieces by lots of people, most of whom never had a chance to draw Death at any other point aside from convention sketchbooks: Arthur Adams, Paul Chadwick, Adam Hughes, Jon J. Muth, Michael Wm. Kaluta, Dave McKean, Kevin Nowlan, Brandon Peterson, Joe Phillips, George Pratt, Chris Bachalo, Joe Quesada, P. Craig Russell, Jeff Smith, Bryan Talbot, Jill Thompson, Charles Vess, Gahan Wilson, Michael Zulli, Brian Bolland, Michael Allred, Marc Hempel, Dave Gibbons, Colleen Doran, Geof Darrow, Mark Buckingham, Vince Locke, Reed Waller, and Kent Williams. Four Color Images premiered the show on October 28, 1993, and it ended up being the biggest opening in their career as an art gallery with more than 400 people through their doors. ❖

NEIL GAIMAN
"THE DEATH GALLERY"
FOUR COLOR IMAGES • 10/26/93

©1993 PHIL MARINO 201.420.0029

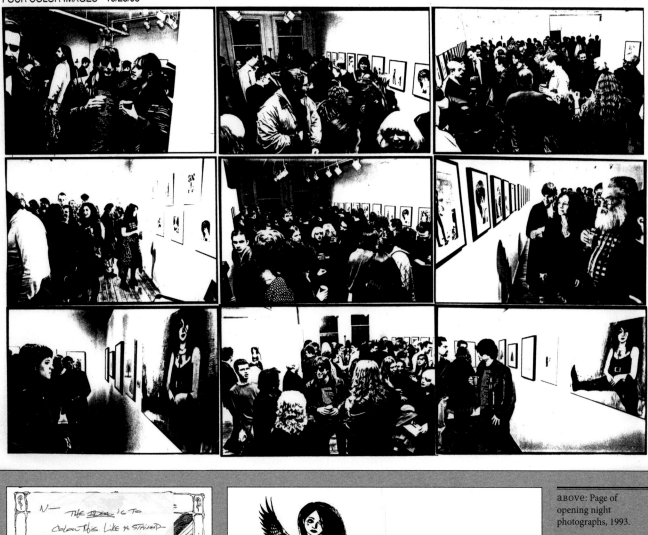

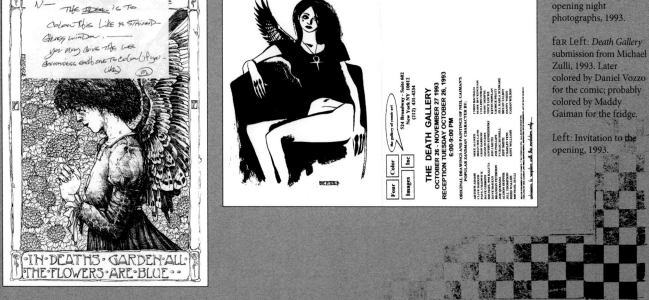

above: Page of opening night photographs, 1993.

faR Left: *Death Gallery* submission from Michael Zulli, 1993. Later colored by Daniel Vozzo for the comic; probably colored by Maddy Gaiman for the fridge.

Left: Invitation to the opening, 1993.

death talks about Life

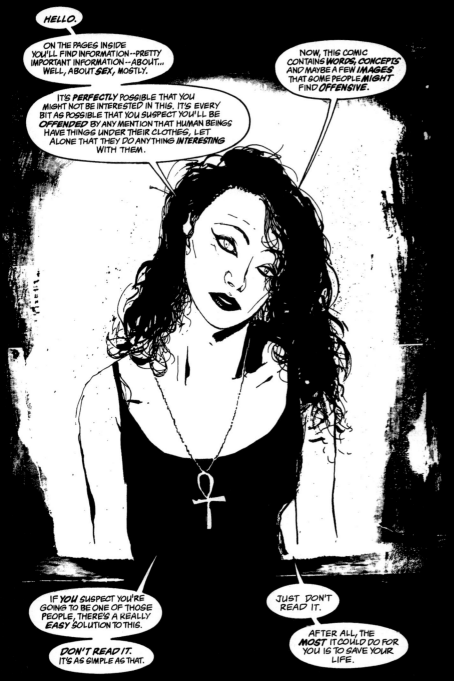

HELLO.

ON THE PAGES INSIDE YOU'LL FIND INFORMATION--PRETTY IMPORTANT INFORMATION--ABOUT... WELL, ABOUT *SEX*, MOSTLY.

NOW, THIS COMIC CONTAINS *WORDS, CONCEPTS* AND MAYBE A FEW *IMAGES* THAT SOME PEOPLE *MIGHT* FIND *OFFENSIVE*.

IT'S *PERFECTLY* POSSIBLE THAT YOU MIGHT NOT BE INTERESTED IN THIS. IT'S EVERY BIT AS POSSIBLE THAT YOU SUSPECT YOU'LL BE *OFFENDED* BY ANY MENTION THAT HUMAN BEINGS HAVE THINGS UNDER THEIR CLOTHES, LET ALONE THAT THEY DO ANYTHING *INTERESTING* WITH THEM.

IF *YOU* SUSPECT YOU'RE GOING TO BE ONE OF THOSE PEOPLE, THERE'S A REALLY *EASY* SOLUTION TO THIS.

DON'T READ IT. IT'S AS SIMPLE AS THAT.

JUST *DON'T* READ IT.

AFTER ALL, THE *MOST* IT COULD DO FOR YOU IS TO SAVE YOUR LIFE.

ᴛʜᴇ same year as *The High Cost of Living*, DC Comics wanted to do an AIDS benefit book. They asked Gaiman to do it and he said no, arguing that doing so would merely be preaching to the converted. He said at the time: "The only people who will buy *AIDS: The Comic Book, John Constantine Fights AIDS* or whatever, are the converted, the people who are interested or care already and go, oh, this is a good cause, I will plunk down my $1.50. So there's that aspect of things. Two, you don't need a benefit book at this time. The most a benefit book is going to raise, if it goes huge, is $20,000 or whatever. You would be much better off giving everybody the information free, sacrificing $80,000 worth of advertising revenue, and donating the paper and so on and so forth, and educating." Instead of the benefit book, they ran an eight-page story in the back of every Vertigo title that month, illustrated by Dave McKean. Death talks about sexually transmitted diseases and risky behavior and calls over an embarrassed John Constantine to hold a banana while she demonstrates how to use a condom. It's funny, and Death is, as always, cute and smart and to the point. She eats the banana.

It was a bastard to write. What was hardest about it in some ways was the day that I actually sat down to write it, I got a phone call saying that a friend of mine had just died of AIDS and had asked that I be contacted, but nobody knew where I was because I was in the process of moving continents. Eventually somebody tracked me down and said, by the way, Don Melia died two months ago. Don was actually the first person I'd know reasonably

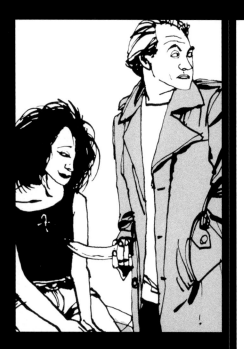

well ever to die of AIDS. There were other people that I'd known peripherally, but Don used to be the publicist at Titan Books for a while, had published a magazine called Heartbreak Hotel, and was part of the English comics scene.

The last time I saw Don, not the last time I spoke to him, but the last time I actually saw him, I was being interviewed, the Amazing Heroes interview that Mike Maddox did. And I was in Titan and Don wandered past and stopped and said hi, and we turned off the tape recorder and chatted, and he told me about his ex-roommate who had just died of AIDS the previous week. She was a transsexual who'd got AIDS from bad blood during a transfusion, and the last thing she'd ever read was The Doll's House. It was the first comic she'd ever read and the last thing that she read. I always figured that was one of the places that Wanda came from, just being told that.

Anyway, the morning I sat down to write the AIDS thing, I'd been really looking at trying to do . . . you know, how will I make this elegant, how will I make it funny, how will I make it this and that, and then I got this phone call saying by the way, Don Melia died and

asked that you be told. And all of a sudden I didn't really give a shit about being elegant and funny and intelligent and so on, all I wanted to do was get up on a little soapbox and start shouting very loudly through a megaphone, and I think to some extent that's what I did in the end. The sheer pointlessness of it is really stupid. There is no reason to die. It's a stupid thing to do. Especially when, with fifty cents worth of rubber, you don't have to (Kraft, 1993).

He dedicated the story to Melia. ❖

FEB 11 '94 12:23 FROM DC COMICS INC PAGE.001

Fax to; Neil Gaiman
 715/235·1037

Norwalk, OH
Reflector

Saturday □ 8,920

JAN 15, 1994

 N4342

LUCE PRESS CLIPPINGS

Neil, FYI
×× OO
(Meaning insanely jealous)

Sex education

Comic book presentation leaves parent disgusted

I am writing to express my concern and disgust over an article in Sunday's *Sandusky Register* titled, "Comic book with a lesson." Co-owners Jerry Minor and Vince Thompson of Asylum Comics here in Norwalk have the nerve to want to impose their sex education beliefs on our children of Norwalk Middle School in what they consider a "natural, appealing way."

This "way" involves a sexy young woman named Death telling our teen-agers about AIDS and recommending the use of condoms, having a friend of hers (John) demonstrate their use. Her instruction continues by suggesting the other "safe-sex" options such as nonpenetrative sex, foundling and petting. Oh — and abstinence as an afterthought. (Hasn't the news traveled to this small burg yet that AIDS and pregnancy can occur with non-penetrative sex?) Finally, Miss Death becomes Miss Manners and tells how to "properly dispose of the condom."

So much for my disgust. My deep concern began after reading that Mary Kay Cillo, NMS health teacher, plans to use this trash in the classroom.

Please don't get me wrong. I am not against our children being taught about sex and the danger of AIDS. My eighth grade daughter was involved in sex-education classes at her former school, and yes, they taught about AIDS and condoms. But — they taught first and foremost that AIDS and pregnancy can only be prevented by abstinence.

I don't know what other parents here in Norwalk want for their kids, but abstinence is what my Christian daughter has been taught, both at home and at her previous school, and this is what we believe in. If Mrs. Cillo wants "to get the message" to our kids, she needs to use one that is based on truth. Trying to educate our children with "Death" in comic-book form is ludicrous.

Rita B. Marrs
Norwalk

EDITOR'S NOTE: In a response from Asylum Comics, Thompson stated the comic book does mention that sexual abstinence is best. But, he said, the publisher of the book has to consider its national audience, not just teen-agers in small towns, and the fact that many young people engage in sexual activity. From that perspective, he said, the book is taking a realistic approach in informing its readers of precautionary methods to avoid sexually transmitted diseases.

02-11-1994 11:52AM 212 636 5598

 ** TOTAL PAGE.001 **
 P.01

ABOVE: Complaint letter from a Christian parent, 1994.

the sandman: overture

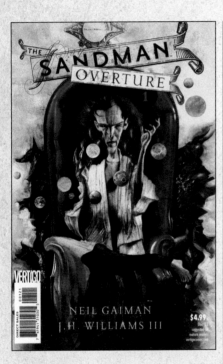

IN 2003 GAIMAN WROTE *ENDLESS NIGHTS*, A COLLECTION OF SEVEN STORIES ABOUT EACH OF THE ENDLESS THAT LANDED A GRAPHIC NOVEL ON THE *NEW YORK TIMES* BEST SELLER LIST FOR THE VERY FIRST TIME. BUT IT'S BEEN TEN YEARS SINCE THEN, AND TWENTY-FIVE SINCE WE MET MORPHEUS AND HIS STRANGE BROTHERS AND SISTERS.

When the seventy-fifth and final issue of *Sandman* had come out, and the series was done, Gaiman still had stories in his head that he never got to tell. There was one about the dreams of an unborn fetus he abandoned because it would probably wind up being adopted and misused by pro-lifers; there was another about Delirium; but mostly the one he really wanted to tell was at the very beginning. He had started the series on reel two of the film and that was where we all came in: with Morpheus naked and imprisoned in a glass cell.

Gaiman had plotted the story for how he got there years ago but never found a place to fit it in. When the twentieth anniversary of the series rolled around he put the idea to DC Comics that they do a miniseries. For various reasons, it never happened. But the moment new people were running DC, the first thing they did was call on Gaiman. For *Sandman*'s twenty-fifth anniversary, Neil has written *The Sandman: Overture*, the story of how the Dream King was caught back in about 1915.

By July 2012, he had written five pages of script for what will end up being a six-issue miniseries illustrated by J. H. Williams III. "I'm excited about the first five pages because they exist and they're really good. I'm terrified about the rest of it. But you know, Karen sent me a note when she read the first five pages and she said, 'This is like coming home!' Which is really nice to hear. Because the first five pages are absolutely completely weird, nothing like anything that's happened before, not set anywhere, you barely encounter anybody who might be somebody you've met before in *Sandman*, but it's still definitely five pages of *Sandman*."

Not wanting to spoil anything, he largely kept quiet about the series until it started arriving in 2013. He gave one interview about it to *Wired* where he talked about the fears that go with writing something so tremendously popular:

> *I'm imagining a hypercritical audience of roughly fifteen million people looking over my shoulders going "Huh. Well that's not* Sandman." *But then I think the great thing about* Sandman *is from the moment that I discovered the internet, and that people were talking about* Sandman *on the internet, which would have been like rec.arts.comics.dc*

circa 1989, what people were saying then never changed. For the next seven years of comics all they said was "It's not as good as it used to be." The earlier stuff was whatever anybody had picked up first and loved. And it carried on, with people talking about when Sandman was good, all the way through to #75.

It's people, and it's human nature. And what's funny is that now nobody knows that. Now people pick up the graphic novel books and they might have favorites—they might like Season of Mists, or Game of You, or Brief Lives. But The Kindly Ones, which people hated when it had come out as a comic, now gets the best reviews of all. So I take a long-term view on this. I almost don't care what people will say when it comes out. ❖

"The first five pages are absolutely completely weird."

ABOVE AND RIGHT: Pages from *The Sandman: Overture* #1, December 2013, illustrated by J. H. Williams III.

Chapter 4

a comics
miscellany

SIGNAL to NOISE

"And I ask myself.
Why am I writing a film I will never make, writing something no one will ever see?
The world is always ending for someone.
It's a good line."

PUBLISHED IN 1989, *SIGNAL to NOISE* IS A TINY, PERSONAL APOCALYPSE. IT'S ABOUT A MIDDLE-AGED FILM DIRECTOR WHO'S JUST BEEN TOLD HE'S GOING TO DIE: A TUMOR IN HIS LUNGS SPELLS THE END.

Instead of going through a battery of tests and surgeries, he signs off on life. He sits at home and writes his final script: a film about the apocalypse. The world is always ending for someone, he figures. The story is about time, about clocks running out of it, and it's told in a quiet, metronomic hum occasionally punctuated with visual buzz and noise. It's about endings, and about how everything that matters has one; it's about coming to terms with life and death and the certainty of uncertainty.

Signal to Noise began a year after *Sandman* arrived, and was serialized in an English magazine called *The Face*: a hugely influential British culture, music, and fashion magazine launched in 1980 by ex–*New Musical Express* journalist Nick Logan. It disappeared in 2004, crowded out of the market by imitators, but in 1989 it was at the peak of its powers—*The Face* of the times. Given that it was so intrinsically eighties, the magazine toyed with the idea of killing itself off in 1990. Sheryl Garratt, the editor at the time, decided to commission a serialized comic story as a final fanfare before the end. McKean had already worked for them on a two-page editorial spread called "Wipe Out"—the text of an article on computer hacking sliced up and "semi-randomly pasted back together in a fragmented looping monologue" over twelve murky panels of a man smoking at his computer (McKean, 2007). Garrett called him and asked him to come up with some ideas for on ongoing story. McKean phoned Neil.

I had a theme that I wanted to tackle, which was the whole kind of millennial, armageddon-y, apocalyptic type of thing—the way that it had already happened once, in the year 1000, and there had been a major anti-climax. Anti-climaxes are always a big part of my fiction. I wanted to do something about that, and Dave wanted to do something about the death of Eisenstein. So we tried to compromise and do something about a dying film director and the apocalypse that never happened. What got interesting was I sat down and wrote, as far as I remember, seven first episodes. Some of them didn't get very far. Some of them went a page and a half. And we got to the point where the deadline was happening. And Dave came over and said, "What have you got?" And I just printed them all out and said, "I've got stage fright. I can't do it. Here." He just went through and took the bits he liked the best and turned them into the first episode. Which then meant that a tone had been set and it had been done, and after that, writing it was very easy. But I was writing these scripts that I don't think anybody else would have understood" (Comics Journal #155, 1993).

Gaiman says the scripts were unlike any of the ones he had done for McKean in the past: it was not like *Violent Cases,* a short story handed over with instructions to "run with it," nor was it the formal "page one, panel one" script of *Outrageous Tales from the Old Testament* (more on that later). *Signal to Noise* was done in some strange format that only he and McKean would understand a word of, and it only worked the way it did because they had been on the phone about it for a month and a half. "I talked everything through with him way ahead of time, and then I just gave him some words, with a few comments in brackets. And he went away and turned that into a comic" (Comics Journal #155, 1993). It was illustrated, lettered, and delivered on the first week of the month and by the fourth, it would be on the magazine racks.

"The joy of *Signal to Noise* was that once every month I'd sit down and write the next four pages. Wherever I was at that month, that was what I'd do, and if I wanted to do it in a different style, or Dave wanted to use a different visual style, it was like *Signal to Noise* was a series of Polaroids of where we were at the time" (Kraft, 1993).

It's a good example of how collaboration works—theirs in particular, but just the act and art of collaboration itself. There was no passenger; there were two drivers at the wheel of this vehicle. "I think what you get when you put two sensibilities together is something that neither sensibility could have done independently in quite that way. I don't think you could have ever gotten *Sandman*'s 'A Midsummer Night's Dream' except by putting me and Charlie Vess together, as an example. You wouldn't have

> *"Signal to Noise was a series of Polaroids of where we were at the time."*

got *Violent Cases* like that except by putting me and Dave together, or *Signal to Noise.* It is in the conjunction that *Signal to Noise* actually works. It's the fact that it's two people, both trying to do things that overlap, that are different. Having to do with communication arcs and all that stuff" (Comics Journal #155, 1993).

The serialized magazine story was expanded and collected into a book in 1992, published by Gollancz. In 1999 it was adapted for the stage by Marc Rosenbush and Robert Toombs of NOWtheatre in Chicago, but three years before that it was the BBC radio play that captured the idea best. Adapted by Gaiman and broadcast in 1996, it featured musical compositions by McKean, who is not only a stellar artist but also an incredible musician. McKean felt that it dealt with the themes of signal

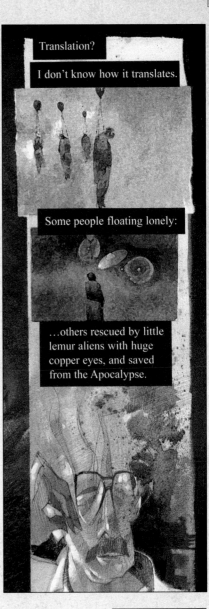

Translation?

I don't know how it translates.

Some people floating lonely:

…others rescued by little lemur aliens with huge copper eyes, and saved from the Apocalypse.

ABOVE: Earlier version of an image used again for *Miracleman* #22 cover. Men in the sky, hoisted aloft by gray balloons.

and noise in the purest way possible: sound. As he said in his introduction: "People generally seem to need pictures to be recognizable, but soundscapes are by definition impressionistic, abstract. The background noise sometimes swamps the foreground. You feel it, like you feel the emotion in music. It doesn't need explanation" (McKean, 2007).

McKean has plans to turn it into a film, but it hasn't happened yet. ❖

miracleman

"The initial thing that attracted me to Miracleman was the idea of setting stories in Utopia. What do you do with Utopia as a writer? What do you use those stories to comment on? [It was] an opportunity to do a series of stories that ask, 'If you've taken away most of the problems of human existence, what are you left with? And what you're left with is people continue to be people. You still get stories; stories don't stop. You just get a different set. I liked the fact that I had no supercriminals to worry about, no alien invasions."

MIRACLEMAN LIVED IN GAIMAN'S HEAD FOR YEARS BEFORE POSING ON THE PAGE IN HIS BLUE SPANDEX.

Before that, he lived in Alan Moore's head, and before that he took up space in Mick Anglo's. He's a character with a long and convoluted history, one which saw him being fought over right up to 2013, by several parties, in a custody battle in which biological details are hazy. Nobody quite knows who gave birth to Miracleman, although as of 2014, his adoption papers seem to have been settled.

Marvelman, as he was called in the beginning—before Marvel Comics suggested a rebrand—was Moore's reimagining of a cheesy 1950s British comic by Mick Anglo—a sort of Captain Marvel with Dan Dare voices. It first appeared in the pre-*Watchmen* days of 1982 in issue one of the Dez Skinn-edited *Warrior* and was a distinctly unusual kind of superhero comic; it was groundbreaking before the word "groundbreaking" was permanently grafted onto the front of Alan Moore's name. Moore said at the time:

What we're attempting to do with Miracleman *is strip away a lot of the accumulated clichés and dross that have built up around the superheroes, and try to get back to what we perceive as the original idea—which was probably something very closely akin to the original function of the Greek and Norse legends. When those particular legends were current, when they had just been evolved, they were contemporary: they weren't set in an exotic faraway land or a faraway time, they were happening at the end of the street. What we are trying to do is reinterpret the idea of a god amongst people, which is basically what the idea of a superhero is, even though the original idea had been diluted.*

We'll also be going into the psychology of the character, trying to get into what it would feel like to actually do all this bizarre and miraculous stuff. Anytime someone jostled you in the line at the cafeteria you could just throw them into orbit. I think it would probably change your view of society slightly.

Those are the areas we're going to get into: what it feels like for the person himself being a god amongst creatures that must look to him like animals. What it feels like for the humans suddenly being confronted with something that's a million times better than they are (Amazing Heroes Preview Special #2, 1986).

Moore had taken the superhero on the page and turned him into a god relevant to the twentieth century. "It's like a new synthesis of politics and religion, a new definition of godhood in comic terms, with social, sexual, and religious implications. It's best described as taking the essential images of the superhero tradition, the Jack Kirby Thor and Asgard imagery, and trying to make them strange and different" (*Amazing Heroes Preview Special* #5, 1987). Then, having carefully removed all of the devices and hooks of comics, making it a purely Alan Moore fiction, he decided to hand it over to someone else: Gaiman.

It was 1986. *Violent Cases* was still being drawn, Gaiman was untried, untested, and absolutely green. *Black Orchid* was not even a glint in the milkman's eye and Alan Moore was on the phone asking him to take over when he was done. Gaiman had only phoned to ask him to put in a good word with Karen Berger (who was just about to

ABOVE:
Full-page spread in Eclipse Comics' *Miracleman* #24, August 1993, art by Mark Buckingham. This was the fifth last page of *Miracleman* art to be published up to now.

board that flight to London to find new British writers), and now he was being given *Miracleman*. This no doubt steeled his nerves and puffed his chest in that meeting with DC Comics. As he told Alex Amado:

Alan is a very hard act to follow. They're very large shoes to get into and carry on walking in, especially since Miracleman *was the first and set the tone for superheroes in the 1980s. It's where it all started.* Watchmen *and everything that came after it, it all goes back to* Miracleman. *He actually asked me to do it a couple of months before I met with DC and talked about doing* Black Orchid. *We are going back a long time. It meant that I actually had a long time to think about it. I had*

"*Miracleman . . . set the tone for superheroes in the 1980s. It's where it all started.*"

three years to think about it. During that same conversation, I said, "What are you going to do? How's it going to end?" and he said, "Well, how it's going to end is that Miracleman is going to take over the world, and he's going to make it into a perfect utopia, all peace and light and happiness, and there will be no war, no criminality, no danger of invasions from space, no insanity, no illness, and it will be a particularly perfect world, thus in one fell swoop I've taken away from you every device for telling superhero stories." I found that concept fascinating, so that was where I started. There was also a level where what I wanted to do began to feed what Alan was doing. I told him what I was planning to do and we fed that back into the last few issues of Miracleman *that he was doing.*

Moore figured it would be about six months, but it was more like three years by the time Gaiman took the reins. When he got it, this particular horse had already weathered the death of *Warrior*, a name-change, enormously long printer delays, fights over payment, and problems with publishers. Nobody knew who owned the idea but Moore transferred whatever it was he theoretically owned to Gaiman, handing him the baby, basket, and all. A short *Miracleman* story, "Screaming," appeared as a backup in *Miracleman* publisher Eclipse's *Total Eclipse* #4 in January 1989, the same month as *The Sandman* #1. By the time Gaiman's first full issue arrived in June 1990, *Sandman* was well underway; the last issue of *The Doll's House* more or less coincided with *Miracleman* #17.

Gaiman liked that he could be as strange and experimental as he wanted in *Miracleman*. He said to Amado, "I can go off on tangents that I probably wouldn't allow myself to do in *Sandman*. In *Sandman*, if there's a choice between telling a story two ways—one of which might work very well or might be a total fiasco, and another way of telling it which probably will work—I will go for the one which probably will work. In *Miracleman* I am far more tempted to go for the way that might be a complete mistake, might be a major fiasco, might make me the laughing stock of the comics industry. I'm more tempted to go for the stranger, more out-on-a-limb way, to see if it's going to work or not."

One of the strangest and most glorious things about *Miracleman*, and which still remains so, more than two decades since it first appeared, is the art by Mark Buckingham. "Bucky" was just twenty when he met Neil at the Society of Strip Illustration back in the *Borderline* days, and Neil recalls, "Hunter Tremayne took us all down to the SSI, I think because we were doing a presentation on *Borderline*. And then we kept going back on the first Thursday of every month or whatever it was. After a year or so I was dragooned onto the board of directors on the board of the SSI. So I went along to board meetings and then I found myself chairman of the SSI. So I had to go. I went every month. And Mark Buckingham,

Post-It™ brand
Fax Transmittal memo 7672 No. of Pages Today's Date 10/1/93 Time

LYNN
eclipse

To
Company
Location
Fax #
Comments

...neverland (!)
...! I've been gabbing?
Telephone # ...P. Pan all morning... :)

...Bucky who says he'll
have...the 15th of this month. That means I'll need more
pages...other quickly. Is there anything you could send today?
What about a couple of five-page batches over the next 2 weeks?

Original Disposition: ☐ Destroy ☐ Return ☐ Call for pickup

3614 Greenbrier Drive
Bettendorf, Iowa 52722
September 27, 1993

Miracleman
c/o Eclipse Comics
P.O. Box 1099
Forestville, California 95436

Dear Cat, Neil, Bucky, etc:

Re: MIRACLEMAN #24. Was it worth the wait? Well, I suppose. Do I want to wait that long again? No, thank you.

I really loved the artwork, the ironic play with the cliche of a title, and most of all the twist of the ending. It was actually satisfying to have Avril proven wrong. When Alan Moore put in the implication that Young Miracleman had a crush on MM, it was a novel idea. Now the idea of homosexual overtones in sidekick relationships has been done over by books like *Bratpack* by Rick Veitch, and homosexuality in comics isn't quite so novel anymore. It seemed much more right for a young man like Dicky Dauntess, considering the time period he's from, to haul off and deck MM. That was a great splash page by Mark Buckingham, and very effective scripting by Neil, using the panel for special effect, having to turn the page wondering how YMM would respond, then having MM sail out at you. I'm sure Neil planned that down to the "T" in his script.

I also thought the introduction was captivating. The idea of a video of the battle with the Adversary in London worked well. It reminded me of that fantastic issue, #15, one of the best comics I've ever read. Reading sent a chill down my spine, remembering that sequence where MM had killed Johnny and then cradled his body while being surrounded by the carnage of the battle. Neil's subtle handling of how Dicky misinterprets what he sees was excellent. Not many comics writers (Alan Moore excepted) are able to add so many levels to such a short sequence.

Number 25 is scheduled for October release, I see. Well, I'm not going to hold my breath, but I will definitely keep my eyes open.

E.J. Larew

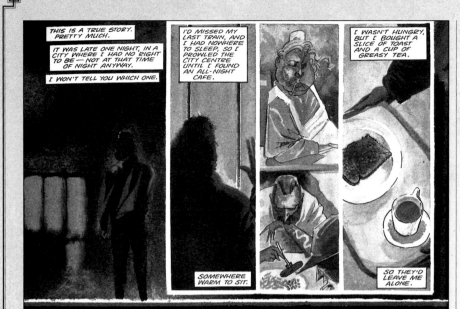

THIS IS A TRUE STORY. PRETTY MUCH.

IT WAS LATE ONE NIGHT, IN A CITY WHERE I HAD NO RIGHT TO BE — NOT AT THAT TIME OF NIGHT ANYWAY.

I WON'T TELL YOU WHICH ONE.

I'D MISSED MY LAST TRAIN, AND I HAD NOWHERE TO SLEEP, SO I PROWLED THE CITY CENTRE UNTIL I FOUND AN ALL-NIGHT CAFE.

SOMEWHERE WARM TO SIT.

I WASN'T HUNGRY, BUT I BOUGHT A SLICE OF TOAST AND A CUP OF GREASY TEA.

SO THEY'D LEAVE ME ALONE.

feeders & eaters

HEY. YOU. HEY... I KNOW YOU. COME HERE.

THEN HE SAID MY NAME.

UM. HELLO?

DON'T YOU KNOW ME?

EDDIE BARROW?

C'MON, MATE. YOU KNOW ME.

I IGNORED IT. YOU DON'T WANT TO GET INVOLVED. NOT WITH PEOPLE LIKE THAT.

I SUPPOSE THAT WAS WHAT WAS SO HORRIBLE.

I DID.

ABOVE AND OPPOSITE: Another 1990 Gaiman/Buckingham collaboration. It began as a dream that Gaiman tried to get down on paper. While he thought that Bucky did an excellent job of painting it, Gaiman was never happy with it as a comic, so he rewrote it as a short story to get it right.

who had also turned up right at the end of *Borderline*, was coming to the SSI and he showed me a strip he did in a magazine by Don Melia and Lionel Gracey-Whitman called *Heartbreak Hotel*."

Heartbreak Hotel was the magazine Melia and his boyfriend Gracey-Whitman produced after *Strip Aids*, a charity comic to raise money for an AIDS care center in London. Buckingham's contribution to *Strip Aids* was a one-page story called "The Party Trick," which was just a guy inflating a condom over his head until it exploded. It was spotted by the people at *The Truth* magazine, and he landed a job illustrating funny articles by the Peace and Love Corporation—the very first Gaiman/Buckingham collaboration. His later strip for *Heartbreak Hotel*, the one he showed to Gaiman, was called "The Wild Side of Life." Purely coincidentally, it was a strip inspired by the work of two *Miracleman* artists, Garry Leach and Alan Davis.

"Mark had done a story in it where he'd adapted the song, the Honky Tonk Angel story. You know, 'Didn't know god made honky tonk angels, might've known you'd have never made a wife, you gave up the only one who ever loved you and went back to the wild side of life'? And in it, a cowgirl flies off. And there's this just wonderful lightness and magic to the drawing. And I said to Mark: would you like to draw *Miracleman*? And he said: Sure! That was how Mark became part of my gang."

Gaiman plotted three books of six issues each, after which he planned to hand it over to another writer. *The Golden Age* was a series of short stories set in Utopia, *The Silver Age* was a long storyline falling away from Utopia, and *The Dark Age* was going to span just two days, 200 years into the future. The plan for *Miracleman* was to start slow and speed up over time. Said Gaiman in 1992: "I wanted, initially, to just explore in a leisurely way this incredible world that Alan had created. Also, partly, I wanted to spend a long time on *The Golden Age* in order to make *Miracleman* mine. Because everyone knew that *Miracleman* was Alan Moore. It was pretty much where he started. We were trying, deliberately, not to do very much in terms of plot, but to do a lot in terms of world and character. So that when I bring all of Alan's characters back on stage, people don't go, 'Oh, but it's not like Alan did it.' That was a bigger concern of mine in 1986, when I plotted *Miracleman*, than it is now. I wasn't confident in my own voice then" (*Comics Forum #2*, 1992).

But in the end, they only got halfway through the second book when the bottom fell out of the publishing company. Gaiman and Bucky wrote and illustrated nine issues before Eclipse died, and the last issue to see